D1598793

COLD WAR MODERNISTS

GREG BARNHISEL

COLD WAR MODERNISTS

Art, Literature, and
American Cultural Diplomacy

Columbia University Press / New York

Columbia University Press
Publishers Since 1893
New York Chichester, West Sussex
Copyright © 2015 Columbia University Press

Chapter 3 appeared in an earlier form in *Book History* 13 (2010).

A shorter version of Chapter 4 appeared in *ELH* 81, no. 1 (2014).

Chapter 5 appeared in a very preliminary incarnation in *Modernism/Modernity* 14, no. 4 (2007). © Johns Hopkins University Press.

Published and unpublished material by James Laughlin, copyright © 2005, 2014 by the New Directions Ownership Trust. Used by permission of New Directions.

Unpublished material from Stephen Spender used by kind permission of the Estate of Stephen Spender.

Unpublished material from Irving Kristol used by kind permission of Gertrude Himmelfarb Kristol.

Library of Congress Cataloging-in-Publication Data

Barnhisel, Greg, 1969–

Cold War modernists : art, literature, and American cultural diplomacy / Greg Barnhisel.

pages cm.

Summary: "An examination of the legacy of modernism as a cultural movement and propaganda tool during the Cold War and the 1950s in America"—Provided by publisher.

Includes bibliographical references and index.

ISBN 978-0-231-16230-2 (cloth : acid-free paper) — ISBN 978-0-231-53862-6 (ebook)

1. United States—Cultural policy. 2. United States—Intellectual life—20th century. 3. Modernism (Aesthetics)—Political aspects—United States—History—20th century. 4. Propaganda—United States—History—20th century. 5. Cold War—Political aspects—United States. 6. Art—Political aspects—United States—History—20th century 7. Politics and literature—United States—History—20th century. 8. United States—Politics and government—1945–1953 9. United States—Politics and government—1945–1953 9. United States—Politics and government—1953–1961. I. Title.

E169.12.B2947 2015

973.91—dc23 2014017122

Columbia University Press books are printed on permanent and durable acid-free paper.

This book is printed on paper with recycled content.

Printed in the United States of America

c 10 9 8 7 6 5 4 3 2 1

COVER DESIGN: Lisa Force

References to Internet Web sites (URLs) were accurate at the time of writing. Neither the author nor Columbia University Press is responsible for URLs that may have expired or changed since the manuscript was prepared.

CONTENTS

CONTENTS

ABBREVIATIONS AND NOTE ON UNPUBLISHED SOURCES

ABBREVIATIONS IN TEXT

AAPL	American Artists Professional League
ABPC	American Book Publishers Council
ACCF	American Committee for Cultural Freedom
AFA	American Federation of Arts
ALA	American Library Association
CIA	US Central Intelligence Agency
CPI	Committee on Public Information
CCF	Congress for Cultural Freedom
HICOG	Office of the High Commissioner for Occupied Germany
ICS	Information Center Service
IMG	Informational Media Guaranty
IRD	UK Information Research Department
IIA	International Information Administration
MoMA	Museum of Modern Art
NSC	US National Security Council
OCB	Operations Coordinating Board
OFF	Office of Facts and Figures
OIAA	Office of Inter-American Affairs

OPC	Office of Policy Coordination
OWI	Office of War Information
PSB	Psychological Strategy Board
RFE	Radio Free Europe
UNESCO	United Nations Educational, Scientific, and Cultural Organization
USIA	United States Information Agency
USIS	United States Information Service
VOA	Voice of America
VOKS	All-Union Society for Cultural Relations with Foreign Nations

UNPUBLISHED SOURCES AND THEIR ABBREVIATIONS

Unpublished source material comes from the following archives, libraries, and collections, and the following abbreviations, in addition to the abbreviations given in the text, appear in the endnotes:

AAA	Archives of American Art, Smithsonian Institution, Washington, DC
ALA	American Library Association Archives, University of Illinois at Urbana-Champaign Library
BU	*Encounter* Magazine Collection, Howard Gotlieb Archival Research Center, Boston University
COL	USIA Broadcast Center Munich Records, Bakhmeteff Archive, Columbia University, New York
DDEL	Dwight D. Eisenhower Presidential Library, Abilene, KS
FFA	Ford Foundation Archives, Rockefeller Archive Center, Sleepy Hollow, NY
HRC	Harry Ransom Humanities Research Center, University of Texas at Austin
HSTL	Harry S. Truman Presidential Library, Independence, MO

ABBREVIATIONS

HVD	Houghton Library, Harvard University, Cambridge, MA
IACF	International Association for Cultural Freedom Papers, Special Collections Research Center, University of Chicago Library, Chicago
IPI	Intercultural Publications Manuscripts, Lilly Library, Indiana University at Bloomington
LOC	Microform Reading Room, Library of Congress, Washington, DC
NANY	National Archives at New York
NARA	National Archives and Records Administration, Archives II, College Park, MD
PUL	Princeton University Libraries, Princeton, NJ
RG	Record Group (used with National Archives records)
RU	Record Unit (used with Smithsonian records)
SIA	Smithsonian Institution Archives, Washington, DC
TAM	American Committee for Cultural Freedom Papers, Tamiment Library and Robert F. Wagner Labor Archives, New York University, New York
UARK	US Department of State Bureau of Educational and Cultural Affairs Historical Collection, Special Collections Library, University of Arkansas, Fayetteville
YALE	Manuscripts and Archives, Sterling Memorial Library, Yale University, New Haven, CT

ACKNOWLEDGMENTS

ESEARCHING AND WRITING this book has been one of the great pleasures of my life, in no small part because of the people and institutions I have encountered along the way. A work like this, so heavily grounded in primary-source research at many libraries and archives, is especially dependent on outside financial assistance, and I am immensely grateful for the support I received from several benefactors, including the National Endowment for the Humanities, which gave me a summer stipend in 2005 and a year-long fellowship in 2013; the Harry Ransom Humanities Research Center at the University of Texas at Austin, which awarded me a Mellon Fellowship in 2007; the Eisenhower Foundation, which awarded me a travel grant in 2013; the Friends of the Princeton University Libraries, which awarded me a fellowship in 2013; as well as the Department of English and the McAnulty College and Graduate School of Liberal Arts at Duquesne University, both of which have provided me with unstinting support over the years.

In addition, many library professionals provided valuable assistance with this book, including Kevin Bailey and Chalsea Millner at the Dwight D. Eisenhower Presidential Library; Jonathan Green at the Ford Foundation Archives; Melissa Salrin at the American Library Association Archives at the University of Illinois at Urbana-Champaign; Tom Staley, Pat Fox, and the reading room staff at the Harry Ransom Humanities Research Center at the

University of Texas at Austin; Rachel Howarth at the Houghton Library of Harvard University; Saundra Taylor at the Lilly Library, Indiana University at Bloomington; Bonnie Marie Sauer of the National Archives at New York; Judy Donald, archivist at Choate Rosemary Hall; Christine Cheng, Special Collections & Archives, George Mason University; and Vera Ekechukwu at the Special Collections Library, University of Arkansas at Fayetteville. I am also grateful to the staff of the Special Collections Research Center, University of Chicago Library; the Tamiment Library and Robert F. Wagner Labor Archives at New York University; the National Archives and Records Administration Archives II facility in College Park, Maryland; Manuscripts and Archives at Yale University Library; the Rare Book & Manuscript Library at Columbia University; the Smithsonian Institution Archives; the Archives of American Art at the Smithsonian Institution; the Howard Gotlieb Archival Research Center at Boston University; the Library of Congress; Princeton University Libraries; and the Harry S. Truman Presidential Library and Museum.

Thanks also go to the late Hayden Carruth; the late James Laughlin; Martin Manning, US Department of State; Margaret Cogswell; Sol Schindler; Yale Richmond; Matthew Corcoran; Elspeth Healey, Kansas University Libraries; Patricia Hills, Boston University; Peggy Fox and Ian Macniven; Neil Jumonville; David Bell and Gertrude Himmelfarb Kristol; colleagues and friends Michael Winship, Linda Kinnahan, Dan Watkins, James Swindal, John Fried, Laura Engel, Magali Michael, the late Albert Labriola, Trysh Travis, Cathy Turner, Kristin Matthews, Jonathan Silverman, Dean Rader, Al Filreis, Lawrence Rainey, and Ezra Greenspan; research assistants Jennifer Collins, Greg Harold, Melissa Wehler, Ian Butcher, and Mariah Crilley; and Philip Leventhal and Whitney Johnson of Columbia University Press and the anonymous readers who provided such valuable feedback on this manuscript.

And, of course, this book is dedicated to Alison, Jack, and Beckett, who have heard entirely too much about the Cold War and modernism over the past ten years.

COLD WAR MODERNISTS

INTRODUCTION

I N HIS 1976 polemic *The Cultural Contradictions of Capitalism*, Daniel Bell argued that modernism in the arts led to what he saw as the social ills of the 1960s and 1970s: divorce, pornography, crime, drugs, the countercul- ture.[1] Bell was not the only prominent intellectual or artist for whom mod- ernism was a deeply insidious threat to the social and cultural order, even after the movement had lost its vitality and energy. In the early 1970s, for example, poet Philip Larkin became a kind of spokesman for antimodern- ist artists when he lashed out against "Pound, Picasso, and Parker['s]" pur- suit of experiment for its own sake. A wide-ranging antimodernist backlash predated Bell and Larkin, as Al Filreis documents, showing how forces as diverse as Harvard poet Robert Hillyer and the John Birch Society united in the 1950s against modernist poetry.[2] Bell and Hillyer and Larkin, like the other antimodernists, identified in modernism a fundamentally antinomian attitude—in Irving Howe's words, "an unyielding rage against the existing order,"[3] an unrelenting drive to reject, break down, and toss out, all in search of the new—that was deeply threatening to the survival of our cultural pat- rimony, to the comforts and freedoms and securities of Western civilization. And yet if modernism wanted to undermine bourgeois culture, it was an utter failure. If anything, modernism came not to bury but to *adorn* bourgeois life, colonizing its houses and its products and its entertainments. "From a cause

that intended to remake the world," Bell's longtime colleague Nathan Glazer wrote in 2007, modernism "has become a style."[4]

What happened? How did modernism move from being a "cause" to being a "style"? And in so doing, how did modernism's self-presentation and the public's perception of it change? For much of the first half of the twentieth century, modernism had no fixed cultural or political meaning. The wildly disparate modernist movements in the arts had little in common apart from a devotion to formal experimentation and a rejection of traditional methods of representing reality. If modernism had a public image in the first half of the twentieth century, it would probably be its rebellion against all existing standards and institutions and its relentless pursuit of the new for its own sake.

In the 1950s, though, modernism took on new and surprising meanings due to the changing political and cultural environment, eventually being used in support of Western middle-class society. In fact, modernism became a weapon in what has become known as the "cultural Cold War," the struggle for cultural prestige and influence between the Communist Soviet Union and its Eastern Bloc satellites on one side and the United States and the nations of western Europe on the other. The battles of the cultural Cold War ranged from heated exchanges at international conferences to dueling theatrical productions to competing literary and cultural journals. In the early 1950s, a key battleground of this war was the sympathies of influential leftist western European intellectuals, the vast majority of whom reviled what they saw as the shallow, business-dominated culture of the United States and its "Coca-colonization" of the rest of the world, but who were also leery of Stalinist dictatorship and militarism. In response, cultural diplomats offered American modernism in painting, literature, architecture, and music as evidence of the high cultural achievement of the United States.

In so doing, they also changed public understanding of modernism. Even as it retained its associations with innovation and the drive for the new, modernism also came to be presented as a pro-Western, pro-"freedom," and pro-bourgeois movement, evidence of the superiority of the Western way of life. These associations, in turn, effaced its previous links with threatening political and cultural movements. Any number of institutions helped modern-

ism move from the fringes to the center and accommodate itself to bour-
geois society (and vice versa) in the 1940s and 1950s: the publishing industry,
academia, the mass media, arts and cultural foundations, the theater world,
and others. But, as this book shows, Cold War political and cultural impera-
tives, carried out through a wide variety of official and unofficial programs,
accelerated and intensified this development. Modernism's specific uses as
cultural-diplomatic propaganda were as diverse as those who put policy into
practice, from government offices such as the United States Information
Agency (USIA) to government-supported groups such as the Congress for
Cultural Freedom (CCF) to private organizations such as the Ford Founda-
tion. Together, they argued that the very innovation and antitraditionalism
that had once made modernist art and literature so threatening to middle-
class society proved that Western culture was superior to the new model of
culture being forged in the Soviet Union and its satellite nations. I call these
1940s and 1950s programs that used modernism for pro-Western propaganda
as well as the politically driven reinterpretation of the modernist movement
that undergirded these programs "Cold War modernism."

In its first stages, Cold War modernism highlighted certain formal ele-
ments of modernist art (in particular its techniques of representation) and
adopted the idea, held by some but by no means all modernists, that art
should be autonomous from the practice of daily life, not subject to evalua-
tion by social or political criteria. It then dispensed with the more revolution-
ary or reactionary political associations that had marked modernism in the
public mind in the first part of the century, replacing them with a celebration
of the virtues of freedom and the assertion that the individual is sovereign.
What remained of modernism, then, was a set of formal techniques and atti-
tudes unique to each art form but sharing some important commonalities
across genres: allusiveness, abstraction, fragmentation and indirectness, the
sense of being belated within a cultural tradition, the subsumption of emotion
under formal technique, the retreat of the personality of the artist into the
background behind different "masks" or narrative voices, and, above all, high
seriousness. Largely emptied of content, modernism as a style retained its
prestige and status, particularly among intellectuals, which made it an appeal-
ing attribute for consumer products and middlebrow artworks that employed

modernist techniques but without the seriousness, aesthetic unity, or moral depths of the best modernist works. It also allowed modernism to serve as propaganda for the West, the United States in particular. Precisely how that happened is the subject of this book.

Cold War modernism isn't a style or a period: it is a rhetorical reframing that capitalized on the conjunctions of government, business, and elite cultural institutions (museums, foundations, and universities) particular to America of the 1940s and 1950s. These conjunctions, then, shifted in the 1960s due to larger changes in American politics, culture, economics, and demographics. This book thus attempts three things: to use original archival sources to document the diverse projects to disseminate American modernist art and literature abroad, particularly in Europe, in the period 1946–1959; to identify, synthesize, and analyze the rhetoric surrounding these projects, in particular how it attached seemingly incongruous American values such as freedom and individualism to modernist artworks; and finally, to suggest that this rhetoric, whatever its effect in the geopolitical or diplomatic arena, worked to "swerve" public understanding of modernism, deactivating or nullifying its associations with radicalism and antinomianism and making it safe for consumption by American middle-class audiences.[5]

This is not an entirely new argument. Until the mid-1970s, it was generally assumed that cultural diplomacy in the 1950s shied away from modernism in favor of popular culture: Willis Conover's jazz shows on Voice of America (VOA) radio, for example, and tours of Europe by a production of *Porgy and Bess* and musicians Dizzy Gillespie, Louis Armstrong, and Dave Brubeck. But reports in 1966 that the Central Intelligence Agency (CIA) had provided funding for the CCF, a European nongovernmental group that promoted experimental art, revealed that the United States had at one point *covertly* used modernist art. But what has become known as the "revisionist argument" about the relationship between modernism and the Cold War coalesced in *Artforum* in the mid-1970s. The revisionist thesis—developed by Max Kozloff, Eva Cockroft, and David and Cecile Shapiro, made famous by Serge Guilbaut, and further elaborated by Frances Stonor Saunders—holds that abstract expressionism, apolitical and internationally prestigious, was an ideal "weapon of the Cold War" for the United States.

Max Kozloff's article "American Painting During the Cold War" appeared in *Artforum* in May 1973 but had served previously, in a slightly different form, as the introduction to the Des Moines Art Center's *Twenty-five Years of American Painting 1948–1973* exhibition catalog. At a time when the standard explanations of abstract expressionism were heavily indebted to Clement Greenberg's formalism and Harold Rosenberg's psychological analysis, Kozloff's article contextualized the movement within its historical and cultural moment. For Kozloff, the postwar period was characterized by "tension," the sense that the present moment was "a series of perpetual crises instigated by a tightly coordinated, monolithic Red conspiracy."[6] American painters of the period drew their energies from this tension (which was artificially created, in Kozloff's view) and, seeing that World War II had ended Europe's dominance of the cultural world, quite self-consciously stepped into the vacuum. Kozloff highlighted the abstract expressionist painters' rhetoric of freedom and liberty, quoting Robert Motherwell's observation that "modern art is related to the problem of the modern individual's freedom. For this reason the history of modern art tends at certain moments to become the history of modern freedom." Kozloff warned that Motherwell was not explicitly endorsing the American model of capitalist freedom and individualism, but he also pointed out that "in a very curious backhanded way, Motherwell was by implication honoring his own country. Here, at least, the artist was allowed, if only through indifference, to be at liberty and to pursue the inspired vagaries of his own conscience. . . . Modern American art, abandoning its erstwhile support for left-wing agitation during the '30s, now self-propagandized itself as champion of eternal humanist freedom."[7]

If Kozloff first identified the connection between abstract expressionism and Cold War values, Eva Cockroft, writing in *Artforum* in 1974, argued that this link was deliberate and purposeful. Where Kozloff had merely said that "the belief that American art is the sole trustee of the avant-garde 'spirit' [is] . . . *reminiscent of* the U.S. government's notion of itself as the lone guarantor of capitalist liberty," Cockroft scolded Kozloff for suggesting that this similarity was merely a "coincidence . . . unnoticed by rulers and ruled alike" and insisted that abstract expressionism's rise was due to its usefulness in Cold War rhetoric.[8] Cockroft's argument rests heavily on the role played by Nelson Rockefeller, who moved in

1940 from being president of the Museum of Modern Art (MoMA) (a "major supporter of the Abstract Expressionist movement") to being the coordinator of the Office of Inter-American Affairs (OIAA) and later the assistant secretary of state. She asserted that MoMA's entanglement in US foreign policy "became unmistakably clear during World War II" and pointed to many specific instances in which MoMA and the Department of State or USIA worked closely together in the service of US foreign policy and to the benefit of abstract expressionism.[9] She concluded that the purported "objectivity" of abstract painting—"objective" in relation to the politically inflected realist art of the 1930s—"served America's needs in the Cold War" in that it "divorced" art and politics.[10] Cockroft also identified but did not develop an argument about the "individualist ethos" of abstract expressionism being used as a contrast to Soviet collectivism. In 1977, David and Cecile Shapiro augmented Cockroft's analysis, writing that

> the critics [Greenberg and Rosenberg] and their theories, the art publications as well as the general press, the museums led by the Museum of Modern Art, the avant-garde art galleries, the clandestine functions of the CIA supported by the taxpayer, the need of artists to show and sell their work, the leveling of dissent encouraged by McCarthyism and a conformist era, the convergence of all varieties of anti-Communists and anti-Stalinists on a neutral cultural point, the cold war and the cultural weapons employed in its behalf, American postwar economic vigor and its sense of moral leadership, plus the explosion of a totally new kind of American-born painting that seemed the objective correlative of Greenberg's early announcement that "the main premises of Western art have at last migrated to the United States"—all these combined to make Abstract Expressionism the only art acceptable on a wide scale during the conforming 1950s.[11]

Serge Guilbaut gave the revisionist thesis its fullest statement in *How New York Stole the Idea of Modern Art*, published in 1983. Like the Shapiros, Guilbaut traced how artists—in tandem with the critics of *Partisan Review* and other journals—rejected the Popular Front leftism of the 1930s and "elaborated, in 1947 and 1948[,] . . . a 'third way,' abstract and expressionist, that was

said to avoid extremes both left and right, that was, or so it was claimed at the time, both liberated and liberating." "Because of avant-garde art's self-proclaimed neutrality," Guilbaut pointed out, "it was soon enlisted by governmental agencies and private organizations in the fight against Soviet cultural expansion."[12] Furthermore, the very bohemianism of the avant-garde artists—the fact that they still lived as *refusés* in a philistine society that scorned their achievements—spoke to the diversity and freedom of American life. "Avant-garde art," Guilbaut argued, "succeeded because the work and the ideology that supported it . . . coincided fairly closely with the 'new liberalism[,]' . . . [which] not only made room for avant-garde dissidence but accorded to such dissidence a position of paramount importance."[13]

Guilbaut also carefully dissected the class politics behind the acceptance of modern/avant-garde art, asserting that middlebrow opposition made it more appealing to intellectuals and cultural (and economic) elites. Finally, for her book *The Cultural Cold War*, published in 2000, Frances Stonor Saunders marshaled an impressive amount of primary-source research (particularly among CIA sources) to bolster this thesis, arguing that in the propaganda war with the Soviets, abstract expressionism became "proof of the creativity, the intellectual freedom, and the cultural power of the [United States]. Russian art, strapped into the communist ideological straitjacket, could not compete."[14] But although Saunders strongly *suggests* that abstract expressionism succeeded largely because of its sponsorship by the CIA, she is reluctant to make that claim categorically.

> Would abstract expressionism have been the dominant art movement of the postwar years without this patronage? The answer is probably yes. Equally, it would be wrong to suggest that when you look at an abstract expressionist painting, you are being duped by the CIA. But note where this art ended up: in the marble halls of banks, in airports, in city halls, boardrooms, and great galleries. For the Cold Warriors who promoted them, these paintings were a logo, a signature for their culture and system that they wanted to display everywhere that counted. They succeeded.[15]

Kozloff, Cockroft, the Shapiros, Guilbaut, and Saunders are important precursors of my work, and I am indebted to their pioneering research. But

in *Cold War Modernists*, I hope both to broaden and to complicate their argu-
ments. The advocates of the revisionist thesis tend to present abstract expres-
sionism as a kind of contentless form into which "the government" could
pour meaning. That is to say, they argue that because abstract expression-
ism—unlike American leftist Popular Front art, Dadaism, futurism, or social-
ist realism—did not have a discernible political stance, art impresarios in the
government could inflect that art with a meaning: in this case, *only a free soci-
ety could create art this challenging and allow artists this daring the freedom to cre-
ate.*[16] Then (the revisionist thesis goes) the cultural and political elites pointed
to abstract expressionism's preeminent place in Western art—achieved in part
due to the material and institutional assistance given the movement by the
same cultural and political elites—and crowed that abstract expressionism's
artistic and cultural success *also* demolished the prejudice that the United
States lacked culture.

Although broadly correct, most elaborations of the revisionist thesis, I feel,
are also oversimplified and conspiratorial; they fail "to address adequately the
decentered and contradictory nature of [the] power relationship" between
the artists and those who wished to use their art for political ends, as David
Craven persuasively charges.[17] Guilbaut, Saunders, and the others lacked a
sufficiently nuanced understanding of the workings of the US government
or other cultural institutions and so read a large, diverse, and messy set of
official and nongovernmental programs as a sleekly efficient covert CIA proj-
ect. But in a government as complex as that of the United States, numer-
ous overlapping offices and agencies and officials collaborate or even work at
cross-purposes to achieve the same aims; some bureaucracies die, while others
arise from their ashes, and personal rivalries and fiefdoms affect particular
programs' and agencies' direction and priority. What this means is that there
is no "government" per se: there are the Office of War Information (OWI),
the office of the assistant secretary of state for public affairs, the International
Information Administration (IIA), the Information Center Service (ICS) of
the Department of State, the Division of Educational and Cultural Affairs
of the Department of State, the USIA, the president and the White House
staff, the Operations Coordinating Board (OCB) and Psychological Strategy
Board (PSB), various presidential advisory commissions, the CIA, the staff

of the House Committee on Un-American Activities, and the various offices of individual members of Congress—all with their own values, constituencies, priorities, shifting concentrations of power and influence, and personal rivalries and agendas. Furthermore, these studies too often rely on guilt-by-association implications focusing on figures such as Nelson Rockefeller: if Rockefeller went from MoMA to the Department of State, we are asked to assume, he must necessarily have brought their interests into alignment.[18]

Certainly, the number of people who moved between the worlds of modernist art and literature and the governmental sphere in this era is striking, and it is hard to resist making assumptions about just how closely together they brought those worlds. Other such figures who appear in this study include poet and assistant secretary of state Archibald MacLeish; James Jesus Angleton, who ran a modernist magazine while at Yale in the 1930s and then served for many years as CIA's chief of counterintelligence; William J. Casey, who worked out of the Office of Strategic Services London office, then sat on the board of directors of James Laughlin's Intercultural Publications, then ran the CIA under President Reagan; Norman Holmes Pearson, another Strategic Service London veteran who taught modernist literature at Yale, acted as poet H.D.'s American representative and executor, and recruited Yalies into the CIA; and the many members of the CCF who had been successful artists and writers and whose degree of knowledge about the CCF's governmental ties is unclear. Absent from many of the revisionists' work, though, is the direct evidence: *to what degree* did Clement Greenberg, for instance, take suggestions from CIA figures about how to present abstract expressionism, even if he did accept money from the agency? What is the documentary evidence of this connection? As I elaborate in chapter 4, which focuses on *Encounter* magazine, the CIA certainly wanted to call the tune (to use Saunders's image from her book on this topic), but the pipers often refused to comply.

Moreover, regarding just the visual-arts programs, the revisionists tend to elide the distinction between abstract expressionism in particular and modernist painting as a whole—not to mention modernism across the arts. They argue that abstract expressionism made good propaganda because of its contentlessness and prestige. Although I agree with this point, it is also crucial to note that when these controversial touring exhibitions drew fire, it wasn't

the Jackson Pollocks or the Robert Motherwells or the Barnett Newmans that conservatives attacked: it was the Yasuo Kuniyoshis and the Ben Shahns and the Jack Levines, paintings that were modernist in technique but were certainly figurative (and often far from apolitical). The publicity materials that framed the shows called attention to a wide variety of modernist representational techniques, not just abstraction. And the conservative congressmen, media outlets, and citizens groups who criticized the inclusion of these paintings did so both because the works were modernist *and* because many of the artists were on the left. Cold War modernism did not just mean promoting Pollock because his works lacked social critique, although that was certainly a part of it. Cold War modernism in the visual arts gathered together works influenced by Dada, surrealism, expressionism, cubism, de Stijl, and other tendencies and argued that those movements, grouped together as "modernism," had come into being and found fertile ground in America because of the West's valorization of freedom and individualism. Nor can abstract expressionism be so easily dismissed as apolitical or as congruent with Cold War liberalism, either now or in its time, as the extensive Federal Bureau of Investigation files on Motherwell, Ad Reinhardt, Mark Rothko, Adolph Gottlieb, Lee Krasner, and Norman Lewis suggest.[19] The revisionists fail to account for—or, with the exception of Saunders, even mention—the much messier, much more conflicted, but still very vital role modernist literature and the other arts played in the Cold War modernist programs.

Finally, the revisionists fail to take into consideration the rhetorical battle over nationalism and "Americanism" that Cold War modernism sparked. Abstract expressionism and precisionism were largely homegrown movements, and the revisionists assert that the coronation of abstract expressionism was an audacious ploy, in Guilbaut's words, to "steal the idea of modern art" for America. But the other varieties of modernism present in art exhibitions were decidedly European, both in fact and in public understanding. Modernism's most vociferous detractors in the United States had warned at least since the Armory Show that modernism was fundamentally foreign, a threat to America's native artistic traditions. The success of Cold War modernism wasn't just a matter of promoting an American variety of the movement as the pinnacle of modernism; Cold War modernism *redefined* modernism as an

affirmation of Western bourgeois liberal values that were considered particu-
larly integral in the American self-construction. The international character
of modernism, like the military and economic alliances being forged through
the North Atlantic Treaty Organization and the Marshall Plan, served to knit
the West together, with the United States leading the way. Many of the artists
whose works were on display in these exhibitions were also either immigrants
or the children of immigrants; their Americanness and "Americanism" were
thus suspect. In using freedom and individualism to "Americanize" modern-
ism, then, Cold War modernism Americanized these artists.

As a project of one state to use its people and institutions (not just the
apparatus of the state itself) to present an argument, usually about culture,
to the people of other states, Cold War modernism falls under the rubric
of "cultural diplomacy," most commonly defined as "the exchange of ideas,
information, value systems, traditions, beliefs and other aspects of culture
among nations and their peoples in order to foster mutual understanding."[20]
Joseph Nye calls cultural diplomacy—which foregrounds "the attractive-
ness of a country's culture, political ideals, and policies"—a prime example
of "soft power," or the ability to persuade through culture, value, and ideas.[21]
Frank Ninkovich specifies that "a bedrock principle underlying the cultural
approach [is] the conviction that peoples ought to communicate directly with
peoples," echoing the State Department's Muna Lee, who wrote in a pioneer-
ing book in 1947 that "the cultural relationship is essentially that of friendship
from people to people, from the citizenry of one country to the citizenry of
another, through such channels of mutual acquaintance as make friendship
rewarding between individual and individual."[22]

Cultural diplomacy is always an informal element of a nation's interna-
tional relations, but most scholars see the period during and immediately
following World War I as marking the birth of modern cultural diplomacy,
brought about by new mass-communications technologies, by the techniques
of persuasion developed by the nascent public-relations industry, and by the
science of public opinion pioneered by Walter Lippmann and others. During
World War I, President Wilson hired George Creel to head the newly created
Committee on Public Information (CPI), often referred to as the U.S. gov-
ernment's first official propaganda agency. Although not a cultural-diplomacy

office, CPI was enormously influential for future cultural diplomats both for its techniques—*who* was targeted and *how*—and for its basic philosophy—that the creation of a positive image of the United States was a key element of the nation's war effort. "In its two years of existence," Richard Arndt writes, "CPI changed America as much as the war itself, and in the postwar years its offshoots helped transform the U.S. mind. CPI put in place a formal mix of government cultural, informational, and propagandistic diplomacy, touching every element of U.S. life."[23] Lippmann was on CPI's staff, along with both Ivy Lee and Edward Bernays, competitors who are considered the fathers of the field of public relations.

The United States, of course, was not the only nation engaging in cultural diplomacy in the 1950s and in fact had been late to the party. The Alliance Française (founded 1883) and the Società Dante Alighieri (founded 1889) were established to advance French and Italian language and culture, respectively; both were created by national intellectuals as nongovernmental organizations, although each received consistent governmental support. After World War I, the French, German, Soviet, and British governments created official cultural-diplomatic agencies: the Deutsche Akademie (now the Goethe-Institut) in 1925, the All-Union Society for Cultural Relations with Foreign Nations (known by its Russian acronym VOKS) in the Soviet Union in 1925, and the British Council in 1934. Those agencies joined other (unofficially) government-supported groups such as the National League of Germans Abroad and the English-Speaking Union to "keep alive a sentiment of cultural unity" and "keep open channels of influence," in Harold Lasswell's words from 1938.[24]

Uniquely among major nations, the United States has traditionally relied primarily on the private sector for its cultural-diplomatic undertakings. Businesses, foundations, trade groups, professional organizations, and private individuals are the best ambassadors for the American Way, goes the thinking, and in almost every one of the programs described in this book private organizations play a major role. Ninkovich argues that early American cultural diplomacy, as practiced by the foundations of plutocrat philanthropists such as Andrew Carnegie and John D. Rockefeller, was "almost childlike in its innocence" and belief that simply being more open could prevent the diplomatic

impasses and misunderstandings that led to war.[25] In 1938, the Department of State created its first dedicated cultural-diplomacy branch, the Division of Cultural Relations, specifying that the private sector would be "the major partner in developing policies."[26] Ninety-five percent of cultural diplomacy, Assistant Secretary of State Sumner Welles specified in 1938, should come from the private sphere: universities, foundations, museums, trade groups, business.[27] And even after the US government decided, in a series of acts in 1947–1948, to authorize, fund, and staff an expansive cultural-diplomacy effort, historian Francis J. Colligan pointed out in 1958, "these [private, non-profit] agencies . . . continued and even expanded their activities."[28] The US Informational and Educational Exchange Act (Smith–Mundt Act) of 1948, a major bill funding overseas information and cultural-diplomatic activities, specified that the secretary of state, in selecting materials to be distributed abroad, should "utilize, to the maximum extent practicable, the services and facilities of private agencies, including existing American press, publishing, radio, motion pictures, and other agencies, through contractual arrangements or otherwise. It is the intent of the Congress that the Secretary shall encourage participation in carrying out the purpose of this Act by the maximum number of different private agencies."[29]

Perhaps in part because of the involvement of the private sector, whose interests do not always converge with the government's, American cultural-diplomatic strategy has always been contested. As Ninkovich and Arndt have pointed out, even the earliest agencies tasked with cultural outreach roiled with conflict between on the one side the "informationalists," who felt that the primary purpose of cultural diplomacy was to serve immediate policy goals, and on the other side the "culturalists," who felt it should instead seek to present the fairest, most objective portrayal of American culture and thus establish long-term understanding.[30] From our postmodern perspective, this debate seems quaint; the notion that a government could produce objective or unbiased information about itself for dissemination among foreign populations seems on its face laughable. But culturalists insisted that a true and full presentation of American culture and society would, because of our nation's democratic and individualistic virtues, ultimately create friendships. They sought to emulate the British Council in establishing a permanent and

positive cultural presence in foreign nations. ("Because of the British Council," Assistant Secretary of State for Public Affairs Archibald MacLeish wrote, "no literate European will again refer to the English as a nation of shopkeepers."[31]) Libraries and reading rooms, exchanges of scholars and students, touring performers and artworks, and other such features characterized this approach, and culturalist stalwarts such as MacLeish and Arkansas senator J. William Fulbright ensured that such programs were established, funded, and supported.

Of course, it can be difficult to see how these "soft" programs advance US policy objectives, and thus the culturalist approach has repeatedly come under attack from diplomats in the State Department and from members of Congress, especially in times of national crisis. The "informational" pole of opinion holds that cultural diplomacy's purpose is spreading specific, targeted messages about American culture and society in support of immediate policy objectives. Drawing upon the propagandistic legacy of the CPI as well as the analytic approach of the public-relations industry and the messaging tactics of the advertising industry (and frequently employing veterans of those industries, from Lee and Bernays in the 1920s to broadcast executive Theodore Streibert in the 1950s to advertising executive Charlotte Beers during the George W. Bush administration), informationalists use culture in a much more muscular, targeted fashion.

World War II forced the cultural-diplomatic agencies to resolve these conflicts. In 1941, with a wary eye on German plans to build influence in the Western Hemisphere, President Roosevelt created the OIAA to spearhead propaganda and cultural diplomacy in Latin America, naming Nelson Rockefeller as its coordinator. OIAA's creation initially seemed a victory for the culturalists; Assistant Secretary of State for Latin America George Messersmith insisted that "we are not trying to make . . . counter-propaganda [but rather] . . . are interested in the broad basic problem of developing friendly relations between this country and our neighbors."[32] But Rockefeller quickly oriented his agency along the informationalist pole, predicating OIAA's work on what Arndt calls "unidirectional flows of information"—*telling* the Latin Americans about the United States rather than relying on free exchange between citizens and private organizations.[33] Unlike the Division of Cultural

Relations, the OIAA viewed its mission as specifically strategic and propagandistic, and Rockefeller (with extensive connections in the business world) encouraged private companies and organizations to defer to the OIAA's lead in forging cross-cultural ties.

Nelson Rockefeller spanned the divide between the art and foundation world, the business world, and the government. Heir to his family's oil fortune, Rockefeller was a primary benefactor and early president of MoMA and a great advocate for artistic modernism. As OIAA coordinator, Rockefeller had responsibility for the nation's "cultural and commercial relations" with Latin America, and as Arndt stresses, "Rockefeller added the phrase 'to help national defense.'" Arndt is critical of Rockefeller's ham-handed, corporate-friendly, unidirectional approach to cultural diplomacy: "Jumbling the words 'commerce,' 'information,' and 'propaganda' and linking them to 'culture,' Rockefeller's disruptive ventures were a mixed bag . . . they set dangerous precedents."[34]

Notwithstanding Arndt's criticism, Rockefeller's own career makes him a microcosm of the Cold War modernist project as a whole. Rockefeller began to elucidate not just a possible but a necessary connection between modernist art and capitalism, a connection that later efforts in cultural diplomacy, from those of the USIA to those of the CCF and the Ford Foundation, drew upon. He embedded this corporate- and government-friendly modernism in cultural diplomacy, putting American modernism in an implicitly authoritarian relationship to its foreign audiences. Finally, Rockefeller embraced the unidirectional and occasionally less than forthright techniques of the nascent public-relations industry in his approach to cultural diplomacy. Ivy Lee had been a family adviser since before Rockefeller entered government service, and his influence, through Rockefeller, helped determine the future direction of American cultural and public diplomacy. "Few left a mark on US informational and cultural diplomacy like Rockefeller's," Arndt concludes, "especially on the future USIA's activities and on the yet-unborn idea of Public Diplomacy, an accidental, ill-defined and contradictory mix of cultural relations and propaganda, vaguely resembling public relations."[35]

If Nelson Rockefeller embodies American cultural diplomacy's informationalist wing, Archibald MacLeish epitomizes its culturalist wing. And

where Rockefeller represents the collaboration of business and plutocracy with government, MacLeish stands in for the artist who engages in public service. MacLeish joined the "Lost Generation" in Paris in the 1920s and then wrote for Henry Luce's *Fortune* magazine in the 1930s, when it featured leftists such as James Agee and Dwight Macdonald on its masthead. Although MacLeish adamantly refused to associate himself with the Communist Party, his public political stances mirrored those of the Popular Front movement, and he published in such Communist-linked outlets as the *New Masses* during this time. Several senators faulted his 1930s leftism during the 1939 confirmation hearings for his nomination as Librarian of Congress.[36]

By most accounts an excellent manager who brought the Library of Congress into the twentieth century, MacLeish expanded his remit to include advocacy for the Roosevelt administration's position on the war in Europe. In speeches and writings, he explicitly linked freedom of information with democracy and opposed both to international fascism. He also stressed the importance of culture: writing in 1940, he urged Rockefeller's OIAA to "persuade the artists and intellectuals of the Spanish- and Portuguese-speaking nations of the American continent that a North American culture exists [and] that it is a culture worthy of admiration."[37] MacLeish soon added to his portfolio the job of director of the Office of Facts and Figures (OFF), which produced research for use by the US military in war planning; his intimate knowledge of the library's holdings was invaluable in that job. Literary critic and editor Malcolm Cowley, painter Ben Shahn, actor John Houseman, poet Charles Olson, and historian Arthur M. Schlesinger Jr. worked under MacLeish at OFF (although Cowley was forced to resign in 1942 under congressional pressure over his Communist activities in the 1930s). At OFF and then at the OWI, MacLeish brought his modernist sensibility to his job; he recruited modernist painters Stuart Davis, Reginald Marsh, Marc Chagall, and Yasuo Kuniyoshi to the OWI but snubbed Norman Rockwell (whose *Four Freedoms* paintings, executed for the *Saturday Evening Post*, later became the "centerpiece of a traveling war-bond sales campaign"[38]). In 1944, Roosevelt moved MacLeish to the Department of State to serve in the newly created position of assistant secretary of state for cultural and public affairs. From here, MacLeish enthusiastically embraced the power of the mass media to

promote the American point of view: "Books and libraries and education are always ours. . . . Mass communications are therefore the big thing on which to concentrate," he wrote in 1945.[39] After the accession of Harry S. Truman, MacLeish was assigned to represent the State Department at the meetings for the creation of the United Nations Educational, Scientific, and Cultural Organization (UNESCO) in 1945–1946. He retired from government service in 1946 and in 1949 returned to Harvard, where he had taken his law degree, to become the Boylston Professor of Rhetoric and Oratory.

Although MacLeish does not play a direct role in the story of Cold War modernism, he prefigures many of the conflicts that would shape the program. First, he fought a losing battle to put culturalism at the center of American cultural diplomacy. He advised the Roosevelt, Truman, and Eisenhower administrations not to make cultural diplomacy unidirectional and protested the structure of the USIA, which explicitly put cultural diplomacy at the service of the "message/information" people rather than allowing culture to operate independently and thus avoid the appearance of propaganda. And in his poetry, MacLeish sought to reconcile daring, even radical modernist techniques with an explicit advocacy for American values of freedom and individualism.

Notwithstanding MacLeish's opposition, informationalists continued to dominate cultural diplomacy for the duration of World War II through both the OWI and—after 1944, when the OWI was terminated—the Department of State. In January 1944, the Division of Cultural Relations was renamed the Division of Science, Education, and Art and placed under the newly created Office of Public Information. Countering Soviet influence and promoting democracy abroad came to dominate the State Department's priorities, and in that shift the division moved definitively toward an informational mission, backed by a series of planning memos authored by Professor Ralph Turner of Yale, who had been tasked with heading the division's research program. Turner's memos argued that cultural relations "should support concretely the foreign policy of the United States" and that American power, even as expressed through cultural relations, should "promote the liberation of all common men."[40]

As World War II gave way almost immediately to the Cold War, culture just didn't seem all that important of a strategic concern. The internal debate

in the US government about how best to confront the Soviets at first centered on military strategy, not diplomacy, and certainly not cultural diplomacy. Although it was clear to most Americans by mid-1945 that our Soviet allies were quickly becoming our Soviet adversaries, Winston Churchill's March 1946 "Iron Curtain speech" definitively marked the polarization of the postwar world, and the Truman administration repeated and amplified Churchill's rhetoric. George Kennan's 1946 "Long Telegram" influentially argued that the Soviet Union was unable to coexist peacefully with a capitalist democracy and that the United States would have to develop a military and diplomatic strategy—containment—predicated on that reality: the Soviets would "withdraw" from military adventures, Kennan speculated, "when strong resistance is encountered at any point."[41] In a 1947 speech, President Truman elucidated the "Truman Doctrine": the United States would "support free peoples who are resisting attempted subjugation by armed minorities or by outside pressures."[42]

It quickly became clear, especially after the Soviet Union tested its first atomic bomb in 1949, that a solely military posture was unwise; an impossibly destructive war could be the result if the United States were to respond to all Soviet threats with force. As a result, members of the administration and Congress looked to diplomacy and psychological warfare, and the newly created National Security Council (NSC), in a series of secret directives (in particular NSC-4 in 1947 and NSC-68 in 1950), called for the various agencies responsible for cultural relations and information to develop a coordinated information program "to influence foreign opinion in a direction favorable to U.S. interests and to counteract effects of anti-U.S. propaganda."[43] The NSC directives recommended an aggressive, muscular informationalist campaign. Arndt argues that under Truman the culturalist and informationalist

> functions . . . [became] a single practice. . . . In Europe only the Soviets and
> their satellites, geared for internal and external agitprop, used culture as a
> tool of propaganda. In the U.S. practitioners and politicians, in the interests
> of "getting it done" and with a profound faith in the flexibility of their ver-
> sion of "true" propaganda, were drilling ever closer to unidirectional infor-
> mation, on the grounds that the Soviets did it. [After 1948] the marriage of
> cultural and informational diplomacy had been institutionalized. . . . The

Creel–Rockefeller–OWI blend of "information" and "psy-war" took charge, dragging cultural relations behind it.[44]

"Truman and Eisenhower," Shawn Parry-Giles concludes, "were the first two presidents to introduce and mobilize propaganda as an official *peacetime* institution."[45]

As we will see, official cultural diplomacy was deemphasized, disorganized, and often desultory during the second Truman administration; people-to-people contacts and the dissemination of culture took a back seat to a unidirectional campaign conducted through VOA, the semiprivate Radio Free Europe (RFE), and the spokespeople of the Department of State. The election of Dwight D. Eisenhower in 1952, though, reenergized cultural diplomacy, primarily through Eisenhower's creation of the USIA to coordinate cultural contacts as well as public-information programs. USIA's approach, though, was overwhelmingly informationalist, its arguments shaped by the White House policy people as well as by outside consultants such as Edward P. Lilly, Harold Lasswell, and Walter Lippmann, who assisted with the OCB's Doctrinal Warfare and Ideological Programs task forces. In fact, when the USIA was created, Senator J. William Fulbright feared what he saw as the agency's unavoidably propagandistic orientation and thus insisted that his foreign-exchange programs remain in the Department of State.[46] Assistant Secretary of State William Benton proposed that cultural diplomacy "should be regarded as a part of our national defense," and his department assured Congress that cultural relations, subsumed under a larger information program, constituted "an aggressive program in support of our foreign policy."[47] "Face it," one USIA officer said, "the cultural program has always been the cover under which the information programs have operated."[48]

Both the cultural-diplomatic campaign and the public-information campaign spoke with the same voice during the Cold War. The basic message, sustained from Truman to Reagan, was that the Soviet Union was an aggressive, militaristic, imperialist power, a police state, and a slave empire, and this argument resounded in unison from presidential speeches, official releases from spokespeople, and broadcast outlets. More relevant here, though, are the *counter*arguments put forth against the Soviet Union's condemnations of

American culture and society and outreach to Westerners and citizens of non-aligned nations. In Soviet propaganda, the United States plotted to spread the most destructive, exploitive aspects of capitalism through economic, political, military, and cultural means. This propaganda campaign had been going on for years, and by the late 1940s the Soviet Union enjoyed significant influence and goodwill in many Western nations through trade unions, national Communist parties, and leading intellectuals and artists. European audiences, leery of America's growing power, were receptive to these Soviet messages as well. In particular, its charges that the United States lacked any culture or sophistication found a receptive audience among European intellectuals, who looked at American culture with a mixture of scorn for what they perceived as its lack of intellectual or artistic achievement and concern that US military might, economic power, and philistine Babbittry would "Coca-colonize" the Old World.[49]

America's European friends had long dismissed cultural accomplishments in the United States. In fact, the creation of the OIAA was spurred by 1930s German propaganda aimed at Latin Americans that drew upon their common European heritage and putatively greater valuation of the life of the mind and art. Thus, American cultural diplomats knew they had to present "convincing proofs of the creativeness and vitality of our culture," as MacLeish put it. "To fail would be disastrous."[50] The playwright Thornton Wilder, reporting to the State Department on a 1941 Latin American tour, agreed about the need to present American "cultural maturity."[51] The problem didn't disappear with the Nazis, either. "There is a popular misapprehension in foreign countries that we Americans are purely materialistic, money-mad and pleasure-mad, and it comes as a surprise to many, and as a new cause for respect, to learn that the United States has a literature, an art and a music of its own," the State Department explained in 1947, and that same year United States Information Service (USIS) officers told a congressional delegation that Norwegians believed the United States was "materialistic" and "devoid of culture."[52] Also in 1947, *New York Times* correspondent Raymond Daniell wrote that European "opinion is divided on whether America is a nation of sentimental altruists or sinister predatory imperialists [with a] jukebox, push-button civilization," but that they definitely thought something was wrong with a country whose "citizens

prefer swing music to Beethoven and Bach."[53] Even President Eisenhower— no intellectual himself, whose campaign had derided his opponent, Adlai Stevenson, as an "egghead"—worried that Europeans saw Americans as "a race of materialists. . . . Our successes are described in terms of automobiles and not in terms of worthwhile cultural works of any kind. Spiritual and intellectual values are deemed to be almost nonexistent in our country."[54]

MacLeish, Wilder, and Eisenhower weren't wrong. European intellectuals—the French in particular—took their anti-Americanism as a birthright and had done so since the mid–nineteenth century. French intellectuals were Europe's most important and influential in the 1940s; in the postwar period, Tony Judt asserts, they "acquired a special international significance as spokesmen for the age, and the tenor of French political arguments epitomized the ideological rent in the world at large." Their anti-Americanism and their sense that France should *not* be thought of as part of the Western alliance—Jean-Paul Sartre's insistence in 1949, for instance, that "one must choose between the USSR and the Anglo-Saxon bloc"—carried a great deal of weight with intellectuals from Italy, Germany, and other western European nations.[55] For them, Judt explains, America was "the most modern of worlds, the human enterprise stripped of tradition and inhibition, of complexity and sophistication." Our nation combined the "terrifying destructive power" of the machine age with "materialism and bourgeois self-satisfaction."[56]

From all this, then, arose Cold War modernism, the public–private partnership to showcase American cultural accomplishments in modernist art and literature and to argue that these artistic achievements were possible *only* in a free, individualistic society. In the Cold War modernist project, we see play out in miniature many of the larger dynamics in American foreign relations: the use of culture to further national policy aims; the leading role of the private sector in the conduct of cultural diplomacy; America's struggle to persuade Europeans of its cultural and intellectual achievements; and the clash between cultural conservatives, in particular those in Congress, and the cultural elites who populated the diplomatic agencies. In addition, Cold War modernism forces us to engage with the amorphous nature of modernism, to question whether modernism was ever radical, and to investigate terms key to American identity itself.

To that end, I trace in chapter 1 the evolution of modernism's public image—how the American public understood it from the early twentieth century until World War II—with the aim of showing that as late as the 1940s the broad American public saw modernism as a threatening, foreign, and fundamentally antibourgeois movement. I then describe the cultural resonances and meanings of the key terms in the domestication of Cold War modernism—*freedom* and *individualism*—and sketch out the broad outlines of Cold War modernism's "other," the officially mandated Soviet style known as "socialist realism."

The rest of the book, then, details specific branches of the Cold War modernist project. Chapters 2 and 3 focus on official programs overseen entirely by governmental agencies. Chapter 2 describes the disjointed and often discouraged art program of the Department of State and USIA, which sponsored several touring exhibitions that included modernist paintings. The 1947 exhibit Advancing American Art is well known because of its humiliating termination when it came under attack from congressional conservatives and the Hearst press, both of whom ridiculed the modernist paintings included in the show and insisted they were fundamentally radical and un-American. After the Eisenhower administration came into office, the cultural diplomats permitted more and more modernist content to creep into their exhibitions, and by 1959 even President Eisenhower defended the challenging works included in the American National Exhibition in Moscow and publicly endorsed artistic freedom as a basic American value. Chapter 3 moves away from art and looks at the State Department's programs to distribute among foreign audiences (particularly in central and eastern Europe) books carefully chosen to convey American values or to further policy priorities. Unlike the art program, the book programs remained quite conservative in their artistic tastes and included very little modernism, framing what modernist titles they did feature as representative not only of freedom and individualism, but of America's regional diversity. Following the influential arguments of Arthur Schlesinger and others, the book programs presented modernism as being congenial to or even constitutive of Cold War liberalism. The chapter concludes by recounting the participation of William Faulkner—Nobel laureate, defender of man's inherent freedom, but also symbol of Mississippi and Jim

Crow—in the cultural-diplomacy program as well as the equivocal and cautious way the book programs included and presented his difficult works.

The following two chapters focus on private organizations. Chapter 4 provides a history of *Encounter*, the CCF's English-language magazine. Although the CCF, a Paris-based nongovernmental cultural-freedom organization, is notorious for the CIA's secret role in its creation and funding, my focus here is *Encounter*'s portrait of modernism as a spent force, a fading monument, but one unquestionably greater than the petty, belated artistic and literary movements of the 1950s. *Encounter*'s memorializing of modernism did much to redefine the movement, particularly in literature, as a collection of styles and techniques and formal devices, still alive but practiced by descendants who were weak imitations of their great predecessors.

Another private organization, the Ford Foundation, is at the center of chapter 5. *Perspectives USA*, published from 1952 to 1956 by the Ford Foundation–funded nonprofit organization Intercultural Publications and edited by James Laughlin (founder of New Directions Books and the most important publisher of modernist literature in America), sought to present the spectrum of American modernism across the genres, from literature to painting to architecture to product design, through original features and reprinted pieces. Laughlin showcased the great achievements in American art of the previous decades to persuade skeptical European audiences that the United States indeed had an advanced artistic scene worthy of respect. Even more than *Encounter*, *Perspectives* formalized modernism, voiding it of content and presenting it as a style common to experimental poetry and kitchenware design, abstract expressionist painting, and residential architecture.

Chapter 6 returns to governmental programs to describe how official broadcasting framed American modernism for a broader, more popular audience than those targeted by the other projects described in this book. VOA's treatment of American modernism relied on the same arguments that characterize Cold War modernism in general but framed it very much as a middlebrow phenomenon, whose success derived from popular acclaim rather than from challenging or innovative techniques. As profiled on VOA, modernism's leading exemplars—Faulkner, Frank Lloyd Wright, Martha Graham, Alexander Calder—had endured initial public incomprehension and hostility but

stuck to their individual visions and eventually won the public acclaim that they deserved. VOA also directly answered many of the Communist International's accusations about American racial segregation with arguments that the wise federal government was ensuring that this unfortunate regional practice would soon die out.

The book concludes with a discussion of the end of Cold War modernism, an end that came about both because of Cold War modernism's success and because of larger changes in geopolitics, American culture, and technology. Communism, at least in its Soviet form, no longer appealed to European intellectuals, and the battleground of the Cold War shifted away from Europe to the "Third World." Moreover, the firmament of culture changed: postmodernism chipped away at the high seriousness of high modernism even as it eroded the distinctions between highbrow, middlebrow, and lowbrow. Modernism survived as a subject for study in the academy and as a style for consumer products, but it lost its dominant position in culture.

Modernism may no longer thrive as a vital artistic movement, but we all live with its remnants. Although the immediate objective of Cold War modernism was geopolitical—bolstering American standing in the Cold War—this project unintentionally accelerated the seepage of modernist devices and ideas into mass culture. Breaking down the barriers between the highbrow and the middlebrow, relieving modernism of its radical identity, and recasting modernism as a celebration of the free individual subject, the Cold War modernist project brought modernism to broad audiences that had never experienced it firsthand. And although in the eyes of many of the artists and critics discussed in this book, the project just tamed and dumbed down the most important artistic movement of the century, it also brought the great works of modernism to populations that might never have read Faulkner, attended a show of abstract expressionist painting, or seen a modern dance recital. Cold War modernism brought modernist techniques to the mainstream, enriching the kinds of creative works that mass publics already knew: genre fiction, Hollywood filmmaking, corporate architecture, Broadway theater, commercial design. It may have even helped win the cultural Cold War.

1

FREEDOM, INDIVIDUALISM, MODERNISM

The current disease is to make Cold War capital out of everything, no matter what. We cannot dedicate a building of Frank Lloyd Wright's in New York without our Ambassador to the United Nations pointing out that such an architect could not have flourished in Russia.

—PAUL GOODMAN, *GROWING UP ABSURD*

ODAY PAUL GOODMAN'S *Growing Up Absurd* (1960) is read primarily as one of the first tentative shoots of what would become "the Sixties." Along with such other influential works as Herbert Marcuse's *Eros and Civilization* (1955) and Norman Brown's *Life Against Death* (1959), Goodman's book attacked the conformity, complacency, venality, and philistinery of the United States in the 1950s, charging that the American way of life damaged the nation's youth. These works inspired many to condemn American society as inherently psychologically repressive and to explore new ways of individual expression and communal living later known as "the counterculture." But in the quote given as the epigraph to this chapter, Goodman cuttingly alludes to public rhetoric, emanating from official channels (such as Goodman's United Nations ambassador) and nongovernmental voices, lauding the modernist and experimental art produced in the United States and suggesting that such exciting, free, individualistic art would be forbidden and its creators persecuted in the Soviet Union. For Goodman, this official embrace of modernism was ironic, if not deeply hypocritical. For many decades, the institutions of high culture as well as broader middle-class society had assailed, feared, rejected, and mocked modernist art, and modernists had responded in kind. But in the post–World War II years, broad segments of the American cultural and political establishment—including the federal

government itself—tentatively welcomed modernism, finding in it an effective propaganda weapon. Its deployment in the rhetorical skirmishes of the Cold War account in part for the evolving attitudes about modernism, as do larger shifts in American society of the time. But shifts in modernism itself and in modernism's public image are equally responsible, if not more so.

Simply put, modernism *meant* something different to the American public in 1960 than it did in 1913, 1922, or 1939, in part because the public had changed and in part because modernism had. By the 1950s, modernism was no longer the rebellious, loose collection of movements it had once been. Its little magazines could no longer claim to be the harbingers of the new and unfamiliar, blowing up (*Blast*) or sweeping out (*Broom*) the old and irrelevant. Its performances no longer kindled riots, and its exhibitions no longer sparked public outrage. Abstract expressionism was the most vital and prestigious style of painting; consecutive Nobel Prizes in Literature for T. S. Eliot (1948) and William Faulkner (1949) enshrined modernist literature in the cultural firmament; bebop jazz, which applied modernist techniques of abstraction to popular music, was at its creative and popular apex; and in architecture, New York's Lever House marked in 1951 the beginning of the modernist International Style's omnipresence in large-scale architecture. Modernism was the establishment.

The formal and stylistic innovations of modernism, once revolutionary, infiltrated consumer culture as well. As early as the 1930s, the American fashion industry had eagerly embraced surrealism, particularly in magazine layout and advertising, and late in that decade Salvador Dali decorated the display windows of retailer Bonwit Teller's Manhattan flagship store.[1] But modernism spread beyond fashion by the 1950s. In his widely read history of the era, Alan Nadel notes the "institutionalization of the 'modern' throughout American culture, as reflected in the taste for Danish modern furniture, modernist architecture, and the Museum of Modern Art. In the 1950s much decorative art displayed a cubist lineage, and many suburban living rooms, spotted with mock Picassos, showed equally the influence of Mondrian."[2]

"The modernist emphasis on crisp lines, abstract designs and uncluttered imagery," Richard Pells remarks, "was perfectly suited to the needs of advertising, packaging, fashion, and interior décor."[3] "In graphics, architecture, design,

and especially in the conventions of media like film and television," Malcolm Bradbury and James McFarlane assert, modernism had become "an invisibly communal style."[4] Modernist values such as speed, simplicity, and stream-lining even filtered into urban planning, as the legacy of Robert Moses still evidences. This formerly radical movement had become the preferred style of cultural elites and, increasingly, the business world in Europe, Latin America, and North America. In the 1950s, even the American bourgeois class, the pre-ferred target of modernist disgust, "discovered that the fiercest attacks upon its values can be transposed into pleasing entertainments," as Irving Howe put it.[5] And because of this preference, at the moment of its widest cultural influence, critics and artists declared modernism dead.

Dead or not, played out or playing out its string, in the 1950s modernism as a style or collection of styles had so much become the establishment that it came to be used to *defend* the very societies and political systems that earlier modern-ist art had reviled. As the so-called free world in which modernism had gained ascendancy emerged from the catastrophe of World War II, it found itself in a newly bipolar arrangement, powerfully and disturbingly confronted by a social, cultural, political, and military force that insisted it was more modern than the moderns, the advance guard of the avant-garde, the end toward which his-tory was unfolding. The Soviet Union, its satellite states, and the revolution-ary movements in the developing world were, according to orthodox Marxist ideology, the concrete manifestations of historical progress, and the decadent, bourgeois West would inevitably fall, destined for the dustbin of history.

Although much of the so-called cultural Cold War centered around each side's claim to superiority in traditionally prestigious forms of high culture (classical music, ballet, drama, poetry, painting), the United States also coun-terasserted its own surpassing modernity, showcasing innovations in literary, artistic, architectural, musical, and graphic modernism in an effort to refute European prejudices and Soviet barbs about shallow American culture. In fact, the CIA informally called this contest "the battle for Picasso's mind," for Pablo Picasso not only was a living link to the glory days of modernism but also had been a member of the Communist Party of France since 1944, and his "Peace Dove" was the emblem of the international Movement for Peace, fronted by prominent scientists and intellectuals but ultimately directed by the

Communist Information Bureau.[6] The American cultural-diplomacy establishment felt that if European artists and intellectuals migrated to "Picasso's side," the West would lose the cultural war. Countering the rhetorical use of the term *peace*, then, the West mustered its own trope: *freedom*. In the 1940s and 1950s, the notion of "cultural freedom" that intellectuals were increasingly invoking in opposition to Stalinism and the broad ideas of "freedom" that had always been a key element of American identity came to be linked in the public mind and in the writings of intellectuals with the creative freedom and bohemianism that were a hallmark of modernism. In the rhetoric and self-imagining of the West, "free-world" artists were free to express whatever they wanted, however they wanted; Soviet artists were told what to paint or write or compose and were silenced, exiled, or murdered when they resisted or followed their own muses. Western artists were *free* and *independent*, whereas Soviet artists were either *puppets* or *victims* of a repressive system. On one side of the divide, according to this rhetoric, Western artists thrived in and Western audiences benefited from their "free society"; on the other side, "totalitarianism" crippled artists and public alike.

"Freedom" became the heart of Cold War modernism, which framed modernist art and literature as the epitome of Western—in particular American—cultural values. In this project, modernism was not a rebellion against self-satisfied middle-class values and stale artistic conventions; rather, it was an expression of freedom, individualism, self-motivated enterprise, and the end of ideologies—in other words, an expression of Cold War liberalism itself.[7] This message emanated not only from the federal government but also from foundations, nongovernmental organizations, the publishing industry, media such as magazines and radio, the academy, and the business world in a diverse and sometimes internally conflicted cultural-diplomacy program. The term *Cold War modernism*, as I use it in this book, does not describe new works in the modernist tradition produced during the Cold War years. Instead, it refers to the deployment of modernist art as a weapon of Cold War propaganda by both governmental and unofficial actors as well as to the implicit and explicit understanding of modernism underpinning that deployment.

To adequately answer the question "How did the United States use modernist art, architecture, and literature in its cultural-diplomacy program?" it

is necessary to define the term *modernism*, both in itself and in how the public understood it and perceived the movement. As scholars of literature, art, architecture, music, and even philosophy have pointed out for decades, this is not a simple task; in fact, the term *modernism* has been used so much and with so little precision or consensus about its definition that it is difficult to state definitively what is *not* modernist. In a typical complaint, Frank Kermode wrote in 1966 that "we all use the word [*modern*] in [an] unexamined way, and nobody notices how nearly meaningless it is until called to order by some pronouncement about The Modern."[8] "Modernism pervades all the arts," Daniel Bell wrote in 1976. "Yet if one looks at particular examples, there seems to be no single unifying principle."[9] However fuzzy its definition, modernism in its various forms had by the early 1940s become a dominant taste, particularly among artists and intellectuals, and was gaining a foothold in some of the same conservative cultural institutions—museums, trade publishers, universities, foundations, magazines, and professional organizations—it had originally rebelled against. This development only accelerated in the 1950s.

Modernism's increasing acceptance in the 1950s makes it no less difficult to define it concretely. It seems clear that a fundamental change occurred, sometime around the late nineteenth century, in how Western artists and intellectuals understood and described the relationship of the individual to the natural world, to society, and to the divine. *Modernism*, then, is the loose term used to classify the artistic movements and creative works that described, depicted, reflected, and at times catalyzed the changes occurring in this new era. Modernism, in the familiar understanding, celebrates the new and rejects tradition; it engages with the changes brought about by the increasing presence of machines in human lives; it embraces an aesthetic of shock, of ugliness, of fragmentation; it calls attention to normative methods of representation and seeks to devise newer ways to depict experience; it incorporates new insights about history, philosophy, psychology, and science pioneered by thinkers such as Marx, Nietzsche, Freud, Darwin, and Einstein. Modernist paintings employ abstraction, distortion, collage, nonrealist use of color, and depiction of scenes and subject matter that had traditionally been deemed unfit for serious art. In literature, typical modernist heroes are questioners who never arrive at satisfactory answers; they are alienated from their families, religions,

societies; they are frustrated by conventional means of depiction and communication and seek out new ways to convey their understanding of the world. Modernist fiction by writers such as Faulkner relies on untrustworthy narrators, slippery time sequences, and untraditional prose style. Perhaps more than anything, modernist works foreground the fact that they are constructed by an individual consciousness; they do not seek to reproduce the world as we are accustomed to seeing it reproduced, but rather they aim to call attention to the ways that we have been habituated to seeing the world and to show us that these ways are simply conventions.

Even defining "When was modernism?"—as Raymond Williams asked—isn't easy.[10] The proposed beginnings of the "modern" era in the visual arts stretch from the obvious—Cézanne and cubism in the early 1900s—to back much further. "One may begin the history of modern art," Alfred H. Barr Jr. wrote in 1934, "with David's dictatorship in 1792, the Delacroix-Constable *Salon* of 1924, Courbet's one-man revolt of 1855, or the First Impressionist Exhibition of 1874—or if one wishes one may start with Caravaggio or even with Giotto."[11] The use of the terms *modern* and *modernist* with clear connections to how they came to be used in the 1950s, though, was widespread earlier in the visual arts than in literature. Public and critical discussion commonly included the specific words *modernism* and *modern art* by the early 1900s, and, at least in the English-speaking world, *modernism* had come to mean oppositionalism, experimentation, bohemianism, and shock, as with the notorious *Rite of Spring* premiere in Paris in 1913 (breathlessly reported by the *New York Times*[12]) or with the contentious Futurist exhibitions and lectures in London in 1910 and 1912.

Popular history generally credits the 1913 International Exhibition of Modern Art (the Armory Show) as the debut of modernist painting in the United States; whether this is true or not, the show was a public sensation and drew an estimated 250,000 attendees over its run in New York, Boston, and Chicago. As Milton Brown describes, the show met with a great deal of derision and ridicule—including satiric doggerel—in the press, and prominent art critics of the time, such as Royal Cortissoz (*New York Herald Tribune*), Kenyon Cox (*Harper's Weekly*), and Frank Jewett Mather (*The Nation*), were united in their judgment that modernist painting was at best amateurish and

at worst "terrorist[ic]" and that modernism was fundamentally foreign and threatened America's healthy homegrown artistic tradition.[13] Meyer Schapiro wrote in the late 1970s that the Armory Show fixed modernism in the public mind—European *and* American—as a swerve *away* from realism and toward tastelessness, shock, and amateurishness.[14] Ultimately, the "immediate influence of the exhibition on the taste of most Americans was scarcely noticeable," Russell Lynes commented in the mid-1950s, and its paintings "produced a small hard corps of disciples and a vast new army of hostiles."[15] And although modernism certainly gained in popularity and respectability over the next thirty years, particularly among critics, connoisseurs, and the cultural and economic elite, it retained its aura of danger, to the degree that in 1929 Barr admitted that "the advanced artist . . . is still called (by the obtuse) madman, degenerate, and (more absurdly) Bolshevik."[16]

There may be no more influential figure in the establishment of modernism's public image in America than Barr, the first director of MoMA, established in 1929. Barr appointed himself modernism's impresario in the United States, immersing himself in contemporary trends in painting from his time at Princeton and even spending weeks in the Soviet Union meeting with avant-gardistes in the early 1920s. Barr taught the first college class in modern art, at Wellesley in 1927; that same year, he published a quiz on modern art in the popular and widely read *Vanity Fair*.[17] But it was through MoMA that he set the terms by which large popular audiences in the United States would understand modernism. "Through the publication of many catalogues and books," Lynes noted, "through traveling exhibitions, color reproductions, loan exhibitions and competitions [MoMA] has made 'Modern' not only palatable but a cause, and a genuine delight to a great many thousands of people."[18] By the early 1950s, Barr's biographer Alice Goldfarb Marquis writes, "the great moderate mass among educated Americans had . . . fully embraced the notion of abstract—or virtually any other kind of—art."[19] "It would appear," Dwight Macdonald concluded in his 1953 *New Yorker* profile of Barr, "that the highbrows have finally convinced the middlebrows that modern art is fashionable and even enjoyable."[20]

Barr's crucial insight was that modernism was a phenomenon happening across the arts and that it needed to be understood as a common response

to the modern world communicated by painters, writers, sculptors, dancers, composers, architects, and even product designers, who responded to each other's formal innovations. Such cross-pollination was a defining feature of modernism. Ezra Pound memorialized Henri Gaudier-Brzeska's sculpture as illustrative of his own theories about poetry, and both Gertrude Stein and William Carlos Williams attempted to reproduce the techniques and effects of the visual arts in verse.[21] By the 1950s, critics took the transgeneric nature of modernism for granted: "Modern twentieth-century literature," poet-critic-editor Louise Bogan wrote in 1950, "is so closely allied to its contingent and sister arts that it can no longer be detached from them."[22] MoMA took this alignment a step further, assembling paintings, sculpture, architecture, and even fashion and consumer products in its exhibitions of modernism. Guardians of the highbrow, such as Lincoln Kirstein, objected to the inclusion of teapots and chairs in MoMA shows, but Barr's policy put a crack in modernism's antiestablishment, antibourgeois façade, as did his choice to bring modernism together with the worlds of media (*Vanity Fair*'s Frank Crowninshield) and business and plutocracy (founding donors the Rockefellers) on MoMA's board.

While Barr defined modernism for the broad public, the critic Clement Greenberg offered perhaps the most enduring theoretical framework for modernism—Fredric Jameson says that Greenberg "invented the ideology of modernism full-blown and out of whole cloth."[23] For Greenberg, who wrote for the *Nation, Partisan Review,* and *Commentary,* modernist art's signal characteristic was its overarching concern with the medium itself. Modernist painting was always primarily *about painting*: cubism called viewers' attention to the act of representing a three-dimensional world on a two-dimensional substrate, and abstract expressionism took this same concern even further. Greenberg's 1939 *Partisan Review* article "Avant-Garde and Kitsch," in which he praised the contemporary artist's attention to "the medium of his own craft" and rejection of the "subject matter of common experience," is a foundational statement of this view of modernist painting.[24] "The essence of Modernism," Greenberg said in 1961, "lies in the use of characteristic methods of a discipline to criticize the discipline itself, not in order to subvert it but in order to entrench it more firmly in its area of competence."[25] (Kirstein had

earlier made a similar comment, disapprovingly noting in 1948 that "the influ-
ential painting of our time . . . is not concerned with what artists see or with
how they see, but with how they paint."[26])

If Greenberg took the idea of modernism as self-referentiality to its logi-
cal extreme, many literary and art theorists of the time agreed that modernist
artworks were self-contained artifacts whose meaning was not dependent
upon social context, the biography of the artist, or the reception of the reader
or perceiver. An artwork stood independent and, moreover, had to be judged
solely on the success of its own internal structure and logic. Clive Bell had
proposed in 1914 that works of art were fundamentally distinct from all other
objects in the world because they "provoke . . . the aesthetic emotion."[27] This
notion of a work of art, in particular a poem or a painting, as an artifact whose
structure and internal tensions *are* its meaning emerged also in literary crit-
ics W. K. Wimsatt and John Crowe Ransom's use of Hegel's term *Concrete
Universal.* Ransom's illustrations of the Concrete Universal included works
by metaphysical poets such as Marvell and modernists such as Yeats, Eliot,
and Stevens.[28]

This powerful concept of the Concrete Universal or the self-contained
artifact drew upon the philosophy of aesthetic autonomy, or the Kantian idea
that artworks and the aesthetic experience were separate from other realms
of human activity. Developed and refined through the 1800s, the concept of
aesthetic autonomy came to mean that artworks and artists had no moral or
ethical responsibility to their societies and were not answerable to or even
interested in social or political matters. Kermode observed that the early
modernists "dissociated themselves from many concerns that seemed charac-
teristically bourgeois, such as politics," and Lionel Trilling noted that writers
such as "Proust, Joyce, Lawrence, Eliot, Yeats, Mann (in his creative work),
Kafka, Rilke, Gide" are "indifferent to" the "liberal ideology."[29] For Michael
Fried, "modernist art in this century finished what society in the nineteenth
began: the alienation of the artist from the general preoccupations of the cul-
ture in which he is embedded, and the prizing loose of art itself from the
concerns, aims, and ideals of that culture."[30] This attitude extended even to
the characters in modernist literary works; Daniel Fuchs argues that modern-
ist protagonists are passive and willfully separated from the world, pointing

to Flaubert's Emma Bovary, Joyce's Stephen Dedalus, and Mann's Aschenbach.[31] We might add to that list Faulkner's Quentin Compson and Eliot's Prufrock or his "young man carbuncular."

Terry Eagleton and Raymond Williams have argued that aesthetic autonomy came about as a defense against bourgeois moral and capitalist economic pressures, a defense initially mounted by romantic artists and refined by the modernists, and in fact if one cannot define modernism as a consistent set of representational techniques or by a coherent ideology, one might do worse than to identify opposition to the bourgeois values of the industrialized, urbanized West as the trait that links almost all modernist art.[32] Irving Howe insisted that "cultural modernism must define itself in terms of opposition to prevailing institutions and norms," that modernism exists only as "a revolt against [the] prevalent style, an unyielding rage against the official order."[33] Modernism is fundamentally an oppositional movement, Howe argued, rejecting the intellectual, spiritual, and even scientific certainties that came before it, but proposing nothing except negation in their place. Daniel Bell argued that modernism offers "renewed and sustained attacks on the bourgeois social structure."[34] Trilling went even further, saying that "the disenchantment of our culture with culture itself . . . the bitter line of hostility to civilization" is "the characteristic element of most highly developed modern literature."[35] From Flaubert's vicious portrayals of Charles and Emma Bovary to Filippo Tommaso Marinetti's gleefully violent futurism, Alfred Jarry's nihilistic *Ubu* plays, the playful profundity of Dada, and Marcel Duchamp, modernism loathes middle-class life for its complacency, materialism, and self-satisfaction. More recent critics agree with these earlier writers. For Astradur Eysteinsson, "modernism . . . subvert[s] and negat[es] the cultural and ethical heritage of traditional bourgeois society," and Douglas Mao and Rebecca Walkowitz note that modernism created a hostile, stubborn, "refractory" relationship "between itself and dominant aesthetic values, between itself and the audience, between itself and the bourgeoisie, between itself and capitalism, between itself and mass culture, between itself and society in general."[36] Crucially for this study, the broad American public in the 1940s largely identified modernism with these threatening, hostile stances and attitudes. The Cold War modernists, then, had to square the difficult circle of using

modernist art to advocate for Western values when the public perceived—justly or not—modernist art as being at best indifferent and sometimes intractably opposed to those values.[37]

Modernist hostility to bourgeois society came to be expressed in attacks on mass culture and the so-called middlebrow. In this formulation, most influentially presented by the philosopher Theodor Adorno, modernism's difficulty and fragmentation were a response to mass culture, the cultural products produced by capitalism with the intention of conveying, reinforcing, and reproducing capitalist ideology. Because everything these products offered was so familiar and similar, varying only in minor details, readers or viewers or listeners found them instantly recognizable and comfortable. But by the late nineteenth century, such mass-cultural products became associated with low-status groups: the working classes, the uneducated, women. The "middlebrow," then, became the space between mass culture and high culture, populated by earnestly aspirational products consumed by the middle classes for cultural betterment. In midcentury America, middlebrow institutions such as the *Saturday Review of Literature*, the Book-of-the-Month Club, *Life* and *New Yorker* magazines, the Chautauqua movement, the Harvard Classics, and provincial symphony orchestras and art museums, whatever their merits, had come to represent the middle classes' pursuit of greater cultural prestige through products and memberships rather than through true engagement with art and ideas. Dwight Macdonald devastatingly attacked the American middlebrow in his essay "Midcult and Masscult," where he defined "Midcult" as having

the essential qualities of Masscult—the formula, the built-in reaction, the lack of any standard except popularity—but it decently covers them with a cultural figleaf. In Masscult the trick is plain—to please the crowd by any means. But Midcult has it both ways: it pretends to respect the standards of High Culture while in fact it waters them down and vulgarizes them. . . . It is its ambiguity that makes Midcult alarming. For it presents itself as High Culture. Not that coterie stuff, not those snobbish inbred so-called intellectuals who are only talking to themselves. Rather the great vital mainstream, wide and clear though perhaps not so deep.[38]

By the 1940s, middlebrow products had started to incorporate some modernist elements. For Macdonald, Ernest Hemingway's *Old Man and the Sea*, Archibald MacLeish's play *J.B.*, Thornton Wilder's *Our Town*, and Stephen Vincent Benét's poem *John Brown's Body* epitomize Midcult in that they use modernism's formal innovations—Hemingway's flat journalistic narrative voice and "iceberg" constructions, MacLeish's and Wilder's foregrounding of the theatrical situation and mixture of the symbolist and realist, and Benét's free verse—but blunt those innovations' critical edges and ultimately celebrate rather than attack middle-class values. Such texts exhibit how middle-class audiences had come tentatively to accept modernist techniques in their prestige entertainments—a development, as Catherine Turner shows, that the marketing industry partly enabled.[39]

But to return to the argument that Cold War modernism defanged the radicalism of early modernism, we must ask: If modernism sprung from a demand for aesthetic autonomy—if modernist artists insisted that their sphere of activity was entirely separate from social concerns, and they willfully and disdainfully separated themselves from the world—how can it ever have been considered radical or threatening in the first place? Peter Bürger's influential *Theory of the Avant-Garde* provides some insight into this question. Bürger differentiates modernism from the avant-garde on the grounds of their stances on aesthetic autonomy. In the Anglo-American tradition up to the 1980s, the two terms were often synonymous; such writers as Greenberg, Howe, Harold Rosenberg, and Renato Poggioli use both *modernism* and *avant-garde* interchangeably to identify the radical changes in art and literature dating from the mid-1800s. Bürger rejects the conflation of the two movements and instead argues that they are not only separate but in polar opposition because of their stands on the proper relationship of the art world to bourgeois society.[40]

Much like Eagleton and Williams, Bürger argues that modernism represents the final stage of the end of artistic patronage. Cut loose from the support of patrons, artists initially celebrated their freedom but then came to realize that they were dependent on the tastes of the market, mass society, and the bourgeois class. This reliance turned to resentment, and resentment ultimately turned to withdrawal: artists developed the doctrine of the

fundamental *autonomy* of art and aesthetic experience in angry reaction to their dependence on bourgeois society. In Bürger's view, modernist art seeks autonomy from society and as a result no longer aims to level attacks on that society except in the broadest, most abstract terms. It thus became rebellion safe for consumption by the targets of its revulsion. The avant-garde, by contrast, wanted art to reform and transform society—in Bürger's words, "to reintegrate art into the praxis of life." Rather than retreating into an autonomous aesthetic world, avant-garde movements such as Dada directly attacked bourgeois society *and* the institution of aesthetic autonomy.[41] In this model, modernism—art withdrawn into a world where art is its own justification—may exhibit *stylistic* or *formal* characteristics that implicitly attack bourgeois certainties such as realist representation. But by virtue of the fact that this art claims for itself autonomy from social concerns or responsibilities, modernism fundamentally bolsters bourgeois society, assuaging the bourgeois' fears that they lack "culture." Modernism in its undiluted form may not be to the taste of the middle classes, but middlebrow art that incorporates modernist elements gives them the sense of consuming something daring and refined yet still uplifting and suggests to them that modernism itself need not be threatening and foreign.

Archibald MacLeish's career is again of interest here as he emblematizes the melding of modernism and the middlebrow. MacLeish joined the Lost Generation writers in Paris in the 1920s, publishing books with expatriate Paris printers such as the Black Sun Press. In long 1930s poetic works such as *Conquistador, Frescoes for Mr. Rockefeller's City, Public Speech,* and *Land of the Free,* MacLeish tacked strongly to the political left, employing an exhortative yet modernist style of verse influenced equally by Eliot and Whitman. Early critical studies of modernism and anthologies of modernism (such as Louis Untermeyer's) put MacLeish squarely in the mainstream of the "new poetry."[42] Later reevaluations of MacLeish, though, dropped him from the rolls. His earnest, vocally pro-American liberalism didn't fit with modernism's political profile; his lines began to look less like Eliot's or Pound's and more like those of out-of-favor poets such as Carl Sandburg and Vachel Lindsay. It didn't help that although some Southern New Critics had a high opinion of him (Cleanth Brooks's *Modern Poetry and the Tradition* placed MacLeish

with Frost and Auden as worthy heirs to Yeats and Eliot[43]), other critics saw in him a programmatic poet, an incompetent imitator of Eliot who had neither the master's temperament nor his skill. A long poem he published at the time—*America Was Promises* (1939)—celebrated America's history and future in terms that paralleled the Roosevelt administration's arguments about the confrontation between freedom and "totalitarianism." Prominent critics such as Louise Bogan and Edmund Wilson panned the book, but their evaluative grounds are more interesting than their assessment of a poem that is today largely forgotten. In their disparaging remarks about this and other attempts by MacLeish to write an earnest, politically engaged form of modernist poetry lie at least two key points that were becoming modernist dogma: explicit, timely political statements were not worthy of "true" poetry, and poetry written for any but a purely aesthetic purpose was by definition second rate. For Bogan, MacLeish wrote "political poetry, even a kind of official poetry, and therefore the strict checks and discipline of poetry written for itself . . . do not hold."[44] MacLeish's verse combined modernist poetics with midwestern, pro-America sentiments seen at the time as inimical to modernism, even as the Cold War modernism project would only a few years later read almost precisely the same values back into other artists' work. Modernism, it seemed, needed to endorse Western liberal values; it just could not do so *out loud* if it wanted to maintain its high-cultural prestige.

Because the redefinition of modernism's politics is an important theme of this book, it is important to note that as critics began to describe a school of "modernist" poetry and painting in the early twentieth century, the critical definition of modernism was not located along a conventional left–right political spectrum, even if its public image was that of an amorphous, undefined radicalism. Modernists politically shared only a disappointment, disapproval, or disgust with Western bourgeois life and values. The challenges of fascism and the Cold War, though, moved Western critics to begin to interpret modernist texts as endorsements of Western freedom and plurality and rejections of totalitarianism. New Critical practice, ironically, bolstered this shift, as in John Crowe Ransom's assertion that a poem is democratic, whereas the directive meaning of prose is totalitarian.[45] The problem, of course, with positing modernism as a kind of endorsement of pluralistic Western human-

ism is that so many modernist texts and other artworks called those values into question or explicitly attacked them. And although public acceptance of modernism rapidly advanced in the 1950s, many conservative critics, artists, and public figures continued to insist that modernism *was* in fact inherently radical and pointed to the involvement of many American modernist artists and writers with communism and the Popular Front in the 1930s. Al Filreis calls this assertion "the Fifties' Thirties," the antimodernist insistence that 1930s left radicalism tainted all modernist art. Pro-modernists instead rewrote literary history, arguing that radical artists of the 1930s had *rejected* modernist techniques in favor of dogmatic socialist realism and thus that modernism had no political inflection. In the early Cold War, Filreis explains, "modernists seized the moment to stand for apolitical art."[46] The ultimate philosophical grounding of the pro-modernist position was aesthetic autonomy.

In fact, the growing acceptance of aesthetic autonomy among highbrow and middlebrow audiences in the United States is perhaps the central factor in the success of Cold War modernism. Modernism historically was confrontational and often offensive, and many modernist artworks were nasty, obscene, subversive, seditious, and even illegal. I am not the first one to point out that making the work "self-subsistent" and divorcing an artist's biography—and political beliefs and activities—from critical discussion of that artist's work were crucial in making modernism safe for middle-class audiences, as was the case with artists as diverse as the Communists Picasso and Henri Matisse, the archconservative T. S. Eliot, and the indicted traitor Ezra Pound. Although critics and philosophers refined the concept of aesthetic autonomy in little-read journals and books, those ideas filtered out to the public through the cultural-diplomatic projects I describe in this book and through publishers' domestic advertising campaigns, book-review sections of major newspapers, articles such as Barr's in popular magazines including *Vogue* and *Vanity Fair*, and other channels of middlebrow culture.[47] These institutions trained American audiences, in particular cultural elites and aspirational middlebrows, to view artworks as autonomous aesthetic objects, which prepared them to embrace a depoliticized, aestheticized modernism, an empty vessel of style and technique that could then be filled with Cold War–specific meaning, a self-congratulatory celebration of the society that had fostered it.

"Neutered often against its will," Christine Lindey writes, "western vanguard art acted as a moral safety valve for the liberal bourgeoisie."[48]

Aesthetic autonomy did much to neutralize modernism's negative public associations, but modernism then had to be redefined in the public (and critical) mind. Cold War modernism settled on the master term *freedom* as the movement's signal attribute. Like the term *modernism* itself, though, *freedom* has many, sometimes contradictory, meanings, even if we take into consideration only (as I will do) its use in mid-twentieth-century American public rhetoric. For Eric Foner, *freedom* is "the central term in our [i.e., Americans'] political vocabulary," and he identifies two grand streams of thought that dominate American ideas about the nature of freedom. "Republican freedom," derived from the classical world through Renaissance Florence and Edmund Burke, emphasized active participation in public life and "putting aside self-interest to pursue the common good." Opposing this communal, civic notion of freedom was the Lockean "liberal" model, which emphasized, as Foner puts it, "personal autonomy" and "shielding a realm of private life and personal concerns—including family relations, religious preferences, and economic activities—from interference by the state."[49] During the early Cold War, the term *freedom* most commonly appeared in a Lockean liberal sense to refer to the lack of constraints on individual action and autonomy in the West, as opposed to the permeating coerciveness of "totalitarianism" (the term *totalitarianism* was originally intended to refer to the fascist states and was extended by Hannah Arendt, Karl Popper, and others to apply to Stalin's Soviet Union). But in the domestic sphere, underneath this simplistic, Manichean opposition roiled a much more complicated and dynamic struggle over the meaning of the term *freedom*.[50]

The Great Depression, the New Deal, and World War II profoundly shaped its meaning during the Cold War. Franklin Roosevelt aggressively employed the terms *freedom* and *liberty* in his speeches, proposing that "greater [economic] security for the average man" was the true definition of liberty. During the Depression, New Dealers and conservatives contested the meaning of the term *freedom*, with Roosevelt's side employing its communal sense and conservatives countering that New Deal policies undercut individual freedoms.[51] World War II returned the Manichean understanding of *free-*

dom to the forefront. Private groups such as Freedom House (founded in 1941) asserted that the fight against Hitler was by its nature a fight for freedom. But even as the president called forth the most atavistic associations of the term in his speeches, he subtly tried to recast it in a New Deal mold. Roosevelt's January 1941 State of the Union Address—delivered when Great Britain was the only bulwark against the Nazis' and Soviets' division of Europe between themselves—proposed that the war would determine whether four "essential freedoms" would prevail: freedom of speech, freedom of worship, freedom from want, and freedom from fear. In other words, the Four Freedoms proposed that the Allies were motivated most deeply by the desire to spread not just Lockean freedoms, but also the communalism that Roosevelt's political adversaries at home abhorred. The OWI, charged with mobilizing American public opinion behind the war effort, became a battlefield about the nature of freedom. Conservative congressmen, with some justification, saw the OWI not as a nonpartisan public-information agency but as an arm of Roosevelt's political shop. Because of these ideological objections, Congress largely defunded the OWI after 1943, and the private sector—in particular the advertising industry—took on much of the responsibility for guiding public opinion on the war.

In a development that would greatly affect the Cold War modernist argument, the private sector and its allies in Congress conjured and then strenuously endorsed a "Fifth Freedom" to be added to Roosevelt's lineup: free enterprise. In *Advertising the American Dream*, Roland Marchand has extensively described how in the 1920s and 1930s individual companies and trade groups such as the National Association of Manufacturers used advertising to link the American ideal to consumerism.[52] With this seed already planted, these same groups juiced the same argument with wartime patriotism and then, after the war, intensified their campaign "to recast the political economy of America" by undermining labor unions and rolling back the New Deal, historian Elizabeth A. Fones-Wolf explains.[53] In 1941, Henry Luce's influential *The American Century* painted government as an impediment to prosperity and freedom, arguing that both were produced and sustained by "free economic enterprise" and darkly suggesting that Roosevelt was "most sympathetic to all manner of socialist doctrines and collectivist trends."[54] Taking

a more extreme position was Friedrich Hayek's antistatist argument in *The Road to Serfdom* in 1944, in which he insisted that governmental economic planning posed a fundamental threat to individual liberty.[55]

The paramount importance of individual freedom, though, simultaneously inspired leftist anti-Stalinist groups such as the Committee for Cultural Freedom (1939–1951, led by Sidney Hook and John Dewey and precursor to the later, more influential postwar group with the similar name) and the Trotskyist League for Cultural Freedom and Socialism (led by Dwight Macdonald).[56] After the war, many of the participants in the earlier cultural-freedom movement—Hook and James Burnham in particular—abandoned their Trotskyism and started similar groups such as Americans for Intellectual Freedom, the American Committee for Cultural Freedom, and the CCF.[57] In fact, the State Department didn't come up with the strategy to trumpet Western artistic freedom to counter Soviet accusations of American philistinery; rather, it (and, later, the USIA) adopted this argument from artists and cultural-freedom groups. In 1952, for example, Thornton Wilder advised the State Department that it should "promulgat[e] the doctrine of the freedom of the artist as a weapon in the ideological warfare against totalitarian governments."[58]

The use of the term *freedom* in the early Cold War, therefore, must be seen in this context. In Western Cold War rhetoric, it primarily refers to the amalgamation of individual liberties cast as the inverse of the coercive communalistic totalitarianism of communism. The United States not only embodied this freedom but pledged to fight for it abroad in such statements as NSC-68 (the NSC policy paper that laid out a "strategy of freedom") and the 1953 "Freedom Resolution."[59] In fact, the White House committee overseeing the ideological programs of the Cold War resolved that "freedom" was to be USIA's "single, dominant propaganda line," with the primary objective being to "create in the minds of our audience acceptance of the concept that the free peoples and nations are united by basic common interests" diametrically opposed to the "Soviet–Communist efforts to destroy free world unity."[60]

This simple dualism, though, overlay a much more local political argument about the legacy of the New Deal, the role of the government in economic planning and in maintaining a social safety net, and the relative importance

The President

~~TOP SECRET~~

NSC 68

COPY NO. 1

A REPORT

TO THE

NATIONAL SECURITY COUNCIL

by

THE EXECUTIVE SECRETARY

on

UNITED STATES OBJECTIVES AND PROGRAMS FOR NATIONAL SECURITY

DECLASSIFIED by authority of

April 14, 1950 HENRY A. KISSINGER-ASST. TO THE

PRES. FOR NATL. SECURITY AFFAIRS

WASHINGTON FEBRUARY 27, 1975

Signature Date
H.C. 4-2-75

~~TOP SECRET~~

FIGURE 1.1 President Truman's copy of NSC-68.
Harry S. Truman Presidential Library, Independence MO.

of economic activity (in producing or consuming) among the fundamental human freedoms. In Cold War modernism, the term *freedom* generally referred solely to the Lockean individual liberties: free enterprise, freedom of conscience, freedom of expression. Arthur M. Schlesinger's 1949 work *The Vital Center* drew upon these ideas of freedom, while also exemplifying the pragmatic strain of American political thought that motivated the New Dealers and much of the State Department establishment. Contrary to Communist arguments that top-hatted capitalists controlled the political establishment in the United States, Schlesinger argued, "The capitalist state has clearly not been just the executive committee of the business community. It has become an object of genuine competition between classes." Liberal democracy is committed to the "limited state," he stated, and the competing classes would, with the help of experts, "work out a sensible economic policy" on Keynesian principles. Minimal government involvement in the economy was desirable to avoid "the interminable enterprise of government regulation." Regarding civil liberties, Schlesinger commented that although the problem of majority rule versus minority rights seems "insoluble," in practice these things tend to work themselves out. Problems arise inevitably, but the "continuity of American development" ensures that pragmatism and reasoned debate will generally solve them. The process takes care of evils, as in the case of child labor, unemployment, and old-age poverty—and will, he was confident, do so regarding civil rights. Even wars serve their purpose: the Civil War "heal[ed] the social wounds opened up in the age of Jackson," and World War II "closed the rifts created by . . . the New Deal."[61] Schlesinger presented America as a humble but inspired experiment that relied on its citizens' ability to make rational, unconstrained, free decisions. No utopian, he endorsed a "moderate pessimism about man" to defend against "authoritarianism" or any kind of all-encompassing system such as communism, but he had faith that the democratic process assisted by technocratic guidance would inexorably continue to improve America.[62] In this, Cold War liberalism asserted the fundamental importance of the *individual* over the *collective*, and thus the Cold War modernist argument that stemmed from Cold War liberalism drew very heavily upon the individualistic Lockean construction of freedom—particularly in its focus on the heroic, dissenting artist free to create as his conscience directs him.

Like freedom, individualism itself, of course, is coded throughout the American national DNA. Individualism is omnipresent in the public imagination, from the Jeffersonian farmer to the pioneer frontiersman to the cowboy to Bruce Willis's John McLain in the *Die Hard* movie franchise, but these popular images translate, disseminate, and reinforce deeper ideas of individualism and self-reliance that had already taken hold at the birth of the nation. Varieties of individualism and self-reliance have been elements of the American character from colonial times: Hector St. John de Crèvecoeur presented the smallholding farmer as the epitome of Americanism and held that becoming a self-reliant American "extinguish[es] . . . subordination [and] servility."[63] Several decades later Alexis de Tocqueville asserted that in democracies the selfishness endemic to undemocratic nations was giving way to "individualism," which he defined as "a reflective and peaceable sentiment that disposes each citizen . . . to withdraw to one side with his family and friends . . . creat[ing] a little society for his own use." Tocqueville worried that democratic individualism would eventually atomize citizens and foster despotism, but he hoped that "the free institutions that the inhabitants of the United States possess and the political rights of which they make so much use recall to each citizen constantly and in a thousand ways that he lives in society."[64] Ralph Waldo Emerson, of course, extolled "self-reliance" in his enduring 1841 essay of the same name, and Henry David Thoreau's *Walden* provided a practical model of self-reliant individualism. In 1922, future president Herbert Hoover published a pamphlet entitled *American Individualism* in which he insisted that collectivism, particularly in the form of Soviet communism, was a doomed and dangerous path and that only the American model of capitalist individualism could create a healthy society.[65] His policies after the 1929 stock-market crash reflected these individualist beliefs.

Individualism and freedom were closely linked. Western liberal philosophy—stemming from Locke and Hobbes in particular—was grounded on the notion that the individual is by his nature "free," meaning (in Reinhold Niebuhr's definition) that "he has the capacity for indeterminate transcendence over the processes and limitations of nature [and that] this freedom enables him to make history and to elaborate communal organizations in boundless variety and in endless breadth and extent."[66] Cold War–era arguments in the

United States held that the cultural and economic liberties of the West allowed for individuals to express their essential freedom and self-determination. Conversely, the Communist system was suspicious of what it called "bourgeois individualism" or the illusion of the free self-determination of individual subjects. "Marxism . . . postulates that individualistic theories and modes of thought, especially those couched in terms of abstract individuals . . . conceal the underlying social relations (above all relations of production) that in turn explain individual thought and action," the *Dictionary of Marxist Thought* explains, and orthodox Soviet communism subscribed to this belief. [67] In Soviet Communist ideology, the nature of the individual was malleable and historically determined, and one of the goals of Soviet society was to create a "new Soviet man" who would be devoted to the furtherance of the party's goals and to the construction of a socialist society, not to individual self-fulfillment outside of a larger social, economic, and historical context (as were the decadent bourgeois individuals in the West). This idea of the individual, then, like the idea of freedom, became a key trope of Cold War rhetoric on both sides: the West exalted its freedom of the individual and condemned communism's reduction of individuals into tools to serve society; communism claimed that bourgeois individualism was what would inevitably weaken the West and showcased how its individual citizens lived to serve the collective.[68]

Key to Western Cold War rhetoric was the notion that the Soviet Union radically curtailed the freedom of the individual in favor of the desires of the state and party and undermined the very existence of the autonomous individual. Secretary of State Dean Acheson, speaking in 1950, called his audience's attention to a "moral issue of the clearest nature . . . the individual's loss of identity in Soviet society and [the] importance of the individual as a basic element of strength in the U.S."[69] Propagandists and anti-Communist intellectuals made this argument in equal measure, and popular culture echoed it. The Red Menace was a faceless, featureless mass—not a few critics have noted that the Blob in the 1950s sci-fi movie suggested the threat of communism. In the imaginations of the West, the "New Soviet Man" sought by Lenin in the 1920s became the mindless and brainwashed Communist (as in the 1959 film *The Manchurian Candidate*) who sought to undermine our society's celebration of the individual or to infiltrate our own bodies, hollow out

our individual identities, and transform us into an army against ourselves (as in the 1956 film *Invasion of the Body Snatchers*). Communism would "enslave" us, the argument went, ironically alluding to America's own historical experience with turning free individuals into nameless and identityless objects.[70]

Although the American individualist was generally a man (emphasis on "man") of action, on occasion even an artist could represent American individualism. In 1945, for instance, Ayn Rand's novel *The Fountainhead* presented the architect Howard Roark (based on Frank Lloyd Wright) as a vital force of creativity and power opposed by a society that refuses to understand him, and a 1949 *Life* profile made painter Jackson Pollock into a romantic rebel.[71] Although the campaigns described later in this book rarely focused on individual artists per se, Cold War modernism relied heavily on the idea that the individual*ism* of the West made these artists' achievements possible and that modernist artworks embodied this individualism. When asked "what abstract art means to [him]," Robert Motherwell responded that "abstract art represents the particular acceptances and rejections of men living under the conditions of modern times. . . . [I]t is a fundamentally romantic response to modern life—rebellious, individualistic, unconventional, sensitive, irritable."[72] Although very different in many ways, both Clement Greenberg and Harold Rosenberg insisted that "individualistic art had to be the future of a successful culture," as Neil Jumonville puts it.[73]

Showcasing innovative, rebellious artists and arguing that an essential component of American freedom was the liberty to dissent and refuse to conform also revealed the worry that Americans were becoming a nation of sheep. In the 1950s, a set of sociological studies that in other eras might have had little impact outside of academia argued that American society was becoming more homogenized, that it increasingly feared individualism and freedom, and that large, powerful institutions and individuals dominated American political, economic, and cultural life. Erich Fromm's *Escape from Freedom* (1941), David Riesman and Nathan Glazer's *The Lonely Crowd* (1950), Sloan Wilson's *The Man in the Gray Flannel Suit* (1955, not a study, but rather a novel that became a popular 1956 film), William Whyte's *The Organization Man* (1956), C. Wright Mills's *The Power Elite* (1956), and Goodman's *Growing Up Absurd* all made the case, in varying ways, that citizens of the West

feared to use the freedoms they had and sought refuge in going along to get along in societies that were becoming more oppressive and conformist. Cold War modernism addressed some of these anxieties, reassuring Americans that our freedoms would still foster innovation, creativity, and individualism.

Cold War modernism's other, of course, was socialist realism, the Soviet Union's official literary and artistic doctrine from 1934 until that state's demise in 1991 (although, as Katerina Clark points out, "after Stalin's death in 1953, writers began to dismantle the tradition"[74]). Socialist realism was everything modernism was not, opposing experimentation and formalism and downplaying the individual artist, stressing instead art's role in helping the state and party achieve political and social goals. The ideas behind socialist realism, in fact, predated the creation of the Soviet Union. As head of the Bolshevik Party, Lenin insisted that writers and artists be conscripted into the revolution: "Literature cannot be . . . an individual undertaking, independent of the common cause of the proletariat. Down with non-partisan writers!" he wrote in 1905.[75] For a brief period during the first few years of the Soviet Union, a pro-Bolshevik artistic and literary avant-garde flourished, particularly in the constructivist and Acmeist movements, but that came to an abrupt end in the mid-1920s. Trotsky was much more friendly to the idea of artistic experimentation than was the fundamentally conservative Lenin—and it was in part for this reason that Trotskyists populated the American cultural-freedom movement—but both leaders endorsed "tendentious" art and literature (that is, works intended primarily to promote a political line) even before the creation of the Soviet Union.[76]

At the first Congress of the Union of Soviet Writers in 1934, novelist Maxim Gorky and party ideologue Andrei Zhdanov established socialist realist doctrine. Socialist realist works had to be intelligible to a popular audience, manifest correct Marxist–Leninist analysis of the historical and social conditions they documented, and inspire audiences to work to advance the struggle to construct a socialist society through the Communist Party. Zhdanov defined socialist realism as "the basic method of Soviet literature and literary criticism. It demands of the artist the truthful, historically concrete representation of reality in its historical development. Moreover, the truthfulness and historical concreteness of the artistic representation of reality must be linked

with the task of ideological transformation and education of workers in the spirit of socialism."[77]

As the Polish poet Czeslaw Milosz clarified, socialist realist writers need not *think*, they need only *understand*.[78] Moreover, socialist realism was an art of the positive. "Pessimism and lack of confidence in man's powers and creative abilities," a 1961 official pamphlet (in English, intended for foreign distribution) explained, "are alien to it. It takes part in the life and struggles of the people, bringing them joy and inspiration. This explains its tremendous aesthetic influence and extraordinary popularity. The Soviet artist makes a thorough study of life and truthfully reflects it, cultivating in people the sterling moral qualities of builders of a communist society. Could an artist have a higher aim in life?"[79]

The common image of socialist realist art and literature, at least in the West, featured comically earnest depictions of happy peasants and industrial workers whose lives were fulfilled in their service of building socialism and a classless society. These simplistic, programmatic works earned the scorn of critics such as Dwight Macdonald and Clement Greenberg, who dubbed them "kitsch." Although much socialist realist art deserves that moniker, a few works succeed even by more traditional or even modernist aesthetic criteria (Mikhail Sholokhov's novel *And Quiet Flows the Don* is an example).

Socialist realism definitively rejected modernism. In official Soviet eyes, modernism—dismissed as "formalism"—was the product of the "deepening crisis in bourgeois-capitalist society" that manifested itself in "art for art's sake" and the "divorce of art from the people." Socialist realism, by contrast, was motivated by "the artists' desire to draw closer to the people; their wish to base their work on the solid foundations of the classics, especially the democratic traditions of their nineteenth-century predecessors; their desire to expunge elements of modernism from their work; and, above all, the infusion of communist ideology."[80]

Socialist realists saw modernism's rejection of realist representation as the manifestation of capitalist development. Capitalism had shattered the union between art, culture, and the people, turning artists into laborers for the capitalist class. But unlike the proletariat, the artist class in capitalist society constructed its own defense in the form of aesthetic autonomy and in so doing

chose to sit out the class struggle (ultimately serving the interests of the bourgeois class). In the historical evolution toward a socialist society in which art, culture, and the people would be reunited as an organic whole, then, modernism was a dead end. Reflecting this doctrine, soon after the 1934 Congress of the Union of Soviet Writers concluded, official Communist Party publications—in particular the daily *Pravda*—began condemning modernism. These attacks began in 1936 against a Shostakovich opera and then were extended to "nonrealist" illustrations in children's books. That year, avant-garde works were removed from Soviet museums.[81] A 1950 article from *VOKS Bulletin*, the official publication of the Soviet Union's cultural-diplomatic All-Union Society for Cultural Relations with Foreign Nations, perhaps explains the overall Soviet attitude toward modernism most clearly:

> "Art for art's sake," "art for the few: the elect," cubism, surrealism, existentialism and other like trends spring from . . . their deepseated hostility to an objective perception of reality, their hostility to the masses, "the rabble," "the mob." . . . Their ideological content is very clear; they are profoundly reactionary and serve the class interests of the bourgeoisie by trying to distract the attention of the wide masses of working people from the class struggle, the struggle against fascism and imperialism. By their endless and empty formalistic trickery, their decadent content, they seek to conceal from the toiling masses their class interests, to blind them to the vital social problems of the day.[82]

Soviet ideologues and cultural commissars often used *VOKS Bulletin* to explain and defend socialist realism to foreign audiences. Edited in Moscow and published in Russian, French, German, and English for distribution abroad, *VOKS Bulletin* eschewed the approach of the US cultural magazine *Amerika*, which provided its Soviet audience with color photographs and punchy, short articles, and instead ran long, turgid Marxist–Leninist argumentation on cheap newsprint in workmanlike layout.[83] Several articles from the early Cold War years, though, illuminate how Soviet authorities refuted Western straw-man portrayals of socialist realism. In 1947, cultural commissar Vladimir Kemenov explained that modernism—the "reactionary bour-

geois art of the epoch of imperialism"—stemmed from artists' "acceptance of capitalism's processes." Modernist theorists explained impressionism, cubism, surrealism, and other movements as an excavation and foregrounding of the otherwise naturalized elements of perception and cognition. Kemenov, by contrast, saw in such movements a distillation of Marx's ideas. Just as capitalism reduced humans to moving parts in an industrial machine, cubism "interpret[s] the human being as a combination of moving volumes." Impressionism "emphasize[s] properties (volume, weight, form, structure) common to both animate and inanimate objects." For Kemenov, the accusations that communism was dehumanizing were absurd, for it was capitalism that reduced humans to their base functions and physical elements. Communism was the true humanism.[84]

Although socialist realism certainly appeared prescriptive and limiting, Soviet ideologues denied that it thwarted individual artistic innovation or expression. The mandates to highlight heroism and virtue of Soviet protagonists, for instance, were not prescriptive, they claimed; they instead "stress . . . the essential and the significant which actually exists."[85] "The method of socialist realism," the 1961 pamphlet held, "gives the artist broad scope for expressing his individuality," pointing to the diversity of "pictorial treatment" in several paintings and sculptures, while insisting that "[these works] have in common an unshakable faith in the Soviet man, in his courage and his boundless devotion to his native land."[86] In the Western literary tradition, according to Gorky, the individual under capitalism recognizes his fundamental alienation but fails to recognize his own role in reinforcing the relations of production and ends up seeing himself as "superfluous." Under socialism, however, no individual is superfluous to the "heroic work of creating a classless society"; thus, the job of all artists and writers is to participate directly in "the construction of a new life and the process of changing the world." Tellingly, Gorky immediately added that this responsibility "should inculcate in each writer a consciousness of his duty and responsibility for the whole of literature and for the things that should not be found in it."[87]

These Soviet critics and writers attacked the very notions of the individual and innovation as used in the West. To equate "personal freedom" with "anarchic, rampant individualism in modern bourgeois decadent art" is ludicrous,

VOKS Bulletin insisted, because "it is just this individualism and this false pretence that the artist is independent of society that really make for the disintegration of the personality, for the death of the artist, and of art as a whole."[88] In a 1952 article, Soviet art critic V. M. Zimenko argued that the "individualism" in "formalist" (modernist) art is illusory: "individual differences never go beyond superficial tricks in the handling of form . . . they have drastically limited their creative possibilities by disregarding realities and distorting the foundations of art."[89] Similarly, Soviet ideologues invariably described Western experimentation and innovation—what Pound called "making it new"— with belittling terms such as *distortion, trick, novelty, formalism, decadence, anarchism, primitivism, animal instincts.*

Soviet attitudes about modernism also tended to reflect the level of tension between the Soviet Union and the West. Cora Sol Goldstein reports, for example, that in 1946 Alexander Dymschitz, the cultural commissar in the Soviet sector of occupied Berlin, denied that socialist realism is a "canon" or "dogma," asserting that it is "open to all forms of art and all themes." As hostilities grew, though, Dymschitz began "demonizing modern art and glorifying Socialist Realism," insisting that art be realistic and that "surrealism and abstraction have no right to exist. All art that does not fit the [socialist realist] specifications is . . . decadent, individualistic, capitalistic."[90] In the aftermath of Stalin's death in 1953, Kemenov dismissed Western accusations of a lack of artistic freedom in the Soviet Union: Western artists, confronted by the demands for "useless and incomprehensible works to satisfy the perverted tastes of their bourgeois owners[,] . . . will realize that their 'freedom' isn't anything but a trick."[91]

Western Cold War rhetoric capitalized on these clumsy statements, pointing out how according to the Soviet model freedom and individualism have no place in art. Schlesinger's *Vital Center* used these pronouncements, arguing that the Soviet system in particular and totalitarianism in general seek to undermine the individual, thinking, acting subject. "Direct political control," Schlesinger wrote in reference to the Soviet (and Popular Front) drive to shape the form and determine the content of pro-Communist writing, "either throttles the serious artist or makes him slick and false." Schlesinger particularly stressed how modernist works of art, because of their ambiguity and strangeness—"the paintings of Picasso, the music of Stravinsky"— can

be appreciated only by free individuals. Such works "reflect and incite anxiet-
ies which are incompatible with the monolithic character of 'the Soviet per-
son.'" Artists, writers in particular, are at the center of Schlesinger's exaltation
of "radical nerve": "Silone, with his profound moral sensibility; Gide, with his
quivering sense of freedom; Koestler, with his probing, insatiable intellectual
curiosity; Hemingway, who disliked people who pushed other people around;
Reinhold Niebuhr, with his tragic sense of the predicament of man; George
Orwell, with his vigorous good sense, his hatred of cant; Edmund Wilson,
with his belief in moral and aesthetic taste."[92]

Illustrating Schlesinger's characterizations of the crippled intellectual and
artistic life under "totalitarianism" was Richard Crossman's influential anthol-
ogy *The God That Failed*, a work compiling "confessions" from six former
Communist Party members in Europe and the United States. Its contribu-
tors—Arthur Koestler, Ignazio Silone, Richard Wright, André Gide, Louis
Fischer, and Stephen Spender—offered personal narratives of their immer-
sion in and eventual rejection of the Communist Parties of their respective
nations. Spender (who later became the editor of *Encounter*, examined more
fully in chapter 4) bitterly regretted the way that the Communists had taken
control of the Popular Front antifascist movement of the 1930s. In terms that
would later appear in *Encounter*, Spender attacked Communist epistemology,
in which "experience could only be drawn on in order to illustrate an aspect of
a foregone conclusion, arrived at independently of the experience." Marxists
even used this methodology in their literary criticism, he noted, praising Keats
as a victim of capitalism, reading *Finnegans Wake* as an illustration of "the dis-
integration of thought and language of the bourgeois individualist world,"
and congratulating Virginia Woolf for recognizing the "historic necessity" of
her suicide.[93] Independent judgment, even on aesthetic questions, is lost to
foregone conclusions; each of the six writers described the ominous fading of
the individual under the glare of the party's imperatives. In his 1952 *New York
Times Magazine* piece "Is Modern Art Communistic?" Alfred Barr empha-
sized the way that "totalitarianism" is opposed to individual expression:

> Lenin . . . said that "every artist claims, as his proper right, to work freely
> according to his ideal where it is any good or not. There you have the ferment,

the experiment, the chaos. Nevertheless," he went on, "we are Communists, and must not quietly fold our hands and let chaos bubble on as it will." . . . [Under socialist realism] abstraction or stylization of form, idealism or fantasy of subject were anathematized with such terms as formalism, Western decadence, leftist aestheticism, petty-bourgeois degeneracy . . . [while] Russian artists who accommodate their art to the dictates of authority are well-paid and deeply honored.[94]

In this argument, the Communist world's rejection of modernist experimentation was one small element of its rejection of freedom and individualism. Thus, by this binary logic, the production and positive reception (if not popular success) of modernist art demonstrated the West's embrace of freedom and individualism. Western liberal writers and critics then read values of freedom and individualism back into the modernist art and literature they already greatly admired.

If the modernism of Cold War modernism seems muddled and ambiguous, with no essential center, that's because it was. Cold War modernism was fundamentally reactive, a phenomenon defined largely *negatively* in terms of what it was not: socialist realism, totalitarianism, communism, communalism. In fact, Cold War modernism was primarily a rhetorical device created for the promotion of a particular kind of Cold War liberalism that valorized Lockean freedom and individualism, intellectual inquiry, and moderately challenging art. Modernism had been a wildly diverse collection of movements and tendencies before the 1940s, of course, but the Cold War modernist project voided it of the one attribute common to all modernist art up to that time— hostility to bourgeois culture. In place of this attribute, the Cold War modernists offered *freedom* and *individualism*, whose meanings crept ever more closely to that of the larger Cold War liberal ideology as elucidated by writers such as Schlesinger. This rhetorically reframed modernism, shorn of its revolutionary character by aesthetic autonomy and now understood largely as technique, was now ready for use in the cultural Cold War.

2

"ADVANCING AMERICAN ART"

Modernist Painting and Public–Private Partnerships

There is no art at all in connection with the modernists in my opinion.

—PRESIDENT HARRY TRUMAN, APRIL 1947

"IF THIS IS art, I'm a Hottentot," President Harry S. Truman said in 1947 when he saw Yasuo Kuniyoshi's painting *Circus Girl Resting*. Not by training an art critic, Truman was prompted to issue his assessment of this and other American paintings because they had become the center of a public uproar. Kuniyoshi's work was one of seventy-nine paintings in a touring US State Department exhibition entitled Advancing American Art. The exhibition sought to demonstrate that, contrary to common belief, the United States did have a vibrant and fertile art scene and that the developments of international modernism, particularly in painting, had crossed the Atlantic. Countering the preconception among European intellectuals (and the arguments aggressively made by the Soviet Union) that the United States was a philistine wasteland with no "culture" beyond comic books and cowboy movies, these paintings were intended to provide documentary evidence that advanced art did indeed thrive here.

Until it didn't. When the Hearst papers, then *Look* magazine, and then conservatives in the House of Representatives attacked the paintings as obscene, grotesque, communistic, and un-American, the show was quickly withdrawn, and the paintings—which the State Department had purchased for a total of $49,000—were auctioned off as war surplus. In its first deployment as a pro-Western weapon in the Cold War, modernism was killed by friendly fire.

FIGURE 2.1 Yasuo Kuniyoshi, *Circus Girl Resting* (1924).
Advancing American Art collection, Jule Collins Smith Museum of Fine Art,
Auburn University. Art © Estate of Yasuo Kuniyoshi/Licensed by
VAGA, New York, NY.

That Kuniyoshi's work in particular became a flashpoint was ironic, for he would appear to be an ideal representative of American culture. A Japanese-American artist who had emigrated—alone—to the United States in 1906 at the age of thirteen, Kuniyoshi was a vocal and visible patriot whose activities on behalf of his adopted nation during World War II had been covered in the press. Kuniyoshi, a resident of New York City, avoided being placed in a detention camp (the fate of large numbers of Japanese Americans in the western United States), but his movements were restricted, and he voluntarily turned in his cameras and radios to law enforcement officials. Perhaps because of his friendship with artist George Biddle, a Groton classmate of President Roosevelt and brother of Attorney General Francis Biddle, Kuniyoshi was "able to continue his daily life relatively uninterrupted" during the war, art historian ShiPu Wang writes.[1] And whether out of genuine conviction or simply a desire to prove his loyalty, Kuniyoshi took an active part in the propaganda campaign against Japan. "At least one Japanese we've heard of is doing his damnedest to help us win the war," the *New Yorker* reported in March 1942, noting that the "anti-Japan man," Kuniyoshi, had drafted radio propaganda scripts aimed at artists and intellectuals to be broadcast into his native country as part of the psychological warfare effort.[2] He also designed anti-Japanese posters for the OWI. A *Time* magazine photograph the following month depicted Kuniyoshi standing on a chair in front of a large, exaggerated caricature of Hideki Tojo that he had painted for an Art Students League party in New York. Kuniyoshi, in his role as propagandist, exemplified the "melting pot" notion of America as a place where people of diverse heritages shed their allegiance to their native *nations* but retained elements of their native *cultures*, which they then contributed to the pot. In fact, the Advancing American Art catalog stressed this process in the biographical note about Kuniyoshi: "He unites in his style the oriental's concern with the aesthetic continuum and the modern artist's interest in a canvas that is alive in all its parts."[3]

Notwithstanding Truman's slap at Kuniyoshi and the inglorious end of the Advancing show, modernist painting did eventually play a key role in the US cultural-diplomacy program during the Cold War. In the 1950s, both official and unofficial US cultural diplomats made the argument that American

modernist and experimental art and literature were not only thriving but thrived *because of* America's embrace of freedom and individualism. Turning the Soviets' arguments on their head, Cold War cultural diplomats put forth modernist painting—both abstract and figurative—as material evidence of the cultural superiority of a society based on cultural freedom, individualism, and capitalism.

Modernist painting's presence and importance in the American cultural-diplomacy program grew significantly over the decade, from its abortive début in Advancing American Art to its starring role in the 1959 American National Exhibition in Moscow. In addition to the exhibitions themselves, though, the internal discussions among governmental and nongovernmental organizations about what these shows should include (and exclude) and the public debate about modernist art's suitability as an ambassador for American culture capture the ongoing reframing of modernism from an insurgent movement to a loose collection of widely divergent works and movements sharing little apart from a rejection of realist representation and a putative embodiment of Western freedom and individualism.

Advancing American Art had its genesis in a 1946 request by the US cultural attaché in Paris to send over some modern American art because a conservative Tate Gallery show of that year had been, in Cyril Connolly's words, "an American tragedy."[4] LeRoy Davidson, former curator at the Walker Art Center in Minneapolis, was named to a newly created art specialist position at the State Department and quickly put together three shows, of which Advancing was the only one that gained notoriety. The imperative to appeal to European sophisticates and to refute the commonly held idea that the United States had no art or culture of interest drove Davidson's choices. In an article in the *American Foreign Service Journal*, Davidson pointed to the prejudice against any show mounted by the American government—"any exhibition chosen by the State Department would surely turn out to be hopelessly 'academic' and 'unmodern,'" he quoted one foreign critic as saying—and then declared categorically that "this critic will soon find that his apprehensions were unfounded for surely the exhibition is not of the 'official' type which he deplored."[5] For his audience of Foreign Service officers, he laid out his plans: organizing an assortment of traveling shows "vary[ing] in type from 'mod-

ern' to conservative,'" arranging "panel exhibitions" on American achievement in the useful arts and product design, relying on nongovernmental agencies such as the American Federation of Arts (AFA) when "it is not desirable for the Department to carry on certain activities through direct operations," and, ultimately, "transfer[ring] the responsibility for American artistic dissemination to private hands."[6]

The Advancing exhibit gathered together seventy-nine oils by artists such as Jack Levine, Ben Shahn, Marsden Hartley, Arthur Dove, Stuart Davis, Georgia O'Keeffe, and Kuniyoshi, as well as thirty-nine watercolors. After an initial showing in New York, Advancing was split into two shows, one (thirty of the oil paintings) sent to Havana and Port-au-Prince and the other (the remaining forty-nine oils and all thirty-nine watercolors) to Paris for the first general UNESCO conference and then to Prague. In a unique arrangement that became the linchpin of the Advancing controversy, Davidson chose to purchase the paintings rather than simply borrow them; the rationale was that no owner would want to lend a painting for the five-year period for which Davidson wanted it, and most of these contemporary works would not be as expensive as better-known works by deceased artists. Several artists (or their galleries) agreed to sell their paintings to the State Department at a discount—Georgia O'Keeffe sold two of her paintings for $1,000, even though the going rate for her paintings at the time was in the neighborhood of $10,000 apiece.[7] The paintings for the exhibit cost the Department of State, in total, $49,000.

Davidson intended his very self-consciously modernist selection to counter the "Americans are philistines" accusation and to forward the master argument that Western freedoms foster artistic experimentation, and his superiors at State echoed these explanations. "In many countries overseas it is the common misconception that our artists are second-raters who, in the main, ape the French school and have no creative individualism," Assistant Secretary of State William Benton explained in response to a congressional critic. "This exhibit . . . illustrates the freedom with which our American artists work."[8] (Benton, it is interesting to note, himself owned a Kuniyoshi and, as publisher of the *Encyclopedia Britannica*, had developed a collection of contemporary art for the company.[9]) The show previewed at the Metropolitan Museum of Art

in October 1946 and received warm notices in outlets such as *Art News*, the *New York Times*, and even the conservative *Art Digest*, where Ralph Pearson called the show "very important" because it will "officially answer the European assumption that there is no American art worthy of notice." Advancing, Pearson stressed, would make it clear that American artists are not slavish imitators of the school of Paris; the show also underscored how we are in "the age of the individual in art," not of the movement.[10]

The catalog of the European show, authored by Hugo Weisgall (a composer and conductor who was at the time the US cultural attaché in Prague), hit many of the key notes of the Cold War modernism argument, in particular the importance of individualism and the individual vision as well as the intrinsically international character of modernism. Weisgall also contextualized the art within the evolution of American painting, arguing that the contemporary works displayed American artists' turn to "internationalism" in the post-1930s period. "The arrival in the United States in the early thirties of refugee artists and teachers who brought to America the message of the most advanced European schools" helped these young American artists not only join but now lead international modernism: "they tend toward an internationalism more in harmony with post-war ideas."[11] As in later catalogs for official US art shows, Weisgall—himself an immigrant from Moravia—alludes to the melting-pot image, which would become ever more important as Communist propaganda increasingly highlighted American racial injustice. The painters in the exhibition, Weisgall argued, "stem from sources as wide as the whole globe. . . . The names *Prestopino, Ben-Zion, Bouche, Weber, Baziotes, Tschachasov, O'Keefe* [*sic*], *Davis, Pereira* are themselves an ethnographic cross section of the United States. As the idea of America has subordinated the concept of racial origins, so the growing international fabric of culture has subordinated nationality in arts to the individual. Hence, the individual is emphasized here."[12]

The State Department initially concluded that the show had achieved its aims. "The French press stated that [Advancing] had corrected the notion generally held in France that American art lacked progressive force," noted a State Department report about the first stop on the European tour, and the Prague show overshadowed a recent exhibition of Soviet art.[13] But the Hearst papers, in particular the *New York Journal-American*, had sounded the first

protest against the State Department exhibition when it had opened at the Metropolitan Museum of Art in October 1946, and the syndicate followed up with a series of attacks in late November and December. The February 1947 *Look* article "Your Money Bought These Paintings" brought the show to the notice of the broad public—and Congress. New York congressman John Taber told Secretary of State George Marshall that the paintings were "a travesty upon art," and Illinois congressman Fred Busbey demanded not only a justification of the $49,000 bill but also biographical information about the artists and Davidson himself.[14] In November 1946, the American Artists Professional League (AAPL) sent a formal letter of complaint to then secretary of state James F. Byrnes and coordinated a letter-writing campaign with other conservative arts groups. In what almost appears to be a direct rejoinder to Weisgall's catalog, the AAPL's complaints often centered on the perceived foreignness of the artists and the movements represented: "[We] question the cultural value of any exhibition which is so strongly marked with the radicalism of the new trends of European art. This is not indigenous to our soil."[15] One of the *Journal-American* articles ridiculing the show said it plainly: the paintings were "not American at all" but rooted "in the alien cultures, ideas, philosophies and sicknesses of Europe."[16]

The popular outcry began to sway the diplomatic establishment. Within State, influential career diplomat Loy Henderson doubted that "some of these paintings . . . would appeal to persons of discriminating taste."[17] In private within the department, Benton himself threw Davidson overboard, writing to W. Bedell Smith (US ambassador to the Soviet Union) that Davidson "should have known enough . . . to have bought pictures of several types so that there would be some pictures that would appeal to everybody."[18] In public at congressional hearings, though, Benton gave the collection a qualified defense, saying that "it is very difficult to get people to agree about art" and that the "theory" behind the Advancing show was that

Americans are accused throughout the world of being a materialistic, money-mad race, without interest in art and without appreciation of artists or music. The men of our cultural institutes, in their desire to show that we have a side to our personality as a race other than materialism, and other

than science and technology, write the Department from the field wanting examples of American art. Now of course, many think the modern art, so-called, is a better illustration of our current artistic interests in this country than the more orthodox or traditional forms of art.

"The theory was sound," Benton continued, but the practice was flawed due to the fact that a single person chose all of the pictures, and "the greatest genius in the world could not select 79 pictures that would appeal to any four of us as all being good pictures."[19] Finally, on April 2, even the administration disowned the show when President Truman made his "Hottentot" comment and added that "there is no art at all in connection with the modernists in my opinion."[20]

Not only the show itself but the very infrastructure that had been created to use American modernist art as cultural propaganda quickly fell apart. The art specialist position was eliminated; the paintings were sold off as war surplus at a 90 percent discount (the bulk of the works reside in the University of Oklahoma and Auburn University art museums today). The unofficial position of the US government became that modernist art was an unacceptable representative of American culture.[21]

Even as the diplomatic establishment dropped modern art, more conservative sectors of the cultural world and Congress were refining their wide-ranging condemnations of modernism. In addition to Busbey and Taber, Michigan congressman George Dondero and to some extent Wisconsin senator Joseph McCarthy had begun to assert forcefully that the problem was not just that modernist art was created by artists whose own personal histories associated them with communism, but that modernism and the avant-garde themselves were inherently tainted with communism (notwithstanding the world Communist movement's explicit and repeated condemnation of modernism as a product of capitalist decadence). Dondero, in a 1949 speech, insisted that "Communist art aided and abetted by misguided Americans is stabbing American art in the back with murderous intent. . . . Leger and Duchamp are now in the United States to aid in the destruction of standards and our traditions."[22] In this view, cultural conservatives in Congress were bolstered by the support of traditionalist artist guilds such as the National

CATALOG

of

117 Oil and Water Color Originals
by Leading American Artists

offered for sale at sealed bid by

WAR ASSETS ADMINISTRATION

P. O. BOX 216, WALL ST. STATION
NEW YORK, N. Y.

FIGURE 2.2 Cover of the Advancing American Art liquidation catalog.
National Archives and Records Administration, College Park, MD.

Sculpture Society, the International Fine Arts Council, and the AAPL. The National Sculpture Society, for example, in 1952 circulated a flyer asking, "Are you conscious of the fact that the pressure brought by certain aspects of the Modernistic Movement threatens not only art, but the fundamental freedoms of our American way of life?"[23]

Wheeler Williams, the president of the AAPL, gave the theory its fullest airing. Williams's case that modernist art was intrinsically Communistic rested on the following key pillars, which I for the most part paraphrase here:

1. The fathers of modernist painting—Picasso, Matisse, Leger, Courbet, Goya—are Communists or "professed Socialists," and thus the argument that communism and modernism are incompatible is untrue on its face.

2. In principle, modernism is "a revolt against the established order" and so is quite compatible with communism.

3 The Soviet Union actually "promoted" modernist art "for a period 12–15 years after the Revolution."

4. Communist criticism of modernist art tends to focus on its insufficient employment of social justice themes, not on its technical innovations; indeed, Wheeler argued, "the Communist party obviously likes 'modern' art because of the revolutionary role it has played in 'liberating' us from the—in its viewpoint—old and outworn classic artistic tradition."

5. Therefore, the most salient qualities of modernism—its revolutionary techniques—are not only compatible but actually congruent with communism. They serve the same purpose; they seek the same ends; there is overlap among the movements' membership; therefore, there is no meaningful difference between them.[24]

Although this testimony dates from 1959, it recapitulated the same arguments the AAPL and allied groups had been making for more than a decade.

However, other members of the American cultural establishment swiftly and angrily protested the withdrawal of the Advancing exhibition. In May 1947, several artists' groups (including Artists Equity, the Sculptors' Guild, and

the Audubon Society) met to protest the State Department's abandonment of the show. MoMA's James Johnson Sweeney, the Whitney's Juliana Force, and *New York Times* art critic Edward Alden Jewell registered their anger, and Edith Halpert of the Downtown Gallery attempted to turn the vilest accusation against the accusers: "We will have Communism in art if Congress can control what we paint, and free and individual expression is stifled."[25] Not all of the angered parties were at that meeting or even from the art world, either; an American Veterans Committee chapter abroad wrote an angry letter to Marshall "vigorously protesting" the cancellation, and a 1948 article in *United Nations World*, alluding to the show and to Soviet attacks on modernism, insisted that "political labels" for art, "whether commendatory or smearing, don't make sense."[26]

For the remainder of the Truman administration, even as State shied away from using modern art in official cultural diplomacy, the art world worked domestically to persuade the public that modernism was neither Communistic nor fundamentally foreign. "We reject the assumption that art which is esthetically an innovation must somehow be socially or politically subversive, and therefore un-American," a 1950 statement jointly authored by officials at MoMA, the Whitney, and Boston's Institute of Contemporary Arts said.[27] Alfred Barr flatly said that the antimodernist argument was "bizarre" and "ignorant to the facts. . . . The modern artist's non-conformity and love of freedom cannot be tolerated within a monolithic tyranny and modern art is useless for the dictators' propaganda because while it is still modern, it has little popular appeal."[28] Robert Goldwater, editor of the AFA's *Magazine of Art*, denied that "modern art is in any way subversive of democracy but [is] rather an expression of its freedom, and we believe that the Communists' objection to it supports our position."[29] And Nelson Rockefeller memorably called abstract expressionism "free enterprise painting."[30]

Notwithstanding the art world's protests, the scuttling of the Advancing exhibit appeared to most of those involved like the end of modernism's role in American cultural diplomacy. The idea that modernism was fundamentally un-American had taken on almost the status of official policy; it was certainly the position of President Truman and Secretary of State Marshall. As late

as 1953, a USIA official said that "our government should not sponsor efforts of our creative energy that are non-representational."[31] But a funny thing happened on the way back to the Academy of Painting. State Department bureaucrats and intellectuals noted that one of the most conservative sectors of American society—the world of big business—had begun to embrace modernist art.

This wasn't entirely a new discovery. The State Department had noted that works by the artists included in Advancing American Art were present in "the collections brought together in recent years by certain of the great industrial corporations, such as IBM, Abbott Laboratories, Container Corporation of America, Pepsi-Cola and La Tausca Pearls."[32] Before that, a 1946 article by Walter Abell in the *Magazine of Art* surveyed the links between American industry and the fine arts, concluding that big business provided more support to individual artists than did any other sector of society and that art's reliance on industry was a positive development in the aggregate. In a sanguine assessment, Abell concluded that industry's desire to use art to promote its own interests served the purpose of widely disseminating the work of contemporary artists and that although there could be some potential problems in using artworks in the service of commercial imperatives, "art for art's sake also has its limitations when pressed to extremes. On the whole a play between art and the other activities of society makes for mutually beneficial integration—something that has been sadly lacking in recent times."[33] Corporate use of modernism predated the 1940s, in fact; James Sloan Allen argues that the abstract, modernist designs used in advertisements for Walter Paepcke's Container Corporation of America from 1937 on were the first "marriage of modern art and business" and the catalyst for the rest of these "corporate courtships of art."[34]

The Department of State had already pointed to the connection between American industry and art. In congressional testimony about the Advancing show, Benton argued that State was only acting like a corporation in its use of art: "Art we believe helps nations understand us, just as some of the biggest industries in the United States believe art helps advertise their products and gain people's support. . . . This important movement started in 1928 when Steinway and Sons commissioned the artist Zuloaga

to paint a full-length portrait of Paderewski to be reproduced for advertising purposes. In the professional advertising circles of the 20's, this venture was considered a freak, but experience has proved otherwise."[35] He went on to cite other corporations that had undertaken similar projects, such as the Container Corporation of America, Dole, DeBeers, Lucky Strike, and Standard Oil.

In his short time at State, Davidson had in fact even organized two other shows that made the same argument. The first, a selection from the collection that IBM chairman and CEO Thomas J. Watson had amassed, was not a modernist show by any means. Among the paintings were charming works by nineteenth-century artists Samuel F. B. Morse, Thomas Cole, Eastman Johnson, and George Inness, but IBM's collection also included the contemporary painters Robert Gwathmey, Stuart Davis, and Karl Zerbe, who appeared in later, more controversial shows, as well as more traditional early-twentieth-century painters such as Thomas Eakins, Childe Hassam, Reginald Marsh, and Grant Wood, whose work had helped to establish America's legitimacy in the art world.[36] The show sought primarily to define American art as having a tradition with a definite trajectory, a character that drew upon but was not slavishly imitative of Europe's, and a deep engagement with the American landscape. The show proposed secondarily that the United States was unique in pioneering how corporate capitalism and a nation's cultural health could be symbiotic: the catalog copy pointed visitors' attention to "the growing tendency of industry to socialize its cultural assets and make them available to the whole of the American people," and a review in *Art Digest* noted that "so far as we know, [industry-sponsored art patronage] scarcely exists outside this country."[37] Davidson also organized and sent abroad the exhibition American Industry Sponsors Art, paintings lent by fourteen different American companies. "This exhibition will bear witness that American industry is supporting not only traditional but also the most advanced forms of modern art," Davidson stated regarding the show.[38]

American Industry Sponsors Art and 60 Americans Since 1800 were only the first of State's (and, later, the USIA's) touring exhibitions highlighting the connection between business and art. The argument was a double one: the same values of freedom and individualism that fostered America's predomi-

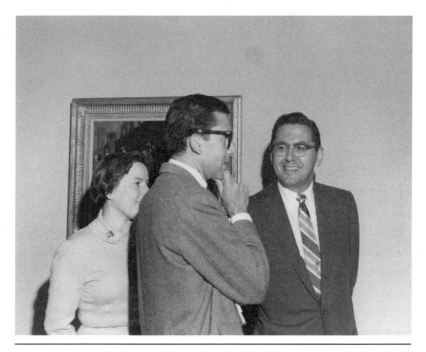

FIGURE 2.3 Lawrence and Barbara Fleischmann showing their collection. Image SIA2014-01210, Smithsonian Institution Archives, Washington, DC.

nance in business were creating a great art scene, and American business and corporate capitalism were not inherently philistine.

In 1956, the USIA sent a selection from the collection of Lawrence Fleischman, at that time a young Detroit industrialist, through Latin America.[39] The Havana State Department field office said that the Fleischmann show "helped to dispel the common misconception that the average American is not interested in, and cannot appreciate, art and culture," and a USIA officer in the Bogota post quoted a "prominent Colombian intellectual['s]" observations that "'the collection is a demonstration that private initiative in the United States has an elevated concept of social values; that the exhibit was a new style of diplomacy, and an application of cultural capitalism.'"[40] The State Department (and later USIA) was making the same arguments through its

publications as well; articles in *Amerika*, the Russian-language glossy mag-azine USIA produced for Soviet audiences to showcase American culture, profiled the Fleischmann collection and noted that American corporations were amassing "outstanding works of art" and erecting modernist-influenced headquarters such as the Manufacturers Trust building in Manhattan.[41]

American cultural diplomacy had been founded on the premise that private, nongovernmental groups were the ideal cultural ambassadors and that the gov-ernment's role should be to foster their involvement as much as possible. We see this approach in the eager use State made of private corporations' art col-lections, but another key relationship of this type was between State (and later USIA) and the AFA, the group that actually handled the logistics of organiz-ing and mounting many of the exhibitions included in the American cultural-diplomatic effort. The AFA had been founded in 1909 in response to a call from Secretary of State Elihu Root for an agency that would send "exhibitions of original works of art on tour to the hinterlands of the United States,"[42] and its role more than forty years later was still precisely that: it organized exhibitions, negotiated with owners of artworks, arranged insurance, and secured venues. On its board sat major figures from the art world, but the group itself remains largely unknown to the broader public, which has benefited from the hundreds of shows it has organized and sent throughout the nation and abroad for more than a century. In the 1950s, the AFA was the primary point of contact between the art world and the official cultural-diplomatic agencies that sought to use art for specifically political purposes; former AFA staffer Margaret Cogswell asserts that State and USIA relied on AFA because it "would be far less sub-ject to criticism" than the federal agencies in the case of a public outcry.[43] And although the AFA did not choose artworks for shows with politics in mind, its tacit acknowledgment that experimentalists and abstract expressionists were the most important painters working in the 1950s, demonstrated in show after show, *became* a political statement when it met up with the conservative strain in culture—and in the art world itself—that rejected modernism.

The AFA helped spread the message that American business was a valu-able supporter of challenging modern art. In 1954, it organized for USIA a show entitled A Corporation Collects: The Glen Alden Corp., featuring works of great French modernists (Picasso, Dubuffet, Chagall, Utrillo) as well

as paintings by the Americans Robert Motherwell and William Baziotes. The AFA tried again in 1960, pitching to the USIA the idea of sending its Whitney exhibition Business Buys American Art on tour in Europe, but USIA declined due to financial reasons. Even though this show never left the United States, the rhetoric in the exhibition catalog recapitulates the argument that business and art had a productive partnership and that there is a "very real connection between beauty and good business."[44] The conservative *Reader's Digest* praised the show for making clear who the senior partner really was: "For the esthetic and financial support that has helped to make [America's] leadership [in the worldwide arts] possible America's artists owe a very real debt to American business."[45]

The friendliness of some segments of the corporate world helped modernist art regain a place in the US cultural-diplomatic arsenal, but more important was the revitalization of cultural diplomacy under the Eisenhower administration. The embarrassing failure of the Advancing exhibition energized congressional Republicans, who had never trusted the "pinkos" in the Department of State and OWI, and they used their power of the purse to gut cultural-diplomatic programs. NSC-68 had called for a beefed-up psychological warfare program, but under the Truman administration the responsibility for this program was divided between the Public Affairs Bureau of the Department of State (whose budgets were overseen by Congress) and, after 1951, the PSB, which worked within the White House and therefore had more independence from congressional oversight.[46] The Smith–Mundt Act of 1948 had allotted some funds to the information program, but its provisions emphasized the role of business in these cultural-diplomatic ventures, and thus the art world, with few for-profit entities, was largely left empty-handed.[47]

Atomized and demoralized after Advancing, the federal government's art program remained largely dormant during the remainder of the Truman administration. The Department of State and the US Army—which governed the American zone of occupied Germany until 1955—sent several AFA shows to Germany, but these exhibitions featured architecture and book-jacket design. The fine arts were off-limits: "positively no painting or sculpture is to be included," AFA officer Eloise Spaeth noted. "We might offend

the sensitivities of some sleuthing congressman and the news would get back to Harry [Truman]."[48] (Oddly, this restriction did not apply to State's educational programs; the department produced and distributed abroad an instructional film entitled *Painting an Abstraction*.[49]) But as part of its 1951 Berlin Cultural Festival, the Office of the High Commissioner for Occupied Germany (HICOG) sought to include some artworks that might do double duty: make explicit the links between German émigré artists such as Albers, Grosz, and Ernst and the current American scene, as well as soften German intellectuals' derisive stance toward American culture. HICOG asked State to organize such an exhibit, but State was gun-shy after the Advancing fiasco and outsourced it to a selection committee that included Bartlett Hayes Jr. of the Addison Gallery of Art and Lloyd Goodrich of the AFA. In a letter to HICOG, Hayes laid out what the committee wanted to convey in the show:

> Art is the product of its own environment and the most significant element in the present-day environment is not geography, but the times—a corollary to this is that nations are less important than the community of the times. . . . Within this unifying atmosphere of time–environment there is, as there always has been, the vital and necessary action of individuals. . . . [The show] has been gathered to show that art in America, unlike the land of the New World, has grown from the people who have come here and has changed as they have changed, no more.[50]

Hayes and Goodrich were not policy men; they were not involved in shaping the official US government stand on the relationship of American culture to Europe's or on the key role of individualism in the struggle between the "free world" and the world behind the Iron Curtain. Nevertheless, the emphasis on the "vital and necessary action of individuals" as well as on the importance of the "community of the times" over that of geography echoes the larger Cold War modernism arguments about individualism and modernism's global nature.

Fearing a replay of Advancing, the governmental organizers of this Berlin exhibition did all they could to distance themselves from the show. The external selection committee chose the paintings, contracted with the AFA

to organize the exhibition, and received funds from the Oberlander Trust to cover expenses, thus providing State with plausible deniability in the case of a public backlash. In the end, sixty-five paintings—including fifty contemporary, challenging works by artists who had also been in Advancing, such as Kuniyoshi—were shown in Berlin in September 1951, and the show was a success: 3,000 visitors took it in during its first week, and HICOG Berlin Public Affairs Division chief W. J. Convery noted that "it is significant that a well-planned and well-executed effort to present one of the more refined aspects of American culture in Germany finds such a receptive response."[51] Convery also expressed satisfaction that a private agency had taken the lead in putting together this show, which not only provided the State Department with cover but also offered a fine model for private-sector-led cultural diplomacy. Nonetheless, this exhibition cannot be seen as anything but a tentative, gingerly reintegration of art into official cultural diplomacy. Historian Michael Krenn, for one, charges that State and HICOG intentionally downplayed, obfuscated, or failed to mention their roles in their own and outside press coverage of the Berlin show. "The virtual cloak of secrecy," he asserts, "together with repeated references to the 'private' nature of the undertaking, ensured that not a peep was heard from congressmen fuming about costs and communism, critics who saw modern art as a sign of the coming apocalypse, or even presidents preaching about 'lazy' modern artists."[52]

The 1952 election of Dwight Eisenhower, a man with a great deal of experience in international relations (at least of the military kind) and intellectual life (from his 1948–1953 stint as president of Columbia University), revitalized cultural diplomacy by placing it squarely in the realm of the information programs. Truman's administration had pursued psychological warfare, but that effort was relatively uniform in register: attacks on the Soviets. Eisenhower's experience as commander of the Supreme Headquarters Allied Expeditionary Force for the last two years of World War II and perhaps his own instincts taught him that psychological warfare had to take a central place in the confrontation with the Soviet Union—and, more importantly, that information programs had to be broad and varied in tone. Immediately upon taking office, Eisenhower convened the Committee on International Information Activities (known as the "Jackson Committee" for its chairman, deputy CIA direc-

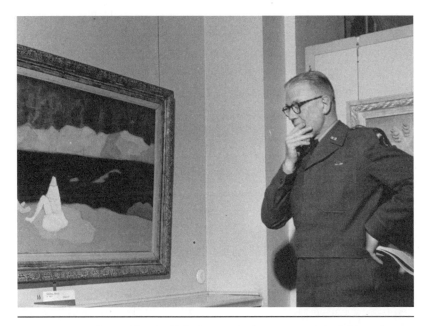

FIGURE 2.4 General Lemuel Mathewson looking at *Bather* by Milton Avery at the Berlin Cultural Festival exhibition in September 1951. Claude Jacoby, photographer. American Federation of Arts Records, Archives of American Art, Smithsonian Institution, Washington, DC.

tor William H. Jackson), which recommended in a June 1953 report that the United States focus, expand, and diversify its information programs and refine its messages. Although American information programs should continue to confront and rebut Soviet "lies" about the United States, the committee warned, it was equally important to explain America to foreign populations so as to create solidarity. "Propaganda . . . must perform the function of informing foreign peoples of the nature of American objectives and of seeking to arouse in them an understanding and a sympathy for the kind of world order which the United States and other free nations seek to achieve," the report stated. "To be effective, it must be dependable, convincing and truthful."[53]

Seeing the disarray of the cultural-diplomatic programs, Eisenhower abolished the PSB, arguing that it was "founded on the misconception that

'psychological activities' and 'psychological strategy' somehow exist apart from official policies and actions and can be dealt with independently by experts in this field."[54] Jackson Committee members also felt that the very name of this body was problematic; *psychological warfare* was an "unfortunate term" and said nothing about the American aim to "build peace and freedom."[55] In the PSB's place stepped the OCB, with similar responsibilities, but with a higher-level membership and more directly under White House and NSC control.[56] The OCB immediately called for "a greatly increased effort to stimulate organized non-governmental action to assure a steady flow abroad of American cultural activities, including art exhibitions and other cultural exhibits, concerts, radio programs, selected motion pictures, ballet, theatre, etc."[57]

But the role of the government itself would also expand. Through Public Law 663, passed in August 1954, Eisenhower obtained the President's Emergency Fund for International Affairs, which made available to him $2.25 million to be spent on tours by performing artists. "In the cultural and artistic fields," he wrote, "we need greater resources to assist and encourage private musical, dramatic and other cultural groups to go forth and demonstrate that America too can lay claim to high cultural and artistic accomplishments. . . . I consider it essential that we take immediate and vigorous action to demonstrate the superiority of the products and cultural values of our system of free enterprise."[58] The idea behind this fund was very much in keeping with the larger intention of the art program: "to counteract the commonly-held belief of the barrenness of American culture, to point to examples of American excellence in cultural achievement which would belie the notion that the American people are preeminently a gadget-loving people produced by an exclusively mechanical, technological and materialist civilization."[59]

These monies went to performing artists—jazz musicians, opera singers, the Native American dancer and artist Thomas Two Arrows—and to a memorable touring production of *Porgy and Bess*.[60] Modern dance artists in particular benefited from this particular allocation; Martha Graham, José Limon, and Alvin Ailey were among the dancers who mounted tours with this money, and Naima Prevots writes that "Eisenhower's fund . . . launched American dance exports all over the world."[61] Perhaps most importantly,

Eisenhower centralized the information programs under a newly created USIA, which was tasked with the job of telling America's story to the world. USIA's purpose was to produce and disseminate positive messages about the United States, while the more negative, propagandistic messages would come from covert or unofficial channels—a change from the earlier days of the government's information program, when outlets such as VOA aggressively attacked the Soviet Union and communism. Reflecting Eisenhower's concern for bolstering the credibility of his newly created agency, USIA was instructed to provide "a full exposition of the United States' actions and policies" in a "forceful and direct" but not "propagandist tone."[62]

The USIA's first director, Theodore Streibert, came from the corporate world (he worked at WOR radio in New York for twenty years and founded the Mutual Broadcasting System) and brought a commercial broadcaster's orientation and an "abrasive" personal style to his job.[63] Streibert wanted USIA to showcase to its foreign audiences everything about America— sports, popular music, even consumer products—or, as Streibert called it, the "culture of the people of the United States—not the culture of an elite or an intelligentsia."[64] Eisenhower specified that VOA and the USIA should not engage in overt propaganda, but Streibert understood that there was a difference between propaganda and *propaganda*. "We are no less engaged in propaganda because we are to minimize the propagandistic," he granted.[65] In terms of the art program, USIA continued to make the same arguments that the Department of State had been making. An internal study in 1953 resolved that "the unfavorable stereotype of Americans as cultural barbarians must be counteracted. Americans are regarded throughout the world as uncultured boors and crude, materialistic people 'who have no time for the finer things in life.'" Furthermore, the agency wanted to stress that the relation of American art to European art was that of coequals, not of filiation: the agency needed to "show that American art and French impressionism are derived from the same tradition rather than that one is derived from the other."[66]

In 1955, the AFA, in conjunction with the Smithsonian Institution and the USIA, assembled a group of sports-related American paintings to be sent to Melbourne, Australia, in conjunction with the 1956 Olympics. (Henry Luce's

FIGURE 2.5 Theodore Streibert being sworn in as USIA director, 1953. Photograph 53-11734, National Archives and Records Administration, College Park, MD.

Sports Illustrated financed the exhibition; USIA provided a venue abroad and official imprimatur.[67]) Exhibited initially at the Boston Museum of Fine Arts and the Corcoran Gallery in Washington, the show then moved to the Dallas Museum of Fine Arts on its way to Melbourne. There it met up with the Dallas County Patriotic Council, a small but vocal group that protested the alleged Communist ties of some of the artists. Although its historical scope was very broad, stretching from colonial times to the present, the exhibition did include works by the perennially controversial Ben Shahn and the now deceased Kuniyoshi, both of whom had been accused of membership in the Communist Party. Margaret Cogswell, who was involved with this show, reminisced in 2011 that "ladies from Fort Worth . . . made a line and stood in

front of the paintings so people couldn't look at them. They felt that whatever the artists were painting would be somehow infectious. I think the word *infectious* was used in some of the coverage."[68] Dismissing fears of potential contagion, the museum didn't budge and issued a statement vigorously defending "freedom and liberty," and so the show went on.

Until it didn't. The USIA concluded, in a meeting about the exhibit, that the work of four objectionable artists (Shahn, Kuniyoshi, William Zorach, and Leon Kroll) should be removed from the show and that in the future USIA would vet any and all cultural-diplomatic undertakings to ensure that nobody involved or included had been linked to communism. This ad hominem–based procedure for vetting shows was controversial, and the State Department's ICS warned Streibert that "the deletion of the works of the four artists in question would pose a public relations problem potentially a good deal more serious than the one we are attempting to avoid. . . . We are not only apt to jeopardize our cultural status in the world, but equally seriously, we are apt to have to forego the services of organizations throughout the country on whom we must depend for the selection and compilation of most of the art exhibits that we send abroad."[69] The latter part of the statement refers to the AFA's 1954 declaration of artistic freedom, which explicitly rejected evaluating works of art based on "the artists' political or social opinions, affiliations, or activities," and the AFA had made it clear that if USIA applied such standards, it would no longer be able to work with the agency.[70] So, fearing a backlash from this abrupt reversal and damage to its ties with the AFA, the USIA simply cancelled three AFA-organized exhibitions that included works by suspect artists: Sport in Art, American Painters 1900–1950, and Universities Collect. Writing to AFA director Thomas Messer, Streibert weakly explained that "over-all program considerations dictate that we take this action at this time."[71]

USIA's change of policy infuriated the art world's luminaries. Alfred Barr wrote to "Jock" Whitney—who, in addition to being ambassador to Great Britain, was an AFA board member and trustee of the Whitney Museum—that the USIA had "knuckled under" to fringe groups.[72] Whitney, for his part, protested directly to Streibert, who responded that the change "has nothing to do with freedom of the arts." Although it is unacceptable to pull

paintings once an exhibit begins, he granted, the agency's policy is that "we would sponsor and support the exhibit abroad of works of art provided that the artists concerned were neither Communists or [*sic*] had close association with Communist fronts and groups. . . . The question actually boils down to whether the Agency may decide for itself which artists are to be represented and which works of art displayed in overseas exhibits sponsored and financed by the Agency."[73]

Tellingly absent from this controversy is any discussion of the art itself. Objections to the Advancing exhibit centered primarily on the ugliness and un-Americanness of the pictures, to the degree that the State Department shied away from mounting any shows of painting for much of the Truman administration because of fears that the press and the public would be angered by modernist content. For the later exhibits, it was not the style that was the problem: it was the artists. Latent in the Sport in Art episode, which at first glance looks like a replay of Advancing nine years later, was the fact that modern*ism* was no longer the issue: the problem was the modern*ists*.

AFA itself had no intention of backing down from its stance that it would not evaluate art by the artists' political activities, but it still wanted its cancelled shows to find a foreign audience. James Schramm, AFA's president, approached the Fund for the Republic—a Ford Foundation–funded nonprofit with a liberal, cultural-freedom orientation, headed by Robert Maynard Hutchins—for support. Pointing to State and USIA's decision to scuttle the Sport in Art show, Schramm complained that there would not have been a problem "if the AFA had agreed to the withdrawal of work by some 10 painters who are considered to be 'public relations hazards' by USIA. . . . Withdrawal under such circumstances would be clearly incompatible with the Federation's stated principles on the freedom of the arts," he concluded in an appeal designed to push the free-expression absolutist Hutchins's buttons. Hutchins, though, declined to fund the show.[74]

Discouraged by official intransigence on this issue, the AFA—doing what the cultural-diplomatic establishment had always endorsed—sought to foster private support for the art program. AFA director Thomas Messer suggested to the Fund for the Republic that it collaborate in printing a set of arguments that could serve as a set of talking points and distributing them

to both the art world and the liberal-minded, affluent, establishment figures who served on the boards of art institutions. Alluding to George Kennan's speech "International Exchange in the Arts," which MoMA had printed and distributed in 1955, Messer proposed "a short pamphlet of our own on 'Why Send Contemporary Art Abroad?' Another might be 'Freedom of the Arts in a Free World.' . . . [I]t is peculiarly our obligation and opportunity to give our membership the kind of broad basic educational material they need in order to counter-act loose talk and false charges in their own communities."[75] Again, though, Hutchins declined.

The art world never forgave Streibert for his lack of backbone. Later, even USIA official Lois Bingham (who had been present for the Sport in Art episode) granted that Streibert had been wrong, but that the agency had learned from its mistakes in the interim:

When Mr Streibert left the Agency, he told me that his decision would have been different had he been aware of the importance to the Agency of the principles involved. . . . Since 1957, when the Agency lost nearly all its friends in the Art world, it has gradually rebuilt confidence among the museum people, art dealers, and collectors by demonstrating ability to organize art exhibitions of aesthetic merit appropriately designed for the particular part of the world for which they were destined. . . . Consequently, our "art policy" is fluid, becoming as liberal as possible within practical limitations.[76]

Streibert's change of heart was due not a little to a change in the culture. With McCarthyism waning, more groups were willing to lend their voices to a defense of artistic freedom and, more importantly, were willing to make explicit the connection between American liberty, artistic freedom, and modernist experimentation. The American Committee for Cultural Freedom issued a statement deploring USIA's retreat on Sport in Art, calling the incident "the latest in a series which betrayed muddled or frightened thinking and did American culture great harm abroad."[77] The press derided USIA for making "concessions to this yahoo standard of art."[78] Several liberal senators made floor speeches criticizing the USIA's decision, calling out Streibert in particular: Hubert Humphrey of Minnesota called the decision "cowardly,"

and William Fulbright of Arkansas said that Streibert's decision was "directly contradictory" to the policies of President Eisenhower, "but that shouldn't surprise anybody."[79]

Underscoring, or perhaps leading, the cultural shift was President Eisenhower himself. As an amateur painter, Eisenhower presumably had greater sympathy with issues of artistic freedom than did Truman and had already lent indirect support to the cultural-freedom movement during McCarthy's 1952–1953 crusade against the presence of Communist-affiliated authors in USIA information centers and libraries abroad when he exhorted, "Don't join the book burners. . . . Don't be afraid to go in your library and read every book."[80] A year later, in a speech recorded for MoMA's twenty-fifth anniversary celebration, the president went further and made explicit the very Cold War modernism argument that Truman and USIA had shied away from. In that speech, Eisenhower stated unequivocally that "freedom of the arts is a basic freedom, one of the pillars of liberty in our land . . . our people must have unimpaired opportunity to see, to understand, to profit from our artists' work. As long as artists are at liberty to feel with high personal intensity, as long as our artists are free to create with sincerity and conviction, there will be healthy controversy and progress in art." If the language equating freedom, individualism, and artistic experimentation wasn't clear enough, Eisenhower continued: "My friends, how different it is in tyranny. When artists are made the slaves and tools of the state; when artists become chief propagandists of a cause, progress is arrested and creation and genius are destroyed. . . . Let us resolve that this precious freedom of the arts, these precious freedoms of America, will, day by day, year by year, become ever stronger, ever brighter in our land."[81]

Responding to the controversy about whether artists and writers with dubious *personal* associations should be used in cultural-diplomatic programs, Eisenhower shifted the terms of the debate to be about the *product* itself: the art, the books. Eisenhower here and elsewhere tacitly endorsed the aesthetic-autonomy arguments that were so instrumental in persuading broad American audiences to accept modernist art: whoever or whatever the artist might be, it is the artwork that is the ultimate expression of that artist's—and his or her society's—freedom.

Eisenhower's public statements endorsing cultural freedom and equating tendentious art with totalitarianism heartened the arts community and bolstered the campaign to demonstrate that modernism expressed not subversion but quintessentially American freedom. In 1952 in the *New York Times Magazine*, Barr refuted Congressman Dondero's argument that modernism bore Communist genes and, as Patricia Hills shows, for years used a widely distributed MoMA pamphlet that he had written to emphasize this point to an audience of educators and students. Published in 1943, *What Is Modern Painting?* explained the techniques of "modern art" (from impressionism to abstract expressionism) for a student audience and, Hills reports, eventually saw more than more than 200,000 copies printed and circulated.[82] In the first edition, Barr insisted that "in order to tell [the] truth the artist must live in freedom" and specifically named Goebbels and Hitler as forces that "crushed freedom in art." A 1952 revised edition equated the Soviets and the Nazis and took a dig at socialist realism: "Similarly the Soviet authorities, even earlier than Hitler, began to suppress modern art, calling it leftist deviation, Western decadence, bourgeois, formalistic. . . . The Soviet artists who remain are now enjoined—and well paid—to paint propaganda pictures in a popular realistic style." Barr quoted Soviet newspapers "thunder[ing]" against modernism as an "'aesthetic apology for capitalism'" and asked: "Why do totalitarian dictators hate modern art?" His answer: "Because the artist, perhaps more than any other member of society, stands for individual freedom: the freedom to think and paint without the approval of Goebbels or the Central Committee of the Communist Party, to work in the style he wants, to tell the truth as he feels from the inner necessity that he must tell it."[83] The 1956 edition of *What Is Modern Painting* inserted the quote from Eisenhower's MoMA anniversary speech given earlier to bolster the argument that the US government, unlike its totalitarian adversaries, supported and fostered that freedom; it also suggested, Hills argues, that "to prove your resistance to Communism . . . you cannot work in realistic styles that are anything like the Socialist Realism of the USSR: you must be 'modern.'"[84]

The official equation of modernism and Americanism—now implicitly endorsed by the president himself—debuted at the US pavilion at the 1958 Brussels Universal and International Exhibition (the World's Fair). In

keeping with his expanded emphasis on cultural diplomacy, Eisenhower had increased American participation in trade shows and exchange programs, and State saw an American presence in Brussels as a key priority because up to thirty-five million visitors, many of them intellectual and cultural leaders of western Europe, might visit the American pavilion and be relieved of their prejudices about the lack of culture in the United States. The pavilion took visitors through a series of installations illustrating typical aspects of American life, with an overarching theme of "a society in ferment" and a people "dynamic, energetic, impatient and restless for change."[85] American affluence, particularly as embodied in consumer products, was the focus of the pavilion, which "was a model of 1950s affluent society in which the anxieties of the atomic age had been subsumed into a paradise of consumption," in the words of historian Sarah Nilsen.[86] The pavilion had originally even included Unfinished Work, an exhibit about problems in American life that listed segregation as one of those problems, but angry protests by southern congressmen forced the removal of that exhibit.

Although the focus was on consumer capitalism, a section of paintings highlighted American achievement in contemporary art. Lloyd Goodrich made the initial selections for the show, but his choices met with resistance from John Walker, director of the Smithsonian's National Gallery of Art (who also disliked Edward Durell Stone's modernist design for the pavilion). Abstract expressionism, heavily represented among Goodrich's choices, was "very much out of fashion" in Europe, Walker argued, and he was personally "against anonymity, uniformity, and all the things that go to make up modernism."[87] When Goodrich's suggestions were rejected, the President's Advisory Committee on the Arts turned to the AFA to select paintings but stipulated that they all should be from artists younger than forty (which would exclude the most consistently controversial artists from previous shows: Levine, Shahn, and Kuniyoshi). AFA's jury chose seventeen painters, most of them abstract expressionists, including William Baziotes, Richard Diebenkorn, Robert Motherwell, Grace Hartigan, Ad Reinhardt, and Ellsworth Kelly.

The show's catalog, written by Grace McCann Morley, director of the San Francisco Museum of Art and one of the jurors for the show, implicitly

defended what the jury knew would be controversial choices and at the same time echoed many familiar Cold War modernism arguments. In its introduction, AFA director Harris K. Prior reinforced the idea that American artists were part of the larger community of (presumably Western) artists, noting that "as the world becomes smaller and the community of mankind moves inexorably closer together, the free artists of America speak their own particular dialect of the international language of art."[88] Morley wrote that "the strong individuality of the artist, his efforts to find his own expression and to be himself in his work, his knowledge of the international movements of today, yet his determination to find his own personality in relation to them, are evident" in the works of the seventeen young painters.[89] Members of Congress, the press, and even some artists' groups (including, inevitably, the AAPL) predictably criticized the show. USIA director George Allen, a career diplomat who had been named to head the agency in 1957, eventually informed Eisenhower that the exhibit seemed to be too "modernistic and impressionistic in content," too "heavily weighted on the side of abstract art."[90] Eisenhower seemed to agree, telling Allen that "there is a place for the modernistic and impressionistic school" but that the fair was probably not the right venue "to try to teach sophistication to the public of Europe or to American tourists."[91] Unlike his predecessor, though, Eisenhower did not feel it appropriate for him to take a public stand, denying that he should "set myself as a critic of any artistic exhibition."[92] In June, Assistant Secretary of State Burke Wilkinson suggested "less abstract art in the Art Show, and more use of the works of Andrew Wyeth, Charles Burchfield and other popular American artists."[93] In the end, a selection of more traditional paintings and works by more established artists was added to the pavilion, but not to the painting show proper; the AFA's show, its original vision intact, stayed up. Internal postmortems ascribed the minor furor not to a mistake by the administration (as with Advancing), but to manufactured outrage: a few letters derided the "emphasis on modern art," but such letters were largely a result of "newspaper articles" by "columnists and editorialists . . . [who] have not actually visited the Fair."[94] In Brussels, the balance of power changed: in a pure reversal of the Advancing and Sport in Art incidents, official cultural diplomacy showcased modernism in a high-profile setting, and when cultural

conservatives challenged the show, the cultural diplomats not only declined to withdraw the show but put the "balancing" works in a subordinate position.

We see this same evolution—official cultural diplomacy coming to embrace modernism and abstraction—in a pair of lesser-known exhibitions of the 1950s circulated by USIA. The shows are, in a sense, twins in that both consisted not of originals but of reproductions, and their catalogs and content evidence the shift in the art program's attitude about modernism. AFA assembled the first show (1955), a sizeable collection of color prints of American paintings from the colonial period through to the present. Highlights of American Painting cloaked its modernism in arguments about the fundamental simplicity of the American artistic vision and defensive assertions about cultural diversity. It included few modernist works (Lionel Feininger's *Blue Marine* and Arthur Dove's *Flour Mill Abstraction* were the most challenging paintings), and Lois Bingham's catalog essay focused not on the connection between modernist experimentation and American freedom, but on what we would call today the "diversity" of the American population as reflected in its artistic corpus: the collection, she wrote, "reflects the character of the American people who are drawn from a variety of countries and races and who have brought with them traditions and customs that have been woven into our national heritage."[95] That this argument about American art appeared in 1955 is significant, for, as many scholars have detailed, one of the most effective Soviet and Communist Information Bureau propaganda campaigns of the time pointed to racial segregation as evidence of American hypocrisy. Indeed, a tacit response to accusations of American racism might have motivated the inclusion of one of the pictures, George Bellows's *Both Members of This Club*, a 1909 painting depicting a boxing match between a black pugilist and a white pugilist (although the catalog explains that the title refers to "a factual announcement that this is a legal boxing match" between members of the same amateur athletic club).[96]

The Highlights show, composed of reproductions rather than originals, could appear in multiple locations at once, and for several years it toured Latin America, Europe, Asia, and Africa. Krenn notes that it was "surely the most popular American art exhibit of the mid-1950s, if one judges merely on the number of people who saw it."[97] Reports from USIA field officers

were enthusiastic but at times reflected the timidity of the selections; both the Brussels and the Belgrade posts emphasized how local audiences wanted to see more challenging, contemporary work.[98] Indeed, both the conservative selection—Gilbert Stuart's portrait of Washington, an Audubon, George Bingham's *Fur Traders Descending the Missouri*, and Grant Wood's *American Gothic*, for instance—and the introductory catalog essay seemed designed to refute the accusations of American cultural conservatives that the art program was obscurantist. "Unusual directness and clarity of vision interpreted with a corresponding simplicity of statement are the underlying characteristics of American art," the catalog asserted. "Even in early Colonial days these features were present, and now, having become sufficiently pronounced, they are recognized as the mark of the American style."[99] Such sentiments are echoed in a USIA film of the same time, *Painting of the New World*, in which the narrator (over a shot of a painting of animals) intones that "these paintings seem to express the innermost corner of the soul of the 19th century American: his faith in life, and the consciousness that nature, through which his life unfolds, is a great gift of God."[100]

USIA's 1958 show Twentieth Century Highlights of American Painting seems in this light almost a rebuttal, not only in its limitation to twentieth-century work but in its identification of complexity, individuality of style, and freedom as the salient features of the American tradition. Like the earlier Highlights in consisting of a set of collotype prints exhibited in Information Centers abroad, Twentieth Century Highlights also drew large audiences. Arshile Gorky and Ben Shahn—whose inclusion had caused USIA to cancel earlier shows—were among the painters represented in this exhibition, demonstrating a new confidence among the art program's officials. Dorr Bothwell, Jackson Pollock, John Marin, and others who were deeply influenced not only by the very American abstract expressionism but also by European movements such as fauvism, surrealism, and cubism appeared in the show as well.

The difference in the way the show was presented to foreign publics, however, reflects the larger changes in USIA's art program. USIA tellingly concealed its involvement with the 1955 Highlights show in the catalog, which emphasized that the show was an AFA production, but the catalog cover for the 1958 exhibition Twentieth Century Highlights clearly states that it

was "organized by the United States Information Agency." Art critic Doro-
thy Adlow's short introductory essay, moreover, hit the requisite notes about
freedom, individualism, innovation, and free expression. The painters of the
1940s, Adlow said, display "an unprecedented independence of restraints and
disciplines in artistic performance [and] and extraordinary outcropping of
individual styles." And contemporary (1950s) painters "continue to express
themselves with even greater freedom," communicating their "individual
temperaments" and "personal idioms of style." "American painters today,"
Adlow concluded, "continue their adventure to new frontiers of style and
ideas in an atmosphere of free speech and free expression."[101] Although the
repeated emphasis on freedom is perhaps a bit overdone, knowledgeable read-
ers would also hear in Adlow's lauding of individual style and temperament
an implicit rebuke to socialist realism. Influencing elite opinion in foreign
nations was always a key priority of the cultural-diplomacy program, and
reports from USIA field officers focused on cultural and intellectual leaders'
positive response to these shows.

A year later an exhibition in the heart of the Soviet Union itself secured
modernism's place in American cultural diplomacy. The American National
Exhibition in Moscow, held in the city's Sokolniki Park from July 25 to
September 4, 1959, was the site for the famed Nixon–Khruschev "Kitchen
Debate," and historian Walter Hixson and diplomat Yale Richmond agree
that this exhibition—and the 1958 cultural-exchange pact that made the
show possible—"signaled the ascendancy of the West in the Cold War."[102]
Although American painting certainly was not the main focus of the exhibi-
tion (American consumer products, Walt Disney's "Circorama" movie pro-
jection system, and Edward Steichen's famed Family of Man photographic
exhibit were), it was a part of the show. USIA had requested that paintings
be chosen by a jury of specialists (which included Goodrich as well as painter
Franklin Watkins, sculptor Theodore Roszak, and Henry Hope, who headed
Indiana University's pioneering fine-arts department) and stipulated that the
show "include an introduction of the three or four paintings of the period of
Homer, Eakins and Ryder and include the best examples of paintings and
sculpture up to the present."[103] The jury decided that "our Government and
the cause of art freedom would both best be served" by depicting "the broad

FIGURE 2.6 Jack Levine, *Welcome Home* (1946). Brooklyn Museum.
Art © Estate of Jack Levine/Licensed by VAGA, New York, NY.

development of American art in the past 40 years" rather than focusing exclusively on "our most experimental young painters and sculptors."[104] In the end, each of forty-eight painters had one picture in the show, and the list included many of the names that had caused the most trouble for the art program over the previous twelve years: Zorach, Shahn, Levine, and even Kuniyoshi.

As expected, everybody involved played their assigned parts. Pennsylvania Democrat Francis Walter stepped in to take the place of the recently retired Dondero and, after looking at USIA's exhibition program, asserted that the show included twenty-two artists "with significant records of affiliation with the Communist movement in this country." The AAPL pointed to the "lamentable . . . dismal, dreary, and technically trivial array" of paintings in the "Red saturated exhibition." Journalists attacked the show in the press, and President Eisenhower himself expressed his misgivings about one painting (Jack Levine's *Welcome Home*), saying that it "looks more like a lampoon than art."[105]

Like Kuniyoshi, Jack Levine had been a constant presence in the art wars of the 1950s. Unlike Kuniyoshi, though, he had been a vocal and visible *critic* of American culture for the duration of his career and had made clear that he considered himself to be a social (but not socialist) realist. Milton Brown explains that Levine "exploded like a skyrocket as an artistic prodigy" at the age of twenty-two when MoMA acquired his painting *The Feast of Pure Reason*, which depicted a triptych of grotesque figures: a police officer, a plutocrat, and, in the center, what appears to be a corrupt urban politician.[106] (The title, Levine noted, came from the Circe episode of Joyce's *Ulysses*, when Stephen Dedalus, knocked to the ground by two constables, says to Leopold Bloom—who is handing him his ashplant—"Stick? What need have I of a stick in this feast of pure reason?"[107]) Levine was politically a liberal rather than a revolutionary and trusted in the Supreme Court of Chief Justice Earl Warren as "our only hope for a liberal free society."[108] Congressman Walter, however, charged Levine with being a member of "at least 21 Communist fronts and causes."[109] Levine writes that he considered himself a satirist and a "dramatist. . . . I look for a dramatic situation which may or may not reflect some current political social response on my part and I improvise the characters as I am painting."[110]

Welcome Home was just such a painting. Far from being an abstract, the painting draws quite directly on the imagery of Berlin Dada, in particular that of Otto Dix and George Grosz. Levine writes that he conceived of the picture as his own troop ship sailed into the harbor on his return home from World War II, and "I thought, as a satirist, that it was just for me to welcome home a returning general. . . . Some officers lived in a world of their own creation. This general has come home and he's still in that sort of a world. I'm not talking about men like [Omar] Bradley and Eisenhower. I have great respect for them. It's just the big slob who is vice-president of the Second National Bank and president of the Chamber of Commerce, only now he's been in the army. I couldn't say that sort of thing while I was in the service. This was my time to howl." Levine notes that, had he been asked, he would not have opted to send the painting to the Soviet Union as part of an official show: "if they'd asked me, I would have chosen something a bit more diplomatic."[111]

Whereas Levine envisioned the painting as a satire of "Babbitt goes to the army," Congressman Walter saw a dangerous message about American disunity. Soviet viewers, he worried, might see in the painting's grotesque general a representation of America's actual feelings about its military; the painting "will help the Kremlin convince its enslaved people that its vicious propaganda about American military leaders is true, and even supported by the American people."[112] (For his part, Levine remarked, "It is fine if the Soviets saw this [painting] as antiwar."[113]) Walter convened hearings on the Moscow art exhibition on July 1, 1959, subpoenaing artists Levine, Shahn, and Philip Evergood. Evergood and Shahn pleaded the Fifth Amendment in response to all questions, and Levine, in Spain with his family, declined to appear. In private, Vice President Richard Nixon also sought to have the show withdrawn, but Undersecretary of State Christian Herter warned him that this would be "the Pasternak thing in reverse," and "we will just have to live with this."[114] (The previous year, Nobel laureate Boris Pasternak, whose *Doctor Zhivago* was critical of Stalinism and strayed too far from socialist realism, had been expelled from the Union of Soviet Writers and was almost exiled.) USIA deputy director Abbott Washburn concurred, noting in a memo that "one *sure* way to draw undue attention to [the controversial paintings] would be to withdraw them from the exhibition."[115]

As had been increasingly the case throughout the 1950s, influential voices in culture and the government spoke up in support of the show. The selection jury forcefully defended its choices, senators (Michigan's Philip Hart in particular) defended the show, and the mainstream press—including the *New York Times* and *Baltimore Sun*—editorialized against censorship. The *Philadelphia Evening Bulletin* even implored Congressman Walter, "No Pasternaks, please." Unlike with the 1955 exhibit Sport in Art, moreover, the USIA did *not* demand prior approval over the artists and in the end refused to withdraw the show, citing the potential public-relations damage that would come from such a reversal (although, as in Brussels, it did add twenty-six more conventional paintings to the show as a result of the controversy). In response, the American Association of Museums "commend[ed] the U.S. Information Agency [for] its policy of engaging professional art juries to select exhibitions for display abroad without restriction that might be imposed by political and artistic bias."[116] Goodrich

wrote approvingly to Boston Museum of Fine Arts director Perry Rathbone as the exhibition was about to open, noting that "the President and the USIA are standing firm against censoring our show, which is something that never happened before. . . . [T]he situation today is quite different" than it was with Advancing or Sport in Art, Goodrich pointed out.[117]

Goodrich's catalog for the Moscow show contextualized the American modernists within the larger modernist movement, refuting the charge that American culture was a backwater and strengthening the claim that modernism and the cultural environment that fostered it were common to all of the nations of the free world. The 1913 Armory Show had engendered "incomprehension, ridicule, and opposition, and for years the modernist pioneers had to struggle against hostility and neglect," he admitted. "But by about 1925 their battle had been won," and "with the advent of the modern movements" across all of the decorative and useful arts "American art had entered the main stream of world art." Nor were ordinary Americans themselves Philistines, he stressed: art museums featuring modern art were thriving across the nation with the active involvement of the government, nonprofit foundations, universities, and the business community. "All in all," he concluded, "modern art for the past fifty years has attracted great interest on the part of the population[,] which loves it and supports it by all possible means." Goodrich also echoed the Cold War modernism argument that the "pluralistic character of American art is the appropriate expression of a democratic society, giving wide scope to individualism and experimentation."[118]

It didn't hurt that Soviet officials were so hostile to the show. The *New York Herald-Tribune* reported that cultural commissar Vladimir Kemenov "blasted the abstract art at the United States exhibition," calling the works "startling in their ugliness and unbelievable tastelessness." Kemenov also complained that the show included too few works by leftist realist painters—an accusation that, ironically, helped undermine the charge that modernism was Communistic. In a May 1960 *Atlantic Monthly* article, exhibition curator Richard McLanathan recounted how when he met Soviet premier Nikita Khruschev, Khruschev "shook hands coldly, pointed at a painting nearby, and said, 'People who paint like that are crazy, but people who call it art are crazier still!'"[119] On July 28, three days after the Moscow show opened, AFA director Harris Prior

told RFE that "abstract art has been with us now for 50 years. In some parts of the world today it is the predominant mode of art expression. . . . Abstract art is still unfamiliar to large segments of the population in some parts of the world. Because it is unfamiliar it is sometimes attacked by those who resist change. In totalitarian countries it is attacked as bourgeois or degenerate. In democratic countries it is attacked as communistic. The fact is, of course, that it is neither."[120]

Controversial or not, the show attracted a massive number of visitors, far beyond what the organizers had anticipated. McLanathan gave a figure of 15,000 visitors a day, for a total of nearly one *million* visitors over the show's run.[121] The organizers took advantage of the show's popularity to explain modernism and abstraction as evidence of the "American concepts of individual freedom of expression and of choice." USIA director George Allen told the National Press Club in August 1959 that "the modern paintings first sent have proved a great attraction, despite the astonishment with which the average Soviet visitor views the examples of abstract art. I was told a large number of visitors ask particularly to see 'the picture President Eisenhower did not like.' . . . The Russians I saw looking at it did not seem to like it very much either, but they were most curious to see it." The American guides, Allen continued, explained to visitors that "many painters in the United States and the rest of the free world are painting abstractions today, and that artists in America are free to paint as they like and are not told what to paint by any government authority."[122]

The *New York Times* reported that even though "loud guffaws and jeering gestures are hurled at paintings [by] Jackson Pollock and Ben Shahn . . . many visitors study these paintings carefully, and many flock around" curator McLanathan to ask questions about abstract art. "The extraordinary thing," the article concluded, "is that more and more Russians themselves are . . . answering the questions, and openly defending the exhibit."[123]

In the *Atlantic Monthly* article, McLanathan unsurprisingly echoed and confirmed the show's own contentions about the programmatic Soviet attitude toward art, American freedom and individuality, and consumerism: "The Soviet [citizen] . . . is told that it is his duty to look at works of art and to have correct opinions about them. . . . By contrast, few Americans consider art as

propaganda, and no Americans are under any compulsion to pay any attention to it at all. The truth of the matter is that most of us would rather watch television or go bowling than go to an art exhibition, and we are perfectly free to do so. Thus, the superficial comparison of American and Russian opinions on modern art misses the point entirely. Under totalitarian government, conformity is the rule." The argument was that art loses its ability to innovate when a command economy orders citizens to engage with it but thrives when it is just another consumer product, when citizens are free to ignore it and business can choose to support it. McLanathan expanded on this economic metaphor: "Just as certain Russians took their first swallow of Pepsi Cola, spat it out with an exaggerated expression of disgust, threw the rest on the ground, walked to the next dispensers and drank a number of cups with great enjoyment, so, after expressing the expected opinion of the art exhibit, many studied the works and asked questions which showed that they were not satisfied with the official interpretations."[124] The Soviet public, habituated to parroting the official line, initially expressed shock and disgust when encountering these American products; then, once they had discharged their duty (or their beverage), they returned to have a more honest, unmediated experience of the product.

McLanathan's consumerist metaphor here is telling, for Cold War modernism cast modernist art as a successful competitor in a free market of culture. Since the 1940s, the term *freedom* itself had taken on a capitalistic sense: in the "free world," we have the freedom to choose whatever products we want, whatever services we please; free enterprise is the fifth freedom. Forced to compete, art changes and innovates, finds its niche market of elites. But, as we have seen, the conservative populists (embodied by Congressman George Dondero and the AAPL) rejected the notion that elites' consumption preferences could or should represent the nation. So the cultural diplomats pivoted and pointed to the social sector, where elite power and popular appeal converged: big business. If IBM and La Tausca liked modern art, it must be good—and how threatening could it be? Like the Soviet citizens with their Pepsi-Cola, the American public needed to be allowed its initial spasm of disgust and incomprehension at modern art: but they would come around, McLanathan was certain, just as surely as Truman's know-nothingism evolved into Eisenhower's tolerance.

3

COLD WARRIORS OF THE BOOK

American Book Programs in the 1950s

N OT WIDELY KNOWN today, Edmund Wilson's 1946 *Memoirs of Hecate County* still holds some interest for a contemporary reader. Primarily, of course, the book is one of the prolific Wilson's few works of creative literature and provides an important perspective on the accomplishments of the dominant literary critic of mid-twentieth-century America. In its setting and subject matter, *Hecate County* also provides a prism for looking at F. Scott Fitzgerald's work in that the fictional Hecate County resembles one of New York City's suburban counties where Fitzgerald set many of his works, and of course Wilson had been a close friend of Fitzgerald's at Princeton and edited two of Fitzgerald's posthumous books. *Hecate County* is structurally an early example of the short-story cycle or collection of stories linked by a common narrator, setting, or plot. Contemporary reviewers called it an innovative collection that employed both modernist techniques (fragmentation, "psychotic, time-dissolving delusions that nevertheless reveal exact historical fact,"[1] and a questioning of the boundaries separating story from novella from novel) and modernist themes, in particular alienation and the shallowness and sterility of modern life.

Hecate County was also a banned book. Charging that passages in "The Princess with Golden Hair," the 200-page centerpiece of the collection, were obscene, the New York Society for the Suppression of Vice sued publisher

Doubleday in New York State Special Session Court in July 1946. The court's three judges read the book and heard testimony from witnesses such as Lionel Trilling, ultimately ruling two to one that Doubleday be fined $1,000 for publishing and selling *Hecate County*. In his dissenting opinion, Justice Nathan Perlman pointed to the US Court of Appeals' rationale in lifting the ban on *Ulysses* and argued that *Hecate*'s artistic merit and appeal to the "mature reader" outweighed its tendency to "deprave and corrupt the young and immature."[2] Doubleday appealed to the US Court of Appeals and eventually to the Supreme Court, which in 1948 upheld by a four–four vote the lower court's decision. (Justice Felix Frankfurter, acquainted with Wilson, recused himself from the case.) The ban stayed in effect until the *Lolita* decision of 1958 emboldened a new publisher—Farrar, Straus and Cudahy subsidiary L. C. Page, based not in the still-iffy locale of New York but oddly enough in notoriously puritanical Boston—to issue a new edition of the book.

Hecate may have been banned in New York, but at least a few staffers in the Department of State found it suitable for foreign audiences. In the same March 1947 House Appropriations Committee hearings that took on the Advancing American Art show, Nebraska Republican Karl Stefan pressed an uncomfortable William Benton about State's plan to purchase twenty-four copies of *Hecate County* for inclusion in libraries and Information Centers abroad. After considerately asking a female staffer to leave the room, Stefan read a passage that he found patently offensive and demanded to know who had recommended that this banned, obscene book be used to represent American culture. Kenneth Holland, assistant director for cultural affairs, responded that staff librarians, along with consultants from the American Library Association (ALA), had suggested the book for the program. "It may cost the taxpayers of the United States $31,000,000 [the cultural affairs office's entire request for 1948]," Stefan admonished, "to undo the damage if such literature is allowed to be circulated in the name of the United States Government." Benton wholly agreed, pledging not only to recall each copy purchased but to "examine our procedures for selecting books." Fortunately, the hearing ended happily for Stefan, Benton, the nation, and hundreds of millions of foreign readers: Holland informed both Benton and Stefan that after reading reviews of Wilson's book, Richard Heindel, chief of the Division of Libraries and Institutes, had cancelled the order.[3]

Wilson's book starred in another congressional hearing later that summer. In July 1947 hearings on the US Informational and Educational Exchange Act (later called the Smith–Mundt Act), Illinois congressman Everett Dirksen pointed to the furor surrounding both *Hecate County* and the Advancing show and staked out a solidly nebulous position:

> I thought perhaps it was a great tempest in a teapot with regard to those paintings . . . but I can well understand how people come by the view that that is not America. When it was indicated that 24 copies of the *Memoirs of Hecate County* had been procured or were to be procured . . . it was easy to understand how people became rather unhappy about it. Perhaps my own case is pretty universal in the literary field. I read what I want to read, and I put aside what I don't want to read. I recognize, of course, that there are some people who do not read with that much discernment. I can understand how they would brandish a copy and say, "This is the voice of America!"

Other congressmen worried that foreign audiences would conclude from *Hecate County* that "all American girls were juvenile delinquents" and from the films *Tobacco Road* and *The Grapes of Wrath* that rural squalor and economic exploitation typified American life.[4]

Although clearly books were fraught with peril, they had since the 1940s been a part of American cultural diplomacy. During World War II, the Council on Books in Wartime (a publishers' trade group intended, in John Hench's words, to examine what the publishing industry "could accomplish for the nation and for itself not only during wartime but afterward as well") collaborated with the OWI to disseminate information "about books about the war and the war aims of the U.S. and its allies for libraries and bookstores, holding book forums and fairs, and utilizing radio and films to promote its message."[5] The council's slogan, "Books are weapons in the war of ideas," became a major theme of anti-Nazi propaganda. A council subsidiary published Armed Services Editions, books sold in bulk to the army and navy for soldiers serving abroad; Hench reports that Armed Services Editions eventually printed almost 123 million copies of 1,322 titles. These books

were initially intended to build morale among soldiers, but in 1944 the OWI and other American information agencies also planned a postwar "consolidation propaganda" push consisting of (1) civilian pacification in the former belligerent and conquered nations, (2) de-Nazification, and (3) explanations of "what the United States had been doing during the war."[6] Although these programs would use radio, film, and newspapers, long-term "consolidation" necessitated reaching opinion makers through *books*. "Books do not have their impact upon the mass mind but upon the minds of those who would mould the mass mind—upon leaders of thought and formulators of public opinion," an OWI internal memo posited. "Books are the most enduring propaganda of all."[7] To accomplish this, the Council on Books in Wartime and the OWI collaborated on Overseas Editions, a series of books, with their governmental origins masked, that was "intended," in the words of OWI's Chester Kerr, "to reacquaint Europeans with the heritage, history, and fundamental makeup of the USA, plus a picture of our role in the war to date."[8] In the end, Overseas Editions sold more than four million copies of more than seventy titles in five languages (English, French, Italian, German, and Dutch).[9]

But Cold War book programs could not simply replicate the World War II projects. Many more books had to be produced and distributed, the target audiences and languages were dramatically different, and the message itself, as reflected in the titles chosen, had to change. Changing realities in transportation, distribution, copyright, and currency convertibility also complicated matters. Because the Cold War was so fundamentally an *ideological* struggle between two totalizing worldviews, the adversaries relied much more heavily on information programs and cultural diplomacy than had the belligerents in the conflict that had just ended. The United States certainly employed informational media such as radio, newspapers, and magazines to reach foreign audiences, but the PSB noted that "in most parts of the world, the radio and television are still novelties; magazines have low circulation; and newspapers circulate mostly among political groups whose opinions are already formed. . . . Books—permanent literature—are by far the most powerful means of influencing the attitudes of intellectuals."[10] Books could provide the fullest (and most favorable) portrait of American culture. "The opportunities to use books and publications abroad are of major importance to U.S.

objectives," a 1954 OCB internal report stated. "American world leadership, the quality of American achievements in scientific, professional, technical, and cultural fields, and the pressing need to reflect this leadership and quality of achievement throughout the world, warrant the greatest possible effort to expand the use of American books throughout the world in the present half-century."[11] This OCB report also shows how the informationalist approach of the Truman and Eisenhower administrations supplanted the book programs' initial culturalist orientation. From the earliest days of the Informational Media Guaranty (IMG) program and the IIA to McCarthy associates Roy Cohn and David Schine's 1953 tour of US Information Centers, the subsequent tightening of book-selection criteria, and the 1961 rewriting of IMG's strictures, the choice of what books the government would send abroad to represent American culture shrank, and the purpose of the book programs veered from fostering international understanding of American culture to actively promoting American policies.

The lists of titles included in the 1950s book programs for audiences in western and central Europe and the rationales behind their inclusion exhibit a cautious, tentative attitude to artistic experimentation that differs notably from that of the art program. Congress and Presidents Truman and Eisenhower charged the information programs with providing foreign audiences a "full and fair" portrait of the United States, its heritage and people and culture, and the internal deliberations about which books would be allowed into the cultural-diplomacy program—and which would be excluded—show a collaborative effort between government bureaucrats and experts in the private sector to craft this portrait. In it, we see major figures of early American literature such as Washington Irving, Herman Melville, and Nathaniel Hawthorne joined by the major writers of the later nineteenth century: Whitman, Dickinson, Twain. Histories of American literature such as Van Wyck Brooks's *Flowering of New England* (1936) and Robert E. Spiller's *The Cycle of American Literature* (1955) provide a clear narrative of both how these works fit together as a tradition and how they create a portrait of the evolving nation.

Twentieth-century literature in general and modernist literature in particular proved more difficult to fit into this tradition as so many of the features of American life that Brooks and others identify in the earlier writers are

either absent or attacked in these later works. As a result, the book programs' treatment of American literary modernism is tentative and at times incoherent. Intent on creating a narrative of American culture and history that would foreground a few key themes—region, the natural world, connection with but not subordination to the European tradition, and of course freedom and individualism—the State Department and USIA book programs erred on the side of conservatism, presenting modernism either as a variant of regionalism or as a kind of inexplicably prestigious coterie taste.

Viewed through a broader lens, though, the book programs' treatment of modernism did bolster the Cold War modernist project in that they conveyed the Schlesingerian, Cold War liberal understanding of American history. The centrality of freedom and individualism, the importance of cooperation between private industry and government, the role of cultural diversity in constructing American identity, and the liberal certainty that history evolves toward greater freedom and fulfillment for the individual: these unifying themes dominate the books circulated through the book programs. Modernism, then, is the *fruit* of societies characterized by such traits. In the art program, modernism led the way, and the cultural diplomats attached Cold War liberalism to those artworks to justify their role. The book programs reversed this dynamic, with the liberalism coming first, and the modernism appended afterward. If the art program approached foreign intellectuals with the certainty that they would appreciate modernist art, the book programs came with a much more pedagogical self-understanding: books were there to *teach* about America, not to showcase American artistic achievement. That said, though, modernist literature did appear in the book programs (and at least one prominent modernist author, William Faulkner, enthusiastically took part in cultural diplomacy), presented to foreign audiences both as illustrative of larger historical strains in American culture and as evidence of American artistic achievement and prestige.

During the Cold War, the United States made books available to foreign audiences in multiple ways: at Information Center libraries abroad; through the IMG program, a market-based export initiative; through donations of textbooks and scientific publications to foreign schools and aid programs; and through a government-directed project to translate, publish, and sell Ameri-

can books (some with their origins disguised) in foreign markets. With these books, the intention was to counter the notion that the United States was a cultural wasteland and to present the United States as a well-meaning liberal democracy whose civil liberties and democratic institutions ensured that it would mature past whatever shortcomings it might currently exhibit.

Because of concerns about literacy, access to books, and their audiences' time and inclination to read, the ideological book programs examined here (as opposed to those programs that distributed technical, scientific, or agricultural books) primarily targeted foreign elites and intellectuals. "Books and related materials reach relatively small segments of any national population," the OCB admitted, but "the coincidence between 'leadership' groups and those who read, however, enhances the validity of books as instruments of understanding and persuasion." The program should target the "intellectual elite," an "infinitely more important target" than the "herd" because "new thoughts cannot be brought directly to the masses without being filtered through, and without proving their plausibility to the elites," who "set patterns of thought which become the unconscious basis for public judgments and popular modes of thinking and acting."[12] Distributing American books abroad, the programs' designers suspected, would not only promote the American models of freedom and democracy but also help to counter the sense that the United States represented the unstoppable, vulgarizing forces of mass culture and mass consumption that were overwhelming a richer, more culturally sophisticated way of life. Particularly after the Advancing show flap reinforced the prejudice that Americans were yahoos, the book programs became especially important to this effort.

Unlike the centrally designed and administered book programs of the Soviet Union, US book programs drew upon the resources, energies, and insight of nongovernmental groups and private companies. Private publishers had taken a leadership role in the creation of Overseas Editions during the war, and the Smith–Mundt Act explicitly called for the private sector to be the dominant partner in the postwar book programs, with government playing a facilitative or advisory role. In 1951, Dan Lacy of the ICS (which ran the reading rooms abroad) "realized immediately that the publishing industry, with some public assistance when necessary, could be far more effective than

FIGURE 3.1 President Truman signs the Smith–Mundt Act on January 27, 1948. Used by permission of Corbis Images.

government programs" in reaching foreign populations.[13] Later, the Jackson Committee recommended that "the greatest effort should be made to utilize private American organizations for the advancement of American objectives" and pointed specifically to the publishing industry, calling for the government to "subsidize its efforts when necessary to combat the flood of inexpensive communist books in the free world."[14] Private involvement was also "preferable to direct governmental operation," the OCB noted in 1954, "because attended with less suspicion as 'propaganda.'"[15]

Realistically, though, only a governmental effort could counter the massive Soviet propaganda push. The United States lagged badly behind its adversary, which had produced and distributed more than forty million books abroad by 1950, largely through the International Book Publishing Corporation, a semi-autonomous branch of the Ministry of Foreign Trade.[16] This effort accelerated over the decade. Amanda Laugesen reports that "in the first half of 1957 alone,

the USSR published 15,631,700 copies of 372 titles in 12 languages."[17] Four years later, according to a State Department report, the Soviet Union was producing approximately forty million books *a year* in free-world languages, up from twenty-five to thirty million annually in the 1950s. The PSB, late in the Truman administration, warned that "the largest selling book in the world—with the possible exception of the Bible—has been the *Short History of the Communist Party*," which implied a "massive, comprehensive, worldwide campaign of ideological indoctrination."[18] Eisenhower's Doctrinal Warfare panel reported that the Soviets had "taken advantage of the weakness of book distribution systems in many places over the world by building up their own. . . . [T]here are reported to be some 200 communist book stores on the European continent," and in 1956 Lacy confirmed "the ubiquitous presence in many countries of editions of Soviet works, translated and well bound at prices obviously below the cost of production, and . . . the profusion of free or inexpensive Communist pamphlets."[19] These books were largely Marxist–Leninist titles as well as handbooks on "organizing demonstrations and how to overthrow governments" and socialist realist novels by writers such as Mikhail Sholokhov, Konstantin Simonov, and Boris Lavreyov.[20] "Long ago [the Soviets] adopted the sound principle," a PSB consultant observed, "that ephemeral types of propaganda such as radio, pamphlets, newspapers, are ineffective unless they are related to a philosophic frame of reference embodied in permanent literature . . . in book form."[21] Alarm at the Soviets' apparently unstoppable ability to produce and distribute ideological materials—and at the assumption that these materials would find fertile ground—continued even after the United States initiated its own book programs: in 1961 an internal report fretted that "the Communists have recognized the role of ideas and information in the battle they are waging; Soviet and Chinese Communist books, films, and other informational materials are available in abundance, seemingly unhindered by problems of foreign exchange. . . . If American materials are not available, the Communists may pre-empt the field by default."[22]

Several acts of Congress, initially passed along with the Economic Cooperation Act of 1948 (the Marshall Plan), authorized the distribution of American books as instruments of cultural diplomacy; later acts expanded the number of programs and continued funding existing initiatives, although

resistance in Congress was often strong. Several programs fall outside of my argument here because they distributed books with little ideological content. Low-Priced Books in English and Ladder Editions primarily disseminated books for the teaching of English as a foreign language. Under the Agricultural Trade Development Assistance Act of 1954, the proceeds from some agricultural sales purchased and distributed textbooks, particularly in India. The Point Four Program, passed in 1949, funded the distribution of technical books and journals in impoverished nations; in the sense that technology in the atomic age was a profoundly political issue, this program *was* ideological, but the materials themselves made no arguments about the superiority of the West or the deficiencies of the Soviet system. Franklin Publications—a book program aimed at the Middle East that concealed its governmental origins and funding—is certainly relevant, but here I want to focus on a slightly earlier time period (the late 1940s through the mid-1950s) and on a different target audience (influential readers in western and central Europe).[23] In terms of disseminating ideologically oriented cultural materials to elites abroad, three major programs—the IMG program, the Library and Information Center Service, and the Books in Translation program—did the majority of the work. Taken together, they and the titles they chose eschewed the hard-line anticommunism that dominated America's domestic politics and instead conveyed the "vital center" argument that the cultural-diplomacy establishment favored in the 1950s.

IMG allowed American publishers and media producers to export their materials in nations short of hard-currency foreign exchange. Under IMG, a foreign publisher or distributor could ask the publisher of an American book to sell it a specified number of copies of an American (generally English-language) book but would pay for those books in the local currency. Such "soft" currencies were not easily convertible to dollars, so the American publisher had little economic incentive to sell to the foreign publisher or distributor. IMG allowed publishers to exchange the foreign currency with the US government, which would then use it for "regular in-country operating expenses."[24] The State Department's IIA ran the program until USIA took responsibility for it in 1953. That year, *Time* magazine explained that IMG "[is] one of the most effective means of getting U.S. publications around the

world, and under it millions of magazines, books and newspapers have gone abroad."[25] In the more than twenty years of its life, IMG operated in twenty-one nations and paid out more than $83 million to publishers. Its initial focus was on Europe—West Germany, Yugoslavia, and Poland, which accounted for $26 million of the $31 million paid out to publishers operating in Europe—but in the mid-1950s the program also began targeting Asian nations such as the Philippines, Taiwan, Indonesia, Pakistan, and Burma.[26]

IMG was largely market driven, with US or foreign publishers (as opposed to the government) choosing titles. Looking back at the program in 1957, an internal policy statement differentiated IMG from the informational activities of USIA (here confusingly called USIS) on the grounds that

> IMG can, but USIS cannot, 1) overcome exchange barriers to the free flow of US information materials through commercial channels, 2) build, in dollar-short countries, commercial markets for the American mass media industry, and 3) meet the tremendous demand for American books and motion pictures which exists in high priority countries where the free flow of such materials is blocked except for IMG. . . . On the other hand USIS can, but IMG cannot, reach selected audiences with specific informational materials designed to give positive support to particular US objectives.[27]

Although American governmental agents could not use the program to get desired books sold in target markets, they could reject a publisher's application for IMG coverage of a specific title. Initially, in a pattern common to most of these programs, the standards for IMG coverage were quite loose. The Economic Cooperation Act mandated only that IMG-supported materials should "promote . . . a true understanding of American institutions and policy among the nations" and that the content of this media be "intended to convey knowledge or [be] expressive of the life or culture of the United States."[28] The media assisted under this provision, IMG administrators specified, should reflect the best elements in American life and not "bring discredit upon this Nation in the eyes of other nations."[29] William Childs and Donald McNeil point out that IIA's interpretation of these criteria was liberal, holding as a guiding principle that "constructive criticism is a hallmark of democracy."[30]

Three years later, however, the Mutual Security Act of 1951 (which authorized IMG coverage outside of European markets) tightened the criteria and excluded certain types of books—hobby books, cookbooks, travel guides not focused on the United States, and fashion publications. More importantly, though, the 1951 act began to proscribe not just genre but *content*: materials that were "patently lewd or salacious [or that] conveyed political propaganda inimical to the best interests of the U.S." would not be eligible for IMG coverage.[31] In 1954 appropriations hearings, the USIA's representative testified that the agency had a "very rigid set of criteria" for eligibility for IMG coverage. Ineligible would be

A. Materials advocating or supporting an unlawful purpose;

B. Materials prepared or distributed in order to convey, disseminate, or reinforce Communist propaganda;

C. Materials of a salacious or pornographic intent though the inclusion of questionable language, episodes, or scenes in a work of bona fide literary or artistic intent shall not automatically be construed to bring it within this category;

D. Materials devoted to the sensational exploitation as opposed to the factual reporting of crime, vice, or similar conditions;

E. Any other material of so cheap, shoddy, or sensational character as to bring discredit upon the U.S. in the eyes of other nations.[32]

Responding to a question from Michigan senator Homer Ferguson (who was also curious about whether books advocating socialism would be ineligible), the USIA representative argued that these criteria did not constitute censorship because the publishers had to agree to these conditions prior to taking advantage of IMG. Other legislators, who had been suspicious of these types of programs and their liberal intellectual bureaucratic champions since the days of the OWI, fretted about the morality of the materials sponsored by IMG. In the 1956 appropriations hearings, Minnesota representative Walter Judd wanted to ensure that "these lousy films that do us so much damage, like *Blackboard Jungle*," were not eligible, and in 1958 Michigan representative Alvin Bentley confirmed that IMG

administrators carefully screened paperbacks with lurid covers.[33] The concern here was that the worst kind of American popular culture, confirming European elites' prejudices about the United States but at the same time irresistible to foreign masses, would be subsidized by the bureaucrats and intellectuals at the State Department and USIA, whose own morality—at least in the eyes of many McCarthy-era congressmen—was as suspect as their loyalty.

IMG became a target for legislators who doubted the program's impact and resented its backdoor funding process. Because IMG had no annual appropriation, it ran debts. These debts were charged to USIA, which would then borrow the money from the Treasury Department, and "for many in Congress, after-the-fact appropriations requests by USIA to repay the Treasury constituted a serious infraction of the historic rule that Congress controls the purse strings and must appropriate all executive branch funds in advance of use."[34] Curtis Benjamin calculates that although the program was supposed to pay for itself, "it cost the taxpayer 38 cents for each dollar the publisher received, exclusive of administrative charges from the agency's budget."[35] The program underwent an extensive review in the late 1950s and into 1961, but instead of terminating it altogether, Congress imposed much stricter criteria by which titles could be covered. Staving off the program's elimination was a small victory for the publishing industry and related trade groups. A 1960 pamphlet produced and distributed by the American Book Publishers Council (ABPC) and the Magazine Publishers' Association (and aimed at Congress) stressed the IMG's key importance to the cultural Cold War:

- Freedom and communism will be competing indefinitely for the minds and hearts of the world's uncommitted people;
- For freedom to win this competition, the people of the uncommitted countries must have the scientific, technical, and administrative information to enable them to meet their fundamental economic problems successfully under a free government;
- The weapons of this competition will be ideas and their successful communication.[36]

The pamphlet argued that IMG "operat[es] at a very low cost" and "*is not a giveaway*" either to foreign audiences or to publishers. Such arguments only postponed the end, though, and Congress terminated the program in 1968.

Although publishers selected the titles covered by IMG, the foreign-policy establishment itself chose the titles for the ICS libraries and the Books in Translation program, and thus those books more directly reflect the ideological policing and the increasingly unidirectional informational approach to cultural diplomacy in the 1950s. These two programs directly illustrate the cultural-diplomacy establishment's approach to the selection of materials to represent American *culture*—including modernist art and literature—to foreign intellectuals and readers as well as the political pressures that affected these programs during the 1950s.[37]

The ICS, with its familiar reading rooms, predated the Cold War. The first Information Center was founded in 1942 in Mexico City, overseen by Nelson Rockefeller as part of Roosevelt's "Good Neighbor" policy.[38] During World War II, OWI took over Information Centers in Europe, and they became part of the US propaganda infrastructure there. After the end of the war, the State Department opened Information Centers in Germany, Austria, Korea, and Japan. The libraries were quite popular; William Benton estimated that three million visitors came to the sixty-seven libraries and cultural centers operated by the State Department in 1946 and reported that "in one month 17,000 people used our library in Paris; 4000 came to our library in Sydney; and 10,000 in Bombay. When our American library opened in Sofia, over 2000 readers came in the first two weeks." Benton also touted the success of the libraries in reaching the specific *kinds* of readers State sought out: "The [Cairo] library is of particular effectiveness because of the influential character of many of those who use it. University professors and other educators, government officials in positions of authority (especially from the Ministries of Education, Agriculture, and Health), lawyers, engineers, journalists, university students, and Egyptian Army officers."[39]

The number of Information Centers and reading rooms exploded through the 1950s, and by 1962 USIA, which administered the program after 1953, had 181 Information Centers in eighty nations, with another 85 smaller "reading rooms" and 145 "binational centers." Each library's holdings averaged

10,000–15,000 volumes, but in locations of particular strategic importance the collections were larger—West Berlin's Amerikahaus held more than 50,000 books.[40] By the mid-1950s, ICS libraries and reading rooms held two million volumes.[41] Even more than an embassy or consulate, the Information Center came to symbolize the nation itself to the people of foreign nations, perhaps because it was accessible to them. In 1961, USIA director George Allen wrote that "our overseas libraries are more admired and appreciated by the people who use them, and at the same time are more often attacked, and more bitterly, than any other American installation abroad."[42]

Adding a title to an Information Center's collection was relatively simple: either the title would be identified by the field officer (often in consultation with local publishers), approved by Washington, and purchased, or the officer would simply choose the title from a monthly circular of preapproved titles, some recently published and some backlisted. The IIA's Bibliographic Division and later the ICS selected the titles listed on the circular, often with the consultation of specialists from the academic, library, and publishing worlds. Books selected should "furnish evidence of the American intellectual, spiritual, and artistic heritage and combat the charge that our people are lacking in cultural background and tradition," the IIA demanded.[43] Audiences who encountered these books in Information Centers, reading rooms, or Amerikahauser knew that the US government had sanctioned these books and their content. It is a testament to the sensitivity of the field officers and the confidence of the State Department that so many titles frankly critical of aspects of American life were available in Information Centers, although books touching on inflammatory topics such as race, labor relations, and the Communist movement in the United States had to hew to a narrow ideological and rhetorical line.

Things worked differently in the Books in Translation program, which began in the late 1940s under the IIA and, like IMG, was transferred to USIA in 1953. This program's explicit goal was to get the kinds of books (often, in fact, the same titles) that the Information Centers stocked directly into the hands of local populations—in particular local intellectuals and opinion leaders—in their native languages. As its name indicates, the Books in Translation program selected American books for a given national market, identified a

local publisher that could publish the book, arranged for a favorable transfer of foreign rights to the title (and often paid the rights fee, if there was one), hired a translator for the book, purchased a large number of the books for local distribution and use in the Information Centers and reading rooms, and eventually sent royalty checks to the American publisher. Books in Translation, like many of the other programs examined here, initially focused on Europe—Germany, Yugoslavia, Poland—but quickly expanded its focus to the Middle East (Israel, Turkey, Egypt), Asia (China, Pakistan, Japan, Korea, India, Burma, Indonesia), and Latin America in the 1960s. Over the course of the 1950s, it (and its subsidiary, the Low-Priced Books in English program) distributed almost fifty million copies of American titles around the world.[44]

For the most part, the Books in Translation program officers wanted to act merely as facilitators; like IMG administrators, they would simply make it simpler for publishers to sell American books abroad by providing connections and some financial assistance. As for books placed at the Information Centers, Washington or field officers would identify the titles to be distributed; unlike the Information Centers, though, in the translations program foreign publishers could initiate a request, although they often did so at the prodding of a USIA officer. As former books officer Sol Schindler explained, "The post overseas had connections with the local publishers. . . . So we talked shop talk. 'Do you have anything good?' . . . as in 'Do I have any good titles that [I] think would really go?' And then I would [say], in a way almost like a salesman: 'Yeah, we've got these books just came in. Would you be interested in this, in this and this?' And then we'd hit upon a mutually agreeable title, and we would go ahead."[45]

In some of these nations, of course, even though an independent commercial publishing industry existed, the internal security apparatus still influenced the book trade. Schindler recounts that

in Yugoslavia . . . the secret police were everywhere, and everybody was very careful. Publishers would never talk to me alone. I called a publisher because I was hoping he would do something, and the guy always came with an assistant, usually a woman. He would never meet me alone; he would call in other people on the side—to make sure that the secret police knew nothing

secret was being discussed. This is the way you had to operate. . . . I should [have] know[n] [if there was prior restraint censorship], but I [didn't] really. They had the kind of censorship where a journalist knows he can't write about certain things, so he exercises self-censorship. . . . He knows if he does it, he'll end up in jail. I imagine that same kind of thinking occurred in Yugoslavia. The publishers were aware. If they wanted to translate John Steinbeck, they knew that was a pretty safe thing, no one was going to bother them. So they would go with John Steinbeck.[46]

In most cases, once a desired title and publisher had been identified, the program officers contacted the American rights holder for a particular title, requesting the rights to that title for the language in question. In the request, the Books in Translation program specified the number of copies to be published; the publisher would receive a nominal rights fee, paid by the program ostensibly because the foreign publisher could not access dollars; and the author would receive his or her customary royalty. What seems at first like an unremarkable subsidiary-rights arrangement was in reality generously underwritten by the middlemen, the US government. In addition to paying the rights fee and subsidizing publication so that the cover price would be at or below the prevailing price of similar books, the Books in Translation program or USIA would frequently agree to purchase, at cover price, enough books to ensure that the foreign publisher would break even before bringing a single copy to market.[47] In cases involving particularly desirable books or recalcitrant publishers, the United States would even provide the foreign publisher with a direct payment to cover production and distribution costs. This arrangement brought with it the danger that the local publisher might just "take the money and run" and thus fail to put the books on the market as agreed, which Lacy regretfully noted: "The publishers involved were too often concerned only with the government subsidy and not with any effective distribution of the titles published."[48] (Schindler confirmed that in his personal experience this theft did on occasion happen.[49]) On the other side, the rights fee paid to the American publisher was often quite paltry in comparison to similar arrangements for books in other languages, but it seems that publishers must have thought that $50 or $100 was more than they could have otherwise expected to glean from that title in Gujarati or Korean.

Unlike the books held in the Information Centers, the products of the Books in Translation program had their origins effaced. Such books, as the State Department and USIA desired, would bear no trace of the fact that they existed only because the US foreign-policy establishment wanted them to. The publisher and USIA took pains to ensure that such books resembled any other published by that firm for that market and could not attest to the US government's midwifing—even if that meant that the books were physically not up to American publishers' standards. In fact, as Schindler put it in reference to one of his postings, New Delhi in the early 1960s, "because Indian publishing in certain [languages] was rather shoddy, some of the Americans would say, 'Can't you bring out a better package?' And the answer was . . . 'We don't want a product that looks different from the other books.' So it was just as shoddy as the other ones."[50]

IIA staffers in Washington and officers in foreign missions (who presumably knew the target audience well enough to judge what books would be appropriate), with some input from consultants with the ABPC and ALA, initially handled the selection of titles. But in late 1951 the Department of State moved to bring book professionals more centrally into the process of screening and selecting titles for the Information Centers, the IMG, and the translation programs. State's Advisory Committee on Books Abroad, initially convened in 1952, brought together a representative from the library field (Harland Carpenter of the Wilmington, Delaware, public-library system), one from the nonprofit or academic publishing realm (Chester Kerr, the secretary of Yale University Press), and another from the for-profit publishing world (Robert L. Crowell, of the firm Thomas Y. Crowell).[51]

Both Kerr and Crowell had worked with the Council on Books in Wartime and brought that perspective to the Books in Translation program. In a 1951 memo to the translation program (on stationery inscribed "BOOKS ARE WEAPONS IN THE WAR OF IDEAS"), Crowell advised that the program select "1. A worthy American novel. 2. A book which refutes the tenets of Stalinism. 3. A book which illuminates an important aspect of American life. 4. A biography of a well-known character. 5. A standard US classic. 6. A book from our history, preferably one that highlights the inherent significance of individual freedom in America's progress."[52] Assuming

FIGURE 3.2 Meeting of the US Department of State's Advisory Committee on Books Abroad, 1952. Seated in the front, *left to right*, are members of the committee Harland Carpenter, Robert Crowell, and (with the pipe) Chester Kerr; the rest of the men are State Department officials, including Assistant Secretary of State for Public Affairs Edward W. Barrett, between Crowell and Kerr. US Department of State Bureau of Educational and Cultural Affairs Historical Collection, University of Arkansas–Fayetteville Special Collections Library.

that the program would take the form of State Department administrators coming to agreements with foreign publishers to publish selected American titles, Crowell reminded the project administrators of the book programs that in many nations the booksellers *are* the publishers and told them not to despair if they could not find a suitable publisher. In suggestions that the translation program implemented almost word for word, Crowell added that the officer should negotiate contracts with publishers specifying print runs of at least 2,000–3,500 (3,500 should be the minimum book run in western Europe) and prices at or below the "prevailing prices for similar books." "To

induce the publisher to price an item below the usual level it may be necessary to increase the subsidy," he cautioned. Crowell also made it clear that the US officer should offer to purchase—at cover price—a significant number of copies from the publisher: 1,000 out of 3,500 was a "frequent arrangement" in such programs, he added.[53] In 1951, Carpenter, Crowell, and Kerr took an inspection tour of US posts abroad to discern what foreign audiences wanted from US books and how the ICS's programs might be expanded. Upon their return, the advisory committee quickly set to work outlining selection criteria for titles and met with groups such as the ABPC and the ALA to present its findings and to ask advice—both the ABPC's Committee on Reading Development and the ALA's International Relations Board expected an advisory role in the changing American book programs, in keeping with the State Department's traditionally welcoming attitude to the private sector in cultural diplomacy.

Having the private sector drive the book programs brought problems, though. IMG facilitated the dissemination of American books abroad and was grounded on the free-market ideology that underpinned all US cultural diplomacy, but some foreign markets had no demand for the products that the US cultural diplomats most wanted to sell. Because of this, the State Department and USIA had to use the libraries and Information Centers and the Books in Translation program to push particular titles on foreign audiences. In this effort, the field agents of the embassies and consulates and later of the USIA collaborated with State Department officers and outside consultants to choose titles that would adequately, accurately, and positively represent the culture of the United States to foreign audiences. The increasing output of the American book industry during the 1950s also necessitated that USIA turn to outside consultants to help it choose appropriate titles. In addition, the US Ideological Program, a working group headed by former OWI historian and OCB deputy executive assistant Edward P. Lilly, identified books that would serve ideological purposes.

As with the IMG program, the criteria by which books were chosen for the Information Centers and the Books in Translation program grew stricter and more directive over the course of the 1950s. Mirroring the evolution of the art program, the debate hinged upon whether to exclude only particular *works*

that were ideologically problematic or *authors* who had leftist or Communist associations. In late 1952, the Advisory Committee on Books Abroad echoed the position of the museum directors and the AFA, resolving that "authorship should not be a criterion in determining whether or not a book is available for USIS libraries abroad. . . . [T]he Committee is unanimous in its recommendation that the content of the book, regardless of authorship, be the criterion which determines its availability for inclusion in USIS libraries."[54]

But pressure from Congress—in particular Senator Joseph McCarthy, who in 1952 demanded a list of the holdings of the overseas libraries—moved officials in the IIA and the Advisory Commission on Educational Exchange to soften their stance against judging books by their authors. The IIA at first issued a directive to Foreign Service officers stating that controversial authors could be included if the works in question supported the mission of positively presenting the United States to the world; McCarthy, though, wanted anybody with questionable political affiliations rooted out. IIA revised its order in February 1953 and directed its librarians to remove materials by "any controversial persons, Communists, fellow travelers, 'et cetera.'"[55] In April 1953, an IIA administrator told the advisory committee that Communist authors would from then on be excluded and that to achieve this objective he needed "a list of known [C]ommunist authors and authors who obviously follow the Communist line and participate in Communist front organizations." In addition, writers who took the Fifth Amendment when questioned about Communist involvement would also be ineligible for inclusion in the book programs.[56] At the same time, McCarthy associates Roy Cohn and David Schine toured European reading rooms, finding what they considered to be 30,000 "pro-Communist" books on ICS shelves, and, in response, nervous ICS librarians pulled books by authors such as Howard Fast, Lillian Hellman, Dashiell Hammett, and even W. E. B. Du Bois. The Cohn–Schine tour dramatically slowed the Information Centers' expansion: Kenneth Osgood reports that immediately before McCarthy's investigation, 120,000 books arrived at ICS libraries every month, but as congressional and public attention turned to them, the flood of books slowed to 400 a month.[57] But in July that year, after the ALA, the ABPC, the Intellectual Freedom Conference, and even President Eisenhower expressed their opposition to

the "book burners" at home and abroad, the IIA felt confident enough to revise its guidelines again, reinstating content-based criteria (although specifying that works by "avowed Communists" had to be "clearly useful for the special purposes of the program").[58] Osgood argues that, ironically, the McCarthy campaign revitalized the book programs by "reestablishing books as critical weapons in the war of ideas."[59]

Nevertheless, the proscription of many titles reflected the paranoia of the times and the caution of the program's administrators. Theodore Dreiser's classic novels *Sister Carrie* and *An American Tragedy* were pulled from the shelves, as were all works by and about Ezra Pound (who was incarcerated in an asylum awaiting trial on a treason charge) and, surprisingly, two books on Thomas Paine: Philip Foner's edition of *The Complete Writings* and Fast's historical novel *Citizen Tom Paine*. Even after IIA softened its internal policies, its outside advisers reaffirmed its most restrictive measures: in January 1954, the Advisory Committee on Books Abroad approved a resolution barring "books by authors [who are] Avowed Communists, Persons convicted of crimes involving a threat to the security of the U.S. [and] Persons who publicly refuse to answer questions of Congressional Committees regarding their connections to the Communist movement." Unsupported accusations were acceptable evidence, too; the committee added that books by authors "generally considered in this country by informed citizens as being . . . person[s] with communist leanings or convictions" should also be excluded.[60] With the bureaucrats, the president, and the advisory committee all taking different stances, it is no wonder the staffers were confused.

In 1961, the standards about what works would be included in the translations program or covered by IMG changed yet again. "Materials to be covered," the USIA specified in a form letter about IMG to American publishers, "must make a positive contribution in support of U.S. policy objectives and must reflect favorably on the United States. Heretofore the rule applied was that materials not inconsistent with the national interest were eligible for coverage."[61] The archive of the Alfred A. Knopf company provides an interesting window on what books the Department of State and USIA thought to be valuable for its programs—and, by extension, for the particular picture of the United States that the State Department wanted to dissemi-

nate abroad. Knopf was by the 1950s arguably America's preeminent literary publisher. Alfred Knopf himself was an active participant in many USIA programs, and his company licensed many of its books to be translated and sold abroad under Books in Translation. In July 1960, for instance, Knopf was informed that it could sell Serbo-Croatian language rights to Dashiell Hammett's *The Thin Man*.[62] Hammett's books had briefly been pulled in 1952 and 1953, but because they were neither lewd nor salacious nor anti–United States, they had been considered acceptable since 1953. However, only two weeks after the 1961 policy change, USIA told Knopf that Hammett's *Maltese Falcon* "does not qualify for sale of publication rights under IMG. This decision is based on the new criteria being applied to all materials submitted for inclusion under IMG."[63]

Many publishers believed that USIA applied its new IMG guidelines haphazardly and illogically, as in the case of John Updike. The USIA had specifically requested to include Updike's work—short stories, mostly—in several different media projects (magazines, books, radio) in 1961 and 1962, but in 1963 IMG turned down Knopf's request for IMG coverage of a work that was to become one of the keystone American novels of the postwar period: *Rabbit, Run*.[64] Knopf's Thomas Lowry, baffled and irritated that USIA rejected *Rabbit, Run* even as it was requesting Knopf's permission to use material from Updike's story "Alligators" in a VOA broadcast and was assembling a collection of Updike's stories for Polish publication, asked Alfred Knopf, "Do you want to raise a loud cry with anyone in Washington about IMG's disapproval of RABBIT, RUN?" but Knopf demurred.[65] (Updike continued to appear in USIA-sponsored media through the 1960s and even toured the Soviet Union on behalf of the State Department in 1964.)

Many of the titles that USIA sought to publish abroad or to add to Information Center and reading room shelves predictably attacked communism or the Soviet Union.[66] But polemic anti-Communist tracts popular among conservative readers in the United States were largely absent because the target audience for these books was presumably not receptive to crude Red baiting. Instead, anticommunism came in more subtle but still emphatic flavors: Czeslaw Milosz's *Captive Mind*—written by a left-leaning poet who had worked for the Polish Communist government until defecting in 1951—

attacked the lack of intellectual freedom in the Communist world without the hysterical tone of many domestic anti-Communist publications, and Crossman's collected volume *The God That Failed* was translated into Greek, Indonesian, Hindi, Chinese, Korean, Portuguese, Tagalog, Turkish, and Gujarati. Some of the anticommunism was literary: Arthur Koestler's 1946 book *Darkness at Noon* was translated into about half of the languages used by the program, and George Orwell's *Animal Farm* appeared in almost every language into which USIA translated books, as was *Nineteen Eighty-Four*. Such books made a culturally sophisticated case against communism that would appeal to the non-Communist intellectuals and opinion leaders who were ultimately the main target of the book programs. What they did not do was bolster American cultural prestige, except by association, because few of the authors were American.

Other anti-Communist books translated into local languages made "behind the scenes of communism" exposé arguments and focused on the most sordid and ominous aspects of communism: slave-labor camps, foreign dupes, interrogations, and prisons. These books—classified by the Ideological Program as "Communist critical analysis"—represent a significant portion of all titles sent abroad (in the period July 1954–July 1955, for instance, USIA distributed 485,000 books in this category).[67] Sometimes, these books weren't translated but instead commissioned to be written: in a meeting with the PSB, a CIA officer suggested that a book on Soviet purges—to be called, irresistibly, *Stalin Murdered Us*—"should be written."[68] Interestingly, some national markets received many more such titles than others. Solely in 1953, for instance, USIA produced Italian versions of David J. Dallin's *New Soviet Empire*, Ernest S. Griffith's *Communism in Action*, Albert Konrad Herling's *The Soviet Slave Empire*, Elinor Lipper's *Eleven Years in Soviet Prison Camps*, Douglas Hyde's *I Believed: The Autobiography of a Former British Communist*, and John W. Riley and Wilbur Schramm's *The Reds Take a City: The Communist Occupation of Seoul*, but essentially no explicitly anti-Communist works appear on the extensive lists of books translated into German that year for the German (sixty titles) or Austrian (twenty-five titles) markets. By far the greatest number and variety of anti-Communist volumes were produced and translated for and distributed in Chinese. Attacks on the Soviets that had

appeared in several other nations were on this list—for instance, Frederick Beck and William Godin's *The Russian Purge and the Extraction of Confession* and Lipper's *Eleven Years in Soviet Prison Camps*—but the number of books commissioned specifically (with their USIA origins concealed) for Chinese readers was remarkable: an entire series entitled *How the Chinese Communists Treat*... had titles on religion, merchants and industrialists, overseas Chinese, farmers, students, and several other subjects, and dozens of other harshly anti-Communist titles were translated into Chinese for readers in Taiwan, Singapore, the Philippines, and Hong Kong.

The anti-Communist titles jump out, but most of the books selected reflect the culturalist strain of cultural diplomacy and the imperative to present a "full and fair" portrait of America, so dozens of credible, even-handed studies of American culture and history also appear in the list. In keeping with the Cold War liberal explanation of the strengths of American culture and of its role in the world, the United States as depicted in these books is unfailingly melioristic: we are a nation that had a special kind of origin but that does not suffer from messianism; our democracy is energized by the reasonable exchange of views among responsible citizens; our artistic and literary heritage is strong and distinctive; we are not without problems but are using that democracy to improve ourselves. The competing forces of society are not, as in the Marxist arguments of Soviet books, in implacable conflict; instead, they negotiate and compromise in the common pursuit of a better America. In these books, the United States is evolving toward greater prosperity and equality, which will come from cooperative enterprise between the races, between the market and the regulators, between labor and management, between classes. Typical of these arguments was Frank Tannenbaum's *Philosophy of Labor*, which argued that trade unionism was a crucial stabilizing social force in contemporary industrial society, and Frederick Lewis Allen's *The Big Change: America Transforms Itself 1900–1950*, which granted that the late nineteenth century had indeed been a time of inequality, injustice, and class conflict, but that the democratic political system and lightly regulated capitalism of the United States brought the freedom and prosperity of the postwar period. (Allen's book appeared in essentially every language represented in the Books in Translation program.) The strategy behind these choices was

to refute the accusation that the United States was a cruel society whose very structure ensured that those with the power—corporations, the wealthy, whites—would continue to dominate. Without going so far as to portray the United States as a social democratic state, these books attempted to dispel the harsh image of America held by many abroad.

As was often the case, VOA conveyed the message of the book programs to a broader audience. "The American economic system can be called Peoples' Capitalism," a VOA feature from 1956 stated, "because it assures a just distribution of the national income. Workers are shareholders in industrial enterprises."[69] A feature on Frederick Lewis Allen, broadcast just after his death, reiterated Allen's insistence that capitalism was genuinely democratic: "America's corporations are owned by more than six and one half million stockholders . . . [m]ore than three-quarters of [whom] have incomes of less than $10,000 a year." The collaboration of organized labor with capitalism has brought "steady cultural and educational enrichment," which has come about "by evolution rather than [by] revolution" and in fact the United States is evolving "*past* socialism" in its ability to "meet the people's needs." Finally, the story concludes, Allen held an "enduring and articulate belief in freedom" and in the fact that "it is man's most precious possession."[70] Importantly, neither Allen's book nor any of the books chosen for cultural diplomacy extol the fundamentalist free-market, anti-state-interventionist philosophy that had been a key component of the anti-Roosevelt Republican backlash of the 1940s. In fact, the US book programs embodied the liberal arguments the books themselves advanced: that the close collaboration between capital, labor, and a wise managerial government had created a stable-growth economy with minimal class conflict. Although the US book programs never compared to the Soviet program in terms of top-down government direction, the US government subsidized, facilitated, and underwrote the publication of many books arguing against excessive government involvement in the markets.

The books chosen also sought to counter the reputation of the United States as anti-intellectual. Many of the Knopf books—such as Learned Hand's *Spirit of Liberty*; Carleton Coon's *Story of Man*; and *Adventures of the Mind*, a 1959 anthology of *Saturday Evening Post* pieces by authors such as Jacques Barzun, Aaron Copland, Paul Tillich, Edith Hamilton, and J. Robert

Oppenheimer "exploring the frontiers of contemporary thought"—had intellectual pretensions, even if they rarely went beyond the middlebrow. Even the best sellers that were included were not the trash feared by legislators, but rather books such as Benjamin Thomas's 1952 biography *Abraham Lincoln*, which had scholarly credibility and popularity. Thomas's was one of the most widely translated books, and the Books in Translation program arranged for its publication across Europe, the Middle East, and Central and East Asia. Other Knopf titles requested by the State Department and USIA were clearly aimed at intellectuals and specialists in the fields of sociology, history, and education: Robin M. Williams's *American Society: A Sociological Interpretation*, Carl Bridenbaugh's *Cities in Revolt: Urban Life in America, 1743–1776*, and Arthur Breston's *The Restoration of Learning*.

European literary critics had always respected a few American writers (such as Poe), but most did not hold American literature in high esteem. In response, the USIA book programs, by design or not, forwarded a canon of classic American literature and offered critical works explaining where American literature drew upon and where it diverged from the Anglo-European tradition. Favored literary titles for USIA were almost evenly distributed between older American classics by Twain, Hawthorne, Dickinson, Henry James, and Melville and contemporary titles (in particular novels) that were middlebrow best sellers of regionalist interest or safely realist. Monthly circulars from 1951 listing books selected for distribution to US Information Centers are heavy on writers such as Willa Cather, William Dean Howells, and Henry James; F. Scott Fitzgerald appears to be acceptable—both his works and criticism on his works are included—but Hemingway is not, although several of his books (*The Sun Also Rises*, *The Old Man and the Sea*, *A Farewell to Arms*, but not *For Whom the Bell Tolls*, which presumably was not hostile enough to communism) did appear after 1954 in the Books in Translation program. Works by and about Ezra Pound were forbidden in all programs after 1953, and, in fact, when locals asked the Information Center in Helsinki, Finland, to provide his works, the director of the International Educational Exchange Service specified in response that they (as well as Dreiser's *Sister Carrie* and *An American Tragedy* and F. O. Matthiessen's *Responsibilities of the Critic*, presumably because of accusations that Matthiessen was a Communist) were off-limits.[71] Frequently appearing in

COLD WARRIORS OF THE BOOK

the translation program were realist novels of social criticism such as those by Sara Orne Jewett and Edith Wharton. By the early 1960s, books officers and other cultural diplomats had begun to think that their arguments about the importance of American literature had been successful or had at least contributed to a general evolution of European critical opinion. One USIA program officer gleefully noted in the early 1960s, "The eagerness with which foreign readers seize on the books of William Faulkner and Ernest Hemingway— does anyone now remember that once an English critic asked, 'Who reads an American book?'"[72]

The choice of literary titles from one national market to another did not differ to the same dramatic extent as did the selection of books about communism, but the variation reflected American policy priorities as well as the predilections of local books officers. In 1950–1956, the greatest number of total titles were translated into Chinese, German, Greek, Japanese, Korean, and Portuguese, but literature played very different roles from market to market. The Greek list of sixty-nine titles, for example, was heavy on literature, and in 1953 the USIA translated into Greek two collections of American short stories as well. By contrast, the more than two-hundred-title Chinese list (for distribution in two main markets, Hong Kong and "Formosa," although a few Chinese titles were distributed in Singapore and one in the Philippines) was extremely thin on literature: from 1953 to 1956 only seven books that might be classed as serious American literature were distributed in Chinese through the State Department or USIA. Certainly the greater cultural commonality between Greece and the United States accounted in part for this difference, but more important was the political difference: Greek communism in the mid-1950s was a tenacious oppositional movement, but its goals of governance had been thwarted, whereas the Chinese in Taiwan and Hong Kong presumably needed their anti-Communist determination stiffened after the 1949 Communist takeover of the mainland. Finally, the books selected for the German market at times did triple duty: explaining US culture and society, attacking communism, and continuing the process of de-Nazification that had begun with Overseas Editions. Books chosen for the third purpose include Hannah Arendt's *Origins of Totalitarianism,* John Hersey's novel *The Wall* (about the Jewish uprising in Nazi-occupied Warsaw), *The Story of the*

Trapp Family Singers (distributed in Austria but, interestingly, not in Germany), and two books on Walter Gropius and the Bauhaus movement, which the Nazis had deemed degenerate.

Although American literature and literary history and criticism came to almost every foreign nation through the ICS or the Books in Translation program, modernist literature and related criticism are relatively rare. A few undeniably modernist titles and authors appeared: Malcolm Lowry's *Under the Volcano* was brought out in German in 1952; Marianne Moore's *Collected Poems* appeared in German in 1954; and Hemingway's "Snows of Kilimanjaro," Fitzgerald's "Babylon Revisited," and Faulkner's "Rose for Emily" ran in USIA-produced anthologies, particularly in Asian languages. The absence of anything by Wallace Stevens, William Carlos Williams, Gertrude Stein, or Hart Crane strikes us today as notable, although less remarkable is the lack of prominent American modernists such as John Dos Passos, Clifford Odets, and Langston Hughes (because of their earlier Communist associations) and, of course, the absence of Pound. Some translated critical works such as Frederick Hoffman's *The Modern American Novel* and William Van O'Connor's *An Age of Criticism* did deal directly with modernism but downplayed the importance of the artistic experimentation that most critics of the time saw as modernism's most important feature. Heinrich Straumann's *American Literature in the Twentieth Century*, available at many European Information Centers, talked extensively about the great American modernist writers; however—in keeping with the general thrust of the book programs—it focused not on their artistic achievement but on how their works help us "arriv[e] at an understanding of the apparent contradictions and puzzling complexities of the modern American outlook."[73] Similarly, Louise Bogan's *Achievement in American Poetry*, Alfred Kazin's *On Native Grounds*, and Frederick Hoffman's *The Modern Novel in America*—all on a 1955 approved list—create a portrait of American modernism as springing from America's native literary traditions.[74]

Some Information Centers, especially those in Europe, featured more adventurous stock, or at least did so after the McCarthy storm blew over. A 1955 list of American literary titles available at the eleven centers in Italy, for instance, includes Dos Passos's *U.S.A.* trilogy, James Farrell's *Studs Lonigan* trilogy, T. S. Eliot's *Complete Poems and Plays*, Robert Frost's *Complete Poems*,

Eugene O'Neill's *Strange Interlude* and *Mourning Becomes Electra*, Gertrude Stein's *Selected Writings*, Edna St. Vincent Millay's *Mine the Harvest*, Delmore Schwartz's *Vaudeville for a Princess*, William Carlos Williams's *Desert Music*, and Wallace Stevens's *The Man with the Blue Guitar*, as well as poetry collections by Kenneth Patchen, W. S. Merwin, James Merrill, John Crowe Ransom, Adrienne Rich, e. e. cummings, Karl Shapiro, and Peter Viereck.[75] Not all of these titles or authors are modernist, of course—Viereck was part of the backlash against modernist poetry—but the selection particularly of the young poets suggests that someone who knew contemporary poetry well had compiled this list. Nor did the Information Centers feature only books: Vienna's Amerikahaus, one of the busiest of all the Information Centers, in 1957 featured an exhibition of prints of abstract paintings, and in 1959–1960 USIA centers in Paris and London mounted a nostalgic show, Paris in the Twenties: An Exhibition of Souvenirs from Shakespeare and Company.

Some foreign posts, judging that their local audiences would be receptive to different messages than those recommended by Washington, undertook more intrepid or singular projects to use American literature—even modernism—to advance cultural understanding. A set of USIA-produced Spanish-language pamphlets on American literature, printed in Cuba in the mid-1950s (presumably for national distribution, in quantities from 20,000 to 30,000), offered a more inclusive treatment of modern American literature but downplayed the formal experimentation and innovations of modernism, explaining modernist writers largely in realist terms and emphasizing, perhaps more than anything, how these writers' works embody the American character. *Willa Cather: The Universal Essence of Pioneer Life* reiterated Frederick Jackson Turner's famous thesis that the frontier is the primary influence on the American character and argued that Cather's novels are clear demonstrations of this thesis, and a pamphlet on Eugene O'Neill mused that "it is strange indeed that the leading tragic dramatist of our time should be an American for the American's view of life is anything but tragic." Most of these pamphlets—and there are several, on authors such as Melville, Dickinson, Twain, Edgar Arlington Robinson, Carl Sandburg, Hemingway, and Frost—provided fairly standard overviews of the author's life and work and importance, but the essays on the more modern authors at times made suggestive points

that reflected the book programs' wariness about modernism. Not certain that his subject would be a literary immortal, the writer of the pamphlet on Ernest Hemingway hedged his bets: "Determining Hemingway's position in literary history isn't the work of this generation. It is enough to acclaim him as a talented novelist, a humanitarian, a writer whom we can read and who conveys the plain sense of simple words." Others revealed their ideological agenda: the 1956 pamphlet on Frost used "Mending Wall" as an example of how Frost's verse "says more than is immediately apparent" ("salta a la vista"). "The friend expresses the idea that good fences make good neighbors.' But Frost doesn't share this idea. This, he says, is a remnant of the concepts of the stone age. And he gives us a lesson that we can easily understand today: that it is evidence of the Paleolithic mentality when a nation hides itself behind what we call today an iron curtain."[76]

Whereas most of the truly daring modernist works in the book programs were available only in English, in Information Centers Alain Bosquet's 1956 *Anthologie de la poésie américaine* (sold in France) was probably the least characteristic of all the literary titles distributed by the Books in Translation program because its focus is very much on the modern and even modern*ist*.[77] The *Anthologie* was the first comprehensive collection of American poetry in French and featured facing-page translations by Bosquet, himself a well-published poet. Of its more than three hundred pages, only one hundred are given to pre-1900 poets, and such contemporaries as Viereck, Stanley Kunitz, and Muriel Rukeyser are represented. Although Bosquet included poems by neither Pound nor Eliot (Pound because of "legal complications" and Eliot because he "considers himself an English poet"), he did decide to offer work by Williams, H.D., Marianne Moore, and e. e. cummings, each of whom takes up as much space as Emerson, Whittier, Bryant, or James Russell Lowell.[78] In his introduction, Bosquet gives careful attention to imagism and even points to the radical "poetry of social reclamation" of the 1930s and the "racial poetry" of African American writers. Bosquet's anthology, in short, draws a picture of the American literary scene that is much closer to the modernist-friendly Intercultural Publications model described later in this book than to the very traditional and conservative model offered to most of the other nations and markets targeted by the translations program.

(This similarity is not surprising: Bosquet in fact contributed to Intercultural's work by providing translations for *Profils,* the French edition of James Laughlin's little magazine *Perspectives USA.* Work by Laughlin himself and by Edouard Roditi, the director of translations for *Perspectives,* appears in Bosquet's anthology as well.)

It seems ironic that a project tasked with countering European assumptions that the United States was an artistic backwater included so little of the most important and most internationally respected recent American *writing,* especially at a time when international modernism was at its apex of influence and prestige. This oversight, or short-sightedness, is especially notable given that the book programs included titles celebrating American experimentation in other arts, such as Gerd Hatje's *American Architecture since 1947,* Rudi Blesch's *Modern Art USA: Men, Rebellion, Conquest 1900–1950,* Ralph Pearson's *Modern Renaissance in American Art,* and Barry Ulanov's *History of Jazz in America,* even as experimental modernist literature was largely ignored. But with the exception of a few locales (such as Italy), the book programs shied away from arguments that literary modernism expressed American freedom and individualism. Experimental literature, it seems, here fell victim to the caution of the book programs' administrators, who were made fearful by the suspicion and surveillance ignited by McCarthy and perpetuated by other conservatives in Congress and who were charged with using books to present American history and culture in ways that foreign readers could understand.

For these reasons, it is particularly striking that the modernist author who played the biggest part in the book programs and, in fact, contributed more to the 1950s cultural-diplomacy program than any other was William Faulkner. As Lawrence Schwartz and others have shown, the Faulkner we know today—Nobel laureate, prophet of the triumph of humanity, the genial Shakespeare of the South—was not the Faulkner that readers and critics of the 1940s knew. For most of them, Faulkner was a minor, obscurantist novelist who worked primarily in the Gothic tradition, creating cruel grotesqueries of race and violence and sex. His most famous work, *Sanctuary,* became the 1933 film *The Story of Temple Drake,* which is credited with spurring Hollywood to impose the moralistic Hays Code. Malcolm Cowley's 1946 *Portable Faulkner,* with an introduction that forcefully argued for the writer's significance, began

the redefinition of Faulkner, a process accelerated by what Schwartz calls "the new literary consensus" between the New Critics and the New York Intellectuals, whose ascendance solidified the cultural dominance of "literary elitism and liberal anti-Communism."[79] Schwartz documents the role that cultural institutions—publishers, universities, intellectual journals, and foundations—have played in literary taste making and persuasively shows that the dramatic improvement in Faulkner's literary reputation in the 1940s and 1950s came about as much because of these agents as because of anything intrinsic to Faulkner's work itself. I would add to Schwartz's catalog of such agents the US government: the State Department's book programs featured Faulkner's works, and he actively participated in USIA goodwill tours and documentary films, and these activities not only contributed to the remaking of his reputation but were also a key, if largely unknown, episode in the reframing of experimental modernism as an expression and defense of the free societies of the West.

Although William Faulkner described himself as "just a farmer who likes to tell stories," his self-deprecating—and certainly disingenuous—self-description belies his true significance as an emblem of American artistic achievement in the mid–twentieth century. Faulkner was almost certainly the most significant figure in the exportation of American modernism to the rest of the world and likely had more direct influence on foreign writers—in particular Latin Americans—than any American writer since Poe. In the 1950s, international awards and accolades came to Faulkner, and his succinct, eloquent Nobel Prize address in 1950 intersected obliquely with Truman's "Campaign of Truth" message, which argued that the Soviets were the greatest threat to peace in the world and that only the humanistic values of the free world could stave off the threat of destruction hanging over humanity.

Faulkner's speech echoed those messages about humanity confronting these threats, foregrounding the role of creative expression. "Our tragedy today," Faulkner said, "is a general and universal physical fear so long sustained by now that we can even bear it. There are no longer problems of the spirit. There is only the question: When will I be blown up?" In the face of this fear, though, stands humanity's ability—indeed, compulsion—to create. Faulkner called his own achievement "a life's work in the agony and sweat

of the human spirit, not for glory and least of all for profit, but to create out of the materials of the human spirit something which did not exist before." Faulkner's vision of humanity's need to express is not, like Samuel Beckett's, that of a "puny inexhaustible voice, still talking"; rather, the creative voice will "help man endure by lifting his heart, by reminding him of the courage and honor and hope and pride and compassion and pity and sacrifice which have been the glory of his past. The poet's voice need not merely be the record of man, it can be one of the props, the pillars to help him endure and prevail."[80] Apart from the dark warnings about nuclear destruction, Faulkner's insistence that "the problems of the human heart in conflict with itself . . . alone can make good writing because only that is worth writing about" implicitly underscores the fundamental value of the individual in contrast with communism's emphasis on the needs of society or the state. Faulkner's speech is a powerful endorsement of the values of individualism, creativity, and freedom.

Faulkner had been reluctant to travel to Sweden to accept the prize, resisting entreaties from the Nobel committee and the US government. "I am a farmer down here and I can't get away," he told Sven Ahman, a reporter for Stockholm's *Dagens Nyheter* newspaper, when asked if he would be attending the ceremony. In a letter to Ahman later that month, Faulkner elaborated, saying that "the award was made, not to me, but to my works. . . . I am fifty now; there is probably not much more in the tank. I feel that what remains after the thirty years of work is not worth carrying from Mississippi to Sweden." The US embassy in Sweden cabled Secretary of State Dean Acheson and pled with other State Department officials to try to persuade Faulkner to come to Stockholm; the department turned to Muna Lee, a poet and cultural-affairs specialist, to appeal to her fellow Mississippian. Lee's intervention and a personal appeal from the Swedish ambassador resulted in Faulkner's agreeing to attend the ceremony.[81] Some years later, Philip Raine (the public-affairs adviser to the Bureau of Inter-American Affairs) noted that Faulkner "finally made [the trip] at last because he had been convinced that it was in the interests of the United States cultural relations that he do so."[82]

However reluctant Faulkner had been at first, he became an obliging participant in the American cultural-diplomacy program, traveling abroad frequently on behalf of the USIA. The USIA heavily publicized Faulkner's Nobel

address; he recited it often, most VOA or USIA stories on him emphasized it, and it was a central focus of *William Faulkner y su condado imaginario*, the pamphlet produced by USIA for Cuban distribution.[83] Moreover, Faulkner's prestige among foreign writers made him a powerful cultural ambassador. Raine said frankly that "William Faulkner is a great aid in furthering the objectives—and the inmost meaning—of our program."[84] "Our program" was not only the cultural-diplomacy program of State and USIA, but the comprehensive military and psychological-warfare strategy for the Cold War outlined in NSC-68. "The free society values the individual as an end in himself . . . [and] attempts to create and maintain an environment in which every individual has the opportunity to realize his creative powers," NSC-68 stated, and it urged the United States to "demonstrate the superiority of the idea of freedom by its constructive application."[85] Faulkner's speech—and the great esteem so many foreign writers and readers had for him—was an ideal "constructive application" of this idea of human freedom.

Faulkner's first such trip was to Brazil for the 1954 International Writers Conference in São Paolo. His appearance at this conference was a priority for the State Department, which wanted to soothe Brazilian anger at the denial of a US visa to leftist writer Joao Lins de Rego. Robert Frost had already agreed to attend, but the Brazilians wanted Faulkner because of the Nobel and his long-standing popularity in Brazil. Lee again approached Faulkner directly, and, as she noted, he "decided to go because—and only because— the Department put it to him as a way in which he could be of definite and immediate service to the United States."[86] In keeping with State's generally conservative literary tastes, the publicity materials that Washington circulated framed Faulkner not as a modernist experimentalist but as a southern regionalist. Knowing that the Brazilian public would be focused on the issue of race, the department also sent over a transcript of Ralph Ellison, Irving Howe, and Lyman Bryson discussing "The Bear" on VOA. "A particularly important item," the instructions specified, "since Ellison, speaking as a Mississippian [*sic*] and as a negro novelist, tells why he considers 'The Bear' a central story in Faulkner's whole work."[87]

To the relief of the State Department, which had an extensive set of plans to deal with the problems stemming from its guest's alcoholism, Faulkner

performed adequately. Drunk on Peruvian brandy when he disembarked, he remained confined in his hotel room for the first forty-eight hours of his visit. But on Wednesday, August 11, he emerged, read his Nobel speech at a press conference, and took questions. Over the next few days, he made numerous successful appearances, and after his departure Lee wrote a glowing internal memo on how revealing Faulkner had been in his interviews with the Brazilian press.[88] Faulkner was also pleased with his initial stint as a goodwill ambassador and wrote to the State Department upon his return that he wanted to "discuss what further possibilities, situations, capacities, etc., in which I might do what I can to help give people of other countries a truer idea than they sometimes have, of what the U.S. actually is."[89]

Faulkner's next foray as a cultural ambassador was much more extensive. In July 1955, he departed for Japan for three weeks of touring cultural sites and speaking at a Nagano seminar for Japanese professors and students of American literature. Dr. Leon Picon, the books officer of the Tokyo embassy, served as Faulkner's escort (or "wet nurse," as Faulkner put it), doling out Faulkner's bourbon allotments and ensuring that there were attractive young women in the audiences to keep up his energy. Picon reminisced that upon Faulkner's arrival in Japan, "he had apparently been doing quite a bit of drinking on the plane and his eyes were almost moving independently." Although Faulkner was, as ever, courtly, his self-control was so bad in a reception with the American ambassador the next day that the ambassador instructed a staffer "to see to it that Mr. Faulkner was on the next plane back to the United States." But Faulkner rallied at the Nagano seminar to the degree that Picon deemed it a "rip-roaring success" and noted that the Japanese took no note of behavior that Faulkner's countrymen found alarming: "The Japanese . . . didn't see anything wrong with the amount of drink that he had, and they understood when he went off completely, and was not communicable again. . . . But I must say that he was fully cooperative. It was blood, sweat and tears, but in the long run he came through. He was not going 'to let USIS down!' Those are the words that he used himself."[90] (Picon's caretaking of Faulkner was so successful that the State Department circulated his "Guidance Recommendations for Handling Mr. William Faulkner During Official Tours" to all overseas posts that would host the

writer. Those cultural affairs officers ignored Picon's suggestions at their peril, and often ended up with an incapacitated Faulkner.[91])

At the events themselves, the Japanese students and public received Faulkner enthusiastically, and the State Department capitalized on the fact that he responded in kind. During his visit, he wrote a short piece entitled "To the Youth of Japan" in which he praised their nation and people and extolled their democracy (comparing it favorably to the development of the South, similarly devastated after a terrible war); USIA printed it as a bilingual pamphlet in August 1955 for distribution in Japan.[92] Another short essay he wrote, "Impressions of Japan," became the script for a USIA-produced film of the same title. Over images of Faulkner's travels through Japan, a voice-over (Faulkner's words, read by a narrator) describes the writer's impressions in a kind of portentous, faux-eastern philosophizing tone, at times verging uncomfortably on an Orientalist idea of "simplicity" typified in the grace and beauty of Japanese culture—geishas, tea, archery, rice paddies, water-color painting—in this "place of beauty, worked wisely by such kind people." Asked by students what truth is, the narrator, "having no such knowledge," just tells them that man needs to stand on his own feet, "believing in his own toughness and endurance, realizing that man's hope is in man's freedom, not given as a gift but as a right and a responsibility to be earned. . . . What they wanted," the voice-over continues, "was just a human being, who spoke not their same intellectual language but who could write books that met their standards of what writing must be, yet who in trying to communicate human being to human being, spoke in a mutual language much older than any intellectual tongue because it is the simple language of humanity."[93]

State was even more pleased with Faulkner's Japanese tour than it had been with his Brazilian visit. A Foreign Service dispatch the next month stated that "in all of his discussions, he unflinchingly answered questions on his works, his style, his philosophy, and American life in general. On two occasions . . . he hit hard against Communism, Socialism, and any form of radicalism in general, defending Democracy as the best system yet devised by man for all its faults."[94]

Faulkner took a circuitous route home from Asia. He made a two-day stop in Manila, then spent three weeks in Italy, and went on to Munich for

FIGURE 3.3 William Faulkner meets the press in Paris, 1955.
US Department of State Bureau of Educational and Cultural Affairs Historical
Collection, University of Arkansas–Fayetteville Special Collections Library.

a performance of the theatrical version of *Requiem for a Nun* and then on to
Paris, London, and Reykjavik. The official report on the Iceland visit deemed
it "particularly successful in University circles, which often have been pecu-
liarly subject to influences cool or even hostile to the United States." Asked
by an audience about the problems resulting from American troops in a
small country, Faulkner had said that it wasn't the United States but the
North Atlantic Treaty Organization that put them there, and "is it not bet-
ter to have American forces here in the name of freedom, than a Russian
one in the name of aggression and violence?"[95]

Faulkner embarked upon two other State Department–sponsored trips
over the last few years of his life. The first was to Athens in March 1957 to see
a Greek production of *Requiem for a Nun* and to accept an award. Although

FIGURE 3.4 William Faulkner and Duncan Emrich,
the cultural affairs officer at the US embassy in Athens, 1957.
US Department of State Bureau of Educational and Cultural Affairs Historical
Collection, University of Arkansas–Fayetteville Special Collections Library.

Faulkner's drinking and a harrowing sailing excursion in the Aegean pre-
sented problems for his handlers, State was pleased with how the trip bol-
stered American cultural prestige and with Faulkner's relentless rhetorical
linkage of freedom and creativity. At the ceremony to present him the Sil-
ver Award of the Athens Academy, he accepted the medal "not alone as an
American nor as a writer but as one chosen by the Greek Academy to rep-
resent the principle that men shall be free."[96] "Mr Faulkner's visit was one of
the most successful events in the whole cultural program of the year," Duncan
Emrich, cultural-affairs officer at the Athens embassy, gushed to Washington.
"Its importance cannot be underestimated."[97] (Emrich had won a $300 prize

for an essay on Faulkner while an undergraduate at Brown and was a fan.) In January 1958, Russell Riley of the International Exchange Program told the President's Advisory Committee on the Arts that Faulkner had been a magnificent cultural ambassador for the United States and that his speech to the Greek Academy had "heightened the pride of the Greeks and made them happy that they invited [him]."[98]

In May 1958, the State Department invited Faulkner to join a group of American writers traveling to the Soviet Union on a goodwill visit, but he declined, saying that it would be a "betrayal" of Dostoevsky, Tolstoy, Chekhov, and Gogol to offer even the "outward appearance of condoning the condition which the present Russian government has established."[99] But he continued to work with the Department of State, attending the 1959 conference of the US National Committee for UNESCO in Denver.

In his final trip abroad for USIA, Faulkner returned to Caracas, Venezuela (which he had visited after his 1954 trip to Brazil), in April 1961 for the Sesquicentennial of Venezuelan independence, where he was to receive the Order of Andres Bello.[100] Again, the State Department was delighted. The cultural-affairs officer of the Caracas embassy, Hugh Jencks, called it "an unqualified success. . . . The cultural leaders of Venezuela, many of whom are pre-disposed to take an anti-U.S. attitude on all international issues . . . tend to agree with the Communist tenet that the United States is grossly materialistic, with no cultural achievements. To bring a literary figure of the stature of Faulkner to Venezuela was an effective refutation of this view."[101]

Both Faulkner and the USIA wanted to speak in general terms about the place of the artist in the free world, and to this end cultural-affairs officers in local posts widely circulated his Nobel address. But he could not avoid the question of race: apart from its presence in his own work and his close association with that notorious state Mississippi, *Brown v. Board of Education* was decided not long before Faulkner went to Brazil, Emmitt Till was murdered while Faulkner was in Rome in 1955, and the vivid television coverage of the forced integration of Little Rock's Central High School in September 1957 circulated around the world. Communist propaganda, disseminated through official party outlets such as the Italian newspaper *l'Unità* and the

French newspaper *l'Humanité*, hit hard on American hypocrisy and racism. Faulkner, in Italy, gave a strong condemnatory statement immediately after the Till murder and addressed the issue in precisely the kind of internationalist rhetoric the USIA endorsed. In fact, his responses to questions about race and the angry and righteous tone he struck went further than the USIA's general treatment of race in the United States, which tended to stress the benevolent role of the federal government and the fact that desegregation was only "unfinished work" or that "violence is going out of fashion" in the South (as stated in a 1962 report).[102]

Race, in fact, was almost as sensitive a topic as communism in the USIA book programs. Communist propaganda, both Soviet and homegrown, had long pointed to the hypocrisy of the American rhetoric of freedom and its Jim Crow social and legal structures. In response, the IIA/USIA chose to respond not by confronting Communist accusations directly—what could they say?—but by making available positive portrayals of race relations in America. As early as 1951, the "Memo on Book Translation Programs," sent out to Foreign Service posts, recommended that officers seek to translate and publish such positive portrayals of the American racial situation as Margery Miller's *Joe Louis: American*, Bill Roeder's *Jackie Robinson*, Augusta Stevenson's *Booker T. Washington: Ambitious Boy* and *George Washington Carver: Boy Scientist*, and Catherine Owens Peare's biography of the African American educator Mary McLeod Bethune. In 1953, responding to congressional complaints that the portrayal of a warts-and-all America overseas was counterproductive, a State Department staff member noted that "the presence of [Gunnar Myrdal's] *An American Dilemma: The Negro Problem and Modern Democracy* . . . impressed readers abroad with the 'credibility of the material.'"[103] (Myrdal's book provided the intellectual model for the Unfinished Work exhibit at the 1958 Brussels World's Fair.[104]) Harry Carman, Harold Syrett, and Bernard Wishy's *History of the American People*, included in the translations program in 1957, forcefully refuted the widespread idea that Reconstruction and its enfranchisement of black voters were a disaster visited upon southern society. In 1962, the USIA recommended that USIA reading rooms and libraries order Bernard Taper's book *Gomillion Versus Lightfoot: The Tuskegee Gerrymander Case*, an "analysis of the difficulties over Tuskegee township boundaries which

disenfranchised the Negro vote and ends with the Supreme Court decision against such blatant discrimination."[105]

For the most part, treatment of the race issue echoed the American liberal stance: segregation is an injustice, but the structures of American democracy can and inevitably will ameliorate it. Not all realistic visions of American race relations were acceptable, though. In 1953, the Book and Library Program removed from its shelves Herbert Aptheker's *Documentary History of the Negro People in the U.S.*, and the writer and historian Dorothy Sterling reported that her book *Tender Warriors*, "a picture and text report of the unbelievably brave young people who were walking through screaming mobs to go to [newly integrated] school[s]," was "disapproved for export" under IMG in 1958, with no reason ever given.[106] As Mary Dudziak has shown in *Cold War Civil Rights*, the ideological conflict of the Cold War provided great assistance to the civil rights movement, spurring the United States to examine (and chip away at) its domestic systems of repression even as it attacked the Soviets'. And conversely, the great orators of the civil rights movement—Martin Luther King Jr. above all—came to employ *freedom* as a rhetorical master term, shrewdly concluding that its Cold War resonances would prove more appealing to American audiences than *equality* or even *justice*.[107]

In the end, modernism played a much smaller and much more subordinate role in the book programs than it did in the art program. The art program foregrounded modernism and in exhibition catalogs pointed out how the techniques of those works—their formal features—embodied freedom and individualism. When the artists themselves were the subjects of the discussion, the focus was on their personal artistic evolution; the way that the artists themselves embodied aspects of the American character and experience (the melting pot, the frontier) was secondary to the treatment of their art*works*. The art program provided an aestheticized way to understand modernism, reflective of the larger trend of viewing modernist artworks as self-contained artifacts. Certainly this approach was in some part inevitable; because so many modernist paintings are nonnarrative and nonrepresentational, it is difficult to talk about how their "subjects" tell the American story. But even given this generic or categorical limitation, the aestheticized portrait of American painting in the art program is notable.

The book programs, with a slightly different mission, ended up with an entirely different product. Charged with providing to foreign audiences "information about the United States, its people, culture, institutions, policies, problems, and achievements," the administrators and consultants of the book programs tended to choose or approve titles with this educational imperative in mind. The programs presented literary works in their social and historical context, not as aesthetic artifacts. The literary criticism was largely free of New Criticism, instead featuring studies such as those by Van Wyck Brooks, Bernard de Voto, Heinrich Straumann, and even Alfred Kazin that subordinated the work to the historical theme, the biographical story, the cultural generalization. The works were important not in themselves, but because of what they told us about America—in particular, how they fleshed out the vision of American history and America's place in the world that Cold War liberalism elaborated and propagated. This means of understanding modernism's place in American literary history, in turn, went counter to the increasingly dominant aesthetic-autonomy approach epitomized by the "new literary consensus" of New Critics and New York Intellectuals—the approach that ultimately ushered modernism into the mainstream. This historical-cultural lens also undermined the larger Cold War modernist argument, so prominent in the official art program and in the nongovernmental Cold War modernist projects run by the CCF and the Ford Foundation, that modernism was fun damentally *international*, that US artists were leading participants in a transatlantic movement. The administrators of the book programs never allowed modernist literature to take center stage. It fell to nongovernmental cultural diplomats—and their magazines—to do that.

4

ENCOUNTER MAGAZINE AND THE TWILIGHT OF MODERNISM

NO CULTURAL INSTITUTION is more entwined with the history of modernist literature than the "little magazine." Modernist literature entered the world in little magazines; in little magazines, modernism's strains and factions and tendencies evolved and defined themselves; reviews and critical articles in little magazines allocated prestige and cultural capital to writers and movements; little magazines even provided financial support for modernist writers by paying for articles and bestowing prizes and jobs.[1] Many little magazines expressed modernism's antipathy to mass culture and commerce, self-consciously employing manual typesetting, letterpress printing, and handmade paper rather than taking advantage of the economies afforded by Linotype or Monotype typesetting, offset printing, and newsprint. Like the movements they printed and assessed, little magazines often appeared and disappeared quickly. Malcolm Cowley (a veteran of these publications) pithily described a typical modernist little magazine: "The first issue consists, let us say, of sixty-four pages, with half-tone illustrations printed on coated paper. The second issue has sixty-four pages, illustrated with line cuts. The third has only forty-eight pages; the fourth has thirty-two, without illustrations; the fifth never appears."[2] A few, however, such as *Poetry*, are now well into their second century.

Modernist literature was born, enjoyed a rambunctious childhood and adolescence, and mellowed into respectable adulthood in little magazines. It

also moved into its august old age and, later, decrepitude there. And during that stage, in two of these magazines, modernism lent its declining force to the cultural Cold War. In this chapter and the next, I look at the portrait of modernism in two 1950s cultural magazines, both founded to use high culture to sway European intellectuals to the American side. These magazines—London's *Encounter* and New York's *Perspectives USA*—mirror each other in many ways, but the portrait of modernism they offer is distinctly different in both content and effect. These journals are interesting not only for how they convey and explain modernism, but also for how their institutional origins and support instantiate the Cold War modernist project. Both were published by private cultural organizations (one, *Encounter*, with covert governmental subvention) deeply invested in the cultural Cold War. Both were headed by men who played important roles in the institutional triumph of modernism outside of their work on these journals. *Encounter* survived—thrived, even—for several decades and became one of the most influential and respected cultural journals in the Anglo-American world; *Perspectives USA*, in contrast, limped along for only sixteen issues and was quickly forgotten.

The Cold War modernist project looks very different in these magazines than in the governmental art and book programs, although they all are part of a larger whole. Over the course of the late 1940s and the 1950s, modernism became a secure part of official American cultural diplomacy (even though it was much more central to the art program than to the book programs). At the same time, the American non-Communist Left and former Communists in western Europe, convinced that the Soviet threat to culture and human freedom was indeed dire, organized themselves independently to confront that threat, to neuter the Communist movement in western Europe, and to offer support to dissenting intellectuals and artists in the Communist world. Working in parallel and often in collusion with governmental informational and intelligence agencies, these unofficial cultural diplomats spread their message through the customary means of reaching intellectuals: journals, books, and symposia. One of the most important and best known of these groups, the Paris-based Congress for Cultural Freedom, adopted and advanced the Cold War modernist argument, particularly in *Encounter*. Never a strictly artistic or literary journal specializing in modernism, *Encounter*

was, in Neil Berry's apt words, a cultural-political journal with "a cool left-of-center profile, promoting the emerging postwar consensus in the West on the virtue of welfare capitalism."[3] In fact, many of the key members of the CCF and important contributors to *Encounter* were not part of the modernist tradition. But *Encounter* contributed to the Cold War modernist project through the links it forged between artistic modernism, intellectual freedom, and anticommunism among members of the Anglo-American literary and cultural establishment. For *Encounter* and its first editors, modernism signified the legacy of the 1910s and 1920s—the relentless drive to innovate, create, and forge new means of representation—which in turn presupposed the kind of freedom and individual self-determination of artists and writers that the West boasted and Soviet communism thwarted. The magazine explicitly and consistently linked literary and artistic modernism to Western ideas of freedom and individualism and figured Soviet art and intellectual life as constrained, dishonest, mindless, and servile. In *Encounter*, modernism represents vitality and individualism and freedom and thus the superiority of the West.

Although *Encounter* used modernism to counter Soviet ideology, modernism's relation to Western bourgeois society had of course always been troubled, and the journal acknowledged this aspect in presenting modernism as spent, done in by its own age and by other powerful forces unleashed by Western freedom and individualism: materialism and mass culture. In its criticism in particular, the journal redefined modernism as a set of formal techniques created by the great generation of the 1910s and 1920s and still used in the present, but to diminishing artistic returns. T. S. Eliot became the pivotal figure in this redefinition, for he epitomized both the innovations of modernism and the sense that contemporary writers and artists could only be belated, attenuated, pallid inheritors of a—*his*—great artistic legacy, struggling against a grasping, acquisitive society. Therefore, the journal actually worked at crosscurrents, claiming modernism as an example of Western freedom, while acknowledging at the same time modernism's lifelessness and impotence in the face of mass culture. In staking its claim that modernism is the dominant tradition of the century and that Western freedom and individualism allowed it to become so, *Encounter* also eulogized modernism as a vital literary and artistic movement.

Many scholars, beginning with Jason Epstein in 1967 and Christopher Lasch a year later, have recounted the CCF's scandalous history. Lasch and Epstein focused on the explosive revelations of the CCF's covert CIA funding (a story broken by the *New York Times* in 1966, augmented by *Ramparts* magazine in 1967, and proudly confirmed to the public by CIA agent Tom Braden in a *Saturday Evening Post* article entitled "I'm Glad the CIA Is 'Immoral'"). As the Cold War ended and the new Cold War history movement began, new histories appeared, first by Australian politician and CCF veteran Peter Coleman (*The Liberal Conspiracy*, 1989), then by British journalist and filmmaker Frances Stonor Saunders (*The Cultural Cold War*, 1999) and the academic historian Giles Scott-Smith (*The Politics of Apolitical Culture*, 2002). These writers provide a much fuller portrait of the organization's genesis and fall than I can or want to do in this chapter, but a brief outline of the CCF's early history is necessary here in order to understand *Encounter's* institutional and politicocultural position.[4]

Although the CCF was a European organization, its organizational roots were in the pre–World War II United States when the Committee for Cultural Freedom was founded in 1939 to oppose Stalinism and the Popular Front. Sidney Hook was the undisputed leader of the group, instrumental in shifting its mission in response to two Soviet-sponsored events: the 1948 World Conference for Intellectuals for Peace in Wroclaw, Poland, and the March 1949 Cultural and Scientific Conference for World Peace held at the Waldorf-Astoria Hotel in New York. Both gatherings promoted the idea— largely accepted among Stalinist leftists in the West—that the Soviet Union sought peaceful coexistence, whereas the United States was an expansionist, militaristic power. At Wroclaw, Dmitri Shostakovich denounced the "hate-mongers" who were seeking a third world war, and perhaps because of his masterful performance there Shostakovich also appeared in New York, but there Russian émigré composer Nicolas Nabokov attacked him as a Stalinist stooge. The New York conference created a media sensation—the *Times* covered the arrival of the Soviet delegation, and American writers Lillian Hellman, Aaron Copland, Arthur Miller, and Norman Mailer joined the program. Members of Hook's organization Americans for Intellectual Freedom (including James Farrell, Dwight Macdonald, and Mary McCarthy)

disrupted the conference to counter what they saw as Soviet lies—"the most dangerous thing we can do . . . is to leave the task of exposing Communist fronts to reactionaries," Hook explained.[5] In January 1951, the American Committee for Cultural Freedom (ACCF) was incorporated in New York, with Hook as president and a membership that included such luminaries as George Schuyler, Richard Rovere, James Burnham, Diana Trilling, Mary McCarthy, W. H. Auden, Ralph Ellison, James Farrell, Norman Thomas, and Daniel Bell; the group's Executive Committee met in the Manhattan offices of the *New Leader*. Their mission was, in Hook's words, to uphold cultural freedom in the United States against both McCarthyism and "those who knowingly followed the Communist Party line"; as the decade wore on, though, Hook became even more adamantly anti-Communist and argued that these groups should defend cultural freedom in a specifically anti-Communist sense.[6]

Although the ACCF became a national affiliate of the CCF, the two groups occasionally clashed, particularly over the issue of covert governmental funding. Diana Trilling remembers that all of the ACCF's board members were "in some measure aware, that the international body with which we were associated [the CCF] was probably funded by the government," and Hook insisted that the ACCF would refuse to accept any money it suspected was coming indirectly from the CIA.[7] Plagued with financial problems, the ACCF dissolved in 1957.

In 1949, though, the internecine war among American leftists greatly excited policymakers who were at that time developing a plan to counter the Soviets' cultural-diplomacy blitz overseas. Collaborating with Hook and other leaders of the cultural-freedom movement, Frank Wisner's Office of Policy Coordination (OPC)—a psychological-warfare and covert-operations shop folded into the CIA in 1951—helped organize an April 1949 International Day of Resistance to Dictatorship and War in Paris, but the resulting "tone [of the conference] was too radical and neutralist for Hook and Farrell."[8] At the conference, Hook made plans with Melvin Lasky (editor of *Der Monat*, a cultural newspaper published by the American military government in Germany) for a more ambitious, more stridently anti-Communist conference to be held in West Berlin.

FIGURE 4.1 Arthur Koestler, Irving Brown, James Burnham,
and Melvin Lasky (*left to right*) at the Congress for
Cultural Freedom, Berlin, June 1950.
Special Collections Research Center,
University of Chicago Library.

With the organizational and financial help of the Estonian American agent
Michael Josselson (who, it was revealed later, secretly represented the OPC
and later the CIA) and Irving Brown, who worked for both the American
Federation of Labor and the CIA, the Congress for Cultural Freedom brought
together intellectuals and artists from across the anti-Communist West on
June 26, 1950, the day after the North Korean army invaded South Korea. It was
a raucous gathering in a city with fresh memories of the Soviet blockade and
Allied airlift that had ended just the year before. Lasky described this initial

congress as "not an official body, but a free association of men and women. . . . It was the initial attempt of the intelligentsia of the civilized world—poets and scientists, philosophers and journalists, socialists and conservatives, church-men and trade-unionists, painters and publishers—to join together freely, to discuss, to criticize, to formulate an independent program for the defense of their common democratic ideal."[9]

The contentiousness of the meeting embodied the freedom of conscience and debate in the West, its organizers boasted. Conversely, they sought to call attention to the *absence* of those same freedoms under communism; several of the attendees had already done so in the collected volume *The God That Failed*. Arthur Koestler, whose *Darkness at Noon* was the definitive fictional indictment of Stalin's show trials and purges, was the "star of the congress" because of his dynamic "tone of urgency" in flatly condemning the Soviets as "evil" and proposing a stark distinction between "total tyranny and relative freedom."[10] Koestler, with Manès Sperber, drew up a fourteen-point Freedom Manifesto that—notwithstanding the fact that Koestler was European—rep-licated the Manichean, us-versus-them construction that dominated Ameri-can discourse about freedom at the time.

Koestler's opposite number at the inaugural congress was the Italian nov-elist and former Communist Ignazio Silone, who pressed for a more mea-sured, less absolutist stance and "urg[ed] the West to promote social and political reforms in order to co-opt Communism's still-influential moral appeal," as the CIA's Mikael Warner put it.[11] This clash over tactics would play out throughout the CCF's early history as the group wrestled over the question of how confrontational it should be, how categorical its condem-nation of all Communists and fellow travelers. Koestler's stridency went beyond what the CCF's sponsors in the CIA desired—he was "too head-strong and too independent . . . *too* militant"—and Silone's biographer, for one, feels that Silone had the better personal and professional relationship with Josselson.[12] In his postconference report, Lasky divided the attendees into two main "tendencies": one, Koestler's and Burnham's, that "put main emphasis on the drive of Soviet imperialism toward world-conquest" and another, led by "most of the French, Italians, British, and non-Berlin Ger-mans," that "concentrated on the strengthening of the Western European

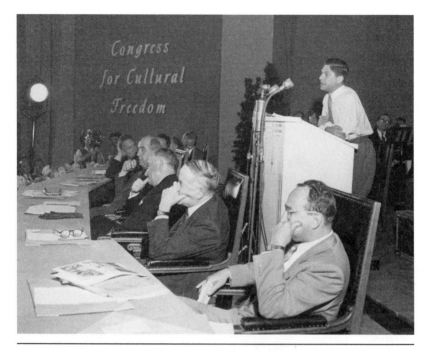

FIGURE 4.2 Arthur Koestler addressing the Congress for Cultural Freedom, Berlin, June 1950. Special Collections Research Center, University of Chicago Library.

unity idea, social and economic reforms . . . and a less polemical attitude toward Moscow."[13]

After the 1950 Berlin conference, the CCF incorporated itself as a permanent organization based in Paris and Berlin. Wisner's OPC secretly directed and financed this process and installed CIA operatives Josselson and Brown in high positions, ensuring that the agency would continue to have a strong voice in the CCF, even if its official leaders—President of the Executive Committee Denis de Rougemont and General Secretary Nicolas Nabokov—were not affiliated with the CIA/OPC or even aware of its involvement and were not even American.[14] For years, the CCF put on conferences on political and cultural matters, meetings that were always centered on questions of intellectual

FIGURE 4.3 Denis de Rougemont and Nicolas Nabokov
at the Congress for Cultural Freedom, Berlin, June 1950.
Special Collections Research Center,
University of Chicago Library.

freedom. It also sponsored festivals and exhibitions of contemporary arts, such as Nabokov's April 1952 Masterpieces of the Twentieth Century festival in Paris and the International Exhibition of Young Painters, dominated by modernist and abstract artists, in Rome in 1955.

These events emphasized the artistic freedom of the West, contrasting it with Communist determinism and central control. The Masterpieces festival, for example, showcased the unique artistic developments of the twentieth century, in particular modernist painting and music, and how they "would not have been possible except in the climate of freedom in which

the great artists, composers and writers of our time have worked."[15] According to the CCF,

> Writers, painters and composers have explored new modes of expression, discovered new techniques and laid the foundations for new styles and forms. . . . [The] essential characteristic [of twentieth-century masterpieces is] their great variety both in form and content. At the same time, the artists of these last 50 years have as never before been painstakingly seeking and in many instances establishing a just relation between the artist and society. . . . The art of the 20th century grew out of the stimulus of the modern metropolis, and thus gained a spirit of internationalism and became truly cosmopolitan.[16]

In this view, all was not well, though; "[there has been] a violent reaction against and the persecution of the free creative spirit of man" by "powerful states . . . whose governments have attempted and are attempting to stifle the free effort of artists and to transform them into obedient instruments of the state." For those who missed the point, CCF officer Stephen Spender elaborated that the festival "demonstrate[s] that the most creative work in the West is outlawed by Stalin, and therefore is a demonstration of the values of a free society."[17] (Nabokov made sure to include in the festival program Shostakovich's *Lady Macbeth of Mtsensk*, a work that the Soviet newspaper *Pravda* had condemned for "formalism" in 1936.[18]) An exhibition of painting and sculpture held at the Musée de l'art moderne included work by almost every major modernist artist: Arp, Balla, Bonnard, Brancusi, Braque, Calder, Cezanne, Chagall, Dali, de Chirico, Delaunay, Derain, Duchamp, Dufy, Ensor, Ernst, Gauguin, Giacometti, Gris, Grosz, Kandinsky, Klee, Kokoschka, Larionov, le Corbusier, Leger, Matisse, Matta, Miro, Modigliani, Mondrian, Moore, Picabia, Picasso, Renoir, Rouault, Rousseau, Soutine, Seurat, Tanguy, Villon, and Van Gogh. In a jab at the Soviet Union's cultural commissars, the exhibit catalog by James Johnson Sweeney noted cheekily that "one will find here artists whose art has been described in certain quarters of the world as 'bourgeois' or 'decadent.'"[19] At public seminars on such topics as "isolation and mass communication" and "revolt and human fellowship," American writers such as Allen Tate, Glenway

Wescott, James Farrell, W. H. Auden, Katherine Anne Porter, and William Faulkner engaged in debate and discussion.[20] The festival also featured an all-black production of Virgil Thompson's opera *Four Saints in Three Acts*, with a libretto by Gertrude Stein. For political reasons, it was crucial to the CCF that the cast not only be black, but be entirely American, which would "counter the 'suppressed race' propaganda and forestall all criticism to the effect that we had to use foreign negroes because we wouldn't let our own 'out,'" festival secretary Albert Donnelly insisted.[21] Nabokov added that

> the participation of an all American Negro troupe in the Exposition per-
> formance of "Four Saints" is of utmost importance. . . . In dance and in
> song, "Four Saints" exploits the sense of music and rhythm which is the
> American Negro's special forte. At the same time, unlike most American
> musical and dramatic vehicles for Negro performers, "Four Saints" presents
> the Negro in an atmosphere of grace and dignity. . . . More important,
> the psychological effect of an all American-Negro "Four Saints" well per-
> formed at the Paris Exposition would be, of necessity, most rewarding. It
> would contradict unanswerably Communist propaganda which claims that
> the American Negro is a suppressed and persecuted race.[22]

In the end, the festival was a popular success but received mixed critical response. (Contrarian Sidney Hook, for instance, sniffed many years later that "although there were efforts at desperate rationalization to show that all of these activities had something to do with the defense of the free world, actu-ally it did more to further Nabokov's career and reputation than to further cultural freedom."[23]) Giles Scott-Smith concludes that the festival "marked the end of any suggestion that Koestler's (or Brown's) wishes for the CCF would now be realized," that it signaled the centralization of the CCF to "a body run by the Paris headquarters with the support and guidance of [CIA's] International Organizations Division," and that it was "the final jettisoning of a militant posture in the CCF's public presentation. . . . From then on [the CCF] was to be directed explicitly at the high-brow cultural scene of the international intelligentsia, expressed perfectly by the arrival of *Encounter* magazine the following year."[24]

The CCF's most influential and lasting projects were its magazines: *Preuves* in France (founded 1951), *Cuadernos* in Latin America (1953), *Quest* in India (1955) *Tempo Presente* in Italy (1956), *Quadrant* in Australia (1956), and, after 1953, *Encounter*, published in London and distributed in the British Commonwealth, the United States, and East Asia. *Encounter* became a leading Anglo-American cultural magazine from the mid-1950s to the 1970s, publishing several articles that have become minor classics (most notably Nancy Mitford's "U and Not-U"), but it is certainly best known for the taint of its CIA funding. In the wake of those revelations, CCF immediately lost much of its credibility, many members deserted the group, and, as the most prominent of CCF's outlets, *Encounter* came in for particular public anger. Critics charged that the magazine, which had always loudly proclaimed the values of freedom and intellectual independence, was nothing but a CIA puppet. Everything *Encounter* had ever published was dusted for CIA fingerprints.

Encounter was not the only ostensibly "independent" periodical of the time that received direct or indirect funding from the CIA, mostly through the conduit of CCF. Saunders documents that the *Hudson Review, Kenyon Review*, and other journals received CCF subventions, mostly in the form of guaranteed bulk purchases, beginning in the late 1950s. In fact, she argues that *Partisan Review* obtained small grants that came indirectly from the CIA (through the ACCF and the Farfield Foundation) as early as 1953 and that CCF support was *Partisan Review*'s lifeline from 1958 until the mid-1960s, the group purchasing 3,000 copies of the journal per year.[25] The CIA also provided funds to the *New Leader*, Sol Levitas's one-time socialist magazine that became an important outlet for the anti-Communist Left (publishing Khrushchev's secret speech in 1956 and introducing American readers to the work of Josef Brodsky and Aleksandr Solzhenitsyn).[26] Even the influential *Paris Review* had extensive CIA connections—founding editor Peter Matthiessen admitted that starting the journal was part of his cover as a CIA agent, but another journalist has unearthed "a number of never-reported CIA ties that bypass Matthiessen or outlive his official tenure at the Agency"—basically evidence that George Plimpton also sought funding from and a collaborative relationship with the CCF.[27]

But, for my purposes, the explosive 1967 revelations and public reaction to them are irrelevant. My focus here is limited to the early years of *Encounter* and the magazine's role in the Anglo-American cultural sphere of the 1950s, particularly in relation to the aging modernist movement (many of whose members appeared in the magazine). What is the picture of modernism that we see in *Encounter*'s contents—the stories, poetry, and criticism that appeared in its pages? How did *Encounter*'s modernism position itself relative to the freedom and individualism of the West? In addition, unearthing how the magazine settled upon its editorial stances and choices illuminates the degree to which those choices and stances reflected the influence of the editors, the CCF hierarchy, or the CIA. And if there is evidence of official direction of *Encounter*'s editorial line, how did that direction affect the magazine's linkages between modernism, freedom and individualism, and the Cold War West?

The CCF had initially sought not to create a new English-language publication but to retrofit the journal *The Nineteenth Century and After* for CCF purposes by changing its name to *The Twentieth Century*, increasing the literary content, and providing minor funding to keep the journal afloat—$2,000 to settle outstanding bills and £150 per month in the last quarter of 1951 to pay off printing expenses.[28] But editor Michael Goodwin, suspecting that the CCF would then set his editorial line, insisted to Nabokov that his magazine must operate "without strings."[29] Spender reassured Goodwin that the CCF had no intention "that *The Twentieth Century* should contain nothing but anti-Communist articles."[30] The CCF simply wanted to "liven up" the magazine, Nabokov added, but Goodwin remained resistant.[31] In early 1952, then, the CCF decided to start its own magazine. As the congress's executive director, Josselson took charge of choosing editors and creating a plan for the magazine. The models he considered most seriously were *The Nineteenth Century and After* leached of its "dullness," Lasky's *Der Monat*, and Cyril Connolly's lively but defunct *Horizon* magazine, which had published and employed many of the leading lights of the late-modernist generation in Britain in the 1930s and through the war: Spender, Louis MacNeice, Cyril Day-Lewis, Christopher Isherwood. If *Nineteenth Century* wasn't literary enough, though, *Horizon* was too literary and "likely to satisfy only a limited number

of readers."[32] In 1953, Irving Kristol rejected the Ford Foundation–sponsored journal *Perspectives USA* as a model, calling it "miserable," a "fiasco," and an "awful example" with "no effect whatsoever."[33] *Preuves* had proven itself successful and was distributed in Britain; Scott-Smith notes that by late 1951 it was "a fully fledged cultural review modeled on the format and outlook of *Der Monat* and with the aim of being more comparable in style to *The Nation* and *The Spectator*."[34] Intelligence and psychological-warfare officials in Washington liked *Der Monat*, which had "a definite impact [on] the relatively limited German intelligentsia who are concerned with basic political and philosophical issues" and had "caused worry and unhappiness to the communist party in Germany."[35] (A member of the OCB also responded positively to a proposal to fund *Confluence*, a cultural and political journal headed by an ambitious young Harvard graduate student named Henry Kissinger, but Kristol said flatly, "I don't think I can imagine anything more boring if I tried."[36])

To achieve a joint Anglo-American perspective, Josselson established a two-editor structure—a Briton and an American. (Saunders asserts that the joint-editorship arrangement was the result of both the CIA's and the British Information Research Department's [IRD] desires to maintain influence over the magazine: the CIA money would fund operating expenses and the American editor's salary, while IRD money was earmarked for the "salaries of the British editor and his secretary."[37]) By late 1952, the Executive Committee settled on its choices. Spender was a natural selection because he was a CCF member with strong personal links to much of the English literary establishment, an influential and vocal member of the international non-Communist Left, and familiar with America and Americans, spending much of his time teaching at US universities. Irving Kristol was a surprising choice, younger and much less well known than Spender. The Brooklyn-born son of Jewish immigrants, Kristol was a veteran of the City College of New York Stalinist-versus-Trotskyite wars as well as of World War II, the former editor of *Commentary*, and most recently executive director of the ACCF. He was seen as a member of the non-Communist Left, but his leftism had come into question because of a 1952 *Commentary* article in which he wrote that "there is one thing the American people know about Senator [Joseph] McCarthy. He, like them, is unequivocally anti-Communist. About the spokesmen for American

FIGURE 4.4 Stephen Spender in Berkeley,
California, in 1959. Photo by G. Paul Bishop.
Used by permission.

liberalism, they know no such thing. And with some justification."[38] Although
both Spender and Kristol were fiercely independent and clashed frequently,
they had great respect for Josselson, whom Spender called "a man of wide
interests, real culture, imagination and humanity."[39]

By naming as editor Spender, with his deep roots in the Bloomsbury/
Oxford literary scenes, the CCF made it clear that *Encounter* would *not* be
a strictly political publication. Writing to Spender in March 1953, Josselson
described his desire for "a magazine . . . in which the literary part . . . and topi-
cal matters of a political nature would be well balanced."[40] (Hugh Wilford
argues that Spender in fact always strove to "reduce the American political

side of *Encounter*'s coverage, and transform the publication into a latter-day version of *Horizon*."[41]) Cultural freedom, artistic freedom, and political freedom were entwined for the intellectuals of the CCF. And although Kristol was best known for his interests in sociology and political theory, he appreciated art and literature and insisted on its central role in a free society. Moreover, he had already looked into using modernist art as pro-Western cultural propaganda—in November 1952 he sent the CCF a copy of *Perspectives USA*, wanting to know "what kind of impact it makes upon the foreign intellectual to whom it is addressed."[42] The choice of Spender, though, also indicated that the literary content would likely be establishmentarian, not avant-garde. In soliciting a piece from Louis MacNeice, for example, Spender wrote that *Encounter* will "have some of the features of *Preuves* and also a good many—stories, poems, art criticisms, etc.—of *Horizon*. Most of our mutual friends have already promised to write for it and support it."[43]

From the beginning, Spender and Kristol clashed with Josselson about *Encounter*'s direction and the degree of freedom it would enjoy. Josselson promised that *Encounter* was *not* an official publication of the CCF—having a central committee that would determine the editorial lines of various national magazines was, presumably, too uncomfortably reminiscent of the Communist Information Bureau for the highly self-aware CCF—but at the same time he was responsible for ensuring that the magazine would not be discordant with CCF stances. On top of that, Josselson secretly represented the CIA, and the agency wanted to support a milder anticommunism that would be appealing to potentially neutralist European leftists. *Encounter* would be assuredly and constantly anti-Communist, but without the taint of American (that is, McCarthyite) anticommunism or of Koestler and Hook's to-the-barricades militancy. In fact, the CCF's Paris office—Nabokov in particular—asked Kristol to keep Koestler out of *Encounter*'s first issue, and Kristol agreed.[44]

If Josselson wanted a compliant editor, though, he picked the wrong man in Kristol, who made up in pugnaciousness what he might have lacked in Old World refinement (although, as Saunders points out, he did start sporting a bowler and carrying an umbrella to his London office). Kristol didn't object to the congress's having a prominent place in *Encounter*; he told Josselson that "I

want the Congress to be *in* the magazine, not merely *behind* it. . . . It helps the prestige of the Congress enormously—and it is only just, besides—to have these associated with it appearing on equal terms with such writers as Edith Sitwell, Albert Camus, Christopher Isherwood, etc."[45]

But Kristol didn't like what he saw as Josselson's encroachments upon the editors' prerogatives. They first butted heads over the degree and type of political content in the inaugural issue. Josselson always saw and commented on articles being considered and grew concerned over the summer and fall of 1953 that the magazine's political content was not "living up to expectations." Kristol shot back that "the magazine obviously should be a 'cultural' periodical—with politics taken, along with literature, art, philosophy, etc., as an intrinsic part of 'culture,' as indeed it is. . . . In the first number, politics is relatively subordinate, since we are aiming to capture the largest possible audience."[46] This response did not mollify Josselson, who, after reviewing the first issue's mockup cover and table of contents, complained that the contents still skewed too literary and that the cover was "lousy." Kristol responded with his typical light touch: "maybe maybe not, but [English journalist Malcolm] Muggeridge loves it and I like it and we know magazine design better than you. It's more political (the contents) than you think. . . . You think the 1st issue is too literary? Well you're wrong. The best thing about this issue is that it *is* so literary, that it has poems by Edith Sitwell and C. Day Lewis. This is our *billet d'entrée* . . . into British . . . cultural circles."[47] Implicit in Kristol's argument is the assumption that these established literary voices, members of the last generation of modernists—Sitwell, Camus, Isherwood, Lewis—brought prestige to the magazine. These paragons of *cultural* freedom lent credibility to the magazine's rhetoric about *political* freedom.

If Kristol and Josselson clashed frequently, neither was the team of Spender and Kristol harmonious. Spender did not like the combative Kristol, and the Oxonian in him looked down on the unrefined Brooklyn Jew. "I have just spent the whole morning rewriting editorial notes by Irving," he grumbled to Josselson in May 1953, remarking about Kristol's "obtuseness . . . attempts at smartness . . . [and] offensive remarks."[48] Seven months later he complained that "a lot of the political side is a kind of slum area worse written than the

FIGURE 4.5 Irving Kristol and Norman Podhoretz in the *Encounter* offices, 1954. Used by permission of David Bell.

literary side and chopped about and 'edited'. . . . [T]he side of the magazine which is owing to America is inferior in quality to the English side."[49]

Spender was concerned not just with Kristol's brusqueness but with his lack of *empathy*: for Kristol, Spender feared, anticommunism was all about the fight and not about the values one should be preserving against communism: "It seems to me essential that an editor in a situation like this must be open, controversial, positive, able to meet a great many people on their own grounds, and above all deeply concerned with human values. The last point is very important: he should be concerned not just with the wickedness of communists but also with the condition of victims, and with victimization everywhere. The concept of the defence of freedom has surely to be based on a concept of the rights of humanity and not just on a 'case' held by anti-communists against communists."[50] (Given Kristol's later "conversion" to the hard political right and his advocacy of so many policies, domestic and foreign, criticized as heartless, Spender appears prescient here or at least a good judge of character.) For three years beginning in 1955, Spender urged Josselson to fire Kristol and replace him with the mercurial American intellectual Dwight Macdonald;[51] in 1958, this

did happen, but it was such a disaster that the CCF brought in Melvin Lasky to clean up the mess in a matter of months. Several years later, Lasky reminisced to Spender about the "open civil warfare" between Spender and Kristol. "You were constantly embarrassed at the 'unsympathetic' political direction of the paper," he reminded him; "you felt alienated by the cliques of authors who seemed to be dominating the pages of ENCOUNTER; you were involved in several office stresses which led to international crises and transatlantic resignations."[52] Kristol, for his part, wrote about his time with Spender—at least in retrospect—in much more cloaked terms. "My relations with Stephen Spender were, against the odds, quite good, all things considered," he wrote in 1995, before unsheathing the dagger: "A poet, a man of letters, and a gentleman, Stephen was absolutely no kind of editor. I ran the magazine, he made major contributions to it. . . . [His circle] never [had] any serious intellectual or political talk, just malicious—often brilliantly witty—gossip."[53]

Oddly enough, given how important the magazine came to be in British cultural life, the CCF originally intended to aim *Encounter* at Asian audiences. On sending the first issue to Richard Krygier, who ran the Australian Committee for Cultural Freedom, Josselson specified that "one of our aims in publishing this magazine is to develop a dialogue between our friends in Asia and those in Europe and America."[54] Early on, Josselson urged the editors to focus on an Asian audience, explaining that "the Congress is not primarily interested in reaching readers in England and in the U.S. because a communist or neutralist problem does not exist in those two countries. Of course, sales in the United Kingdom and in the U.S. are desirable in order to reduce the financial loss." Moreover, publication in England (as opposed to the congress's home in Paris) allowed the magazine to take advantage of intracommonwealth/pound-region economic arrangements.[55] Kristol, in responding to Josselson's criticisms of the first issue, pointed out that the literary content was *Encounter*'s way to impress those in Asian "cultural circles." "We have been in touch with Indian students and journalists here in London; they are extremely interested in, and impressed with, the magazine just because of the Big Literary Names than they would be by Big Political Names. It stands to reason: would Raja Rao prefer to have his short story about India appear next to something by Auden or Spender, or Brogan or Ward?"[56] Josselson remained

unconvinced by Kristol's assurances and a year later speculated that an overall circulation drop was in part due to the magazine's becoming "too highbrow" for its intended Indian and Japanese audiences—a dubious conclusion, given that in March 1954 circulation in India had been only 650 and in Japan 250.[57] As late as 1956, Josselson reminded Kristol that "the main raison d'etre for *Encounter* remains Asia" and that "you should not unnecessarily jeopardize the very existence of the magazine" by neglecting prompt distribution in the East.[58] In the end, Josselson and *Encounter*'s editors realized that they were *not* going to have a great impact in Asia and were more influential in England than they expected, so for the most part they scaled back their Asian plans by the late 1950s.

It is difficult to uncover the journal's finances, but when judged by circulation figures *Encounter* was successful from the very beginning. Ten thousand copies of its first issue were printed and sold out in a little more than a week. The second issue saw a print run of 11,000, and the editors set a goal of 20,000 by September 1954, the journal's one-year anniversary.[59] Circulation dropped in late 1954 to a little more than 8,000 but over the years rebounded: by 1958 monthly circulation was greater than 16,000 and jumped to 37,000 by 1963.[60] Critics have dismissed *Encounter*'s impressive circulation figures as part of its covert funding; Saunders charges that CIA and IRD purchased bulk quantities of the magazine as in-kind support. Clearly, the secret financing brings more than the journal's circulation and sales figures into question. Historians of the CCF differ on whether *Encounter* was created directly in response to CIA demands or the CIA just facilitated a project that the congress would have undertaken independently. Saunders holds that the magazine's genesis was in the CIA and IRD's desire for an explicitly anti-Communist English-language literary and cultural magazine to counter the neutralist stance of journals such as the *New Statesman and Nation*, whereas Giles Scott-Smith and Peter Coleman, although not denying that the CIA was present at the creation, focus on the CCF as the originating force.[61]

CIA money generally came to the CCF through the Farfield Foundation, which was headed by Julius Fleischmann of the Cincinnati-based Fleischmann's yeast and liquor companies, and was then funneled to *Encounter*. (Farfield was not the only foundation implicated in such arrangements;

Josselson explained that in the early 1950s "the CIA . . . appeal[ed] to the patriotism of the officers of many small foundations . . . to accept money from the CIA in order to pass it on to recipients in whom the CIA was interested."[62]) The CCF always publicly insisted that private groups and foundations provided the money. A 1957 RFE broadcast reassured listeners that "the Congress would not accept any State money [or any] Wall Street money[,] as Communist propaganda would like you to believe; on the contrary, the main source of revenue of the Congress comes from the pockets of the workers, i.e. from American labor organizations [while] the Ford and Rockefeller foundations also contribute notable sums for the great tasks the Congress is faced with."[63]

Fleischmann was a central figure in the CCF from early on, serving on the Executive Committee after 1953, although Kristol viewed him mostly as a wealthy gadabout who would "float over to London every now and then, on his yacht, and Spender would give a 'London literary party' for him."[64] Josselson, in fact, initially proposed that Fleischmann be named the majority shareholder in the *Encounter* corporation but changed his mind "because [doing so] would otherwise involve the Farfield Foundation in a whole series of legalistic matters which might as well be avoided."[65] Farfield provided the entirety of *Encounter*'s $40,000 startup payment as well as the continuing subvention of the American editor's salary and operating expenses, constituting, just to take one year, more than $79,000 in 1959.[66] Predictably, when the CIA funding story broke, CCF members expressed outrage and quit the organization in droves. Kristol said in 1968 that "had I known what has since been revealed, that both the congress and *Encounter* were subsidized by the CIA, I would not have taken the job."[67] Spender resigned when the revelations became public and protested that he never knew anything about the CIA funding during his tenure on the magazine.[68] The ever pugnacious Koestler, in contrast, said that "I knew from the beginning that there was American government money behind the Congress" and that he "had no objection as long as there were no strings attached." If his contributions to *Encounter* served "the American power structure," that was better than the alternative.[69] Roy Jenkins, Home Secretary for Harold Wilson's Labour government, assumed that *Encounter*'s American subsidies were common knowledge and frankly

stated that "it did not seem to me to be worse that these should turn out to be [from] a US government agency rather than, as I had vaguely understood, [from] a Cincinnati gin distiller."[70]

The principals in the magazine—both those who knew about the CIA funding (Josselson) and those who aver they did not (Kristol and Spender)—insist that there was no editorial influence coming from the CIA, either directly or indirectly through the CCF. In his *Saturday Evening Post* article defending the funding, Tom Braden asserted that one of *Encounter*'s editors was a CIA agent, but this claim appears to have been either a baseless boast, a misunderstanding, or a loose use of the term *agent*.[71] Even Saunders agrees that "Josselson did his utmost to protect the magazines from Agency interference" and quotes former CIA director William Colby categorically denying that there was any "imposition of control" from Washington.[72] Josselson himself stated, "I was . . . assured that there would be no interference on the part of the CIA with any of the activities [regarding *Encounter*] and that there would be no attempt ever made to use the new organization for any intelligence or penetration purposes. . . . These promises have been kept."[73]

Kristol wrote in 1968 that "any secret editorial wire-pulling by the CIA was not only unthinkable, it was literally impossible: Spender and I made our editorial decisions in London, and there was just not anyone around to look over our shoulder while we did so."[74] He persuasively pointed to the choice to replace him with Macdonald as editor—a man who had "spent a fruitful life and a distinguished career purposefully being a security risk to just about everyone and everything within reach of his typewriter"—as something the CIA would hardly have signed off on.[75] It is possible, though, that such an imposition was simply unnecessary—that in terms of appealing to European intellectuals, the CIA and *Encounter*'s editors were largely of one mind. To this point, Norman Podhoretz wryly observed that "a certain proportion of the talent used in this ideological offensive was secretly paid for by the CIA. . . . But we also know that scarcely anyone who benefited from those subsidies (and evidently most of those who did were, in the jargon of the intelligence trade, 'unwitting') needed to tailor his views in order to qualify."[76]

Moreover, although Josselson frequently suggested articles and ideas, Kristol and Spender never hesitated to *reject* those ideas without deference: "You are

100% mistaken about the place for such Editorials in our magazine," Kristol shot back when Josselson proposed reprinting a *Preuves* piece by François Bondy.[77] The irony of a cultural-freedom magazine having its contents determined by a government agency is almost too delicious to pass up, but I have unearthed no compelling evidence that the CIA or the IRD took steps to influence *Encounter*'s editorial choices on anything but the rarest occasions, despite Saunders's claim that a "Tri-Magazine Committee" within the CCF coordinated editorial policy for *Encounter, Preuves,* and *Der Monat.*[78] In that sense, *Encounter* really was substantially "independent" from CIA control and "free" (at least within the constraints of the liberal anticommunism that the CCF's members shared with much of the American and British foreign-policy establishment).[79]

It is important here not to conflate "CCF influence" with "CIA influence." Josselson represented both constituencies: the CCF openly and the CIA secretly. Moreover, even though Josselson was the official conduit between Paris and London, other CCF figures—Nabokov in particular—communicated with *Encounter*'s editors, as they did with the editors of the other CCF-affiliated journals. (Bondy, like Kristol and Spender, had demanded and received editorial independence for *Preuves*.[80]) Spender noted later that CCF did attempt to exercise some influence over what went in the magazine, "although [that] influence . . . was by no means always political: simply, the people in Paris had bright ideas about the kind of articles we should put in."[81] Nabokov, for instance, promised George Kennan in 1956 that the pages of any CCF magazine "are always at your disposal."[82] A 1967 editorial note from *Encounter*'s trustees insisted that "the Editors of *Encounter* from its very beginning have always enjoyed complete freedom from the Congress for Cultural Freedom with respect to every aspect of editorial policy."[83] Josselson wrote to Kristol in 1967, in language perhaps a bit too transparently intended for public consumption, that "it was I, in my capacity of Administrative Secretary of the CCF which first started the magazine *Encounter*, who offered you the position of American co-editor of the magazine. I was the only person fully aware of CIA financial support to the CCF and to the magazine *Encounter*, but at no time did I disclose this fact to you. . . . I would also like to state that at no time did I, on the behest of the CIA, try to influence the editorial policy of the magazine."[84]

Suspicions about the relationship between *Encounter* and the American government predated public knowledge of the CIA links, however, and even before the magazine's first issue appeared British and European writers sneered that the magazine would simply be a mouthpiece for Yankee anticommunism. (Kristol's McCarthy article, noted earlier, didn't help.) After seeing the first issue, T. S. Eliot demurred when Spender asked him to contribute a piece, suggesting that *Encounter* had to live down its reputation of being, in Spender's words, "American propaganda under a veneer of British culture."[85] Kristol was well aware of this preconception and wrote to the CCF's International Committee in November 1953 that "it is very important to forestall and negate any notion of the magazine being 'American propaganda' or that its point of view is in any way 'official.' All political problems must be discussed with utter frankness, and space must be made available to all respectable points of view. If this is done, the fact that the magazine is vigorously anti-Communist will be accepted without qualms or reservations by our readers."[86]

Ironically, many readers saw one of the journal's most famous articles—Leslie Fiedler's "A Postscript on the Rosenberg Case," which appeared in the first issue in 1953—as clear evidence that *Encounter* was an American governmental mouthpiece, when in fact Josselson was hesitant to publish it, and the CCF had come out publicly *opposing* the article's stance when it sent a telegram to Eisenhower asking him for clemency for the convicted and condemned atomic spies.[87] In the piece, Fiedler sardonically dismissed the Rosenbergs' defenders as dupes and in many readers' views was outrageously disrespectful, particularly to the executed Ethel Rosenberg. Kristol loved the article, however, telling Josselson that it "[is] extraordinarily fine . . . it strikes exactly the right tone, politically. That is, it is not merely anti-Communist, in the conventional way. It rejects Communism at the roots, as something that a civilized person must find, not simply objectionable, but also hideous and loathsome. At the same time it is written with a sense of compassion, of humanity, that establishes a bond with the cultured, civilized reader."[88]

Spender—who had signed off on Fiedler's piece, although not without reservations—wasn't so sanguine. In the wake of the article, eminent writers such as E. M. Forster, Albert Camus, and Czeslaw Milosz wrote to express

their concerns about the journal's independence, and Spender alerted Jossel-son that the article "has been very badly received by a good many . . . espe-cially among the intelligentsia [I]t is regarded here as being the kind of Trojan horse contained within *Encounter*."[89] Spender agreed with Milosz that "the magazine should not have any political line which appears to be dictated by the Congress or the Americans" because it would be "automati-cally discredited on account of our connections," and he reassured Camus (whose story "The Wind at Djemila" also appeared in the first issue) that "we edit *Encounter* with an entirely free hand . . . there is no control or supervi-sion exercised upon us."[90] The editors knew the potential problems this image might pose and noted in 1954 that the first few issues were "warmly welcomed, but at the same time criticized for being 'official-looking,' impersonal, and too 'anti-Communist.' We were twice referred to by broadcasters on the BBC as being a magazine of political propaganda with a cultural décor—this reflected a fairly widespread opinion."[91]

Whatever qualms English writers might have had when the magazine began, *Encounter* later made it clear that it was not an American apologist: "In what ways, may it be asked, is the State of Poland less democratic than Mississippi, U.S.A.?" asked Peter Wiles in January 1957. Essentially none, he concluded, except that in the Magnolia State the party in power holds pri-mary elections.[92]

In its self-presentation, *Encounter* embodied the progression of modern-ism from the fringes to the center. Whereas early modernist magazines used strident rhetoric and wild design to signal their resistance to the literary mar-ketplace and consumer capitalism, *Encounter* strove to situate itself in that market—in part so that readers and critics did not perceive it as an "official" propaganda publication with no need to turn a profit or even cover expenses. The magazine's cover price of two shillings sixpence (rising to three shillings in 1957) was comparable to the price of other similar magazines—*Horizon* and *Scrutiny* had the same cover price, and by the early 1960s the magazine obtained less than half of its sales through subscription. In its back pages, *Encounter* also ran advertisements, largely for publishing houses, London bookstores, and other journals and magazines. Its circulation was impressive for an intellectual journal, to say nothing of a little magazine, beginning at

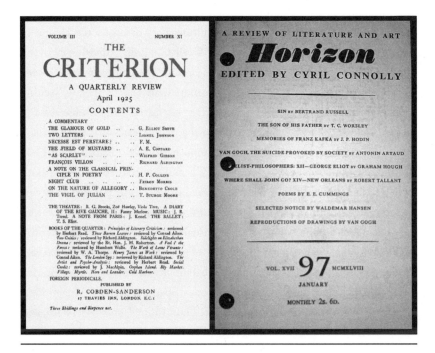

FIGURE 4.6 Covers of *The Criterion* and *Horizon*, showing the cost of each.

10,000 and rising to almost 40,000 by the early 1960s. By way of comparison, 10,000 was the high-water mark for *Horizon*; *Partisan Review* (with a much larger potential audience) never had a circulation higher than 15,000; and *Scrutiny*'s topped out at 1,400.

Apart from *Horizon*, *Encounter*'s most salient precursor—not surprisingly—is almost certainly Eliot's *The Criterion*, whose model subtly colors the first ten years of *Encounter*. Both journals positioned themselves not as modernist "little magazines," which Frederick Hoffman, Charles Allen, and Carolyn Ulrich define as "magazine[s] designed to print artistic work which for reasons of commercial expediency is not acceptable to the money minded periodicals or presses," but more as "intelligent, dignified, critical representatives of an intelligent, dignified, critical minority."[93] These two journals self-consciously sought to set the terms of critical debate in the literary—and,

often the larger cultural—world; as Jeffrey Williams wryly puts it, "though they separated themselves from mass culture, they assumed the charge of creating public opinion."[94] In terms of Cyril Connolly's division between "dynamic" and "eclectic" literary magazines, both *The Criterion* and *Encounter* were "eclectic" in that they were "cosmopolitan and temperate, seeking to mediate the arguments and personalities associated with advanced writing, to readerships with stronger links to the mainstream of literary discussion."[95] Both journals were dependent upon patronage—Eliot's from Lady Rothermere and *Encounter*'s from the CCF and sub rosa sources—yet both eschewed being merely coterie publications: both earnestly pursued subscription and newsstand sales, if unsuccessfully. *Encounter*'s circulation dwarfed *The Criterion*'s, though, whose sales eventually reached only around 1,200.[96] *Encounter*'s spare design, particularly that of its cover, mirrored *The Criterion*'s almost exactly. Even the contributors substantially overlapped. *The Criterion* had published work by *Encounter* mainstays Spender, Auden, Muggeridge, Geoffrey Grigson, Kathleen Raine, Stuart Hampshire, Louis MacNeice, and Herbert Read (whom Jason Harding calls Eliot's "closest collaborator" on *The Criterion*), among others.[97] Finally, if *The Criterion* "opened up a firmer distinction than had been apparent hitherto between [Eliot's] increasingly conservative modernism and a more oppositional or anarchistic avant-garde characterizing movements across continental Europe," as Harding suggests, *Encounter* showed the next generation's coming to terms with the aftermath of that distinction and writing that "anarchistic avant-garde" almost entirely out of the Anglo-American modernist tradition.[98]

Oddly enough, it was Kristol—not Spender, who was often viewed, at least in Britain, as Eliot's heir—whose career after he left *Encounter*, at least in terms of employment, mirrored Eliot's. Just as Eliot edited *The Criterion* to advance his arguments about literature and culture, Kristol and Daniel Bell used *The Public Interest* (1965–2002) to develop and forward neoconservative domestic policies in opposition to Great Society liberalism; and just as Eliot's position as managing director of Faber & Gwyer (later Faber & Faber) from 1925 allowed him to promote the careers of poets he favored, Kristol's role as executive vice president of Basic Books from 1961 to 1969 gave him the power to publish key works of political science and sociology that advanced neoconservative positions.

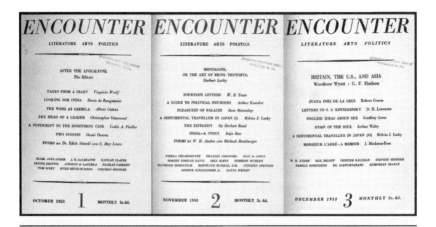

FIGURE 4.7 Three *Encounter* covers.

Encounter came into being in the wake of the end of Stalinism, and in that historical moment many intellectuals, including the magazine's writers and editors, hoped that the Soviet Union would move away from what they referred to as "totalitarianism." Writing to contributor Herbert Luthy while preparing the first issue of *Encounter*, Kristol marveled that "few people seem yet to realize that with the death of Stalin [March 5, 1953]—following the deaths of Mussolini and Hitler—an era has closed; in the first issue of our magazine, we should like to pronounce the glad tidings."[99] Kristol's lead editorial for the first issue asked, "Is it our fancy, or does this first issue of *Encounter* appear in a good season? . . . Has the apocalypse we were waiting for come and gone?"[100]

Encounter echoed and refined the Cold War modernist argument that the West's valorization of freedom and individualism made its cultural and artistic life vibrant and fertile as well as that communism ensured that Soviet art would be sterile and shallow. *Encounter* paid close attention to Soviet aesthetics even in the office, where, for example, in 1954 the staff passed around and commented on Mikhail Sholokov's speech to the 1954 Second All-Union Congress of Soviet Writers. (Kristol had always been interested in the role of art in the Soviet Union and while still at ACCF had planned to publish a

book on Soviet culture with eight chapters focused on art and aesthetics.[101])
It was the rare issue of *Encounter* that did not contain an article directly con-
trasting the intellectual or cultural shortcomings of Communist societies or
"the Communist mind" with the society and mind of the West. Modernist
art was frequently a component of such comparisons. Why would Western
artists be attracted to communism? asked Michael Polanyi: "The moral appeal
of a declared contempt for moral scruples is explained in terms of a moral
inversion. An extension of this explanation will resolve yet another paradox:
the fact that Stalin's regime was acclaimed by eminent Western writers and
painters whose very works were suppressed and condemned by that regime.
As Czeslaw Milosz has shown in *The Captive Mind*—its appeal was actually
due in part to its proclaimed disgust with modern art and literature, and its
determination to make all cultural pursuits subservient to the State."[102] Her-
bert Luthy sounded much the same note in his article " 'Of Poor Bert Brecht' "
when he enthusiastically praised the work of Brecht's "Weimar" period— "a
time of fermentation and upheaval, filled to the bursting-point with cosmo-
politanism, modernism, and radical experimentation in every form of litera-
ture"—but charged that since relocating to East Berlin and wallowing in con-
trarianism, Brecht had become a sterile, silent artist.[103]

If many of the articles contained anti-Communist polemics, though, oth-
ers were much more neutral—Mark Alexander's "New Directions in Soviet
Literature?" raised the possibility that the Second All-Union Congress of
Soviet Writers might actually result (given the deaths of Stalin and Andrei
Zhdanov) in a "New Deal for Soviet writers."[104] In the later 1950s, *Encounter*
ran a regular feature entitled "From the Other Shore" that surveyed "news of
recent trends in the Communist world"; the briefs are markedly uninflected
by opinion, although it is hard to conceal the smirk in this item:

> The "English revisionists of Marxism" are castigated in a long article in the
> Soviet journal *Oktiabr* (No. 8, 1958) for their revulsion against Stalinism,
> advocacy of "humanitarian socialism," and their tolerant attitude toward
> modern art. . . . Among those who excite particular displeasure is . . . Mr.
> John Berger: *John Berger* [the article states] *presented himself as an ardent
> defender of contemporary modernism. . . . It is not difficult to divine what is the*

appeal of the officious apologist of modernism: he scolds the art of socialist realism
and thereby gives himself away . . . he opposes to realism the so-called contempo-
rary, sometimes openly decadent, art, which allegedly is deeper and expresses more
adequately the spirit of the epoch.[105]

Perhaps because so many of *Encounter*'s contributors had been Commu-
nists or Marxists of various stripes at one time or another, the journal always
maintained a distinction between Soviet communism and other types of
Marxism. Rarely did *Encounter* attack Marxism per se: its target was commu-
nism, specifically of the Soviet variety. George Steiner underscored this care-
ful distinction, praising Marxists such as Theodor Adorno, Sidney Finkel-
stein, and, above all, Georg Lukacs. He argued that the distinction between
Soviet and Marxist literary criticism went back to Engels: whereas Engels
refused to mandate so-called *Tendenzpoesie* (poetry with a primarily politi-
cal or social intent) for the Communist movement, Steiner argued, Lenin
always held to his stance that "literature must become Party literature . . . [and
advance] the general cause of the proletariat." Whereas Soviet literature and
criticism "assumed the dour and turgid guise of Zhdanovism and Stalinist
aesthetics," non-Soviet Marxist criticism was much more diverse and open to
various kinds of aesthetic programs and experiences.[106]

Although modernist art was frequently *Encounter*'s evidence for the cre-
ativity and fertility fostered by Western freedom and individualism, a deep
ambivalence characterized the magazine's rhetoric about modernism. On
the one hand, modernism demonstrated the energy and, in that, the superi-
ority of the West. But *Encounter*'s writers at the same time felt that modern-
ism's moment had passed. Modernism was victorious; dominant standards
of literary and artistic judgment now valorized characteristically modern-
ist techniques and themes. New works were judged according to modernist
standards, and a "modernist tradition" (once an oxymoron) had coalesced.
But as modernism came to dominate, it lost its character not just as an
insurgent movement, but even as a vital movement. In *Encounter*'s poetry
and fiction, and in the magazine's literary and artistic criticism, modernism
was presented as a once-great movement now running on fumes. A melan-
choly and self-aware belatedness, a wistful resignation, colored *Encounter*'s

modernism. The urgency of the modernist *movement* was dying; for these writers and critics, modernism survived only as a set of formal devices, artistic moves, and narrative strategies that, to be sure, could only have come into being in a free society, created by free individuals. This change in attitude was due in part to the writers themselves growing older, certainly, but *Encounter*'s writers also significantly faulted the accelerating, unstoppable forces of materialism and mass culture in the free West. They reviled the Soviet model but at the same time looked warily to the materialism of the West, in particular that of the United States. *Encounter*'s vision of modernism was similar, in this way, to what Fredric Jameson calls "late modernism": "Late modernism is a product of the Cold War . . . [that] spelled the end of a whole era of social transformation and indeed of Utopian desires and anticipations. For the emergence of consumerism throughout this whole period is evidently not at all the same as the heroic moment of the conquest of productivity that preceded it. . . . Later modernism... transforms the older modernist experimentation into an arsenal of tried and true techniques, no longer striving after aesthetic totality or the systemic and Utopian metamorphosis of forms."[107]

In their choices of what art and literature to include or write about, the *Encounter* editors and writers looked primarily backward to the 1920s and 1930s. This perspective was due in part to the nature of the contributors: especially in the first few years of the journal's existence, members of the "Mac-Spaunday" group (MacNeice, Spender, Auden, Day-Lewis, and Isherwood) and their modernist idols (Lawrence, Woolf, Yeats, Wyndham Lewis, Edith Sitwell) dominated. Relatively few poems appeared by so-called Movement poets such as Philip Larkin, Thom Gunn, Kingsley Amis, Donald Davie, and Roy Fuller, who were so active at the time. Interestingly, of the younger poets who did appear in the early years of the journal, many tended to be from the periphery of the British literary world—Dylan Thomas and R. S. Thomas from Wales; Sydney Goodsir Smith, Tom Scott, and W. S. Graham from Scotland; David Wright from South Africa. When in 1964 Spender resolved to expand his purview, he extended invitations to eminent writers outside his circle who were nonetheless in the modernist line: Samuel Beckett, Robert Creeley, Ted Hughes, and Randall Jarrell.

The poems included in the journal for the most part eschew the radical fragmentation and polyglot experimentation of high modernism, and many use form and rhyme. But these poems are certainly in the modernist tradition, particularly as filtered through Auden, whose work appeared frequently. Many of the poems marry regular stanzaic form to themes of isolation, urban alienation, and historical belatedness. Tom Scott's "A Ballad—After Villon," for example, translates François Villon's melancholy "Ballade du temps des dames jadis" into Scots:

> Prince, this week I can noucht weill,
> Nor this year, say whaur nou they shine.
> Ask—ye'll but hear the owrecome swell:
> Ay, whaur are the snaws lang syne?[108]

Clever and innovative and pleasing, Scott's poem nevertheless calls to mind not just modernism in general, but one very specific strain: Ezra Pound's counterhistory of English-language poetry as stemming from southwestern Europe and his practice (as in "Homage to Sextus Propertius" and the early *Cantos*) of translating predecessor texts not faithfully, but rather into dialect or slang. (Pound, moreover, strenuously and loudly proclaimed Villon's particular importance in many of his early critical writings.)

Poundian modernism came through also in the constant presence of the classical and Renaissance heritage in *Encounter*'s poetry as well as in its mournful sense of the inferiority of the present in the face of past greatness. Villon's ballad, of course, refers admiringly to the lost "Thaïs" and "Archipiades," but in the same issue Edith Sitwell asks in "An Old Song Re-Sung,"

> Where is all the bright company gone—
> The Trojan Elaine and the Knight Sir Gavaine?

"A Mi-Voix," Sitwell's other poem in this issue, is similarly belated.

> Once I was young like you—
> My breasts were the bright swan on Lethe river[109]

Spender, like Eliot and Pound in their ways, believed that modernism was essentially archaeological and wrote in a rejection letter to a hopeful contributor that "modern art (apart from one or two very minor movements, like Futurism) is not a rejection of tradition. It is, rather, a frantic search for unexploited Golden Age traditions (e.g. geometric Greek vases, primitive painting, Negro art, even the artists' own Golden Age of childhood). Picasso and Stravinsky are both surely traditionalists of a new Musee Imaginaire kind."[110]

Fittingly, in the early issues of the journal the classical heritage dominated the poetry. In the second issue, Frances Cornford's "Lost Sailor" imagines a sailor watching the Pharos of Alexandria fade in the distance as he voyages to Greece, and Michael Hamburger ventriloquizes "Philoctetes." The third issue featured Arthur Waley's "Hymn of the Soul," which tells of a merchant traveling from Maishan in the Persian Empire to Egypt. (Waley was an important "Orientalist," working in the Oriental Prints and Manuscripts division of the British Museum, and Pound had helped Waley publish translations from the Chinese in the *Little Review* in 1917.) Another Scots dialect poem, Sydney Goodsir Smith's "The Tarantula of Love," employs classical images that Joyce and Picasso had come almost to own, speaking of the pain of "luve . . . in its ain labyrinth" and asking,

> What use the talk, the torment
> The minotaur's rank braith upon us—?

Other poems focus on contrast between the present and the past. The third issue also featured two poems by Chester Kallman about the feral cats of Rome and their persistence in the ruins of the city, and in the following issue Elizabeth Jennings writes in a notably placid and contented mood about the enduring *natural* beauty of Florence: "Here I say the mind is open, is freed."[111]

In these early years of *Encounter*, of course, Pound was still incarcerated at St. Elizabeths Hospital in Washington, DC. Although his poetic reputation was steadily improving, he was still a controversial figure, and his public associations with fascism made him a poor martyr to "cultural

freedom." So although *Encounter*'s poetry everywhere evidenced Pound's influence, he was rarely *named*. Robert Fitzgerald provided a rare exception to this taboo, asserting that "Ezra Pound's place in the story of poetry is not in question" in an otherwise equivocal discussion of Pound's influence over contemporary poets in the face of his personal and artistic decline.[112] Other modernist predecessors, though, were celebrated and eulogized. Robert Lowell's "Ford Madox Ford" (April 1954) looks back to the days of Lloyd George, when Ford's modernism was condemned as "filthy art, Sir, filthy art!" The poem echoes the traditional modernist lament about the marketplace as well:

> Master, mammoth mumbler, tell me why
> The bales of your left-over novels buy
> Less than a bandage for your gouty foot.[113]

(Interestingly, Lowell enclosed this poem in a letter he sent to Pound in March 1954.[114]) Excerpts from Yeats's diaries appeared in the first issue, and of course Eliot's influence was everywhere, as I explain more fully later.

In *The Program Era*, Mark McGurl argues that modernism's most enduring legacy in fiction is its primary attention to narrative perspective, with what a narrator can and cannot see or know.[115] Much of *Encounter*'s short fiction uses such modernist narrative techniques (one might look at Elizabeth Montagu's "From Me to You" from September 1957, a mix of first- and second-person perspective, and Ann Chadwick's "The Story" from February 1957, which is almost parodically Hemingwayesque). Themes of these works also gesture to modernist preoccupations. Edmund Wilson's "The Messiah at the Seder," which employs a Jamesian third-person modernist narrator, describes the ancient Haggadah in terms that could almost be an idealized blueprint for the modernist epic itself: "excreted, as it is, by the anonymous process of centuries, it concentrates in one vibrant poem the despairs and the hopes of millennia."[116] Although not a work of fiction, William Faulkner's long historical/personal narrative "Mississippi," leading off the October 1954 issue, employs Faulkner's characteristic transhistorical narrative technique and paratactic style.[117]

Encounter's literary critics reinforced the message that modernism had become the dominant tradition, but that contemporary writers writing in that tradition could not hope to measure up to their predecessors. For Herbert Read, the "clear line of progress" of twentieth-century poetry was "the isolation and clarification of the image, and the perfecting of a diction that would leave the image unclouded by rhetoric or sentiment"—and "Yeats, Pound, Eliot, and [Dylan] Thomas" had led the way in that development.[118] (Spender, writing in 1963, agreed that imagism and the imagistic method were the very "archetype of a modern creative procedure" and "the basic unit of the modern poem."[119]) Imagistic poetry in the 1950s "[is] exhausted," Graham Hough wrote, but contemporary poetry "is not moving in any interesting direction; mostly it appears to be marking time."[120] (Alberto de Lacerda's imagistic poem "Lago," from issue 1, might illustrate this "exhaustion" of the imagist imperative.[121]) The stale dominance of the imagistic mode was only a microcosm of the larger cultural moment. "It sometimes seems at the moment as if the modern movement . . . [is] coming to an end," Anthony Cronin wrote in 1956.[122] Lowell's poem on Ford, referred to earlier, memorializes the greatness of the modernist moment of the 1910s, as does George Aldis's "Portrait of D. H. Lawrence," which celebrates Lawrence's earthy sexual essentialism that was so revolutionary in its time:

> Adam straight as a pine,
> Hard as steel.
>
>
>
> Eve rounded as the rainbow and soft as a storm.[123]

Spender, in several articles through the 1950s, repeatedly expressed his sense that the artistic fire of modernism was burning out and that nothing was coming to replace it. For Spender, materialism, which had only intensified since the turn of the century, was the most powerful obstacle to artistic experimentation. "Youth has been a diminishing commodity since the 1910s," he wrote, lamenting that fewer and fewer young writers were throwing themselves into experimentation and that "the modern movement [is] now outmoded" because "larger and larger areas of life are today becoming paralysed

by conformity" and the unstoppable momentum toward materialism.[124] "Our poetic aspirations are incommensurable with our world set headlong on the straight broad path of material Progress," he glumly concluded.[125]

Looming over *Encounter*'s ideas about modernism—its celebration of the energy of the movement's early years, its valorization of modernist technique, and its sense that the movement was fading—was T. S. Eliot. Lasky wrote of Eliot's role in the creation and vision of *Encounter* that "although he has no knowledge of it and certainly no responsibility," he "was the begetter of it all."[126] In the 1950s, Eliot dominated public understanding of modernism, and his presence in *Encounter* was doubly powerful because of his personal acquaintance with and influence over Spender (who rarely mentioned Eliot in the magazine, though). *Encounter*'s other critics did most of the wrestling with the poet, acknowledging his incalculable influence. "The doctrines of Eliot's early essays have imposed themselves," Graham Hough proclaimed, "and nothing will ever be quite the same again."[127] The journal's book reviews made this especially clear: essentially no review of a book of literary criticism lacked a reference to Eliot, even if that reference was simply a pro-forma nod to his eminence. In an article titled "Blake and Tradition," for example, Kathleen Raine had immediately to confront "Eliot's strictures on Blake as a poet outside the great tradition . . . not by a rejection of Mr. Eliot's view of tradition but by a re-examination of Blake's" (Eliot, of course, had dismissed Blake as exhibiting "a certain meanness of culture . . . which frequently affects writers outside the Latin tradition").[128] Anthony Cronin's review of Joseph Chiari's *Symbolisme from Poe to Mallarmé: The Growth of a Myth* dealt as much with Eliot and Eliot's preface to the book as it did with the book itself. Reviewing Alfred Alvarez's *Shaping Spirit*, Hough asserted that "the distinctively modern note in modern poetry has largely been the creation of two writers—Eliot and Pound."[129] In a profile of the German poet Gottfried Benn, Michael Hamburger explained Benn's importance to a presumably non-German-speaking audience by saying that his "status in post-war Germany is very nearly as high as T. S. Eliot's in post-war England."[130]

Admiration of Eliot was not unadulterated, though. *Encounter*'s writers darkly worried that his overwhelming shadow and the gloomy reactionary values he espoused might have been what sapped modernism's vitality. At

this time, Eliot was issuing pessimistic pronouncements about the state of Western civilization in books such as *Notes Toward the Definition of Culture*, in which he lamented that "our period is one of decline; that the standards of culture are lower than they were fifty years ago; and that the evidences of this decline are visible in every department of human activity."[131] Harold Rosenberg charged that Eliot's combination of "poet and academician, word-specialist and snob, made him destructive in the moment of America's decline in poetic and individual independence. With his famous formula of the supremacy of tradition over individual talent, he succeeded in making poetry appear as a *thing*."[132] Hough, reviewing Frank Kermode's *Romantic Image*, snidely referred to Eliot's "objective correlative" as something more often cited in retrospect by poets than used as a principle of creation and joked that "students arrive from remotest Wales, Africa, or Iowa, already primed with the knowledge that the 17th century was a good thing because its sensibility was not dissociated, and the 19th century a bad one because this calamitous fission had taken place."[133] Reviewing Eliot's *On Poetry and Poets*, Stuart Hampshire called it "a depressing book . . . only the shadow of a great authority remains, and perhaps it is possible to see why the substance has gone."[134] And Fiedler trenchantly asked, "How can we come to terms with one [Eliot] whose political values we find false, but whose example as a poet has delivered us from bondage to a language at once dead and consecrated?"[135]

Encounter treated other major modernist writers as monuments whose authority and importance were no longer in question because their movement had triumphed. There was no attempt in Patricia Hutchins's article on Gilbert's edition of *The Letters of James Joyce* to compare Joyce with other novelists; his stature was assured. A March 1957 essay on Hugh MacDiarmid implicitly elevated MacDiarmid to the high-modernist pantheon: MacDiarmid's poetry's "notorious difficulty reflects the stupidity of its critics rather than the intentions of its creator. It is much easier to read than the *Cantos* of Ezra Pound and passages of *Ulysses* are linguistically less accessible."[136] K. W. Grandsen unfavorably compared Samuel Beckett's *Endgame* to Eugene O'Neill's *The Iceman Cometh*, a modernist "masterpiece" that makes the later play "look narrow and limited," further commenting that *Endgame* is a superior work to *Godot*, with its "superfluous second act."[137]

Because of its alternately respectful and resentful acceptance of the weight of the modernist tradition as well as its suspicious or hostile attitude toward contemporary movements *not* stemming from modernism, *Encounter* depicted an English literary scene drained of energy and focused on the past. The journal dismissed the "Angry Young Men" group of the 1950s—in particular John Osborne. Lindsay Anderson, in 1957, criticized them for falling into cynicism and disengagement, and Spender, checking in from drab Communist Warsaw, wondered what Osborne had to be so angry about.[138] On the American side, the Beats received *Encounter*'s opprobrium—in particular Kerouac, whose *On the Road* K. W. Grandsen condemned as a "decline into barbarism."[139] (Kerouac defended himself and the Beat Generation in the August 1959 number.[140]) Fiedler, one of the few dissenting voices that appeared frequently in the magazine, instead lauded the new generation for defining itself against "the class [it] replaces: against the ideal of 'Bloomsbury,' which is to say, against a blend of homosexual sensibility, upper-class aloofness, liberal politics, and avant-garde literary devices"—that is, Fiedler coyly hinted, against Spender himself.[141]

Encounter's immersion in the past is particularly glaring when one compares its literary contents with those of its American contemporaries such as *Partisan Review*, not to mention devotedly experimental journals such as *New Directions in Prose and Poetry* and *Evergreen Review* (which started publication in 1957). In 1955, in fact, the ACCF complained that *Encounter*'s literary material was of "questionable merit," and that same year even Josselson had grown impatient with Spender's tunnel-visioned literary editorship, encouraging him to contact up-and-coming American writers such as Saul Bellow, Truman Capote, and Shirley Ann Grau: "Since *Encounter* is a joint Anglo-American undertaking it should publish more American writers and poets and not call upon the Americans only for political and sociological articles and book-reviews."[142] A few American literary writers did appear in the magazine in the 1950s (Mary McCarthy's "Confession" in February 1954 detailed her journey to and away from communism; Edmund Wilson's "The Messiah at the Seder" appeared in 1956; Robert Penn Warren, Robert Lowell, W. S. Merwin, Randall Jarrell, Delmore Schwartz, and e. e. cummings all published poems in the magazine), and the journal praised

American writers such as Tennessee Williams and Arthur Miller, but, like the contemporary English writers included, the Americans tended to fall within the modernist tradition.[143]

In an important rhetorical shift, as modernism lost its radical avant-garde public image, it came to be described less in terms of a movement (such as Dada or futurism) in which individual participants drew their identity from the overall group. Modernism was now about the expression of the individual's imagination and his or her response to the modern age, and *Encounter*'s critics echoed this orientation. (Several *Encounter* critics confronted but never solved the conundrum that Eliot's own critical statements, in particular "Tradition and the Individual Talent," advocated impersonality in poetry and argued forcefully *against* individualism.) Spender lauded his pantheon in these terms: "James Joyce, who crammed night and day in Dublin into the heads of Leopold Bloom and Stephen Dedalus; the early Eliot, whose *Preludes* and *The Waste Land* include an experience of urban civilization implying Spengler and Toynbee; Apollinaire, who measured his sensual body and his gay intelligence against the guns of the Western Front; D. H. Lawrence, who thought he could change civilization by creating the pattern of a more instinctual relation between the sexes."[144]

In Spender's mind, the materialism of contemporary society opposed artistic fertility, but the high modernists, drawing on their own individual strength of character, never let materialism thwart them: "The 'moderns,' Joyce, Lawrence, Eliot, Woolf, would, as literary artists, feel an entirely different kind of responsibility. They would feel responsible to a past which had been degraded by commerce, a past of realer values betrayed by advertising. They would feel that their responsibility towards themselves was as artists, and not as money-makers pursuing a consumers' product."[145] Spender even excused Eliot's most reprehensible political beliefs as being a "defen[se of the] spiritual world . . . against modern materialism."[146] In the lead editorial of the third issue, he pointed to signs of a "renascence" among the younger writers in Britain, who looked to the "substantial ghost" of individualism that "feeds life."[147]

In this rhetoric of the free, individualistic artist struggling against a commercial society, Spender echoed not only romantic ideas but similar contemporary descriptions of avant-garde painters by American art critics such

as Meyer Schapiro and *Encounter* contributor Harold Rosenberg. According to Rosenberg,

> The American vanguard painter took to the white expanse of the canvas as Melville's Ishmael took to the sea. On the one hand, a desperate recognition of moral and intellectual exhaustion; on the other, the exhilaration of an adventure over depths in which he might find reflected the true image of his identity. . . . Guided by visual and somatic memories of paintings he had seen or made—memories which he did his best to keep from intruding into his consciousness—he gesticulated upon the canvas and watched for what each novelty would declare him and his art to be. . . . The act on canvas . . . attempts to initiate a new moment in which the painter will realize his total personality-myth of future recognition.[148]

And Schapiro wrote on similar lines:

> The stroke, the brush, the drip, the quality of the substance of the paint itself, and the surface of the canvas as a texture and field of operation . . . may be regarded as a means of affirming the individual in opposition to the contrary qualities of the ordinary experience of working. . . . [Abstract expressionism] is deeply rooted, I believe, in the self and its relation to the surrounding world. And the pathos of the reduction or fragility of the self within a culture that becomes increasingly organized through industry, economy, and the state intensifies the desire of the artist to create forms that will manifest his liberty in a striking way.[149]

Here, the arguments about modernism, freedom, and individualism took on another wrinkle: Soviet communism and totalitarianism are inimical to artistic freedom and creativity, but the freedom and individualism of the West can also be an obstacle to the creation of art. In fact, freedom and individualism exacerbate materialism and the commercial production of mass culture, which leads to the erosion of cultural standards. Just because artists in the West are free does not mean that they will be recognized or celebrated in their own lifetimes, *Encounter* warned. The more innovative they are, the less they

appeal to mass taste. *Encounter* feared the inexorable spread of "masscult" or "kitsch," and George Kennan worried to a CCF conference that "we can live, I think, with mass culture as it is now developing; but God help us if it is all we have, and if the pursuit of beauty, in thought and feeling, is not permitted to continue to proceed in certain older, more selective, and more individual ways, as well."[150] These *Encounter* writers also, however, shared the conviction that in the West artists are *free* to experiment and that a small elite will recognize and understand the importance of their work.

Leslie Fiedler reassured artists that "under our system you will survive. You will be harassed by movies, television, and comic books; but you will be permitted to fight back and you may win in the end. Under the Soviet system of mass culture, you would have to choose among conformism, silence, or death!"[151] What differentiated the West from the totalitarian world in this model was that in the West one could confront philistinery and mindless veneration of the classics with challenging art. In the Soviet sphere, doing so meant the gulag.

Hugh Wilford has argued that the British literary scene in the late 1950s was moving "away from the anti-Modernist mood of the mid-1950s towards a rejuvenated Modernism," adding that "[t]he modernism [*Encounter* was] helping to defend was itself a highly Americanized construct, consisting as it did mainly of critical theories borrowed from the New York [I]ntellectuals and New Critics, and a canon of texts that, in poetry for example, ran from TS Eliot and Ezra Pound to Robert Lowell and John Berryman."[152]

It seems to me, however, that Wilford isn't quite right. Where he sees the influence of the new cultural consensus between the New York Intellectuals and the New Critics, I fail to see much of the presence of the latter group; in fact, much of *Encounter*'s criticism (including some by Spender himself) rejected New Critical doctrine and judgments. Spender still looked to socially committed art, in opposition to the aestheticist formalism being refined by the American New Critics of the time: "Bless externals, and damn, for the time being, music boxes and cork-lined interiors."[153] Lionel Trilling, too, disposed of New Critical doctrine, writing in a 1957 *Encounter* article: "It is one of our strict modern feelings about literature that the mind which makes the work of art ought to be defined only by the work of art itself—that there is

something illicit and low, or at least un-literary, about inquiring into the personality of the man whose name is signed on the work. This is quite wrong."[154]

More telling for me is the troubled attitude toward Eliot that *Encounter* constantly exhibited. In transforming the meaning of modernism, these critics had to disentangle Eliot's innovations and achievements from his beliefs. By the 1950s, Eliot had come to marry high-modernist technique with an almost premodern ideology—not for him the lionizing of the free individual in a bourgeois consumer society or even the celebration of the atavistic power of artist's imagination. *Encounter* instead constructed an idealized predecessor Eliot bearing ever less resemblance to the real man, who was inconveniently still writing, still editing, still appearing in public at the time.

Encounter stood witness to the death of modernism, while at the same time trying to rescue and revive those elements that served its editorial (and political) ends. Rather than a "rejuvenation" of modernism, in *Encounter* we see a rewriting of the modernist tradition, a desire to separate the overwhelming influence of Eliotesque criticism from the formal innovations of his poetry and to attach the idea of modernism solely to the techniques. Such techniques, *Encounter*'s critics held, could only have arisen in a society of free individuals—the very kind of society threatened by totalitarianism. *Encounter* grafted onto this new modernism the Cold War liberal values of freedom and individualism and then used the domination of modernist art as irrefutable evidence of the superiority of the West. But in so doing it wrote modernism's eulogy and preemptively found wanting the next generation of writers and artists, whether they worked in the modernist tradition or not. Charged with championing Western values of freedom and individualism, *Encounter* blunted its own defense of these values by making modernism—dying because of the very materialism that Western freedoms invigorate—its chief weapon. As Dwight Macdonald said in 1952, in words that could serve as the epigraph for *Encounter*'s first ten years: "I choose the West. . . . I support it critically—but in general I *do*."[155] A more cynical perspective on this same relationship, though, came from Mary McCarthy—who, upon seeing the first issue, remarked to Hannah Arendt that *Encounter* "is like a college magazine got out by long-dead and putrefying undergraduates."[156] The whiff of rot, though, wasn't coming from the undergraduates.

Finally, we see in this elegiac view of modernism a prefiguration of one of the most powerful intellectual currents of the following two decades: neoconservatism. Few have remarked upon the surprising role modernism played as a seedbed of neoconservatism, but writers such as Irving Kristol and Norman Podhoretz began their careers writing on art and culture as well as politics (Podhoretz credits Lionel Trilling as one of his most important mentors[157]), and their early views of culture reveal much about the underpinnings of their neoconservative philosophy. The sense that modernism's once-thrilling experiments had become rebellion for rebellion's sake and that growing consumerism was only accelerating this development dominated *Encounter*, and this same sense fueled neoconservatives' disgust at what they saw as the permissive and nihilistic culture of the 1960s. Ironically, as this evolution toward barbarism accelerated, even the Beats, the original barbarians, the "know-nothing bohemians," as Podhoretz called them,[158] ended up being on the side of the defenders of high culture. "Kerouac and Podhoretz were both from the universe of book-reading intellectuals faced with the middlebrow trend for refrigerators and mass entertainment," Andrew O'Hagan has observed recently. "Ironically, the 'poisonous glorification of the adolescent in American popular culture' that so obsessed Norman Podhoretz . . . didn't lead to murder, as he feared and seemingly half-hoped, but to commerce. And in that sense both he and the Beats are losers."[159]

What had been valuable about the great works of modernism, for the neoconservatives, was the jolt of energy and innovation they gave to what Eliot called "the tradition"; but for the neoconservatives, as for Eliot, it was the tradition, not the jolt, that was of lasting value. Understanding this, makes it easier to understand how these writers, once so enthusiastic about modernist experiment, came to see modernism's legacy as nothing but nihilism.

5

PERSPECTIVES USA AND THE ECONOMICS OF COLD WAR MODERNISM

> *[T]he center of western culture is no longer in Europe.*
> *It is in America. It is we who are the arbiters of its*
> *future and its immense responsibilities are ours.*
>
> —JOHN PEALE BISHOP, 1941[1]

F *ENCOUNTER* PUT forth a vision of modernism as a brooding Ozymandias spawning despair in later writers, a whited sepulcher full of dead men's bones, another parallel project offered a much less moribund portrait. Although *Perspectives USA*, a short-lived journal headed by James Laughlin of New Directions Books and underwritten by Ford Foundation money, never really competed with the much more widely circulated *Encounter*, it played a small but key role in identifying a characteristic American modernism; in directing modernism away from its radical origins and toward bourgeois individualism; in transforming modernism from an avant-garde, oppositional movement to a style, common to the fine and applied arts alike, that could be comfortably embraced by diverse spheres of elite culture; and in constructing a coalition of elites in the private sector who embraced modernism as America's high culture. *Perspectives* depoliticized and aestheticized modernism, presenting it even more than *Encounter* did as the natural product of free individualist artists exercising free inquiry and free expression in a free society. Backed by the wealthiest foundation in the United States, *Perspectives* maintained a high-modernist withdrawal from the capitalist economy even though it was created and directed by figures from the business community. Finally, the journal implicated modernism—a movement defined in its own pages as the creation of rebel individuals who rejected the commercialized

mass taste of dominant society—in the collaboration between intellectuals, universities, foundations, the business world, the publishing industry, and the national-security state.[2]

Unlike all of the other projects and programs examined in this book, *Perspectives* was the product of just the kind of free, individual creative agent that the Cold War modernist project celebrated. However, that agent wasn't a writer or a painter or a sculptor, but a publisher. Like New Directions, *Perspectives* embodied the vision of a single man, even though it was never a one-man operation. Its parent corporation, Intercultural Publications, Incorporated, received its funding from the Ford Foundation and benefited from the special attention of the foundation's superstar associate director Robert Maynard Hutchins. Laughlin assembled a board of directors for Intercultural, some of whom vocally expressed what they wanted to see in the magazine— their objections to material or their ideas for particular issues and articles. Laughlin didn't edit many of the issues but instead established a rotating editorship that drew in luminaries such as Lionel Trilling, Jacques Barzun, and Malcolm Cowley. For much of the magazine's run, Laughlin wasn't even present in the office, and project administrators Hayden Carruth and Ronald Freelander oversaw its day-to-day operations.

But Laughlin was the unquestioned head of the project, its conscience and leader and rudder, much as he was with New Directions Books. Accordingly, the magazine celebrated the individual artist, the modernist who had to realize his vision no matter how fierce the opposition. But *Perspectives'* modernism is aestheticized, existing primarily on the level of style. *Perspectives* opened the door for highbrow modernism's adoption by the middlebrow, even as it still policed the increasingly permeable boundaries between the two. It is perhaps too amateurishly psychological to see New Directions and *Perspectives*— which used commercial culture to promote a modernism that was aestheticized and purified of commercial connections—as projections of Laughlin's own anxieties, the resentment of the rich industrialist scion from the smoky provinces who was snubbed upon his arrival at Harvard.[3] At the same time, this view is hard to dismiss. Unlike the vast majority of the Cold War modernist projects, *Perspectives* was the product of an individual, not of an agency or office or bureaucracy, and everywhere it bears the stamp of Laughlin's phi-

losophy and personality; perhaps for that reason, it is the most interesting, the most influential, but the least immediately successful of all of these projects.

Tall, athletic, wealthy, and charming, James Laughlin IV did not lack for self-confidence, even audaciousness. Jones & Laughlin, his family's Pittsburgh company, was one of the three largest steel producers in the United States during his youth, and its Aliquippa facility, occupying a seven-mile stretch on the left bank of the upper Ohio River just downstream from Pittsburgh, was the largest steel plant in the world. But Laughlin had no interest in the family business (except as a subject for a prospective novel); like his cousin Duncan Phillips, who founded the pioneering Phillips Collection in Washington, DC, Laughlin was to make his mark on the world through promoting modernism.[4] Sent to the Choate School, Laughlin fell under the influence of Carey Briggs and Dudley Fitts, teachers who were interested in (and in Fitts's case produced) modernist poetry, and his involvement with them appears to have rooted out his earlier veneration of the works in Palgrave's echt-Victorian *Golden Treasury of Verse*. Laughlin was soon producing poems stamped with the influence of Pound and Eliot, both earnest imitations and parodies. (Laughlin passed through this phase quickly and by the early 1940s had settled upon a style much more reminiscent of William Carlos Williams or even Catullus.)

Perhaps more important than their literary tastes were his teachers' connections, though, and in 1933 Fitts provided Laughlin with introductions to Gertrude Stein and Ezra Pound. After an unhappy freshman year at Harvard, Laughlin availed himself of these introductions and traveled through southern France with Stein and Alice Toklas, writing promotional copy for Stein's 1934 American lecture tour, before settling with Pound in Rapallo for an extended stay for study at the "Ezuversity." After this trip, Laughlin, still an undergraduate, made himself into a publisher, producing a literary annual he dubbed *New Directions in Prose and Poetry* and books by Pound and Williams from his rooms in Eliot House at Harvard, and employing Delmore Schwartz as his office assistant. Some of his Harvard teachers, including Ted Spencer, F. O. Matthiessen, John Berryman, and Schwartz, fueled his fierce devotion to modernist literature. He was probably equally motivated by the *anti*modernist fervor of Robert Hillyer and Bread Loaf founder Theodore Morrison, who administered the writing courses. After graduation, he moved

New Directions to his aunt's barn in Norfolk, Connecticut, and before he was twenty-five years old, he found himself the primary American publisher of both Pound and Williams.

Like the Modern Library, New Directions initially emphasized publishing translations of public-domain foreign authors and leasing works whose publishers had let them go out of print (including, in the mid-1940s, *The Great Gatsby*). After the war ended and restrictions on paper eased, Laughlin embarked on a wide-ranging project to bring contemporary world literature to America in translations commissioned for New Directions. The firm published authors such as Italo Svevo, Giuseppe Berto, Elio Vittorini, Henri Michaux, Raymond Queneau, Vladimir Nabokov, Pablo Neruda, and José Garcia Villa—some for the first time in America—between 1946 and 1949, and these pioneering translations gave it a loyal following among European and Latin American writers, critics, and even governments: in 1952, Laughlin was awarded the Chevalier of the Legion of Honor by the French government.

In one sense, it is surprising that Laughlin—who maintained an apolitical public profile through most of his professional life—should have been so deeply involved in the Cold War modernist project. Hayden Carruth, Laughlin's collaborator on *Perspectives,* reminisced that "Laughlin did not want to be involved with anything that was controversial. . . . He was very frightened of the idea that someone would sue him and that he would have to go to court, and that the Laughlins that were still living in Pittsburgh would be all upset and there would be trouble with the family."[5]

At the same time, though, for Laughlin the question of freedom versus totalitarianism transcended politics. For him, the basic premises of Cold War modernism were simply factual. Artists are individualists. Artists need freedom to create innovative works. Innovative art renews language, consciousness, civilization. Totalitarianism, whether Nazi or Communist, kills language and individualism and creativity. These ideas had motivated Laughlin from his earliest days, as he expressed when he was twenty-two in the first issue of *New Directions in Prose and Poetry* in 1936: "The world is in crisis, and language is at once the cause and the cure. New social concepts could stop the waste and the destruction. But they can only be introduced into minds ready to receive them, minds *able* to think along new lines, minds

capable of imagination. . . . Experimental writing has a real social value, apart from any other. . . . However my contributors may see themselves I see them as agents of social reform as well as artists. Their propaganda is implicit in their style."[6]

Laughlin also had come to feel, as a result of World War II, that the United States had a special responsibility to advance artistic and intellectual freedom worldwide.[7] In 1942, New Directions published Fitts's English-language *Anthology of Contemporary Latin-American Poetry*, whose costs were subsidized by the OIAA in an effort to increase cultural ties between the United States and Latin America.[8] In 1946, traveling in devastated Germany on behalf of the State Department, Laughlin was struck by the desperation of the German people and concerned by what he saw as their vulnerability to the specious promises of communism and to the "false idea . . . that America is a nation of 'materialists' and 'barbarians' incapable of spiritual and cultural activity on a high plane."[9]

To counter this view of America, Laughlin decided to export culture. He initially floated the idea of a magazine of American culture to be directed at Europe in *New Directions* 10 (1948), grumbling that "the only American 'culture' which the average European can now see is not representative of our best tendencies—*Life*, *Reader's Digest*, Hollywood movies and translations of bestsellers" are the only things available, while "our serious cul ture—the Little Magazines and the good books—hardly permeate Europe." His plan for this magazine was almost exactly what *Perspectives* ended up being: funded by "one of the great Foundations," guest editors drawn from the "existing Little Magazines," reprinted articles, translated editions for the different nations. (He criticized one existing example of this sort, *Der Monat*, for being "too tame.")[10] Three years later, when Laughlin's friend Robert Maynard Hutchins, then at the Ford Foundation, approached him about undertaking just such a project, Laughlin "suggested to Hutchins and his associates that it might be worthwhile to attempt to put out a magazine of American culture which would be made available in translation in some of the principal languages of Europe and which would be sold, particularly to students and intellectuals, at a subsidized low price and that the successive issues of this magazine would attempt to bring together a panorama of what

had been going on in American writing, in American philosophy, in archi-
tecture, in art, in music, in the whole cultural spectrum."[11]

With an initial $5,000 grant, Laughlin prepared a sample issue of *Perspec-
tives USA*. He reassured Hutchins that *Perspectives'* modernism was not of
the threatening type: "This will not be the 'advance guard' issue, which might
frighten your trustees, but a conservative, though thoroughly top-level one."[12]
He was right. *Perspectives*, through its short run, presented a defanged mod-
ernism, safe—and, indeed, seemingly designed—for consumption by enlight-
ened corporate executives, broad-minded foundation officials, and the newly
ascendant liberal elite.

It is difficult to imagine just how big the Ford Foundation became when
at the deaths of Edsel Ford in 1943 and Henry Ford in 1947 the Ford family
gave 90 percent of the stock of the privately held Ford Motor Company to
the foundation. Given the governmental assessment of each share's value of
$135, the gift was worth $416,880,000, but the real worth on the open market
was significantly more. When the foundation sold 20 percent of that stock to
the public in 1956, the sale brought in $643 million, suggesting that the foun-
dation had owned $3.2 billion worth of Ford stock. Dwight Macdonald noted
that the foundation's assets at that time (1956) were "considerably more than
half as much money as all the other foundations in the country have among
them."[13] And Ford spent its money on a scale beyond what other foundations
could imagine: in 1954, it disbursed four times as much as the Rockefeller
Foundation (the second-largest American foundation at that time) and ten
times the amount of the Carnegie Corporation (the third-largest). Not only
its wealth but its projects were massive: one initiative, for instance, was to
increase higher-education faculty salaries in the United States, and to accom-
plish this it divvied up $210 million and distributed a proportional share to
every college and university in the nation.

The Ford Foundation's mission, as set forth in its 1949 *Gaither Report*, was
(and remains) to "strengthen democratic values, reduce poverty and injus-
tice, promote international cooperation, and advance human achievement."[14]
This initial plan for the new foundation, to the humanist Hutchins's delight,
called for "*no* spending on medicine, health, welfare agencies, or the natu-
ral sciences."[15] "The prime threat to human welfare today," the *Gaither Report*

insisted, "is the danger of war. . . . Society needs to find ways of reducing such tensions and of deepening the understanding among men everywhere."[16] Culture was an avenue by which these goals could be achieved. "The officers," the foundation noted in the *1951 Annual Report*, "regard the exchange of ideas, and possibly also of artistic and literary productions, as one of the most promising methods of fostering the development of World understanding and a sense of the moral and cultural community among the peoples of the world."[17] "People everywhere understand one another through literature," Hutchins told a colleague at Ford, "and . . . through art as well. . . . We need to understand man for the purpose of advancing human welfare."[18] The foundation's mission meshed with the liberal vision of America's role in the world.

The Ford Foundation was deeply involved and invested in cultural diplomacy, nowhere more than in Europe, where it, the Department of State, and the CIA worked along parallel or even intersecting tracks. In the 1950s, Ford's mission to "strengthen democratic values" and promote cross-cultural understanding led it to sponsor programs such as the Salzburg Seminar in American Studies, Kissinger's Harvard International Summer Seminar, and the CCF (see chapter 4).[19] Ford's officers, moreover, had practical experience in international programs. Paul Hoffman, who became the foundation's president in 1950, had been the administrator of the Marshall Plan and brought with him Milton Katz; Shepard Stone, who joined the foundation in 1952 and later ran its International Affairs program, had been director of public affairs in HICOG.

The Ford Foundation was eager to use culture as a weapon to prevent war and against Soviet totalitarianism. As Matthew Corcoran explains, "For Hoffman, Katz, and Stone, the humanities were simply one mode of human activity that could be used by the Ford Foundation to combat communism and improve the U.S.'s reputation in Europe and other areas of the world. But for Robert M. Hutchins . . . the humanities were an end in themselves."[20]

Hoffman and Hutchins—"men of extremely large ideas," Dwight Macdonald called them—"ran the show," but in point of fact Hutchins was first among equals, "dominant" at the foundation's headquarters in Pasadena.[21] An epically energetic and accomplished man, Hutchins had been dean of Yale Law School at age twenty-eight, president of the University of Chicago at age

thirty, editor-in-chief of the *Encyclopedia Britannica*, and a nationally known figure in the fields of educational reform and freedom of the press. In an indelible portrait, Dwight Macdonald described Hutchins as "tall, dark, and almost alarmingly handsome, . . . as dramatic in behavior as in appearance. Not only is he a 'controversial' figure of maximum visibility but he also rather obviously enjoys being one. He likes to tread on dignified toes, he rarely produces the soft answer that turneth away wrath, and his formula for troubled waters does not include oil. . . . [He is like] a bright young sophomore who becomes a college president without ever ceasing to be a sophomore."[22]

Hutchins's job description put him in charge of projects dealing with "education and peace," and as these massive areas overlapped with the new mission of the foundation itself, Hutchins quickly became the most influential figure in the newly organized nonprofit. After an administrative shakeup a few years later, Hutchins was cut loose and put in charge of his own foundation-funded independent corporation, a controversial cultural-freedom group called the Fund for the Republic. Although he fancied himself an expert in many things, art was not one of them. As he told George Kennan, "In the fine arts . . . we [directors] are ignorant—at least I am. . . . If we are going into the fine arts, we shall have to do so with an independent agency."[23] So when Laughlin approached him with a proposal to create just such an "independent agency," Hutchins was amenable.

Hutchins's desire to advance high culture free from the pressures of commercialism meshed perfectly with Laughlin's outlook. Unlike New Directions, Intercultural under Laughlin's leadership had the luxury of abstaining almost entirely from participation in the capitalist economy.[24] *Perspectives* was funded by a foundation, was not expected to turn a profit or even to earn its investment back, and was distributed free of charge through US embassies and consulates or at cultural events. (It was also sold in bookstores and at newsstands.) Its editors worried more about *who* read it than about how many bought it. In this approach, it further sheltered modernism—for there was no question that the project would be dominated by modernism—from its bogey, mass culture. The proposal for the creation of *Perspectives USA* specified that the purpose of the project was "to promote peace by increasing respect for America's non-materialistic achievements among intellectuals abroad"

because "at present, America's cultural standard is judged by such popularized media as Hollywood movies, certain popular magazines in the mass field, etc., which arouse the derision and contempt of foreign intellectuals and students, creating an attitude which contributes to the concept of America as a commercial imperialist."[25] Interestingly, although Laughlin blamed economics for the propagation of the idea that Americans are materialists, his solution was also economic: offering a product at an artificially low price.

From the beginning, Laughlin sought to create a balance between the Ford Foundation's cultural-political objectives and his own desire that the journal focus exclusively on art and literature and "avoid militant politics," as he put it to *Perspectives* advisory board member Allen Tate.[26] "This was not going to be a CIA kind of thing or even a USIS kind of thing," he recounted in an oral history. "It was going to be purely aesthetic . . . very unpolitical, straight culture, no 'cold war' stuff at all . . . not propaganda, pure culture."[27] Indeed, this approach transcended even what finally appeared on the page. In contrast to the policies of the Department of State and USIA, Laughlin refused to vet a subject's or contributor's politics when considering his or her work for inclusion in *Perspectives* and informed Hutchins that "at New Directions I have always printed people entirely on the basis of their art, not their politics. I would like to see the magazine follow a similar policy—I think the Europeans would respect us for it and it would give the lie to any aspersions that we were a propaganda organ."[28] He did reassure Hutchins that he would ensure that none of the guest editors would be Communist infiltrators: "the worst offenders are known," he said, "and if we pick our rotating editors carefully none of them will be invited."[29]

Laughlin was intent that European audiences not view *Perspectives* as pro–United States propaganda. In the initial proposal for the magazine, he suggested that it be priced at twenty-five cents for foreign markets—enough to make it seem like an independent venture, for "if the magazine were 'given' away it might acquire the taint of propaganda."[30] (In the United States, the journal initially cost seventy-five cents in 1952, rising to $1.50 by the end of its run in 1956.) Identifying the National Association of Manufacturers' style of advertising that was increasingly giving pro-business forces a powerful vocabulary of words and images in American public life, but that would only

play into Europeans' worst prejudices about America, Laughlin insisted that the journal should print "*no* propaganda for the 'American Way' etc."[31] Echoing Laughlin, Project Administrator Hayden Carruth wrote to Hutchins in September 1952—immediately before the first issue appeared—that "there is . . . a danger inherent in any attempt to subsidize the acceptance overseas of American achievements. Enthusiasm may inspire a breach of taste; zeal may turn publishers to propagandists, artists to proselytizers."[32]

"Balance" was the key. The official press release for the launch of the journal noted that "*Perspectives USA* will present significant American writing and art, with attention as well to music, the theater, architecture, philosophy and creative scholarship. The magazine will contain no propaganda or advertising."[33] "Each issue is supposed to be balanced," Laughlin explained to Tate; "that is, it can't just be literature. There must be philosophy and history, as well as things in the arts."[34] (Laughlin must have understood "balance" differently than did his funding body because art and literature's domination of *Perspectives'* few issues became a point of contention between the two.) In its feature on the magazine's launch, VOA France explained that

> PROFILS a étée crée pour corriger les idées fausses que l'on se fait à l'étranger sur la culture americaine. Bien des valeurs en sont défigurées par l'insuffisance de certains réalisations américaines (quelques illustrés et des films de Hollywood, par exemple). Or, l'une des premières taches de PROFILS sera donc de montrer que dans le domaine spirituel et artistique, l'Amerique n'a point été stérile.

> [*Perspectives* was created to correct the false ideas people abroad have about American culture. The inadequacy of certain depictions of America (various kinds of illustrations and Hollywood films, for example) has misrepresented its values. Now, one of the first tasks of *Perspectives* will be to show that in the spiritual and artistic realms, America has never been sterile.][35]

Perspectives USA officially came into being in February 1952, when the Ford Foundation allocated $500,000 to Intercultural Publications, Incorporated, expressly to publish the magazine.[36] In choosing a board of directors

for Intercultural, Laughlin, who had already yoked art to the world of foundations and the objectives of American foreign policy, brought in the business community, precisely the element of American society so reviled by leftist intellectuals. Approved with the initial proposal was a board of directors consisting of bankers James F. Brownlee (a Ford Foundation trustee) and Joseph Hambuechen; Charles Garside of Associated Hospital Services of New York; H. J. Heinz II, a childhood friend of Laughlin from Pittsburgh and president of the H. J. Heinz Co.; the publisher Alfred A. Knopf; Richard J. Weil, a vice president at R. H. Macy & Co.; and businessman William J. Casey, who had worked in the Office of Strategic Services London with Yale professor Norman Holmes Pearson and Pearson's student James Jesus Angleton, future counterintelligence chief for the CIA and former editor of *Furioso*, a 1930s modernist-oriented Yale magazine.[37] With the exception of Knopf, the board had little credibility in the literary and intellectual world, so Intercultural also convened "an Advisory Committee drawn from such fields as literature, philosophy, history, music, scholarship, the arts, and theater and architecture" that included Pearson as well as a heavy representation of New York Intellectuals, New Critics, and modernist writers; Laughlin told Tate that he wanted the board "to represent all the different groups that are doing valid work in the different cultural fields in this country today."[38]

Intercultural initially had two full-time employees in its posh office suite at Manhattan's Pierre Hotel: Laughlin and Carruth. Others worked for the magazine more casually. Henri Matisse's granddaughter Jacqueline served as Laughlin's secretary from September 1952 to May 1954, and Delmore Schwartz also received $550 a month as a "literary consultant" but was so erratic and unpredictable that Laughlin, who had helped support Schwartz for many years, had to fire him in September 1953.[39] Carruth came to *Perspectives* from Chicago, where he had been an editor for *Poetry* magazine and worked in book publishing. Carruth's father, Gorton Veeder Carruth, was a political radical who edited the Waterbury, Connecticut, *Republican* newspaper until he was fired in the 1930s and moved south to Westchester. Carruth himself had dabbled in Kropotkinian anarchism and Marxism and had frequented bohemian and radical circles in New York while a young man.[40]

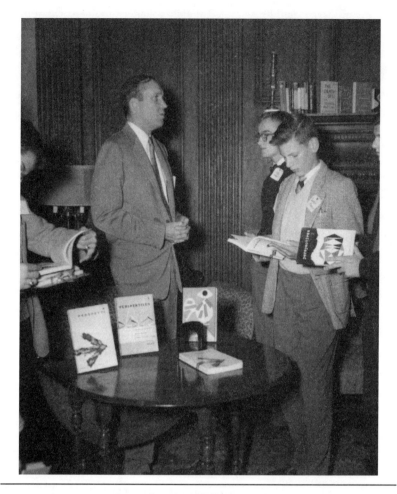

FIGURE 5.1 James Laughlin showcasing *Perspectives* in the
Andrew Mellon Library at Choate, November 1954. Copyright © 2014
by the New Directions Ownership Trust. Used by permission.

Laughlin and Carruth had initially met in 1949 over "the hullabaloo over the
awarding of the Bollingen Prize to Ezra Pound for his *Pisan Cantos*," which
New Directions had published and Carruth admired.[41] With *Poetry*, Carruth
had an influential position from which to comment on the controversy, and
when Norman Cousins, Robert Hillyer, and the *Saturday Review of Literature*

used Pound's award to launch an attack on modernism and cosmopolitanism in literature, Laughlin decided to respond forcefully. Carruth tells of his fateful first meeting with Laughlin, "in a dark basement restaurant somewhere in the Village," where the two decided that neither Laughlin nor Eliot (who had been named in Hillyer's articles) should respond to the attacks. Rather, "the rebuttal was left to *Poetry*, i.e. to me," Carruth writes. It took the immediate form of a pamphlet entitled *The Case Against the* Saturday Review of Literature, but perhaps more importantly and more enduringly *Poetry* continued to publish work in the Poundian–Eliotesque modernist tradition excoriated by Hillyer and the *Saturday Review*.[42]

But "why did [Laughlin] hire me to come from Chicago and join him at Intercultural in New York when so many other qualified people were already on the scene? I never knew," Carruth wonders in his memoir of Laughlin.[43] In an interview in 2005, Carruth explained that "I was at loose ends. I was living in Chicago, working for the University of Chicago Press. . . . He wrote me a letter, said, 'Come to New York, I'll give you a job.'"[44] Carruth's personal troubles at this time were weighty. In addition to being a combat veteran, he was also an alcoholic and suffered from depression. Three months after the birth of their daughter, Martha, Carruth's wife Sara took a job at Auburn University and brought the baby with her. "I couldn't blame her," Carruth wrote later. "In many ways I had been in bad shape for a long time and was not much good for anyone."[45] Carruth's charge was to be *Perspectives'* project administrator or, given Laughlin's frequent and extended travels throughout Europe and Asia during this time, to run Intercultural in all but name. As he details,

> I dealt with widely scattered editors, writers, artists, and translators, and with printers and binders in England, the Netherlands, Germany, and Italy. I set up—at this point I've no idea how—a network for international distribution. But the problems were far beyond my range of competence. What do you do, for instance, when half a carload of finished magazines disappears in transit from Madras to Calcutta, or when a hundred copies are impounded by customs in Australia or Argentina? I had no experience in such matters, nor did more than a few other people at that time. I sat in my

office in the Pierre and thumbed the yellow pages constantly for experts who could help me.[46]

Just as Carruth had come to *Perspectives* in a time of great personal turmoil, he left in the same way. In the end, he saw the magazine through only four issues; his last appearance as "project administrator" on the masthead came with the fourth (Summer 1953) number. In the following issues, he is listed as "Editorial Consultant," and the position of project administrator, now renamed "associate publisher," went to Ronald Freelander, a McGraw-Hill editor who was also a veteran of the OWI. Carruth departed when an emotional breakdown, exacerbated by alcoholism, necessitated an eighteen-month stay at Bloomingdale Hospital for the Insane in White Plains, New York, and a period of rest afterward. Carruth later wrote that "my sojourn at Bloomingdale, including the electroshock, the hydrotherapy, and all the rest, did me no good whatever, and later I was told that my emotional problems were unamenable to treatment in a hospital."[47] Laughlin kept in touch with Carruth during his recuperation, though "never obtrusively; he did not visit or send long letters of sententious advice, as others did. . . . Usually his letters would contain requests for help of some kind, editorial advice or jacket copy for a particular book New Directions was publishing."[48]

Years later Carruth again worked for Laughlin when the publisher hired him to tend to his files of little magazines and gave him a place to live at his Norfolk, Connecticut estate. Carruth eventually became an accomplished and widely recognized poet, editor, and teacher, compiling the influential 1970 American poetry anthology *The Voice That Is Great Within Us*, serving as editor for the *Hudson Review* and *Harper's*, teaching at Vermont and Syracuse until his death in 2008, and receiving Guggenheim and National Education Association fellowships and the 1996 National Book Award in poetry for *Scrambled Eggs and Whiskey*.

At first, the journal's editorship rotated issue by issue among a group drawn almost exclusively from the advisory board. Tate had advised Laughlin to consider such an arrangement as a way to avoid the problems inherent in having a single editor try to represent all of American culture to the western European intelligentsia. "A permanent editor would inevitably try to be 'representative'

and fair-minded, with the result that the magazine might well become merely average, and thus represent nothing," he warned.[49] Laughlin edited the first number, followed by Lionel Trilling, Jacques Barzun, Malcolm Cowley, R. P. Blackmur, and Columbia University philosophy professor Irwin Edman; Tate declined Laughlin's invitation to guest-edit one issue.[50] The editor's job was less to solicit contributions than to make selections from work that had previously appeared in American publications and to provide an introduction framing the issue's pieces. Carruth explained that "we gave the individual editors free rein to do what they wanted. . . . The editors never assigned anything; they never accepted any unsolicited manuscripts. They never assigned any programs or essays or anything like that. They simply read the little magazines that were being published in this country and chose things from them to be put into *Perspectives*."[51] (Many readers dismissed *Perspectives'* content as stale, in fact, because of its reliance on reprinted material.) In the publisher's introduction to the first issue, Laughlin explained that "this magazine will present literary texts from and about the United States and examples of American art and music. Its editors will try to set materials before their readers that may enable them to view the culture of the United States in accurate *perspective*."[52] In the second issue, Trilling granted the truth of *some* European prejudices, writing that "I have . . . tried to represent only a special and particular part of [American literary] culture. I have drawn the prose from only a few periodicals, all of relatively small circulation although their ultimate influence is, I believe, rather considerable in the moral and intellectual life of the country."[53]

Perspectives USA was published initially in English, French (*Profils*), Italian (*Prospetti*), and German (*Perspektiven*) and distributed to European and American bookstores and newsstands for sale as well as to US embassies and consulates abroad for free dissemination. The content was substantially the same across all language editions but not always identical. For instance, the ninth issue featured a symposium on artist and audience with contributions by Saul Bellow, Robinson Jeffers, Robert Motherwell, and Roger Sessions—a regular feature that appeared in each edition—but responses by French critics such as Roger Callois appeared only in the French edition, by Italian critics such as Salvatore Quasimodo only in the Italian, and by German critics such as Karl Hofer only in the German. In advance of the first issue (which

appeared in October 1952), an internal memo suggested printing 6,000 copies of the French edition, 5,000 of the British, and slightly lower numbers for the German and Italian versions, "with sights set on an eventual 15,000 or more" in each market.[54] Although the magazine never reached this goal, internal documents show that *Perspectives* saw total circulation across all language editions of 45,000 of issues 8 and 9; 42,000 of issues 10 and 11; 41,000 of issue 12; and 39,000 of issue 13.[55]

The first issue clearly and loudly pronounced the Cold War modernist argument, particularly stressing the transgeneric nature of modernism and the message that American modernism was a mature and healthy current within the larger international modernist movement. Faulkner's Nobel speech led off the number, which also included poems by William Carlos Williams, La Fontaine translations by Marianne Moore, a poem by Kenneth Rexroth, an overview of Ben Shahn's work by Selden Rodman accompanied by color reproductions of Shahn's paintings, an appreciation of Aaron Copland by Arthur Berger, an essay on Van Gogh by Meyer Schapiro, and reviews of books by Williams, Faulkner, and Mary McCarthy (Laughlin also had asked T. S. Eliot to review Marianne Moore's *Collected Poems* for the inaugural number, but the poet declined[56]). Laughlin asked for Tate's poem "The Cross" because he wanted to "have a good American poem that represented the Catholic tradition," and although that poem never appeared in the English-language edition, it ran in issue 1 of *Profils* and *Perspektiven* and issue 6 of *Prospetti.*[57] The "selective listing of new books" focused heavily on modernist art and literature (but also included a complimentary note about Whittaker Chambers's anti-Communist touchstone *Witness*, which was admired by the non-Communist Left). Anything about popular entertainments was largely absent, with the exception of an article titled "Recent Trends in Motion Pictures and Television" by Gilbert Seldes (of *Seven Lively Arts* fame) in issue 4. Experiments in form were praised, while excessively realist or explicitly political art was ignored or denigrated. But *Perspectives'* modernism was an institutional modernism, framed not as a revolutionary movement but as the latest phase in art's eternal inquiry into the human condition.

Although *Perspectives* did not have a house definition of the term *modernism*, in its pages modernism inhered in the style or form utilized by the artist.

In the introduction to the third issue, editor Jacques Barzun—who established his bona fides by pointing out that he had been "an early and close eyewitness of the modern movement in literature and fine arts"—called modernism "nothing distinct, but a miscellany [of] the new forms evolved between 1905 and 1915." He stressed that although Americans had not publicly embraced modernism, yet neither had Europeans: "Its poets are *maudits*, which is to say, marginal and inaudible."[58] *Perspectives'* vision of modernism focused less on the sense of history or even belatedness central to Pound, Joyce, and Eliot (so prominent in *Encounter*) and more on traits such as abstraction, narrative perspective, and the rejection of ornament. LeRoy Leatherman's article on Martha Graham, for instance, compared her to "Picasso and Kandinsky" rather than to "Joyce and Kafka" because she, like the painters, does not have to "work with the details of personality," as a realist must, but rather can focus her depictions on abstractions, "particular images which emerge out of a dominant image of man in his individuality, his wholeness."[59] *Perspectives* also stressed, in its discussion of any genre, the way that modernist artists' true subject matter is the *individual*: individual personality, the individual in conflict with society, the individual striving to create art, the individual's ethical responsibilities not to class or party but to human freedom. This is true, the journal argued, even in bebop jazz, the most modernist of the popular-music genres, whose "complex, highly individual styles," Dave Brubeck himself observed in issue 15, are a "controlled, masterful . . . return to 'raw emotions.'"[60]

In its evaluation of literature, *Perspectives* tended to denigrate works written to achieve sociopolitical aims, and it scoffed at criticism that read literature sociopolitically. This approach, of course, aligned with the precepts of the "new cultural consensus" between the New Critics and New York Intellectuals as well as with the strategy Laughlin had adopted to market Pound after 1946.[61] In a survey of "the novel in America, 1920–1940," Arthur Mizener argued that "the real history of the American novel in this period" was that of Fitzgerald, Wolfe, Hemingway, Cozzens, and Faulkner, who "believed in the individual life and the final reality of the individual apprehension of experience, and very little in mass attitudes."[62] The second issue featured "Everybody's Protest Novel," James Baldwin's famous attack on the "very bad novel" *Uncle Tom's Cabin* and by extension on all works of art that seek primarily to

achieve political rather than aesthetic aims. "It is, indeed, considered the sign of a frivolity so intense as to approach decadence to suggest that these books are both badly written and wildly improbable," Baldwin noted, invoking the Popular Front/socialist realist condemnation of modernism as "decadent." "Literature and sociology are not one and the same," he insisted.[63]

Ironically, these critical articles—in particular, their dismissal of realism—were much more congenial to the poetry reprinted in *Perspectives* than to the fiction, which consisted largely of reprints by familiar authors such as E. B. White, William Maxwell, Jean Stafford, and John Cheever. Although Laughlin had initially intended to rely on much more experimental work, the magazine had moved to the middlebrow by the middle of its run. German readers received two stories by Faulkner, but all others got only one (an excerpt from his novel *A Fable* in issue 9), and just about the only other notably "modernist" stories included were "Three Players of a Summer Game" by Tennessee Williams (a narrative precursor of *Cat on a Hot Tin Roof*) and "The Life You Save May Be Your Own" by Flannery O'Connor, one of the very few female writers to appear in *Perspectives'* entire run. The contributions of most of the short-story writers (including Cheever, Stafford, Wallace Stegner, St. Clair McKelway, R. V. Cassill, the Beat novelist Herbert Gold, the Catholic writer J .F. Powers, the southern writers Thomas Mabry and Shirley Ann Grau) fit comfortably into the "*New Yorker* story" type that was coalescing at the time, and in fact many of the stories had previously run in that magazine. In *Perspectives*, modernism thrived in painting and poetry more than it did in fiction, but the *New Yorker*–type story itself, as Mark McGurl points out, is a characteristically American genre, modernist in its compression and its preeminent concern with narration rather than with plot.[64]

Perspectives' poetry selections, though, suggest that American modernism, at least refracted through the Laughlin lens, differed in at least one key way from Eliotesque high modernism as presented in *Encounter*. *Encounter's* poetry, in addition to being saturated in images of and allusions to the past, was marked by the kind of "impersonality" that Eliot prescribed as necessary for good poetry. The poems were not devoid of emotion; instead, the emotion was detached from the poet and, often, from the speaker and was lodged in that Eliotesque shibboleth, an "objective correlative." By contrast, *Perspectives'*

poetry embraced personality, voice, and emotion even while being recognizably modernist in many other ways, thus implying that American modernist poetry would not be "impersonal." The Williams sheaf in issue 1 included many of his most recognizable early lyrics ("The Red Wheelbarrow," "Poem"), but also the touching, personal, and vaguely comic "This Is Just to Say." Poems by Richard Eberhart (issue 10), Yvor Winters (issues 4 and 15), May Swenson and W. S. Merwin (issue 12), and Kenneth Rexroth (issue 1) employed the tones and images, the metrical experiments and free verse, of modernism but expressed emotion through an "I" and—importantly—suggested the identity of poet and speaker. Conversely, of Marianne Moore, perhaps the least personal of the great American modernist poets, the magazine had nothing except selections from her translations of La Fontaine.

Carruth took it upon himself to define what was particularly American about the American modernism showcased in *Perspectives*. In a short essay introducing a selection of work from nine contemporary poets "who have worked largely in the traditional forms of English poetry," Carruth argued that although the "startling formal and technical innovations" of high modernism are the most immediately notable feature of contemporary poetry, "the fact is that probably most—and indubitably a very large part—of good poetry written in the United States during the past fifty years has been composed in rhyme and in the standard English meters and verse-forms." American modernism has, to be sure, "modified" these traditional forms (he pointed to how iambs "subside" in Wallace Stevens and how John Crowe Ransom's use of "the informalities of prose . . . loosen language"), but that "rhyme and meter are the necessary concomitants of the poetic concept." That said, Carruth argued that there *is* a distinctly American way of speaking and thus of writing poetry: "a dry inflection, a level cadence, an elongated phrasing; there is a national style which bespeaks the American's reserve, his refusal to make an ultimate commitment to any fatality." Wresting back across the Atlantic the current of modernism defined by Eliot's exaltation of the seventeenth-century "Metaphysicals," Carruth pointed out that "the scholars are pretty well agreed that the language of the Tudor and Stuart poets is nearer in vocabulary and pronunciation to the language of modern America than to that of England."[65]

The major figures of American modernist poetry were not only present in *Perspectives* but also presented in portfolios: Williams in the first issue, Cummings in the second, Kenneth Patchen in the eighth, Archibald MacLeish in the ninth, Richard Eberhart in the tenth, Auden in the fourteenth, Pound in the last. Wallace Stevens was represented by "To an Old Philosopher in Rome" in all editions, "The Auroras of Autumn" in issue 8 of the English edition, and several poems in issue 8 of the French, German, and Italian editions. Like entries in an anthology, these selections frequently included a critical introduction arguing for these writers' importance. It is not surprising, given his long-time friendship with Laughlin, that Williams contributed to the journal, but the first issue is almost a tribute to him, with fifteen poems, a short story, and the essay "The Destruction of Tenochtitlán." Although his contemporary work was essentially absent, here were many of his best-known early poems, signaling that he had been welcomed into the literary establishment embodied not just by Laughlin, but by Knopf, Tate, Edmund Wilson, and other eminences associated with *Perspectives*. Knopf worried to Laughlin that there was too much Williams, prompting Laughlin to explain that "I consider him one of the really significant writers of our generation in America, because of the things he has done, especially in his poetry, to create an idiom which would be distinctly American, and which would reflect the rhythms of our natural speech. . . . My reason for representing him so heavily was to give a fair picture of his total achievement. He is almost unknown in Europe, and has never been taken up by any English publishers at all."[66] Williams, who angrily rejected much of Eliotesque high modernism, sought to carve out a strain of distinctly American modernism, rooted in the American language and not enslaved to a narrow classical and European past. Laughlin joined Williams in this quest, both in his own poetry and in his editing, and his foregrounding of Williams as the emblematic American modernist pronounced this objective powerfully.

Perhaps the boldest statement, though, was the prominent inclusion in the final issue of a set of Pound's poems dating from 1909 ("De Aegypto") to 1948 (the "Pull down thy vanity" section of Canto LXXXI), accompanied by a long critical essay by Carruth on Pound's poetry. The intent was clear: to forward Pound as a central figure of the international modernist move-

ment and to package him in the apolitical, apersonal mode that Laughlin had been employing since the early 1940s. Carruth's essay, though, did not entirely stick with the plan: unlike the other Pound publicity materials that Laughlin produced in these years, Carruth explicitly addressed Pound's life, his persistent economic "obsession," and even his arrest and incarceration. And in this essay lay exposed all of the fault lines of Laughlin's project to use aesthetic autonomy to smooth over Pound's rough edges in order to make him a part of a cultural-diplomacy campaign, for Carruth was unable or unwilling to parrot New Directions' line about Pound—that his politics were an irrelevant sideshow to the real accomplishment of his poetry. Carruth made it clear that they were not; they and Pound's misuse of his own brilliant poetic technique of the mask or "persona" marred the *Cantos*, which should have been, Carruth insisted, the "major poetic text of modern English literature."[67]

The deeper contradictions of Laughlin's grand project emerged here, for the very desire that initially motivated him to be a publisher and to create *Perspectives* (using language to heal the world) also drove his emulation of and friendship with Pound, who like Laughlin saw poetry and literature as an indicator and even source of a culture's health. But where Pound's ideas of what "health" meant had not changed, Laughlin's had. Laughlin had made his peace with liberal capitalist America, while Pound languished in St. Elizabeths, his trial for treason indefinitely delayed, his anti Semitic and anti–Federal Reserve disciples at the foot of his bed, lapping up their master's conspiratorial wisdom. This contradiction or dissonance between Pound's defiant marginality and Laughlin's establishmentarianism laid bare all of the problems inherent in using unruly modernism to champion Western culture. Elspeth Healey has argued that "inherent in the premise of *Perspectives USA* was a series of nested synecdochal relationships: the artists it published were to represent the larger community of American highbrow culture, which in turn was to function as a representative of the nation itself."[68] But Laughlin's plan to use modernist literature as an advertisement for America was, if not doomed to failure from conception, always a fraught and contingent and precarious undertaking, never more so than when it finally deployed Pound, who so implacably denied such a synechdochal relationship could exist in any but an ideal culture. "In its extremity," Healey trenchantly points out, the case of

Pound "magnifies those conflicts which, though less glaring, were nonetheless present throughout *Perspectives'* institutionalization and instrumentalization of modernism."[69]

Perspectives' individual issues, much more than *Encounter'*s, feel "curated," chosen not to highlight what an editor found interesting but to forward a larger argument. Trilling's issue, the second, neatly encapsulated the New York Intellectual worldview: the qualified admiration for the United States (Mary McCarthy's "America the Beautiful"), the loyalty to experimental modernism (thirteen mostly early poems by e. e. cummings, an essay on cummings's technique by Ted Spencer, and an overview of Arthur Dove's painting), the exploration of the problems of being a metropolitan intellectual in the United States (Trilling's introduction, McCarthy's piece), and the critical engagement with America's artistic and literary heritage (Randall Jarrell's piece on Whitman, Robert Warshow's on Hollywood, a review of books on Melville). Trilling even included an excerpt from Saul Bellow's forthcoming novel *The Adventures of Augie March*, itself a kind of distillation of the New York Intellectuals' preoccupations, a rewriting of the archetypal American novel *Huck Finn* by a Chicago Jew. Jacques Barzun, in his issue (number 3), chose to include the work of two major poets—Stevens ("To an Old Philosopher in Rome," reprinted from the *Hudson Review*) and Robert Lowell ("Satayana's Farewell to His Nurses," original to *Perspectives*)—and work by Robert Pitney. Barzun's inclusion of his friend Pitney, a poet largely forgotten today, was a touching gesture of admiration and memorialization, for Pitney had died in 1944 at age thirty-seven and never attained great renown. Barzun had eulogized Pitney in the autumn 1944 issue of the literary magazine *Chimera*, and in *Perspectives* nine years later he reminded readers of Pitney's achievements. By contrast, philosophy professor Irwin Edman's issue (number 7) marked the start of the journal's move toward the Harold Ross middlebrow, with poems by John Hall Wheelock and *New Yorker* poetry editor Howard Moss and stories by *New Yorker* fiction editor William Maxwell and *New Yorker* fixture E. B. White.

Readers and reviewers had long chastised Laughlin's tendency not just in *Perspectives* but also in the *New Directions in Prose and Poetry* annuals to present past innovations as current, although Laughlin justified it as necessary, given *Perspectives'* mission to acquaint Europeans with developments

in American art that they had missed over the previous decades. Critics had long made such acerbic comments about *New Directions* as "I can best begin this piece by observing that there are no new directions in prose or poetry," that the annual's raison d'être "was dead and unburied ten years ago, like Hoover," and that it was hard to present Pound, Williams, Stein, and Cummings "as innovators" of the 1940s when the work intended to make that case dated as far back as 1921.[70] Even Laughlin's friends bit the hand that often fed (or at least published) them: Delmore Schwartz responded to the 1944 *New Directions* by asking "[I]s there anything less experimental than the deadly earnest imitation of experimental writing from twenty-five years ago?" and Kenneth Rexroth—not only a New Directions author but Laughlin's hiking and skiing companion—had complained in 1948 that New Directions was "printing warmed over nonsense from the Café Dôme."[71] For instance, given how innovative and productive Williams was in the 1940s and 1950s, it seems strange that most of his work included in *Perspectives* issue 1 dates from much earlier. But Laughlin was devoted to his vision of the key accomplishments of modernism and its contemporary inheritors, and he brought these ideas to *Perspectives* even though, not surprisingly, readers, reviewers, and the Ford Foundation's own internal studies consequently faulted the magazine for being "stale." Although it is reductive to accuse Laughlin of crudely engaging in product placement for his company, it is hard to overlook the fact that *Perspectives*' run is bookended by issues featuring sometimes fifty-year-old verse by New Directions' two cornerstone authors, Williams and Pound. Tate warned Laughlin that a single editor would stultify the magazine; Laughlin avoided this with his rotating-editor plan, but in the end *Perspectives* was always his baby, and it shows.

In its treatment of the visual arts, *Perspectives* frequently forwarded abstraction, which had provided the United States with its most internationally prestigious movement, as evidence that the United States had incubated its own modernism through the 1930s and 1940s. Unlike *Partisan Review*, Rosenberg, and Greenberg, though, *Perspectives* did not throw its loyalties in with abstract expressionism, instead favoring painters who used abstraction without being defined by it. As it did with the poets, *Perspectives* dealt with painting through short overviews providing biographical information and discussions of style

and technique; attention to any kind of political or social intent or context for the works, though, was essentially absent. In issue 4, for instance, Jerome Mellquist contextualized Marsden Hartley as one who "turned successively to postimpressionism, fauvism, cubism, symbolism, expressionism" but who turned "back to realism" in the 1930s. Was Hartley's the radical, working-class social realism that was characteristic of the 1930s? No: "He was back to Maine, Maine and a new realism" focused on Mt. Katahdin and the New England coast.[72] Writing about the painter Jacques Villon, Cleve Gray continued to define modernism as that which avoids commenting on the immediate, positing that Villon—even after the German invasion of France—"began to paint an ideal world . . . [in] a language drained of the immediate and the sensational, an idiom in which he could speak of pure inwardness and serenity."[73] Arthur Dove, according to Robert Goldwater, "simplifies and eliminates until his whole design is unified by a single strong rhythm of free fluent forms and a few striking colors [T]here are no human figures in Dove's pictures . . . his desire is to portray [nature's] immensity in symbolic terms."[74] Even the magazine's covers—many by Alvin Lustig, the house designer at New Directions and one of the most prominent book-jacket designers of the 1950s— were abstract designs, implicitly arguing for the supremacy of that kind of visual representation.[75]

Ironically, *Perspectives'* first article of this sort was on Ben Shahn, who had already been a flashpoint for controversy in State Department/USIA exhibits. Shahn was the kind of painter that a European leftist could love: "Creator of the most 'American' of images, he is more critical of his country's 'materialism,' political backwardness, and local prejudices than any Paris Existentialist on a six-months shopping tour of native blight," wrote Selden Rodman for *Perspectives*.[76] However, although Rodman's article did not skirt over Shahn's political views and a reproduction of Shahn's painting *Death of a Miner* accompanied the article, Rodman was careful not to portray Shahn as the kind of revolutionary who could not make peace with American society: Shahn also worked for "the Container Corporation, the Columbia Broadcasting Company, and such magazines as *Fortune* and *Harper's*." Striking at Shahn's endorsement by the Popular Front, Rodman—who was perhaps even more hostile toward what he saw as the aggressive emptiness of abstract

expressionism than toward programmatic or tendentious art—argued that Shahn should really be seen as one who balanced social conscience and mission with a devotion to form, process, and abstraction.[77]

Similarly, in an overview of Morris Graves, Kenneth Rexroth argued that although abstract expressionism "has come to maturity and begun to influence painting around the world," Graves "stands apart," a follower of a "visionary tradition" that descended from Blake through John Martin, "the later Turner, the Pre-Raphaelites, [and] Odilon Redon." Rexroth—whose indelible association with the West Coast likely excluded him from consideration as a major American modernist and placed him in the "regionalist" category—claimed the same kind of identity for Graves, a native of the Pacific Northwest who was as influenced by "Far Eastern" art as by "the architectural deep-space painting characteristic of Western Europe." Like Williams with the American language, Rexroth wanted to claim that Graves's use and transformation of Asian techniques and imagery were typical of another strain of definitively American modernism.[78]

Abstraction, though, was to Laughlin's mind not appropriate for all audiences: the European intellectuals targeted by *Perspectives*, yes; the unsophisticated citizens of a nonaligned nation, probably not. Although Intercultural's primary purpose was to publish *Perspectives*, as part of its initial Ford Foundation grant it also received $200,000 to engage in other cultural activities, particularly in India. Laughlin and Katz undertook a project to distribute American books in India, and at the same time Laughlin contracted with the AFA and the MoMA to assemble an exhibition of "20 Americans in India" at the All-India Fine Arts and Crafts Society in New Delhi. The March 1953 Intercultural-sponsored show was billed as "a glimpse of outstanding American art before the eyes of the people of a new, free nation," but Laughlin had warned the AFA to stick to a "very conservative" selection because "the Indian public is not yet ready for very advanced modern art." Laughlin recommended such painters as Charles Sheeler, Andrew Wyeth, Edward Hopper, Thomas Hart Benton, and Grant Wood and cautioned that "our most non-objective school should probably be limited to one painter, probably Pollock." "We want to avoid propaganda, of course, but we should send paintings which are comprehensible to simple people," he cautioned.[79]

Perspectives' articles on architecture—both domestic and institutional—rejected the collectivist architectural philosophies of Gropius and Le Corbusier for, again, a pragmatic individualism. Frank Lloyd Wright was praised as a "bitter enemy of the classical tradition" in that he believed that "all great architecture grows out of an individual response to an individual's needs."[80] In terms of domestic architecture, while European modernists designed multiunit dwellings such as Le Corbusier's "Tower in the Park," *Perspectives* focused on the single-family home, even the California ranch house. Hugh Morrison, in "American Houses: Modern Style," praised Mies van der Rohe's Farnsworth House as "less a house in the ordinary sense than a work of abstract structural art." In terms that echo the description of modernism throughout the run of this journal, he described van de Rohe's concern as "the creation of pure forms of an uncompromising technical perfection and aesthetic integrity." Morrison concluded that "modernism has won a decisive victory over eclecticism."[81]

Although not explicitly about artistic modernism, Barzun's article "America's Romance with Practicality" could serve as the philosophical core of *Perspectives'* approach to modernism and culture in that it linked American pragmatism to modernity and the role of the artist in a free society. Barzun responded to the European accusations that "pragmatism is the national creed glorifying the businessman" and "now that American business dominates half the globe, practicality is king" not by denying but by turning the accusation of pragmatism back on the Europeans: the very discovery of America, he pointed out, was motivated by "the search for comfort and power." American pragmatism is in fact the potential savior of a "polyglot planet"; it *is* modernity itself, he granted—and a good thing, too. Barzun concluded with a remarkable notion of the relation between the artist and his society:

> The pioneer, trader, or businessman succeeded because there was plenty of room and plenty of substance to waste. Now we need a different order mind, still wedded to practicality—still in love with it—but more conscious, more complex, more self-critical. He may be a businessman still, or an administrator of private or state concerns, but he must learn the new lesson of effectiveness by stripping every purpose bare and seeking the mini-

mum means to attain it. . . . This lesson he can and must learn from the only type of man who is and has ever been an incorruptible pragmatist—the artist. . . . If America's great romance is to continue and thus prolong Western civilization, it will be because the child of that romance, the artist, has begun in our midst and with our aid his endless task of raising images of good and teaching practicality.[82]

In this view, just as modernism expresses the essential character of free individuals in the modern world, our businessmen and administrators should learn from and emulate artistic modernism in their own pursuits. And the "complexity" of modernism, far from being impenetrable, esoteric, and arcane, actually creates "images of a good and teaching practicality."

Finally, *Perspectives* maintained the New Critics' and New York Intellectuals' stance that artists should be "critically distanced, but engaged," a stance perhaps best adumbrated in Allen Tate's "To Whom Is the Poet Responsible?" a speech from a 1951 CCF conference reprinted in issue 6. In the essay, Tate responded with characteristic sarcasm and irony to the charges, first leveled by Archibald MacLeish in 1940, that the modernist poet had ignored his "total responsibility for the moral, political, and social well-being."[83] The responsibility of poets is to be *poets*, Tate insisted; and, perhaps eventually their insights on the nature of what it is to be human will inform political action: "The human condition must be faced and embodied in language before men in any age can envisage the possibility of action. To suggest that poets tell men in crisis what to do, to insist that *as poets* they acknowledge themselves legislators of the social order, is to ask them to shirk their specific responsibility, which is quite simply the reality of man's experience, not what his experience ought to be."[84]

Although the Ford Foundation was not precisely collaborating with the governmental information programs in *Perspectives*, the two echoed each other's messages, and in fact USIA reading rooms in Europe stocked the magazine. VOA—which had trumpeted *Perspectives'* début in 1952—featured *Perspectives* in its broadcast of May 25, 1953, in a segment written by painter and World War II veteran Nathan Glick. Glick's script explained that *Perspectives* was a smash hit—"all editions" were an "immediate sell-out"—and even

FIGURE 5.2 Italians read *Prospetti* at a USIA reading room.
Courtesy Lilly Library, Indiana University–Bloomington.

though there had been "some criticism" that the material was "not represen-
tative of the whole American scene . . . the critics admit that the material
is fresh and provocative, and that it will upset many preconceptions about
American cultural life." Glick's commentary reiterated that modernism was
common ground between Europe and America: "American novelists have
learned much from the work of Europeans like James Joyce, Marcel Proust,
and Thomas Mann. The Austrian Rilke and the Spaniard Lorca have been
models for American poets. American musicians have studied under the
Russian-born Stravinsky and the German-born Schoenberg. . . . Europeans
know and admire and sometimes emulate such leading American novelists
as Hemingway, Faulkner, Steinbeck, and Dos Passos. They are beginning to
learn more about American painting, drama, and music."[85]

As the editors expected, the journal was received enthusiastically in a few overseas circles, skeptically in others, and antipathetically in one. The American, English, German, and Italian issues of the first number in the fall of 1952 sold out in just a few weeks, but "the French edition did not do as well as the others—there is a strong wave of anti-American feeling in France at present—but the press reviews, in France as well as in the other countries, were predominantly favorable, except for attacks in the pro-Communist papers."[86] A year later Laughlin observed that "*Prospetti* is a terrific success in Italy—beyond my best hopes. But . . . it is tough going in France. . . . They apparently just hate an American looking package."[87] Overall numbers, though, were impressive. Reviewing the activities of Intercultural at a February 1953 meeting of the Ford Foundation's board, Laughlin reported "high demand" for *Perspectives* resulting in a total circulation of 40,000—a number that he envisioned easily could increase to 75,000 or 100,000.[88]

However, quickly and increasingly over the short life of the magazine, its sponsors at the Ford Foundation grew impatient with Laughlin's inflexible refusal to print *anything* he considered excessively political. This change in attitude toward the magazine coincided with a shakeup at the foundation's top levels. During Christmas 1952, Henry Ford II ousted Paul Hoffman from his post as president and moved the offices from Pasadena to New York, thus isolating Intercultural supporters Hutchins and Katz in California. Ford replaced Hoffman with Rowan Gaither, a San Francisco lawyer who had headed the study group that issued the eponymous 1950 report, and a new group of administrators. The foundation was also receiving attacks from the right, aimed at Hoffman and Hutchins's Fund for the Republic.

The tension at the foundation quickly filtered down to Laughlin's little project, manifested in a rejection of Hutchins's generalized humanism and a heightened emphasis on an "informationalist" approach similar to that of the book programs. Healey explains that Ford wanted "to move away from an 'avant-garde' aesthetic to a more generalist focus through essays treating trends in the social sciences and 'serious' articles about the American way of life. These texts, they believed, were more representative of and better propaganda for the United States."[89] Even before Hoffman left the foundation, Katz wrote to Laughlin in regard to the Books for India program, urging

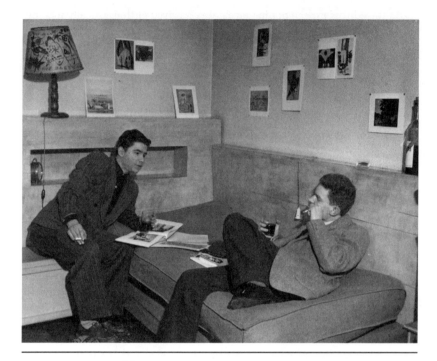

FIGURE 5.3 This publicity shot depicts two French existentialists straight from central casting—smoking, drinking, slouching, and discussing the latest number of *Profils*, c. 1953. Tacked to the wall are reproductions of Arthur Dove's paintings from issue 2. Courtesy Lilly Library, Indiana University, Bloomington.

Laughlin not to shy away from distributing *any* work that could be read as endorsing Western systems of political or economic organization. Asking Laughlin if he would feel that John Stuart Mill's *On Liberty* or *The Federalist Papers* would be "propaganda," Katz demanded, "Would it not be a rather precious definition of 'culture' which would exclude books of this kind? . . . I take it that all of us would quickly agree that Intercultural Publications, Inc. should not be used as a vehicle of propaganda or cultural warfare. But the border lines are not always clear. In the anxiety to avoid propaganda it is possible to slip unwittingly into a sort of propaganda in reverse."[90]

After Hoffman and Hutchins left Ford, the pressure became more direct. Shepard Stone, who had joined the foundation in 1953 to head its European outreach programs, preferred projects such as the CCF that combined culture and politics more purposefully. In 1954, urged by Stone to consider aping *Encounter* and print political writing, Laughlin responded that *Perspectives USA*'s place had "always been to keep out of the political fight, to think of the field of culture as one where people of opposed ideologies can still meet on friendly ground and learn to respect each other as human beings." Culture, rather than politics, was "an ideal channel of communication because it so often seems to appeal to the best side of our natures. It is a natural symbol of our aspirations for a better life."[91] In a remarkable display of obliviousness to what his own magazine was doing, Laughlin suggested directly to Stone that Ford pull back from its political stances and separate itself from the CCF because the dissemination of high culture by itself would inevitably make things better: "Frankly, I would hate to see the Foundation make its cultural program a weapon in the cold war."[92] At the end of that year in his annual report, he reiterated, "PERSPECTIVES does not carry any propaganda material, nor touch directly on any political issues."[93]

Although it is clear that the foundation had urged him to alter his conception of the journal's mission and editorial policy, Laughlin downplayed this request to outsiders: "no pressure of any kind has ever been exerted," he assured Dwight Macdonald and explained that "no one at The Foundation has ever said one word to us about what they wanted done or not done. There has been, of course, what you might call 'a climate.' But I would hate to have you give the impression that anyone had 'pressured' me, because nobody has. And I would like to point out that where we have avoided articles which gave a very gloomy picture of conditions here, we have not attempted to do a sugar-coating job. If you read through the 'think' pieces you would find all kinds of frank references to the deficiencies existing here." Laughlin also wrote to correct Macdonald's "impression that The Foundation simply set out to run a literary magazine. And that is just not true. The whole idea was centered on the conception of cultural exchange."[94]

Even the directors on Intercultural's board at times were unhappy with *Perspectives'* orientation. William Casey, for one, took offense at Mary McCarthy's

article "America the Beautiful" in issue 1, in which McCarthy lamented the "vulgarity" and impoverishment of American commercial culture even as she attacked Europeans' hypocritical attitudes about the United States. The reprinting of McCarthy's article, which had originally appeared in *Commentary* magazine in 1947 (and then in *New Directions in Prose and Poetry* in 1948), also triggered an angry response from conservative writer Alice Widener in the *American Mercury*. Widener savaged McCarthy and extended her attacks to *Perspectives* ("a vehicle for the writings of many well-known pro-Communists . . . the magazine fails, miserably and viciously"), the Ford Foundation, and foundations in general. "What investigations are being made to prevent Ford money—in whatever form—from reaching subversives or being used for subversive purposes?" Widener demanded. Echoing the arguments of Congressmen George Dondero and John Taber, Widener also criticized the predominance in the magazine of the "small literary avant-garde who pride themselves on a lack of appreciation for American life as it is enjoyed by the vast majority of American citizens" and the "unintelligible . . . unsuitable" modernist verse by poets such as cummings.[95]

In response to McCarthy's article, William Casey told Laughlin, "I agree that we cannot eliminate criticism [of American society]. But we have managed to concentrate on it and to ignore those aspects of American society in which we can have pride." In a tirade that recapitulated the 1950s conflict between the disengaged critical highbrows and the cultural middlebrows that issue 2 itself embodied, Casey then turned his ire on Trilling, the issue's editor, "who in his introduction, remarks that many Americans resent and resist intellectuals for being what they are. This is typical self-praise. I don't think that I resent or resist the people who call themselves intellectuals. But I do resist their frequent attempts to decide all things for all men on the grounds that they represent some superior casts [*sic*]. . . . [M]ost [intellectuals] are unintelligent, ignorant of many of the facts of life, and substitute slogans, cliches, and the juxtapositioning of half-baked ideas for the process of thought." Echoing the arguments of Herbert Hoover and Henry Luce, Casey then added that Trilling, McCarthy, and the other intellectuals who dominated the journal were regrettably "ignorant of the great principles of liberty and the concomitant requirement of decentralized economic and political power, the theory and practice of which represents [*sic*] one of the great American contributions to world culture."[96]

Laughlin defended his magazine's record but promised Casey that the "fourth number stresses what I would call the conservative tendencies in contemporary American culture," and indeed issue 4—edited in house by Laughlin and Carruth—was known as the "conservative issue" among *Perspectives'* staff.[97] Casey also pushed for *Perspectives* to run an article by the management theoretician Peter Drucker, calling it "a good change of pace," but both Laughlin and Carruth balked, Carruth insisting to Laughlin that the article was "poorly written" and also "anti-European. . . . [Drucker] equates Europe and Socialism and Planning and Controls, and all these are bad. Conversely, everything American is wonderful, and big business is the most wonderful thing of all. . . . He insists upon the prerogatives of business in a way which I should think would offend almost everybody in Europe and Asia."[98]

Casey's objections underscore the difficulty of using modernism to achieve these political ends. As director of Central Intelligence under President Ronald Reagan, Casey eventually became the very embodiment of the national-security state, but here his objections stem much more from his self-conception as a businessman and as a defender of "decentralized economic and political power." One can depoliticize modernism, Laughlin shows us, but it is much more difficult to de-"highbrow" it—to make it friendly to liberal capitalism and to the image of the United States that the Ford Foundation sought to spread. But Laughlin's project was to reinforce modernism's association with the highbrows, while at the same time expanding the category of "highbrow" to include elites outside of the cultural world.

Additional pressure on Laughlin to alter his editorial stance came from the Reece Commission, more properly known as the House Select Committee to Investigate Tax-Exempt Organizations.[99] Conservatives in Congress had long been suspicious of foundations for providing funding and safe haven for politically suspect or dangerous persons. The Reece Commission's 1953 report, based on questionnaires submitted to foundations rather than on sworn testimony, concluded that they were indeed "loyal" to the aims of the United States. Unhappy with this outcome, Tennessee representative Brazzilla Carroll Reece reconvened his committee and authorized an investigation by a consultant named Norman Dodd, who reported that "it seems incredible that the trustees of typically American fortune-created foundations should have

permitted them to be used to finance ideas and practices incompatible with the fundamental concepts of our Constitution. Yet there seems evidence that this may have occurred."[100]

In hearings held in May and June 1954, the Reece Commission came down hard on the Ford Foundation especially for supporting groups such as the Fund for the Republic and Intercultural Publications. Hutchins was a particular target of these hearings and of invective in the press. The commission produced no legislation, but its report—described by one historian as "a weird conglomeration of immoderate charges and ultraconservative diatribes"—did help distill anger against the Ford Foundation and the Fund for the Republic in right-wing circles.[101] For years later, national radio commentators such as Fulton Lewis Jr., Paul Harvey, and Walter Winchell regularly attacked Hutchins for the Fund's "anti-anti-communism" (in the words of the American Legion), and the Fund's Paul Jacobs even had to broker a meeting between Hutchins and the ACCF, at which Sidney Hook warned Hutchins that he was too lax about "guilt by association, employment of subversives, and employment of CPers [Communist Party members] in universities or such institutions as the Fund." Hutchins consistently held that one had to judge the suitability of employing Communists on a case-by-case basis and tried to persuade the ACCF that they were fighting the same fight for cultural freedom, but the committee's otherwise fractious factions were in agreement that the Fund for the Republic was "soft" on communism.[102]

Political pressure and negative public opinion had had some effect on the Ford Foundation's decision making, but Hoffman and Hutchins's departure ultimately determined *Perspectives'* fate. When Laughlin requested $2.5 million in 1954 to keep Intercultural running for another four years, the board responded with a terminal grant of $500,000, enough to publish *Perspectives* through issue 16 and keep Intercultural afloat until October 1956. The foundation's new leadership was increasingly unconvinced that the arts were an effective means of achieving its goals, and Laughlin could not convincingly quantify or explain what Intercultural was accomplishing. The foundation sent Stone and trustee Charles Wyzanski to Europe in mid-1953 to gauge the impact of its programs there, and Wyzanski's report, based on focus groups, faulted *Perspectives* for its exclusive focus on the arts, an approach

unlikely to reach any audience beyond the "avant-garde of the intelligentsia." Wyzanski found the journal "too esoteric and therefore not truly representative of American culture" and recommended that Ford retool the journal to more closely resemble *Der Monat.*[103] After the Wyzanski study, *Perspectives* jettisoned the rotating-editor structure, which readers and members of the board had criticized for undermining *Perspectives'* personality, and began expanding its content beyond art and culture. Laughlin grudgingly noted in his annual report for 1954 that "the system of guest editorship has been, since issue Number 7, replaced by staff editorship in order to achieve better balance and continuity from issue to issue; and second, the content of the magazine, which in the first year was predominately literary and artistic in character, has been broadened to give better representation to all phases of contemporary American culture within the accepted wider interpretation of the term 'culture.'"[104]

The exhaustive "Study of *Perspectives* in England, France, Germany and Italy" by Frederick Burkhardt, submitted to the Ford Foundation in July 1954, concluded that the culture-exclusive orientation of *Perspectives* was "on the whole . . . good," but that the actual focus was too avant-garde and too literary, to the detriment of other forms of art such as music. Responses by targeted readers were equivocal—the Italian intellectual Carlo L. Ragghianti, for instance, wrote that "*Prospetti* has a very limited success and very little penetration. . . . I believe that this review has no value, or at least very little."[105] The report, ordered by Stone, was on the whole complimentary when evaluating the magazine on its own terms but would disappoint a reader looking for evidence that *Perspectives* was directly affecting European leftists' attitudes about American political aims. Advisory board member Alfred Knopf, writing to Laughlin after seeing this report, empathized: "I think it undignified and even to a degree insulting to have our work constantly— evaluated I think is the word you used—by outsiders."[106] Many of the European intellectuals at whom these propaganda efforts were aimed, moreover, were perfectly aware of what this publication was intended to accomplish and consequently ridiculed it. "The magazine provoked widespread resentment in Europe, not only because it was 'so obviously an American package,' but also because of its 'inauthentic' institutional origins," Hugh Wil-

ford remarks, quoting a letter from Stephen Spender—who knew something about compromised magazines—to Tate.[107] Michael Josselson also remarked that Europeans saw the magazine as "fairly obvious American propaganda because of its slick cover and low price" and, furthermore, that these audiences dismissed the material as "out of date" and Lustig's cover designs as rehashes of 1920s European art.[108]

The journal impressed some, though. Melvin Lasky dismissed the opinions of CCF colleagues such as Nicolas Nabokov and Irving Kristol that *Perspectives* was a failure, saying that "in many respects it has indeed succeeded in making the grade." Although "it does not change minds" in Germany, "it reinforces the sympathies and views of a considerable section of the democratic-minded internationalist pro-American high-brow public opinion."[109] Many of Burkhardt's respondents praised *Perspectives*, and in March 1956 the Brussels office of the USIA reported happily that the magazine was "one of the most effective instruments at the disposal of USIS/Brussels for informing Belgian intellectuals of developments in the arts. . . . The response to 'Perspectives' has been uniformly favorable, even in certain circles of 'intellectuals of the left' who are normally very critical of the United States." The public-affairs officer writing this dispatch praised the journal's fiction, poetry, art criticism, and reviews, noting that "'Perspectives' has performed for the European intellectual a unique function in providing him with a panorama of contemporary American activity in the field of arts and of ideas, which is matched by no other single American periodical."[110]

Laughlin gently disputed Burkhardt's conclusions that "a majority of our correspondents favor more social and political content," noting that responses to the magazine's own questionnaires "give a contrary reading."[111] Asked "Would PERSPECTIVES interest you more if it published some articles about current political problems?" only 464 respondents answered "Yes," whereas 1,117 answered "No." This *Perspectives'* reader survey seemed to justify the choices that Laughlin had made: the ratio in favor of the rotating-editor system was four to one, and 71 percent of readers wanted the magazine to avoid covering "current political problems."[112]

In July 1956, *Perspectives USA* published its sixteenth and final issue, noting to its readers that "we continue to believe that cultural exchange of this kind

contributes substantially to better world understanding." Epitomizing both the founding vision and the fate of the journal was George Kennan's essay "International Exchange in the Arts," reprinted in the final issue. In familiar terms, Kennan bemoaned European misconceptions of Americans as "vulgar, materialistic nouveaux riches, lacking in manners and in sensitivity, interested only in making money, contemptuous of every refinement of aesthetic feeling," and he regretted that "the blind workings of our commercial interests" do nothing to correct those misconceptions. Culture—"artistic creation and the higher forms of scholarly thought"—must be brought to bear on this problem, for through culture we can find common ground with our friends in Europe even if they do not share our immediate political interests. "What we have to do," Kennan concluded, "is to show the outside world both that we have a cultural life and that we care something about it." But Kennan turned his argument around as well, insisting not just that we need to do a better job of disseminating our high culture to Europeans but that we must truly devote ourselves to openness and exchange with other societies for our *own* good: "However great the importance of international cultural exchange from the standpoint of our relations with other countries, this is not the main reason why we Americans have need for cultural contacts with other peoples at this time. The main reason lies rather in our own need as Americans for just this sort of enrichment of our national spirit. I am persuaded that any really creative development in the field of art or literature is intimately connected with international contact and is, in fact, unthinkable without it." Kennan argued that "there has grown up among us a most reprehensible habit, a totalitarian habit in fact, of judging the suitability of cultural contributions by whatever political coloration we conceive their creators to have acquired. I know of nothing sillier than this."[113] This remark must have rung painfully true to Laughlin, now facing the end of his pet project in part because of just such a "totalitarian habit."

In his 1967 attack on the CCF, Jason Epstein argued that the problem was "not a matter of buying off and subverting individual writers and scholars"— this, in fact, would be a process quite in keeping with the capitalist model of organization that the CIA was pushing. Rather, Epstein charged that the CIA "set . . . up an arbitrary and factitious system of values by which academic

personnel were advanced, magazine editors appointed, and scholars subsidized and published, not necessarily on their merits . . . but because of their allegiances. The fault of the CIA was not that it corrupted the innocent but that it tried, in collusion with a group of insiders, to corner a free market."[114]

The market metaphor here is surprisingly appropriate, even if it isn't applicable in precisely the same way to *Perspectives*. As the publisher of Pound, Williams, H.D., and many other American modernist writers, Laughlin had already done much to shape public understanding of literary modernism through the tools of commerce: advertising, distribution, marketing, and shrewd capital investments in authors and works. To continue the business metaphor—for it really was with *Perspectives* that commerce began to influence the Cold War modernist project—Laughlin ran into trouble with the Ford Foundation, his shareholders, who doubted the viability of his business model. Changing directions and altering his product to appeal to a broader audience, though, didn't work, and his investors pulled their money out. In fact, in his own effort to corner the market of ideas about modernism, Laughlin found that his strategy was faulty, that pure aestheticism wouldn't work to sell American modernism to European intellectuals the way it had worked to sell Pound to the arbiters of literary taste. *Perspectives* was not going to corner the market of ideas about modernism. Laughlin and Cold War modernism in general learned that it was necessary to tack to the middlebrow in order to bring the project to a successful culmination.

6

AMERICAN MODERNISM IN AMERICAN BROADCASTING

The Voice of (Middlebrow) America

N 1952, LATE in the second Truman administration, Voice of America director Foy Kohler wrote to his boss, newly installed IIA head Wilson Compton, to tell him—perhaps self-servingly—that "radio is the principal medium for the conduct of the cold war, carrying the entire burden (with the relatively limited aid of *Amerika* magazine) of the psychological warfare effort behind the Iron Curtain."[1] Whether this was actually the case or not, the several official and unofficial American radio broadcasters that produced programming for foreign consumption certainly did conduct a significant portion of the psychological-warfare campaign of the early Cold War. Their remit was also broader than the other undertakings examined in this book. Unlike the official art and book programs as well as the CCF's and the Ford Foundation's privately run efforts, VOA focused relatively little on art and culture, filling most of its airtime with news, descriptions of American politics and society, and anti-Communist propaganda. Moreover, VOA aimed its content at a much broader audience than any of those other programs (even the book programs) sought to reach: essentially every radio listener in Europe, the Soviet Union, much of East Asia, the Middle East, and parts of Latin America—an estimated potential listenership of 300 million.

But although VOA had a much wider reach and more comprehensive mission, it—like the art program, the book programs, *Encounter*, and *Perspectives*

USA—also advanced Cold War modernism. In fact, precisely because it was aimed at such a broad audience and conveyed a highly American middle-brow sensibility about art and literature, we can see VOA as the institution that closed the deal on Cold War modernism, that confirmed that once-threatening modernism had indeed become the house style of the American bourgeoisie—and could be exported to the rest of the world as such. In its features on art, artists, writers, critics, and key ideas about American culture, VOA increasingly over the course of the 1950s sounded the themes of Cold War modernism. It did so, moreover, truly as the "voice of America": it was the official voice of the US government, expressed in the style and voice of American commercial broadcast journalism.

The glossy Russian-language magazine *Amerika* should be considered here as well, even though it was not a broadcast outlet, for it mirrored VOA in aim, tone, and coverage. *Amerika*, produced by the Department of State for sale in the Soviet Union, predated the Cold War. Starting in 1944, the United States and the Soviet Union exchanged official magazines (*Soviet Life* was *Amerika*'s counterpart) with a strict limit on the number of copies that could be distributed. The exchange ended in 1952 but was revived in 1956, and *Amerika* continued publication even after the fall of the Soviet Union, finally shutting down in 1994. Soviet citizens could subscribe to the magazine—approximately 13,000 did in 1957, for instance—and *Amerika* was also sold through newsstands.[2] Like VOA, *Amerika* covered American culture broadly and in a friendly tone, combining reprints from American magazines with articles produced in house by some of the same reporters and commentators who wrote VOA stories (indeed, some *Amerika* stories and VOA features repeated each other almost verbatim).[3]

VOA wasn't the only official American broadcaster of the early Cold War, either; to reach and persuade target audiences more effectively, the Department of State and other official agencies created overtly propagandistic broadcast outlets separate from VOA, which had always been intended as a putatively objective source of news and information. It had originated as the Foreign Information Service in Nelson Rockefeller's OIAA in 1940 before moving to the OWI in 1942. OWI expressly forbade VOA to engage in "black" propaganda—the disinformation and falsely sourced messages that were the

purview of the CIA's precursor, the Office of Strategic Services—and instead charged it with dealing solely in "information." In the summer of 1942, the broadcast service took on the name it carries to this day, and by 1944 VOA had 3,000 employees and broadcast 168 unique hours a day in more than forty languages.[4] VOA moved to the Department of State in 1945 and then to the USIA in 1953. The first of the other broadcasters of the Cold War, Radio in the American Sector, headquartered in West Berlin, began operations in 1946 under the auspices of the US military occupation government. Three years later, the National Committee for a Free Europe created RFE to beam propaganda messages into the nations of the Soviet orbit. Although the National Committee was ostensibly private, most of its funding came from the CIA (whose director, Allen Dulles, served on the committee's board, along with General Dwight Eisenhower and General Lucius Clay, the military governor of occupied Germany). RFE drew upon the expertise of the American media establishment through board members Henry Luce, Time–Life executive C. D. Jackson, and *Reader's Digest* owner Dewitt Wallace. Modeled on RFE (and with a similarly "private" group behind it, the American Committee for the Liberation of the Peoples of Russia), Radio Liberty started broadcasting into the Soviet Union in 1951. According to James L. Tyson, "while the Voice was supposed to be just that, 'the Voice of America,' reflecting American policy and disseminating world news from an official American viewpoint, the mission of the 'private' Radios was to be 'surrogate home services.' The voices they transmitted to a target country were generally those of émigré nationals of that particular target country, speaking the native language and idiom and reflecting their own interests and concerns."[5]

Whereas Radio in the American Sector, RFE, and Radio Liberty were all overtly propaganda outlets, VOA's mission was to provide a "free and fair" portrait of American society, culture, and policies to foreign populations across the world—not just in the Communist sphere. Although the two were never cognates, VOA saw the British Broadcasting Corporation as a model and sought to convey an even tone and a balanced presentation of the news so that its most important audience (opinion makers and elites) would not dismiss it as propaganda, which would have been likely with RFE and the other radio services. "RFE is more popular—more dramatic, more aggressive,

more exciting," wrote the PSB's Mallory Browne in a 1952 internal report. "It is probably true that the two programs . . . complement each other, with VOA appealing more to the intellectuals and high-level people, while RFE has a more powerful appeal to the peasants and industrial workers."[6]

VOA's evenhanded coverage, in fact, earned it the hostility of conservative legislators. In its early years, the majority (up to 75 percent) of VOA's content came from private broadcasters such as NBC, which provided scripts for VOA talent to read on air. These scripts often did not convey the uncompromising anti-Soviet tone that many in Congress desired. Furthermore, a number of Republican congressmen suspected that VOA's programming, like that of OWI before it, was advocating not American values, but the political priorities of the Democratic administration. New York congressman John Taber, for example, attacked VOA in 1947 for reporting positively about Truman and labor unions, and in 1948 congressional committees investigated the charge that VOA's programming was frivolous or even offensive. Assistant Secretary of State William Benton, the main target of congressional anger, dismissed the furor as "grow[ing] naturally out of the fears and prejudices which surrounded the OWI, not to mention Archie MacLeish's operation," and President Truman concurred, reassuring Benton that "you are exactly right—the Arthur Krocks, the Byrds, the Bridges, and the Tabers are all in the same boat. They are not particularly interested in anything but attaining power for themselves."[7] (These Republican fears of an official broadcaster serving as a mouthpiece for the Democratic administration led to a provision in the Smith–Mundt Act forbidding any information agency to disseminate its message domestically. In 2013, the Smith–Mundt Modernization Act partially repealed this restriction.[8])

Even some Truman administration figures worried that VOA was not sufficiently making the case against the Soviets due to its excessive emphasis on soft topics such as culture. David Krugler writes that "shortly after VOA began broadcasting to the Soviet Union, [US ambassador to the Soviet Union] Walter Bedell Smith cabled [Secretary of State George] Marshall that the VOA was struggling to show that the United States was 'highly-cultured' rather than neutralizing Soviet propaganda." Smith urged Marshall to sharpen VOA's edge.[9] NSC-4 urged a more propagandistic approach to VOA

programming, a change difficult to achieve at the time because of VOA's heavy reliance on private contractors. These domestic political concerns and the intensifying confrontation with the Soviet Union led VOA to become fully responsible for its own programming after October 1948. Over the next two years, it sharpened its content, and after President Truman announced the Campaign of Truth in a speech to the American Society of Newspaper Editors in April 1950, VOA became relentlessly aggressive and hostile toward the Soviet Union's leadership. In reaching the Soviet *people*, though, VOA instructed its programmers to "promote friendliness and interest among the widest possible audience" through means such as giving over one-fifth of the total broadcast time to "good American folk music such as hillbilly songs, cowboy songs, railway and other work songs."[10] The Campaign of Truth resulted in heightened Soviet jamming of American radio broadcasts, and the outbreak of the Korean conflict motivated Congress to boost VOA's budget by almost 50 percent, from $9 million in 1950 to $13 million in 1951, in addition to allocating $50 million for building radio transmitters in a ring around the Communist world to foil jamming.[11]

In addition to exhibiting a change in tone, VOA's content, once uniform across all language services, was now targeted by region and language. Eastern and central Europe received political and economic news and comment, whereas western Europe got cultural information and features. News and political features dominated broadcasts to the Far East, whereas Latin American audiences heard "features and lighter programming."[12] But for most of the Truman years, there wasn't all that much programming, period: the Soviet Union received two and a half hours of original content per day (repeated round the clock), and the Polish and Czech desks broadcast just one hour daily. Western Europe received programming ranging from ninety minutes a day for the French service to only a half-hour for the Spanish.

Like almost everything related to the Department of State, VOA came under attack from Senator Joseph McCarthy in the early to mid-1950s. Spurred by a faction within the broadcaster's New York offices calling itself the "Loyal Underground," the Senate Permanent Subcommittee on Investigations turned its attention to VOA in 1953, seeking to root out communism and disloyalty. The televised February 1953 hearings ostensibly

targeted redundancies and wasted money in the network's infrastructure and management, but the hottest questions were about the content of the broadcasts, which was (in Roy Cohn and McCarthy's opinions) insufficiently anti-Communist. McCarthy also charged that Roger Lyons, the religion desk editor, was an atheist and made his customary unsupported accusations about subversives among the staff. Because of this public shaming, VOA was, in the words of historian Robert Pirsein, "enfeebled" and "abandoned."[13]

The McCarthy hearings were a nadir for VOA, but things changed quickly. The Committee on International Information Activities, known as the Jackson Committee, convened by newly inaugurated President Eisenhower in June 1953, recommended that a broadened psychological-warfare and information campaign be diffused across more outlets, each with specifically delineated missions. Information and cultural-diplomacy programs, the committee urged, should dial back on the stridency of the Truman years. VOA would take a lead role in this new campaign and should "avoid a propagandist tone," the committee advised. "Objectivity should be paramount," but "VOA output should be direct and forceful both in tone and content."[14] Eisenhower concurred with his committee's recommendations and insisted that in "this information business" it was crucial for official outlets to convey an "accurate statement of the American position on great questions and problems, embellished only by giving the facts, circumstances and conditions that have brought about the formulation of the policy. This particular function must be done so accurately, with such careful regard for the truth, that it will come to be respected and trusted throughout the world. To my mind this is the real function of the Voice of America."[15]

"Voice of America is destroying a great deal of its own usefulness when it engages in the field of propaganda," Eisenhower stressed to his secretary of state, John Foster Dulles. "Other agencies, with the governmental connection concealed," should handle propaganda, and "Voice of America ought to be known as a completely accurate dispenser of certain information."[16] The American information services, in particular VOA and its parent USIA, needed to be more "respected and trusted" than they had been in the Truman years, Eisenhower told Benton in May 1953.[17]

In addition, the Jackson Committee stressed the role of private, non-governmental partners in the information program. "The numerous private American organizations active abroad constitute a very substantial asset which has been insufficiently exploited by Government information agencies," the report continued, pointing to wire services, universities, foundations, missionaries, business firms, and labor groups as potential allies. "The gain in dissemination and credibility through the use of such channels will more than offset the loss by the Government of some control over content."[18] Jackson Committee recommendations also resulted in the moving of VOA offices and studios in 1954 from New York to Washington and in greater centralization in the production of scripts. Professional writers, often with backgrounds in journalism or politics, wrote the master scripts, which would then be relayed to each language desk for translation, customization to fit that particular nation or culture, and broadcast by announcers who were native speakers of the language.[19]

The prevailing ethos at VOA, particularly after Eisenhower's election, was to avoid seeming propagandistic while actually propagandizing. Eisenhower and the Jackson Committee made this charge clear to Theodore Streibert, the USIA's first director, but perhaps because of his background in commercial broadcasting Streibert had a hard time preventing a partisan, boosterish tone from pervading USIA's communications. After Streibert left the USIA, Pirsein notes, the administration reminded VOA to avoid "value judgments, argument, rhetoric, polemic, loaded or 'purple' adjectives, and a tone that was excitable, emotional, sarcastic, or self-righteous." Arthur Larson, who replaced Streibert in 1957, agreed that propaganda did more harm than good and stressed "greater objectivity" and "believability" in USIA and VOA.[20]

Accordingly, descriptions of American culture in the 1950s had an expository rather than a celebratory tone. In stories about life "behind the Iron Curtain," though, VOA went on the attack. This was true even in coverage of the arts, which foregrounded the constraints socialist realism put on artists. In a March 1953 editorial, Bertram Wolfe gleefully reported on how, when French Communist writer Louis Aragon condemned his fellow party member Pablo Picasso's insufficiently realist rendering of Stalin, "Picasso the artist and Picasso the party propaganda hack who draws monstrous peace doves are

FIGURE 6.1 USIA director Theodore Streibert at the Voice of America Munich Radio Center, April 1954. Photograph 54-13863, National Archives and Records Administration, College Park, MD.

brought face to face with each other."[21] VOA reminded listeners that André Gide had swerved quickly away from communism after visiting the Soviet Union in 1951, and the March 1953 death of Sergei Prokofieff provided an opportunity for Nathan Glick to remind listeners that the composer had been accused of "bourgeois formalism" and was forced—twice—to publicly repent.[22] Debunking the idea of a post-Stalin thaw, Glick reported that at the Soviet Writers Congress in 1954 a "party secretary concerned with ideology and propaganda" told the assembled writers that their mission was "not to tell the truth about Soviet life as the writer[s] saw it, but to conform to the 'guidance' of the party and government."[23] In 1956, VOA called listeners' attention to a minor "literary stir behind the Curtain," stressing that although some writers were starting to criticize Stalinism, official voices inevitably reminded

them that their role was to obey party dictates. "Judging from speeches by
leading Soviet writers at the Twentieth Congress of the Communist Party,
Soviet literature will continue to be an even more faithful transmitter of the
party line," a report concluded.[24] (Sadly in retrospect, this feature optimis-
tically pointed to the "irrepressible" climate in Hungary, which would end
with the Red Army's invasion in November.) When the Hungarian regime
failed to award the Kossuth literary prize in 1958, it was "a serious and damag-
ing admission . . . that the best Hungarian poets, writers and playwrights . . .
have refrained from writing and publishing anything which could be useful
to the regime from an ideological point of view" and that, conversely, those
books that "conform to the policies of the regime . . . were below the stan-
dards even of the Kadar regime's own cultural authorities."[25] A 1958 report
on Soviet theater quoted *New York Times* critic Brooks Atkinson saying that
although Stalin's death had prompted a temporary thaw in the artistic cli-
mate, "the Communist bailiffs are again tightening the discipline of writers in
Russia. . . . They cannot afford the luxury of freeing from total control a group
of people who deal in critical ideas, moral judgments, imagination, beauty
and wonder."[26] And the debacle resulting from the publication abroad of *Doc-
tor Zhivago* and Boris Pasternak's Nobel Prize offered a rich opportunity for
VOA to pay tribute to this martyr to cultural freedom. A six-part series in
October and November 1958—broadcast while the Soviet Writers Union met
to recommend a suitable punishment for Pasternak—lovingly summarized
the writer's life and achievements and gave an extended and at times drama-
tized synopsis of his famously bootlegged novel. (Interestingly, internal notes
specified that this series was to be broadcast only to China and the Soviet-
orbit nations.)

Unsurprisingly, discussions of freedom were frequent. A January 1953
broadcast commemorated Freedom Day (the anniversary of Lincoln's signing
of the Thirteenth Amendment on February 1, 1865, a holiday one suspects may
have been created for propaganda purposes), emphasizing that freedom did
not just mean "choos[ing] between doing one thing and doing another" but
rather "a knowledge of the alternatives among which one can choose"—a state
embodied by the free availability and exchange of opinions and ideas in the
United States. A 1955 *From the Bookshelf* book review feature focused on the

Quaker chaplain Elton Trueblood's *Declaration of Freedom*, which made the familiar argument that the freedom of the individual derived ultimately from God. The review, then, suggested that the official atheism of the Communist states was yet another prong in these states' campaign to destroy freedom and individualism. In 1957, Don Agger offered a "special talk" on "The Freedom to Write," a declaration issued by the First National Assembly of Authors and Dramatists. Whereas "freedom to write . . . is non-existent in many parts of the world . . . the United States of America was born in the belief that freedom is the essence of life and that freedom to write is the essence of the life of the mind."[27]

Voice of America devoted surprisingly little airtime to the activities of the CCF, but it covered the CCF's 1955 Future of Freedom conference in Milan. The stories noted the "previously unimaginable forms of human enslavement" in unnamed parts of the world but, in an intriguing move, stressed how the CCF's unfettered intellectuals called into question *any* unexamined category or assumption that came their way. "It is possible," the reporter promised, "that during the next week we will see a good many . . . of our dearly held clichés exposed to . . . probing. . . . [A]bout the only thing the Milan delegates seem to take for granted is the inherent right of man to engage in free inquiry and expression." In his commentary on the conference, Leonard Reed explained how Sidney Hook and Hugh Gaitskell carefully distinguished between "political freedom" and "economic freedom," subtly arguing that although heavy state intervention in the economy (as seen in "free-world" nations Sweden and Great Britain) may diminish "economic freedom," it had no effect on "political freedom."[28] The goal here was to advance Cold War liberalism, where economic and political freedom were loosely related but not parallel—a response, of course, to the libertarian and Republican arguments that any state intervention in the economy necessarily undermined political freedom.

During the Truman administration, VOA covered art only minimally. The broadcast agencies focused their attention on geopolitical news, framed to put the Soviet Union in the worst possible light. That said, the arts did receive some airtime on VOA, as in a 1952 discussion of the work of Edmund Wilson by Gilbert Highet and lectures on Indian art by MoMA's René d'Harnoncourt. The *American Bookshelf* program, which aired beginning

in April 1952, focused primarily on popular titles, including Mark Twain's *Roughing It*, Mary O'Hara's *My Friend Flicka*, Stephen Vincent Benèt's short story "The Devil and Daniel Webster," and a biography of Grandma Moses.[29] Echoing the arguments that national and ethnic diversity characterized the American artistic scene and that modernism was fundamentally international, a VOA news report on the 1952 Pittsburgh International Art Exhibition (also known as the Carnegie International) stressed that "the U.S., of course, is so much a melting pot, with so many of the artists now bearing its label having come from other lands, that what they are contributing firmly supports [Carnegie Institute curator Gordon Bailey] Washburn's contention that contemporary art, especially in its abstract phase, is not national but universal."[30]

VOA arts coverage during the Truman years could be almost belittling at times, as in a 1951 discussion between painters Howard Gibbs, Vernon Smith, and Elliott Orr on regionalism. The artists—described by the announcer as "three of the better American modernists"—praised the regionalist tradition and the variety it had brought to the nation's art and then concluded by defending experimentation in art. Their presentations were anodyne, but more notable was the announcer's patronizing response: "Most painters," he told his audience, "are much more orderly and more rational than the layman traditionally gives them credit for being." Implicit in his attitude, of course, was the persistent prejudice that modernists—even the "better" kind—are unpredictable, wild-eyed bohemians, countered by his disingenuous reassurance that some, in fact, are not. A feature several months later on the painter Robert Brackman, whose work the announcer described as "more conservative than that of most outstanding painters here," focused on "what it means to be a painter in this country"; Brackman, it argued, emphasizes that in the United States painting can indeed be a profession in which an individual can "succeed." The oddly defensive argument here is that America indeed values its artists; the United States has culture, and painters are not outcasts there.[31]

Unsurprisingly, in the Truman years VOA's arts features were often transparently, even clumsily propagandistic. In one typical example, the announcer began by describing the current Broadway theater season in almost embarrassingly purple language: "The month of March came in like a lion, theatrically speaking. Within its first ten days, Broadway first-nighters saw a

Shakespeare and a Barrie revival, a new Lillian Hellman play, and a hit comedy by F. Hugh Herbert. . . . As yet, there is no indication that the theater is going to slacken this extraordinary pace. . . . It is interesting to note with what acclaim both critics and public alike have welcomed the second coming of Marc Connely's *The Green Pastures*, this reverent fantasy taken from the folk legend of the South."[32] If the primary objective was to emphasize the fertility of the American arts scene, a secondary objective was to highlight and promote anticommunism in the arts. To that end, the overview of the arts in this segment focused on Manès Sperber's novel *The Burned Bramble*, newly translated from the French and published that week. Sperber—a Jewish, Austrian, French, former Communist writer and psychologist—was a CCF leader, and, according to VOA, his novel

> is a look into the workings of the Communist system and mind. It is a look with a microscope. In *The Burned Bramble* the reader is given the chance to join the Communist party, of meeting its leading members and finding out about them. That Mister Sperber has been a Communist is evidenced from every page of the book. That he no longer is a Communist is equally evident. . . . [The book] shows the reader the Communist fighting the devil with fire and learning all the devil's own tricks. And, finally, it shows how the use of evil methods molds the minds of men and how it forces them to become that which they hate.[33]

Writers themselves also contributed to sounding the key themes of the information program. In a 1952 VOA discussion of *The Grapes of Wrath*, John Steinbeck reflected on how the American government and people had worked together to better the plight of the farmworkers whose hardships he chronicled. "I don't intend to say that everything is working perfectly smoothly," he granted. "But I think we have solved many of our problems, and the solutions have been the product of ourselves: the product of our own people, working together[,] [and of] the government, [who] took full responsibility for all these stricken people."[34]

The year 1952 also saw the debut of a series called *My Credo*, in which high-profile American artists and writers—including, among others, Stein-

beck, John Marquand, Claude Rains, Thomas Hart Benton, Robert Frost, and Marianne Moore—"open their hearts and minds to overseas listeners on the importance of spiritual freedom in their artistic creations," as producer Eugene Lohrke explained.[35] (Religious themes were common in VOA programming, both as a means to present American culture and as a tacit rejoinder to official Communist atheism.) VOA was clearly taking programming, if not content, cues from commercial broadcasters: *My Credo* premiered soon after Edward R. Murrow started his secularist *This I Believe* series for CBS Radio.

In keeping with Eisenhower's desire to use VOA to provide a rounded portrait of American culture, coverage of all of the arts grew after 1953 and expanded further after George Allen replaced Arthur Larson as USIA director (although, to be fair, world affairs and commentary continued to take up the bulk of VOA's broadcast day). Allen, in fact, reported to Congress in 1958 that "the Agency is placing more emphasis on the broad field of American culture, embracing not only art and music but also America's educational processes, its democratic political institutions, its social customs, its religious interests and practices and its record of reliability and responsibility as a nation."[36] Regular VOA series such as *Arts in America, Critic's Choice,* and *From the Bookshelf* discussed artistic and literary developments (and even controversies) in the United States, and the rhetoric of those series illustrates the balancing act typical of VOA cultural programming: it had to present a full and fair picture of the United States; it had to counter European prejudices and Soviet accusations that the United States was a materialistic, philistine society; it had to advance the larger argument that freedom had not only made these cultural achievements possible but was the commonality that knit together the "free-world" societies. These series, though, also had to be careful not to be *too* daring or experimental or avant-garde; they had to embody the comfortable middlebrowism that the United States sought to inhabit in its information programs abroad. Unlike the art and book programs, which were aimed primarily at cultural elites, VOA's content had to appeal to a broad audience in each target nation: intellectuals and elites, yes, but also to a popular audience who, audience surveys reported, preferred portraits of daily life in the United States.[37]

FIGURE 6.2 George Allen introducing President Eisenhower on Voice of America, 1957. Dwight D. Eisenhower Presidential Library, Abilene, KS.

In terms of the visual arts, the scripts focused more on explaining the role of the visual arts in American cultural life than on presenting the work or life of a particular artist. This was, of course, to be expected; painting does not make for good radio. Such shows made subtle arguments that the arts—traditional and experimental—thrived in the United States, were accessible to and popular among its citizens, and sparked lively discussions among an engaged and cultured populace. The weekly feature *Arts and Letters in the USA* (with scripts often written by the American Catholic novelist Harry Sylvester) first aired in April 1955, with a profile of "America's first modern art collection," the Phillips Gallery in Washington, DC. The Phillips Gallery was "unusual" among art museums in its "day-to-day availability to whoever might want to see" its works. The collection was also proof in microcosm, the feature empha-

sized, of the role that art plays in human freedom: "In a world menaced by what [Duncan Phillips] calls the evil forces of tyranny, he avows that 'we must cling to our faith in art as the symbol of the creative life and as the stronghold of the free and aspiring individual.'"[38] A 1956 *Amerika* story on MoMA similarly emphasized the "broad popular support" for the museum and its ability to survive on "membership and admission fees."[39]

As we have seen throughout this book, this notion of the individual as the ultimate source of creativity permeates the Cold War modernist project, and in advancing this idea VOA was no different from any other arm of the endeavor. Although the news stories and features that appeared on the network were ephemeral by design, in its *Forum Lectures*, a series beginning in January 1959, VOA aired more serious talks by prominent experts in fields ranging from linguistics to oceanography to contemporary poetry, which were then collected and published by USIA. These features were aimed at a different audience but echoed the same arguments. The 1961 *Forum Lectures* volume *The Visual Arts in Mid-century America* provides particularly salient examples of such features. In this collection—circulated in the United States but also translated for distribution abroad—editor Lamar Dodd, a member of the President's Advisory Committee on the Arts, unabashedly identified the controversial painters Marsden Hartley, Charles Demuth, John Marin, and Yasuo Kuniyoshi as key figures of midcentury American art, and the essays he included foreground arguments about individualism. Bartlett Hayes insisted that the individual is the building block of American democratic society, and Lloyd Goodrich wrote that art today is more individualistic than it was in the period "of the old masters." The artist "is no longer the visual preacher, the historian and storyteller for society. He has lost most of his former practical and utilitarian functions." But he has a "new freedom of expression . . . he has gained a new creative role, equivalent to that of the musical composer or poet. His work has become as purely an expression of thought and emotion as the poem or symphony. This pluralistic art of ours," Goodrich concluded, "is the appropriate expression of a democratic society, free and fluid, offering wide scope to individualism."[40]

Interestingly, several of the contributors to this volume addressed government support of the arts and their stances on whether such support helped

artists thrive or pushed the United States toward a Soviet-style official art vary widely. Hayes historicized the question, explaining that the diversity of America—"the mixture of many people" who sought to preserve the "independence of each group and the independence, particularly, of the individual who was universally recognized as being an important element in our democracy"—militated against any governmental role in cultural affairs. The Ford Foundation's McNeil Lowry warned that government support of the arts would necessarily favor traditionalism over experimentation, but Goodrich defended at least some governmental art programs—those of the New Deal—as "an example of democratic freedom of expression unique in modern history."[41]

In fact, VOA frequently reported on the controversies over modern art roiling within American culture. Although such stories did acknowledge an antimodernist movement in the United States, their real purpose was to emphasize that healthy debate and a free exchange of ideas characterized the American public sphere. In May 1955, for example, *Arts and Letters in the USA* reported on "another controversy over modern art," which was less "another" controversy than one incident in the ongoing series of cultural dust-ups over modernism. This time, the spark was a full-page *New York Times* ad taken out by businessman, A&P heir, art collector, and sometime theatrical producer Huntington Hartford, who had wondered if modern artists and museums had decided that "THE PUBLIC BE DAMNED?" (The ad reproduced Hartford's piece of the same title that had appeared in the *American Mercury*.[42]) VOA reported on the "controversy" with a dutifully nonpartisan stance: while Hartford "has stood up and been heard in unmistakable terms . . . the painters and the critics . . . will surely have something to say in rebuttal." The substance of the controversy isn't what is important, though, the report concluded; it is the fact that such a controversy exists (demonstrating that there are pro-modernist partisans in the United States) and that it happens in public (unlike in the Eastern Bloc, where such arguments would be circumscribed and would never take place *en plein air*). The winner is the public.

It is always thus when the traditionalists—or those who consider themselves traditionalists—confront the modernists—or those whom the tra-

ditionalists consider to be modernists. And perhaps it is good that this be so. Opinions are aired, lungs are ventilated, convictions and prejudices are candidly presented to the public for appraisal. And in the course of such controversies the public, in whose name both sides occasionally claim to speak, sometimes takes its own private look at the works of art in question—and formulates its own opinion.[43]

VOA had covered almost precisely the same topic the previous month in a story on critic (and Bern CIA station chief) Henry Pleasants' attack on modern orchestral music. Pleasants had savaged contemporary composers for being indifferent to popular appeal; in a *New York Times Magazine* forum, composers such as Aaron Copland responded by arguing that the modern era was fundamentally different than past times and needed an art suited for its times. VOA summed up the flap by suggesting that we all benefit by having such an intellectually and culturally challenging question debated in the outlets of our mass media.[44] VOA even contributed to this debate, as when in 1960 it broadcast and then published Clement Greenberg's well-known lecture "Modernist Art," which categorically defended modernist painting.

VOA also took on the question of "the highbrow and the lowbrow" that increasingly occupied American intellectuals in the 1950s. Reporting on a 1953 "series of round-table discussions" (sponsored by the Advertising Council) among educators and intellectuals, VOA contrivedly set up a debate by quoting unnamed members of this discussion group throwing out the accusations that European leftist intellectuals were most likely to have: that serious art was dead in the United States and only popular or commercial art thrived; that capitalism and "free competition . . . will drive off the market for the books admired by smaller and more discriminating groups"; that America does little to encourage or support artistic experimentation. The playwright and translator Lewis Galantière, serving as the de facto "voice of America" (and not identified in the script as an RFE employee), countered all of these worries with assurances that the very grounds of these accusations—the idea that radio had severely cut into the numbers of Americans attending classical concerts, for instance—were false. Culture is not a zero-sum game, this "round table" concluded: "There is no contradiction between a democratic

mass culture and an elite or quality culture. In the United States, the different cultural levels have served to vitalize each other. Film directors, for example, are looking more and more to serious literature for their material. Television is providing an outlet for original work in opera and dance. A democratic culture has its problems, of course. But what is more important, it has possibilities of growth undreamt of in earlier aristocratic societies or present-day totalitarian states."[45]

Two years later a feature on John Erskine and Robert Hutchins's Great Books program made much the same case: that in the United States culture is not vertically stratified, that "ordinary" people even outside of the academy and the higher economic classes engage with serious art and literature. Leading with an anecdote of a tractor-driving New Hampshire farmer reading Plato's *Republic* while plowing, the story underscored that humanism, the desire to "read and study not simply . . . for a trade or profession, but in order to become better citizens and better human beings," was central to the nation's identity, and it offered an implicit rejoinder to the European prejudice against uncultured, materialistic Americans.[46]

Unlike *Encounter, Perspectives USA,* or even the book programs, VOA had a much more equivocal charge when it came to modernist art and literature, still marked as elite and highbrow even as they moved quickly into the mainstream. VOA had to reach skeptical Europeans with the message that the United States had a vital artistic scene and remind them that American artists and writers had been key participants in the international modernist movement from its beginnings. At the same time, though, it had to rebut accusations that American culture was stratified, that whereas cultural and economic elites might patronize challenging art and literature, the vast majority of US citizens were satisfied with the most disposable cultural products. Add to that task the subtle imperative to recast modernism—indeed, all of the arts—in the rhetoric of freedom and individualism as well as the fact that VOA's audience was much broader than the audience for *Encounter* or the art program, and the result was unsurprisingly an innocuous, inoffensive, surface-deep picture of modernist art in the United States.

Furthermore, what differentiates these VOA scripts from the materials covered in the rest of this book, even the promotional materials surround-

ing the art shows and World's Fair exhibits, is their ephemerality. Although they were, to be sure, carefully written and edited and vetted in New York (or, later, Washington) and then refined further by the national VOA desks in being translated for their target language audiences, they quite literally diffused into the air upon being read. As radio stories, they were not printed or circulated in any permanent form. These scripts lacked the analytical language of the scholar or the caution of the cultural diplomat; their inflection was the upbeat voice of midcentury American broadcast journalism. Because of that, the VOA features are more valuable in the aggregate than in individual examples, few of which say much of interest (or incisiveness or even opinion) about their subjects. *Amerika* is similar, although as a physical object certainly not as fleeting; its articles, read as a group, express a kind of middlebrow boosterism, high-minded but never highbrow.

That said, it is instructive to see how VOA described these difficult writers' and artists' work and lives in a way that both was informative and advanced American national interests. The treatment was, for the most part, rather shallow, which was probably appropriate for a general-interest radio broadcast, but at times some key themes of the Cold War modernist project emerged, in particular those that undermined the image of radical or rarified modernism. In one of the earliest examples, dating from before Eisenhower's reorganization of the agency, Robert Hillyer profiled Amy Lowell as a signal example of American leadership in poetry, praising her imagism, sneering at T. S. Eliot's personal evolution ("as though the *Mayflower* had sailed home again"), and insisting that the United States had a vibrant and healthy poetic tradition entirely apart from that forged by modernists such as Eliot and Pound. A story about John Dos Passos's gold medal from the American Academy of Arts and Letters perceptively quoted Malcolm Cowley's observation that Dos Passos was "two novelists at war with each other"—the modernist aesthete and the realist offering social commentary—that the latter had won. Insurance-company lawyer Wallace Stevens was an "almost complete refutation" of the image of "poets as recluses, preferably starving in garrets." At his 1956 Minnesota lecture, T. S. Eliot drew "the largest [audience] ever to hear a poet in person—almost fourteen thousand persons," unsurprising for a poet whose play *Murder in the Cathedral* "is presented periodically by our colleges

AMERICAN MODERNISM IN AMERICAN BROADCASTING

and little theater groups." (In this story, Ed Gordon attempted the difficult task of explaining that Eliot actually *opposed* the New Critical method so often associated with him and thought one should not overinterpret but just read for pleasure.)[47] And in *Amerika*, Karl Shapiro emphasized the theme of individualism, especially visible in the "American poet's concern for the fate of the defenseless individual."[48]

To be fair, the VOA *Forum Lectures* volume on contemporary American poetry, appearing in 1965, treats modernist and contemporary poetry more deeply and analytically. Extended essays by such distinguished contributors as Marianne Moore, Howard Nemerov, John Berryman, Robert Duncan, and May Swenson address questions such as "Has there been a 'revolution in poetry,' or is all that a matter of a few sleazy technical tricks?" and "Does the question whether the world has changed during this century preoccupy you in poetry?" These "lectures," though, were, as I have stated before, not part of VOA's coverage of the arts, and most of them aired after 1959, the end of the time period covered in this study.[49]

VOA's treatment of William Faulkner deserves particular attention, both because Faulkner was so visible in the official cultural-diplomatic effort and because, as a consequence, VOA covered him often. As was true in the book programs and in Faulkner's trips abroad, the ancillary materials surrounding Faulkner (articles and films about him, radio features, tip sheets for USIA librarians and cultural officers, and so forth) portrayed him primarily as a humanist and a regionalist. These he certainly was; however, it had become increasingly clear by the late 1940s that Faulkner's importance to modernist fiction was second only to Joyce's. Although both Don Agger and Ed Gordon produced short features on Faulkner in 1956 and 1957, Harry Sylvester's 1955 assessment of Faulkner's accomplishments exemplified the effort to acknowledge Faulkner's very difficult and very experimental works while still insisting that his novels are humanistic and accessible to middlebrow audiences: "His triumph is a triumph of nonconformism . . . and yet he is a traditionalist. This apparent paradox may be described thus: Faulkner believes in the aims of traditionalism. But he does not believe that the conventional or accepted means of achieving these aims are the best for doing so. He has a highly developed sense of social morality and personal obligation. Or, to put

236

it another way—he believes each individual has an obligation toward society." Sylvester continued by explaining that the theme of *A Fable*, Faulkner's most recent novel (a retelling of the Christ story set in the World War I trenches) is "identical" with that of his famous Nobel Prize speech that VOA broadcast repeatedly. And although Faulkner is "almost magnetically drawn to the disagreeable, the violent, the sordid," his works are fundamentally moral, deeply rooted in a humanistic understanding of the worth of the individual in confrontation with the past, the eternal wild, and "the wilderness of empty and unfeeling minds."[50]

If Faulkner was treated as a regionalist, several other eminent modernists contributed their own kind of regionalism to VOA. Beginning in July 1955 and continuing sporadically for several years, a few modernist writers— most of whom would have been obscure not only to VOA's European audience but also to the majority of American readers—recorded impressionistic descriptions of their hometowns and cities. The point here presumably was to advance the VOA objective of conveying the flavor of everyday American life to its listeners, while also signaling to culturally sophisticated listeners who *would* know these names that American modernists were not alienated, not outcasts. Modernists loved America—or at least their own slice of the country. Wallace Stevens described Hartford, Connecticut, not "in a purple light" but in late winter grays, and Kenneth Rexroth's portrait of San Francisco stressed not the city's memorable hills and bay but the nearby Sierras and the ethnic variety and tolerance of the population: "it would be impossible for an anti-Semite to get a public hearing," Rexroth boasted—"nobody would come." Both William Carlos Williams and Marianne Moore talked obliquely about Manhattan's magnetism while focusing on the charms of their homes on the periphery of the great metropolis (Rutherford, New Jersey, and Brooklyn). All of these casual features, though, emphasized the *diversity* of these places, the fact that their residents come from all over the world. Stevens, in fact, improbably averred that there are no "foreigners" in New England— "once you are here you are—or you are on your way to become—a Yankee."[51]

Although VOA treated modernism respectfully, it saved some of its highest praise for works straddling modernism and the middlebrow, inhabiting the space that Dwight Macdonald so witheringly anatomized in essays such

as "By Cozzens Possessed" and "Midcult and Masscult." Among these works was Archibald MacLeish's verse drama *J.B.*, a retelling of the Job story set in a shabby circus tent that is largely forgotten and rarely produced today. But VOA ran a breathless feature on it in May 1958, asking whether this new work (which, staged by the Yale School of Drama, had just ended its initial run in New Haven) was perhaps "a modern classic[.]" VOA's enthusiasm is not surprising, given that Yale's production was to appear at the upcoming Brussels World's Fair, but a year later the broadcaster doubled down on its praise in a story on MacLeish's Pulitzer Prize. To be fair, the play had earned effusive plaudits from critics both mainstream (Brooks Atkinson, Kenneth Tynan) and highbrow (John Ciardi, Dudley Fitts), but in retrospect the VOA stories seem over the top in their exaltation of it, which Atkinson's called "one of the memorable works of the century as verse, as drama, and as spiritual inquiry." Thornton Wilder, another of Macdonald's targets, earned his own fawning profile on VOA in January 1958, coinciding with the American television dramatization of *The Bridge of San Luis Rey*.[52]

These features epitomize the assimilation of modernism into the mainstream. Although not downplaying—in fact, emphasizing—the works' unconventional formal features such as the verse dialogue in *J.B.* and the metatheatricality of Wilder's *Our Town*, the narrator reassured listeners that they are *not* works with radical messages. Quite the contrary: the message of *J.B.*, according to Ciardi, is the triumph of humanism. The Wilder profile as well insisted repeatedly that his works are "universal," that Wilder possesses a "deep sense of the universal in the history of mankind." Wilder is also on message regarding the importance of the individual, and the feature quoted Malcolm Cowley explaining that Wilder is a "novelist of morals rather than manners. . . . Morals would be defined as the standards that determine the relations of *individuals*, one with one . . . and also the relations of any man with himself, his destiny, and his God. . . . They are the answers found by individuals to the old problems of faith, hope, love or charity, art, duty."[53]

The USIA had in fact sponsored productions of Wilder plays abroad, including *The Skin of Our Teeth* (starring Mary Martin) at the 1955 Salute to France festival in Paris. Thanking Martin for her performance, Secretary of State John Foster Dulles wrote that "the Department has become increas-

ingly aware of the importance of exhibiting abroad outstanding representatives of American theatre, dance and music. . . . Such an activity not only enhances the cultural prestige of the United States in other countries but, in general, builds and strengthens good will and understanding for our country." Martin agreed and expressed surprise and disappointment at the concerns of "some officials" that Wilder's play was too experimental and challenging.[54]

Robert Frost in many ways is the inverse of Wilder and MacLeish. He largely avoided modernist formal techniques, famously referring to free verse as playing tennis "with the net down," and in that sense was rarely identified with the modernist movement. Such seemingly simple poems as "Stopping by Woods on a Snowy Evening" and "The Road Not Taken" had already, by the 1950s, become widely beloved even by readers who generally avoided poetry. And unlike Wilder and MacLeish, who cultivated their public images as high-achieving, deeply engaged artist/intellectual/public servants, the public knew Frost, at least by the 1950s, as a gruff, white-haired New England farmer who might be coaxed, on occasion, to "say" a few poems. But Frost's poetry, when one reads it attentively, resists the middlebrow image that had accreted around it: it is dark, often unsettling, and it questions the easy humanism that the Cold War modernist project sought to foreground in modernist artworks. For that reason, the several features on Frost that ran on VOA in the late 1950s seem much less engaged with Frost's actual *work* than do the features on many other writers. In three segments (which recycled much of their copy), the narrators recounted the expected details about Vermont winters, Frost's flinty plainspokenness, and his modest and gradual rise to prominence in the American literary world, but they talked little about his poems.[55]

Stories on Willa Cather, Thomas Wolfe, and Carl Sandburg, writers whose connections to modernism are much less obvious than those of Faulkner or Moore or Stevens, similarly focused on aspects of the writers' lives and work that would be most appealing to an audience unfamiliar not only with their writing but also with American culture in general. A 1956 story on Cather's *Death Comes for the Archbishop* stressed the novel's serious treatment of religious faith but also the "sense of freedom and release" that "still can be found in our southwest," the setting of the book. Ed Gordon perhaps inadvertently underscored the evanescence of Thomas Wolfe's literary reputation in saying

that he "illuminated the American literary scene of the nineteen-thirties like a flash from a thunderbolt." He aptly captured Wolfe's fevered romanticism but still brought the profile back to the Cold War mission: relating the writer to American culture so as to enlighten foreign listeners. "'I think the true discovery of America is before us,'" Gordon quoted Wolfe as saying. "'I think the true fulfillment of our spirit, of our people, of our mighty and immortal land, is yet to come... certain as the morning, inevitable as noon.'" The profile of Sandburg, which unsurprisingly stressed his Chicago roots and his popular biography of Abraham Lincoln, also pointed to Sandburg's connection with the modernist *Poetry* magazine in its heyday and then quoted Sandburg extolling the virtues of being a writer in America: "'Under no other system can a man be so many different kinds of a fool and get away with it. . . . Personal freedom, a wide range of individual expression, a complete respect for the human mind and the human personality—this is the ideal of the democratic system.'"[56]

Coverage of contemporary literary culture in general (apart from news briefs on the Pulitzer Prize winners) was rare, but the VOA script archive holds some surprising stories. A 1958 feature on the Beat Generation couldn't decide if it wanted to be condescending or to take the movement seriously. Quoting Kerouac's garbled explanation—"'Beat means beatitude, not beat up. You *feel* this. You feel it in a beat, in jazz—real cool jazz or a good gutty rock number'"—the narrator reassured listeners that it is natural for Kerouac's language to seem "vague and unclear," for it is "a pictorial language . . . like non-objective art." And if the Beats seem self-destructive and shallow, Don Agger's script suggested, we should keep in mind that "the very last thing which a person who believed only in the fleeting sensations of the moment, and had no faith in the future, would do, would be to write a book." Similar notes emerged in 1959 stories on J. D. Salinger and Tennessee Williams (VOA had broadcast the American National Theater and Academy's production of *The Glass Menagerie*). If American youth culture has some surprising depths, these stories asserted, so does the American Midwest, a region too often tarred with philistinery and cultural conservatism, and this is particularly evident in the enduring importance of the journal *Poetry*. D. C. Levine's story on the magazine repeatedly stressed that Chicago, not cosmopolitan New York,

is the "poetry center of America." American readers get the best of contemporary world literature as well, a feature on the magazine *New World Writing* told listeners: the magazine has featured work by authors from twenty-eight nations, including Austria, Korea, India, and Romania. But unlike the coterie "little magazines" of the modernist moment, this one is popular, boasting a circulation higher than 100,000.[57] Karl Shapiro, writing in *Amerika*, similarly framed little magazines as an international modernist phenomenon that promoted "the philosophy of individualism" not only in their contents but in their very titles: "*Egoist, Others, Phoenix, The Wild Hawk, The Fugitive, Exile . . .*"[58]

Stories about critics' arguments also tended to echo comfortable middlebrow themes and humanist arguments about literature. A feature on critic Van Wyck Brooks, the dean of American literary historians, approvingly noted Brooks's impatience with "the 'new' critics who are obsessed with pure formalism rather than with literature's bond with the life of men" and his commonsensical, humanistic insistence that literature has a public function. In 1959, VOA gave a platform to critic Edmund Fuller, who blasted the dead-end, violent, brutal heroes of contemporary writers such as Norman Mailer, Jack Kerouac, James Jones, and Tennessee Williams and called for a return to the classic "Dostoyevskian" themes of "good pitched against evil with the author taking sides." Also that year, VOA summarized the *Harper's* symposium "Writing in America," focusing on the arguments presented by Alfred Kazin (who lamented the current state of fiction that emphasized alienation above all things and avoided social themes), Budd Schulberg (who boasted that he was breaking down the assembly-line model of the Hollywood studios and "making the writer more important than the stars"), and young poet Stanley Kunitz (who, echoing *Encounter*, acknowledged the overwhelming weight of the modernist legacy and dismissed the Beats but pointed to poets such as Roethke, Eberhart, and Lowell as inspiring models).[59] Glick, writing in *Amerika* on "trends in the modern American novel" in 1960, offered up unremarkable explanations for the evolution of American fiction: the migration from small towns to the city, disillusionment due to war, "personal liberation" in Fitzgerald, "the search for human dignity" in Hemingway, social reform in Farrell and Steinbeck as well as in—almost the only mention of African American artists in *Amerika*—Ellison and Baldwin and Wright.[60] (*Amerika*,

it bears remarking, did accompany Glick's article with short excerpts from several of the writers mentioned, as well as from Faulkner, Wolfe, Dos Passos, and Sinclair Lewis.)

Outside of literature and painting, VOA tended to profile artists who had fundamentally changed the contours of their chosen art form, often through modernistic formal techniques and stubborn devotion to an individual vision. Refuting the idea that popular acclaim is the only reward American artists seek, these features also pointed to the difficulty of their subjects' work and the criticism they endured. Several stories on Frank Lloyd Wright emphasized his self-regard and prickliness, and one even quoted a critic of the Guggenheim Museum saying that the building diminishes the pictures exhibited therein, and the pictures diminish the building. Martha Graham lost her desire to be a virtuoso of the conventional repertoire and forged a new kind of dance that is not always inviting or pleasant for the spectator. Detractors dismissed Alexander Calder's "radical experimentation" as "sheer sensationalism and novelty for its own sake." Eugene O'Neill's *Long Day's Journey Into Night* is pessimistic, and Alfred Steichen's photographs don't shy away from ugliness, even in the wildly popular *Family of Man* set exhibited at the Sokolniki Park exposition. But each of these artists, the scripts made clear, had followed their muses and made challenging art of enduring value. Taken as a whole, these profiles centered on American artists as brave individualists, innovators who had not withered under critical and popular attacks, which placed them squarely in the tradition of modernist self-representation.[61]

No discussion of Voice of America in the 1950s can ignore Willis Conover's series *Music USA*, airing for two hours six times a week beginning in 1955. *Music USA*, VOA's most popular program worldwide, made Conover an international celebrity and brought American jazz to the world. Although Conover scrupulously avoided sending out any messages that could be interpreted as propaganda, he understood that VOA was intended to serve policy interests. It was, in Conover's own words, "the most effective tool in Western efforts to challenge Soviet hegemony over Eastern Europe and in the USSR itself."[62] That said, as late as the 1980s VOA officials insisted that Conover was not a propaganda organ, except incidentally. If we denounce *Music USA* as part of a propaganda campaign, asked a VOA official, "should we therefore

denounce Charlie Parker, Benny Goodman, and Art Tatum and other jazz artists as propagandists?"[63]

While Conover disseminated and popularized jazz music, VOA's news and feature programming did the work of *contextualizing* jazz within the larger cultural firmament: Was it disposable pop music, or was it a more serious art form, worthy of respect from those European intellectuals who disdained the United States? VOA scripts generally aimed for the middle, referring to jazz as an "art," while emphasizing that it is highly popular (and, implicitly, not elitist or highbrow). Jazz did not arise among self-consciously rebellious artists, as modernism did, but these features argued that this demotic genre is evolving toward modernism and highbrowism while maintaining its popularity. Jazz has a "universal appeal"; it is both a "popular art" and increasingly marked by "highly complicated contrapuntal techniques" and collaborations with composers of "serious music." A 1958 profile of George Gershwin stressed the highbrowism of jazz, referring to Gershwin as a "composer" (rather than a "songwriter"), and noting that "from the beginning, jazz was Gershwin's chosen idiom." Gershwin himself explained that "jazz . . . uses the same notes as Bach used. . . . Jazz is the result of the energy stored in America. . . . I regard jazz as an American folk music [that] can be made the basis of serious symphonic works of lasting value." The evidence of this claim, the program proposed, is that "in recent years Gershwin has received more performances by American symphony orchestras than have such world-famous personalities as Stravinsky, Bartok, Milhaud, Shostakovich and Hindemith." These features also reiterated, while flipping on its head, the Cold War modernist argument that American modernism was just one strain of a larger transatlantic cultural movement that had begun in Europe. A feature on Nat Hentoff's jazz history *Hear Me Talkin' to Ya* explained that although jazz is very American in its origins, born in New Orleans before moving to Memphis, Chicago, Kansas City, and New York, "the jump to Europe was not a great one," and Paris had become similarly important in the genre's continuing evolution. A synopsis of a different book explained jazz as "the result of a three-hundred-year blending in the United States of two great musical traditions, the European and West African." And, of course, jazz is about freedom, "the free expression which is a part of all of us as human beings."[64]

One major work in particular had come to embody jazz's melding of popular, folk, and serious music, and because of its artistic success, wide appeal, and frequent performances in Europe, received heavy coverage by VOA. George and Ira Gershwin's "folk opera" *Porgy and Bess*—in a production with William Warfield, Leontyne Price, and Cab Calloway in the lead roles—began a tour of Europe in the fall of 1952, and for the next few years audiences across western Europe as well as in Prague, Warsaw, Zagreb, and Moscow had the opportunity to hear this unique work in several separate touring productions sponsored by the State Department. Although *Porgy* cannot truly be described as a modernist work, modernist elements certainly inhabit the opera's bones: the mixing of high- and lowbrow; the presentation and use of "primitive" genres (such as the spiritual) in a high-cultural context; and the influence of jazz on the score. Moreover, in the coverage of and publicity surrounding the show, American cultural diplomats explained it in some of the same terms they used to describe more strictly modernist works. A June 1955 *Arts and Letters in the U.S.A.* feature—airing when a *Porgy* production was between London and Brussels engagements—explained that the show was an example of how American musical theater was no longer invariably "light and frothy" or "tongue in cheek." These new, more serious musicals were more properly called "dramatic spectacles," it stated, incorporating "the best elements of serious theater, ballet and opera" and "meaningful theme[s]." The message here to European audiences was that the new American musicals (including *Porgy*, *Pal Joey*, *Of Thee I Sing*, *Carousel*, *South Pacific*, *Oklahoma!* and even *The Pajama Game*) weren't chewing gum and cowboy movies; these shows were examples of particularly American innovations in high culture.[65] Furthermore, the very criticism of the opera as an unsuitable or counterproductive depiction of the United States ("This thirty-year-old version of fictional Negroes living in a fictional 'Catfish Row'? Wouldn't *Porgy and Bess* give the wrong impression?") offered the chance to reinforce formalist modernist *interpretive* practice. "'In the realm of art,'" VOA commentator Leonard Reed quoted Atkinson as saying, "'nothing matters so much as the quality of the art—which in the case of the Gershwin opera is magnificent. People who take a literal attitude toward it are as impervious to culture as the Soviet bigwigs who haggle over every detail in Russian plays and fiction, trampling down any spontaneity an author

FIGURE 6.3 Poster for the 1956 production of *Porgy and Bess* in Moscow. Special Collections and Archives, George Mason University.

may have inadvertently contributed to a work of imagination.'"[66] Eisenhower himself lauded the *Porgy* tours, pointing out their "fabulous success" to the Senate as he requested a special appropriation for cultural diplomacy in August 1954.[67]

Porgy did double duty here. It was a "uniquely American opera . . . steeped in the rhythms of American jazz,"[68] rapturously received by the sophisticated, jaded audiences at operatic shrines such as La Scala, La Fenice, and San Carlo, but it also provided the opportunity for American cultural diplomats to refute arguments about pervasive American racism. Although the setting of *Porgy* did little to undermine such accusations (as one commentator fretted in the quote given earlier), the fact that a State Department–sponsored, "all-Negro" company toured Europe with this demanding symphonic work, the cultural diplomats internally assured themselves, would at least show that most of America did not share the ugly racism and bigotry on display in such news events as the Little Rock high school integration. Robert Breen, *Porgy*'s producer, observed to VOA that "the American company's recent visit to the USSR helped to mitigate Soviet suspicion and misunderstanding" of the American racial situation.[69] But *Porgy* wasn't the only tool to rebut arguments about racism. VOA profiled African American sculptor John Rhoden in March 1956, and a 1959 story on Lorraine Hansberry's play *A Raisin in the Sun* hit the same notes as the *Porgy* coverage, not shying away from the play's subject matter—white flight and residential segregation in the North—but stressing that in the United States, even "Negroes" could present these issues without rage and with great artistry: "this is not a Negro play, but a play about honest-to-God, believable, many-sided people who happen to be Negroes."[70]

Indeed, the official line on race relations in the United States was melioristic: they were a problem at some times in some parts of the country, but because of (federal) government action the problem was gradually improving; and, furthermore, it was nowhere near as bad as Communist lies alleged. VOA news stories and features echoed and amplified this narrative. In October 1953, VOA reported that "six outstanding American Negro leaders" sent a letter of protest to Premier Georgi Malenkov in response to *Silver Dust*, a Soviet film about American capitalists and generals testing a new weapon of mass destruction on black Americans. The following week VOA crowed

that "the next president of the borough of Manhattan will be a Negro." A 1954 series of stories, whose conclusions fall somewhere between Pollyanna-ish and farcical, discussed "the Negro in America today." Among the notable assertions here are that "where school integration has begun . . . the transi-tion has been astonishingly smooth" and that in the "overwhelming majority of schools . . . white–negro integration is proceeding without a hitch." The story stipulated that the Deep South was different, but that even there change would certainly come soon, led by a wise federal judiciary. Several follow-up stories to this one focused on a *Collier's* article by South African novelist Alan Paton, also titled "The Negro in America Today," in which Paton made the same argument: racism in the South is a problem, but *Brown v. Board of Education* is a significant political and moral step forward for America, and segregation is certainly dying.[71]

These reassuring refutations of the most devastating attacks on American hypocrisy echoed the same arguments made in the book programs and the exposition program (most notably the withdrawn Unfinished Work exhibit from Brussels). They also remind us that like the book and exposition pro-grams, Voice of America was at its core a propaganda operation, whose cover-age of the arts had to serve a greater master. For all that *Encounter* and *Perspec-tives USA* paralleled the official cultural-diplomatic outlets in their messages about modernism and freedom and individualism, for them those messages were the *end*, not the *means*. Voice of America, in contrast, quite transpar-ently used its relatively scanty coverage of modernism to advance the larger goals of fostering goodwill toward the United States in foreign populations, defusing charges that the United States lacked serious culture, and eroding listeners' confidence in Soviet assertions and intentions. Modernism here was embroiled in internal American political and cultural dramas: partisan fights about economic regulation, the struggle over self-definition (are we a nation of rural small towns populated by white yeomen or of modern cities with wildly diverse populations?), and, most fundamentally, both the celebration of and the resistance to the dominance of the tastes of the middle class—the middlebrow—in our cultural life.

At the same time, American modernist art as presented in VOA news and feature programming was, to be frank, banal and unremarkable; unlike

the art shows or the books featured in the translation programs and libraries, this programming did little to explain why anyone would find experimental modernist art *interesting* or even different from the styles that preceded it. The proof of its value is esteem: Pulitzer Prizes, awards from the American Academy, its practitioners' status as elder statesmen or stateswomen of poetry or novel writing or composing or architecture. Macdonald, Greenberg, and other critics of the time (followed in their turn by contemporary scholars such as Joan Shelley Rubin and Catherine Turner[72]) pointed out that part of what defines the middlebrow is that it is what middle-class audiences like because they *should*—because it is prestigious and good for them and because associating oneself with that art brings cultural capital; any deep engagement with the artwork itself is ancillary, nice but not necessary. In VOA's programming, modernism was precisely that: valuable because it was prestigious and memorialized and lauded by mainstream institutions of culture. Rarely did VOA's programming point out—except when the theme was the determined individual artist's struggle against a conservative establishment—that what brought that prestige and cultural standing to these artists and artworks was their formal innovation, their experimentation, their challenge to realist representation. Modernism, then, here truly had become just a style, a set of formal features marking some artworks as distinct from others, their formal innovations so familiar that they did not even require identification or explanation.

CONCLUSION

THE END OF the Eisenhower era, then, largely marks the end of the Cold War modernist project. The Kennedy administration did not abandon art and literature as tools of cultural diplomacy, but its focus shifted away from unidirectional informational programs to contacts between individual citizens. Person-to-person cultural exchange had been taking place since 1946, when the Fulbright Act (Public Law 584) authorized the use of funds from the sale of post–World War II surplus properties abroad to finance international educational exchange programs. The Lacy–Zaroubin Agreement between the United States and the Soviet Union in 1958 expanded the number of citizens of each nation visiting and learning about the other, and in 1961 the Mutual Educational and Cultural Exchange Act (also known as the Fulbright–Hays Act) established the Bureau of Educational and Cultural Affairs in the Department of State, dramatically increasing the number and scope of cultural-exchange programs. Eisenhower had been particularly enthusiastic about cultural exchange and "people-to-people activity"; George Allen reminisced that Eisenhower had wished to "exchange ten thousand students a year with the Soviet Union. Let their students come to this country and see what freedom is like."[1] Nonetheless, USIA and information programs overshadowed person-to-person cultural diplomacy under Eisenhower. But after J. William Fulbright ascended to the chairmanship of the Senate Foreign

Relations Committee in 1959, and Kennedy came into office in January 1961, exchange flowered. From this point on, the main energy in cultural diplomacy moved away from official agencies such as the Department of State and the USIA and instead toward what people such as Muna Lee had defined it to be in the first place: contacts between citizens.

In addition, Kennedy's inauguration marks the end of the Cold War modernist project because, in essence, it had succeeded with its most important target audience. No longer did the United States have to woo European leftists away from the Soviet Union; by 1960, after Soviet tanks extinguished reform in Poland and Hungary, only the most die-hard Communists still harbored illusions about the true nature of the Soviet state. Whatever internal Communist threat that had existed in western Europe in 1946 dissolved: the Italian Communist Party, the West's largest, retained its size and its local influence (particularly in central Italy) but after the 1948 elections never threatened to take power nationally, and in France the French Communist Party marginalized itself electorally and in May 1968 even alienated the student radicals, calling them "false revolutionaries." Anti-American prejudice still thrived among European intellectuals, but their loyalties in the great conflict were no longer in doubt. Europe's bipolar equilibrium, which had seemed so precarious in 1946, 1953, and 1956, had stabilized.

Without culturally sophisticated western European leftist intellectuals as the target, both the content and the means of cultural diplomacy changed. Modernist art and literature lost importance, and efforts aimed at more popular audiences such as low-priced books, textbooks, radio, and films ramped up. The dynamic theaters of the Cold War shifted to what was then called the "Third World"—client states and proxy wars and low-intensity conflicts in Latin America, the Middle East, Africa, and of course Southeast Asia. The same public and private agencies—USIA, the Ford Foundation, the CCF—still sought to persuade elites in those places to side with the West and against communism, but the concerns and interests and tastes of intellectuals and opinion makers in those parts of the world were very different. American cultural diplomats had to deal with an entirely new set of issues, such as the push for decolonization and the legacy of colonialism, the appeal of communism to populations suffering from dire poverty, and the challenge of communicating

with societies that had no common cultural or linguistic heritage with the United States.

Finally, Cold War modernism ended in the early 1960s because culture itself changed. Although the idea that Western society underwent an immediate and cataclysmic transformation as "the Sixties" began is overstated and obviously oversimplified, in this case the turn from the late 1950s to the early 1960s really did end the Cold War modernist project and with it the dominance of the pro-modernist consensus among intellectuals. Simply put, high culture quickly lost some of its importance as modernism shifted to postmodernism, and as George Kennan, James Laughlin, and the writers of *Encounter* feared, the appeal of camp and pop culture undermined the seriousness of the highbrow, even among intellectuals. Modernist art and literature moved to the universities, where the New Critical method of formal, quasi-scientific analysis of the workings of a poem still dominated. Outside of the academy, though, the new cultural consensus of the New Critics and New York Intellectuals gave way to the playfulness of Roland Barthes and Susan Sontag. Younger artists in almost every genre abandoned modernism. For many who had resented the modernists' oppressive weight, its end was welcome. The Middle Generation of poets—John Berryman, Randall Jarrell, Robert Lowell, Elizabeth Bishop, and others—consciously rejected their modernist ancestors' impersonality and desire to impose a transcendent order and coherence on the world, choosing instead to focus on emotional straightforwardness and engagement with the minor experiences of living in the world. As Lynn Keller writes, the generation that followed modernism "doubt[s] the value of constructing order and creating controlling patterns. In their eyes the modernist insistence on coherence constitutes an evasion of the immediate experience that art is supposed to capture."[2] These Middle Generation poets as well as the "confessional" group and Beats such as Allen Ginsberg and Lawrence Ferlinghetti resurrected the poem as a direct expression of the poet's experience. At the other extreme, the postmodern fiction of John Barth, Donald Barthelme, Robert Coover, and others stressed "metafictionality," or the idea that there are *only* stories in the world, and a school of poetry stemming from modernist precursors Williams, Stein, and Louis Zukofsky foregrounded not language's ability to communicate a speaker's meaning, but the independent existence and operation of language

itself.[3] Austere abstract expressionism's dominance faded in the visual arts, and the movement evolved into pop art and minimalism, while many younger artists began exploring entirely new forms—conceptual art, performance art, film and video art, earth art. Leslie Fiedler saw artists of the late 1950s returning to sentimentalism, "joyous misology and prophetic irresponsibility," "distrustful" of the "self-protective irony" that marks modernism. Critics of the new era, he hoped, would be "comical, irreverent, vulgar."[4] Modernism's veneration of form and structure was crumbling.

Writing in 1979, Jean-François Lyotard identified this preoccupation with form—which Cold War modernism only intensified—as a key point of distinction between modernism and postmodernism. Modernism is an aesthetic of "the sublime" in which perceivers receive pleasure from the sense that an intelligible, understandable form imposes order on sublime experiences of "pleasure and pain," reason and sensibility. Postmodernism, though, "denies itself the solace of good forms. . . . The artist and the writer . . . are working without rules in order to formulate the rules of *what will have been done.*"[5] Modernism foregrounds form in its search for new means of more accurately or impressionistically representing experience, but the tension between experiment and form always provides a coherent structure that the viewer or reader can perceive and decipher. Postmodernism, however, jettisons preexisting form entirely and seeks not just for new ways of representing experience but for new, non-rule-bound ways of *structuring expression.* Without form and structure, then, hierarchy means nothing. In *Utopia Limited*, Marianne DeKoven argues that whereas modernism is characterized by "sincerity, originality, authenticity, aura, depth, reality, and directionality," postmodernism offers "a pervasive irony, a pervasive culture of the commodity, the image, and the simulacrum." Confirming the modernists' fears that cultural strata were being flattened and becoming permeable, she notes that "the high culture and avant-gardes of modernity and modernism have been not so much supplanted by as absorbed into postmodern egalitarian, popular indifferentiation, 'sampling,' 'versioning' pastiche: the open-ended, free mixing of previously distinct modes of cultural practice and form. . . . Popular culture, vehicle and expression of postmodern egalitarianism, is no longer meaningfully distinct either from high culture or from consumer culture."[6]

Fiedler and DeKoven identify precisely what the grim modernists of *Encounter* were predicting. The seriousness of modernism, its celebration of the alienated artist misunderstood by and hostile to bourgeois society but responsive to aesthetic standards, was giving way to the dissolution of aesthetic hierarchy and an accommodation with or even celebration of bourgeois society and its commercial culture. With this shift, all of the stylistic attributes of commodity culture, from sentimentality to shallowness, were becoming hegemonic. Worse, the end of modernism marked the end of "the happy assumption of the inherent relation of reason to freedom," as C. Wright Mills feared,[7] and would result in a "postmodern society of blind drift and empty conformity."[8]

Even before the 1960s began, VOA had begun to identify some of these incipient changes and some of the new voices who were rejecting high modernist aesthetics. The August 1958 VOA feature "The 'Beat Generation,'" for example, wavered between scorn and something nearing respect: the language of the Beats is "a special one which cannot really be taught," the feature commented, because it is the expression of "the phenomenon of youth in rebellion." The "essentially conservative" *New York Times* praised Kerouac's *On The Road*, the VOA script admitted, but then it quoted Norman Podhoretz's attack on these young men "spiritually underprivileged [and] crippled of soul" in his well-known "Know-Nothing Bohemians" essay.[9] Like Podhoretz, like *Encounter*, here VOA grappled with what would soon become the youth culture, the advance guard of the movement that would turn its back on high modernist seriousness and call for an "erotics of art," as Sontag put it.[10] Was this Beat Generation a good thing (an expression of freedom) or a bad thing (confirmation that American consumerism was ending in thrill-seeking nihilism)? VOA wasn't certain and so offered up this question for the critics. A feature on J. D. Salinger the following year struck many of the same notes, noting that the reclusive, relatively unproductive Salinger had been dubbed the "spokesman for a generation," but wondering why: Was it the self-pity, the "interior monologue[s] of the most vulgar and gutter language," the rebellion that older critics saw as self-indulgent immaturity? Like Bob Dylan's Mr. Jones only seven years later, here VOA knew something was happening but didn't know what it was. (*Amerika* was more sympathetic to Salinger, with

Granville Hicks identifying Salinger's main theme as "how to reconcile high moral and intellectual standards with tolerance and love."[11])

At the same time, many of the intellectuals, particularly among the New York Intellectual and *Partisan Review* group, began questioning the value of modernism. Daniel Bell, Irving Kristol, Norman Podhoretz, Hilton Kramer, Roger Kimball, and other neoconservatives saw modernism behind the frightening social upheavals of the 1960s: Podhoretz's mentor Lionel Trilling, for example, called the 1968 student takeover of Columbia University "modernism in the streets," and Bell's *Cultural Contradictions of Capitalism* portrayed modernism as an unstoppable force eroding away all cultural value and certainty. Antibourgeois modernism lay behind what Trilling dubbed "adversary culture" or what later was called the "counterculture" (although Bell drew a distinction between the two, stipulating that the "adversary culture" was fundamentally serious, whereas the "counterculture" was merely hedonistic). Certainly, not all of the prominent members of this group moved right; Dwight Macdonald, for one, would have been horrified to be called a neoconservative, and, indeed, in the second great crisis that tested these people's loyalties (the rise of the New Left in the 1960s in response to the Vietnam War) Macdonald placed himself firmly—and physically, as in the famous photo of him in front of Alma Mater during the 1968 occupation of Columbia University—with the hippies. Norman Mailer, too, publicly sided with the New Left on many issues while still vocally supporting modernist-influenced aesthetic hierarchies, calling himself a "left conservative." However, most of the other veterans of the anti-Communist fight of the 1950s were just as solidly on the other side, and many of them had become vocal supporters of Nixon's policy in Vietnam and his law-and-order stance.

The art critic Hilton Kramer, who worked for the *New York Times* throughout much of the 1960s and 1970s before leaving to found the *New Criterion*, perhaps best expressed these neoconservatives' disillusionment with what modernism had wrought, particularly as the frivolity and (in their view) pointlessness of postmodern art began to pervade the New York galleries. Kramer admired the great modernist painters—Cezanne, Picasso, Miró, Mondrian, Matisse—because of their "high purposes and moral grandeur" and saw their culmination in the New York school of abstract expressionism,

painters "who revitalized a fading and nearly moribund modernism by giving it new vigor, complexity, and graphic expressiveness." Like Trilling, his counterpart in literary criticism, Kramer was a pro-modernist but opposed the "facile extensions of modernism" of the 1960s and shared Trilling's distaste at how late modernism and postmodernism had moved from high seriousness to parody, pastiche, and amorality.[12] Indeed, after representing the very antithesis of Marxism during the Cold War modernist period, modernism again became linked with communism. In 1999, Kramer, quoting Raymond Aron, observed that "'the two avant-gardes'—Marxism and modernism, the dream of a socialist utopia and the promise of unending innovation in the arts—have . . . shaped the agenda of modern intellectual life."[13] Throughout his collection *The Twilight of the Intellectuals* and other writing of the 1980s and 1990s, Kramer yokes together radical leftism and modernist or avant-garde art, frequently in an attempt to condemn what he sees as their pervasive influence over the twentieth century. Both movements were "utopian"; both were totalizing theories of the world; both sought to tear down the existing structures and impose, instead, a dynamic and constantly self-reinventing way of living in the world (for Kramer, Stalinism and Trotskyism are scarcely distinguishable). After inspiring a wealth of genuine masterpieces for much of a generation, modernism's *productive* capacities had been exhausted, though. Only its unstoppable destructive force remained. In Kramer's writing, modernism's very drives were its downfall, and it would drag down with it all cultural standards themselves.

Other philosophers and critics, Marxists as well as liberals, have dismissed this diagnosis. Fredric Jameson and Jürgen Habermas agree that capitalism, not modernism, is ultimately responsible: "Neoconservatism shifts onto cultural modernism the uncomfortable burdens of a more or less successful capitalist modernization of the economy and society," Habermas notes.[14] And even many of the *Encounter* critics see capitalism's energies in the cultural field as both fecund and destructive. But if modernism was born from technology, from the profound changes that new tools brought to the ways people perceived and represented the world, we should not dismiss the role that technology—not some destructive force inherent to modernism and not just the logic of capitalist development—played in killing it.

Specifically, the early 1960s mark the advent of the age of the mass electronic media, particularly in the United States. The Telstar satellite, allowing live broadcasts from anywhere in the world, relayed its first broadcast signal in 1962, and the percentage of American homes with a television went from 9 percent in 1950 to almost 90 percent in 1960.[15] Modernist artists and intellectuals had despised, feared, but also at times embraced the earlier mass communications media, newspapers and radio and film. Television, though, was another matter entirely; in their eyes, it was a dire threat to the very existence of serious art and culture. As Perry Anderson puts it, television was "the first technological advance of world-historical moment in the post-war epoch. . . . What the new medium brought was a combination of undreamt-of power: the continuous availability of radio with an equivalent of the perceptual monopoly of print, which excludes other forms of attention by the reader."[16] Television would rot society's collective brain, it was argued; its rapid-fire images and insipid commercialism and endlessly repeated formulaism would make it impossible for viewers accustomed to that sort of media ever to give sustained, careful, critical attention to books, paintings, or other works of high culture. "It strikes me," James Laughlin wrote to Robert Hutchins in 1951, "that with about 20 more years of comic books, television, movies and LIFE magazine, American kids are not going to know how to read at all."[17]

The argument here, of course, is that the medium constructs its perceivers, that human minds are reorganized by the forms and conventions of the stimuli they receive. Clement Greenberg and Theodor Adorno had made such arguments about how fascist, Communist, and capitalist kitsch—films, sentimental radio programs, and insipid popular music, for example—was in fact designed to prevent individuals from being able to access and appreciate complicated works of modernist art (which, in its turn, inculcated cognitive habits uncongenial to those fascist, Communist, or capitalist regimes). Several influential scholars have posited that the advent of the age of print also fundamentally changed humans' understanding of the concepts of truth, the individual, and the nation. Elizabeth Eisenstein's *The Printing Press as an Agent of Change* contends that circulation in standardized printed forms made scientific truths somehow more "true," thus paving the way for the Enlightenment, and Marshall McLuhan argues that print and the possibility for

vast numbers of people to engage privately with written ideas made possible nationalism, democracy, and individualism itself.[18] Eric Havelock and Walter Ong, McLuhan's student, went back even further to argue that the transition from orality to literacy had profound effects on the development of individual cognition, interpersonal communication, and societal organization.

Although I cannot speak to the validity of Eisenstein's or McLuhan's or Ong's or Adorno's broad contentions, I do think that the shift—still very much in progress—from a print culture to a dynamic, electronic, image-based culture also bears responsibility for the end of the Cold War modernist project and the modernist era in general. Modernism in literature, for all of its engagement with machine-age technology, was fundamentally a print phenomenon. Similarly, modernist painting, in particular abstract expressionism, was essentially two-dimensional, concerned above all with the medium of paint on canvas. Much of modernism in the visual and literary arts concerned itself with the problems of capturing dynamic motion in a static medium. Although modernism was truly transgeneric, and there was modernist theater, film, music, and dance, in its most characteristic genres—painting, literature, photography—modernist art existed in print and in two dimensions. Moreover, to a great extent audiences learned about and engaged with modernism in all of its forms through print: posters, little magazines, manifestoes, small-press books, broadsides, magazine and newspaper advertisements, gallery flyers and catalogs, programs for theater and musical performances. This was also true for modernism's last stage, which I have documented here. Although radio and to a small extent film did serve as a means for disseminating Cold Mar modernism, it was overwhelmingly print that did the job, and modernism indeed made its last stand in print publications such as *Encounter*, *Evergreen Review*, *New Directions*, and *New American Writing*.

But as print itself became no longer the default medium for disseminating information, modernism found itself less suited for the job, less relevant for the time. The Cold War modernists saw their age closing and another one dawning, and they were gravely concerned that not just modernist art but the very ability of audiences to access and process and appreciate such challenging work would disappear. Here Adorno and Spender, Kristol and Greenberg found themselves in agreement. In an address to the CCF's tenth anniversary

conference in 1961, like the original held in a Berlin not yet rent by a con-
crete wall, George Kennan spoke to these cultural Cold Warriors' fears that an
age illuminated by television screens would be in fact a dark age—that mass
culture would simply extinguish audiences' desire for more sophisticated or
fulfilling or challenging art and culture. Pointing to "the cultural stimuli con-
veyed to great numbers of people by the centralized media of journalism, cin-
ema, radio, television, comic books," Kennan worried that "mass culture, with
its equalizing and standardizing influence, will gradually destroy the possibili-
ties of the continued existence, side by side with it, of another sort of cultural
life, operating on different standards, amenable to other means of control,
in need of other sources of support. The danger of modern mass culture, in
other words, lies not so much in that which it provides as in that which it
may crowd out and exclude." "It is possible," he granted, "that many of us have
exaggerated the manipulative power of these media—their power, that is, to
shape thought and behavior directly; and certainly in my own country, what
is occasionally surprising is not the sinisterness, but rather the innocence, in
some instances the childishness, of the motivation from which their func-
tioning has proceeded." Nonetheless, he reminded the audience, it was their
responsibility to ensure that the light of high culture was not extinguished.[19]

Kennan concluded his remarks by recounting an event from American
history, "New England's Dark Day," May 19, 1780, which brought an abnor-
mal and unexplained darkening to the midday sky. Many members of the
Connecticut state legislature, fearing that the end times had come, called for
an immediate adjournment, but Colonel Abraham Davenport, serving in
the upper house, imperturbably stated that "the Day of Judgment is either
approaching, or it is not. If it is not, there is no cause for an adjournment; if it
is, I choose to be found doing my duty. I wish therefore that candles may be
brought."[20] The age of mass culture may be here, Kennan told his audience,
and it may well spell the end of everything we stand for: cultural freedom,
modernist art, and the intellectual development of the human race. If that is
the case, we can do nothing about it. But if it is not, we need to continue our
work, so bring the candles.

NOTES

INTRODUCTION

1. Daniel Bell, *The Cultural Contradictions of Capitalism* (New York: Basic Books, 1976), esp. 33–146.
2. Philip Larkin, introduction to *All What Jazz: A Record Diary 1961–71* (London: Faber and Faber, 1985); Alan Filreis, *Counter-Revolution of the Word: The Conservative Attack on Modern Poetry* (Chapel Hill: University of North Carolina Press, 2007).
3. Irving Howe, "The Culture of Modernism," in *Decline of the New* (New York: Harcourt, Brace, and World, 1970), 3.
4. Nathan Glazer, *From a Cause to a Style: Modernist Architecture's Encounter with the American City* (Princeton, NJ: Princeton University Press, 2007), 2–3.
5. Many scholars have examined this topic and are cited later. Other valuable related studies include Naima Prevost's *Dance for Export: Cultural Diplomacy and the Cold War* (Hanover, NH: Wesleyan University Press, 1998), which details the State Department and USIA-sponsored tours of modern dance in the 1950s; Penny von Eschen's *Satchmo Blows Up the World: Jazz Ambassadors Play the Cold War* (Cambridge, MA: Harvard University Press, 2006), which tells the story of the jazz tours of the same time period; and David Caute's *The Dancer Defects: The Struggle for Cultural Supremacy During the Cold War* (Oxford: Oxford University Press, 2003), which comprehensively overviews the role all of the arts played in the dueling cultural-diplomacy programs of the early Cold War.
6. Max Kozloff, "American Painting During the Cold War," *Artforum*, May 1973: 44.
7. Ibid., 45.
8. Ibid., 44, my italics; Eva Cockroft, "Abstract Expressionism, Weapon of the Cold War," *Artforum*, June 1974: 39.

9. For instance, the Rockefeller Brothers Fund granted MoMA $625,000 in 1953 to develop an international cultural-exchange program ("Grant Will Spur Exchange of Art," *New York Times*, April 6, 1953).

10. Cockroft, "Abstract Expressionism," 40.

11. David Shapiro and Cecile Shapiro, "Abstract Expressionism: The Politics of Apolitical Painting," *Prospects* 3 (1977): 210.

12. Serge Guilbaut, *How New York Stole the Idea of Modern Art* (Chicago: University of Chicago Press, 1983), 2, 11.

13. Ibid., 3.

14. Frances Stonor Saunders, "Modern Art Was CIA 'Weapon,'" *Independent*, October 22, 1995, http://www.independent.co.uk/news/world/modern-art-was-cia-weapon-1578808.html. Saunders develops this argument fully in *The Cultural Cold War: The CIA and the World of Arts and Letters* (New York: New Press, 2000).

15. Saunders, "Modern Art."

16. In *Music on the Frontline: Nicolas Nabokov's Struggle Against Communism and Middlebrow Culture* (Burlington, VT: Ashgate, 2002), Ian Wellen makes the same claim about music: "Nabokov . . . argued that the great musical revolution of the early twentieth century should be seen as the fruits of political freedom," and the CIA's involvement in the CCF advanced, with similar political aims, "the legitimation and support of contemporary art music" (119). Like me, though, Wellen cautions against making too sweeping a claim about this relationship, stipulating that "the New Music was no CIA plot" (124).

17. David Craven, *Abstract Expressionism as Cultural Critique: Dissent During the McCarthy Period* (Cambridge: Cambridge University Press, 1999), 41.

18. Michael Kimmelman makes much the same point in "Revisiting the Revisionists," arguing that "to link as one the USIA and the International Council [of MoMA], as some have done, is a generalization that simplifies the byzantine cultural politics of the era" (in Francis Frascina, ed., *Pollock and After: The Critical Debate*, 2nd ed. [London: Routledge, 2000], 300).

19. Craven, *Abstract Expressionism as Cultural Critique*, 80–102. Also see Erika Doss, "The Art of Cultural Politics: From Regionalism to Abstract Expressionism," in Lary May, ed., *Recasting America: Culture and Politics in the Age of Cold War* (Chicago: University of Chicago Press, 1989), in which Doss argues that "interpretations . . . which focus on an external cause such as the cold war" for the ascension of abstract expressionism are inadequate (198).

20. Milton C. Cummings, "Cultural Diplomacy and the United States Government: A Survey," Institute for Cultural Diplomacy, 2002, http://ics.leeds.ac.uk/papers/pmt/exhibits/1434/MCCpaper.pdf, accessed February 2, 2009.

21. Joseph Nye, *Soft Power: The Means to Success in World Politics* (New York: PublicAffairs Books, 2004), x.

22. Frank Ninkovich, *The Diplomacy of Ideas: U.S. Foreign Policy and Cultural Relations, 1938–1950* (New York: Cambridge University Press, 1981), 87; Muna Lee and Ruth Emily McMurry, *The Cultural Approach: Another Way in International Relations* (Chapel Hill: University of North Carolina Press, 1947), 3. The wife of Luis Muñoz Marin, the first elected

governor of Puerto Rico, the Mississippi-born Lee was a successful poet, translator, and mystery novelist who served the State Department as a Latin American cultural specialist from 1941 to the 1960s.

23. Richard T. Arndt, *The First Resort of Kings: American Cultural Diplomacy in the Twentieth Century* (Dulles, VA: Potomac Books, 2005), 27.

24. Harold Lasswell, *Propaganda Technique in the World War* (New York: Peter Smith, 1938), 7.

25. Ninkovich, *Diplomacy of Ideas*, 8.

26. J. M. Espinosa, *Inter-American Beginnings of U.S. Cultural Diplomacy 1936–1948* (Washington, DC: US Department of State, 1976), 96.

27. Arndt, *First Resort of Kings*, 60.

28. Francis J. Colligan, "The Government and Cultural Exchange," *Review of Politics* 20, no. 4 (1958): 549.

29. USC 22, chap. 18, subchap. I, p. 1437.

30. See Ninkovich, *Diplomacy of Ideas*, and Arndt, *First Resort of Kings*.

31. Archibald MacLeish, introduction to Lee and McMurry, *Cultural Approach*, vi.

32. Quoted in Arndt, *First Resort of Kings*, 60.

33. Ibid., 78.

34. Ibid., 79, 84.

35. Ibid., 85.

36. Mike Gold, "Out of the Fascist Unconscious," *New Republic*, July 26, 1933: 295.

37. Archibald MacLeish, "The Art of the Good Neighbor," *The Nation*, February 10, 1940: 171.

38. Deborah Solomon, *The Life and Art of Norman Rockwell* (New York: Farrar, Straus, and Giroux, 2013), excerpted in *Smithsonian*, October 2013.

39. Quoted in Ninkovich, *Diplomacy of Ideas*, 117.

40. Quoted in ibid., 67–68.

41. Kennan's "Long Telegram"—an actual telegram to James Byrnes—is reproduced in full at the Harry S. Truman Presidential Library website, http://www.trumanlibrary.org/whistlestop/study_collections/coldwar/documents/index.php?documentdate=1946-02-22&documentid=6-6&pagenumber=1.

42. This March 12, 1947, speech to a joint session of Congress is reproduced at http://avalon.law.yale.edu/20th_century/trudoc.asp.

43. NSC-4, "Coordination of Foreign Information Measures," December 9, 1947, Federation of American Scientists Intelligence Resource Program, reproduced at https://www.fas.org/irp/offdocs/nsc-hst/nsc-4.htm, accessed May 12, 2014.

44. Arndt, *First Resort of Kings*, 163, 185.

45. Shawn J. Parry-Giles, *The Rhetorical Presidency, Propaganda, and the Cold War, 1945–1955* (Westport, CT: Praeger, 2002), xvii. Other valuable studies of the American information programs during the Cold War include Walter Hixson, *Parting the Curtain: Propaganda, Culture, and the Cold War 1945–1961* (London: Palgrave Macmillan, 1997); Scott Lucas, *Freedom's War: The American Crusade Against the Soviet Union* (New York: New York University Press, 1999); Michael Krenn, *Fall-Out Shelters for the Human Spirit: American Art and the Cold War* (Chapel Hill: University of North Carolina Press, 2005); Kenneth Osgood, *Total*

Cold War: Eisenhower's Secret Propaganda Battle at Home and Abroad (Lawrence: Kansas University Press, 2008); Laura Belmonte, *Selling the American Way: U.S. Propaganda and the Cold War* (Philadelphia: University of Pennsylvania Press, 2010).

46. Arndt, *First Resort of Kings*, 157.

47. Quoted in Ninkovich, *Diplomacy of Ideas*, 134–35.

48. Quoted in Arndt, *First Resort of Kings*, 255.

49. On Europeans' receptivity to Soviet charges against the United States, see Richard Pells, *Not Like Us: How Europeans Have Loved, Hated, and Transformed American Culture Since World War II* (New York: Basic Books, 1997), esp. 2–36.

50. Macleish, "Art of the Good Neighbor," 171.

51. Wilder quoted in Arndt, *First Resort of Kings*, 91.

52. "Art Program of the Department of State," 1947 (?), Advancing American Art Microfilm Collection, AAA; David F. Krugler, *The Voice of America and the Domestic Propaganda Battles, 1945–1953* (Columbia: University of Missouri Press, 2000), 68.

53. Raymond Daniell, "What the Europeans Think of Us," *New York Times Magazine*, November 30, 1947.

54. Quoted in Ninkovich, *Diplomacy of Ideas*, 24.

55. Tony Judt, *Postwar: A History of Europe Since 1945* (New York: Penguin, 2005), 210, Sartre quoted on 214. Also see Rob Kroes, *If You've Seen One, You've Seen the Mall: Europeans and American Mass Culture* (Urbana: University of Illinois Press, 1996), 17.

56. Tony Judt, *Past Imperfect: French Intellectuals, 1944–1956* (Berkeley: University of California Press, 1992), 188, 189.

1. FREEDOM, INDIVIDUALISM, MODERNISM

1. Dickran Tashjian, *A Boatload of Madmen: Surrealism and the American Avant-Garde, 1920–1950* (New York: Thames and Hudson, 1995), 2.

2. Alan Nadel, *Containment Culture: American Narratives, Postmodernism, and the Atomic Age* (Durham, NC: Duke University Press, 1995), 89.

3. Richard Pells, *Modernist America: Art, Music, Movies, and the Globalization of American Culture* (New Haven, CT: Yale University Press, 2011), 85.

4. Malcolm Bradbury and James McFarlane, "The Name and Nature of Modernism," in Malcolm Bradbury and James McFarlane, eds., *Modernism: A Guide to European Literature 1890–1930* (New York: Penguin, 1978), 24.

5. Irving Howe, "The Idea of the Modern," in *Selected Writings 1950–1990* (New York: Harcourt Brace Jovanovich, 1990), 151.

6. Hugh Wilford, *The Mighty Wurlitzer: How the CIA Played America* (Cambridge, MA: Harvard University Press, 2008), 102 n. 10; Tony Judt, *Postwar: A History of Europe Since 1945* (New York: Penguin, 2005), 221.

7. Daniel Bell popularized the notion of the "end of ideology" in his book of the same name (*The End of Ideology* [New York: Free Press, 1960]), but the concept had been circulating

among Western intellectuals for some time (and the inaugural issue of *Encounter* in 1953 mentioned it in the editorial note). For Bell and others, "ideologies" were the totalizing systems of thought and practice typified by communism and Nazism, and World War II ended them in favor of nonideological, pragmatic, technocratic leadership of societies. Later thinkers would point out that the rational humanism that Bell and the others endorsed was its own kind of totalizing ideology.

8. Frank Kermode, "Modernisms: Cyril Connolly and Others," *Encounter* 26, no. 3 (1966): 53.

9. Daniel Bell, *The Cultural Contradictions of Capitalism* (New York: Basic Books, 1976), 46.

10. Raymond Williams, "When Was Modernism?" *New Left Review* 175 (May–June 1989): 48–52.

11. Alfred H. Barr, "Modern and 'Modern,'" in *Defining Modern Art: Selected Writings of Alfred H. Barr*, ed. Irving Sandler and Amy Newman (New York: Harry Abrams Books, 1986), 82.

12. "Parisians Hiss New Ballet," *New York Times*, June 8, 1913.

13. Milton Brown, *The Story of the Armory Show* (New York: Joseph Hirshhorn Foundation, 1963), 109–13, 128–33.

14. Meyer Schapiro, "The Armory Show," in *Modern Art: 19th and 20th Centuries* (New York: George Braziller, 1978), 135–78.

15. Russell Lynes, *The Tastemakers* (New York: Harper and Brothers, 1954), 220–21.

16. Alfred H. Barr, "A New Museum," in *Defining Modern Art*, 74.

17. Alfred H. Barr, "A Modern Art Questionnaire," *Vanity Fair*, August 1927.

18. Lynes, *Tastemakers*, 263.

19. Alice Goldfarb Marquis, *Alfred H. Barr: Missionary for the Modern* (Chicago: Contemporary Books, 1989), 272.

20. Dwight Macdonald, "Action on West Fifty-Third Street (Part II)," *New Yorker*, December 19, 1953.

21. See especially Marjorie Perloff, *The Futurist Moment: Avant-Garde, Avant Guerre, and the Language of Rupture* (Chicago: University of Chicago Press, 2003); Ezra Pound, *Gaudier-Brzeska: A Memoir* (New York: New Directions, 1970); Karin Cope, *Passionate Collaborations: Learning to Live with Gertrude Stein* (Victoria, Canada: ELS Editions, 2005); William Carlos Williams, *A Recognizable Image: William Carlos Williams on Art and Artists* (New York: New Directions, 1978).

22. Louise Bogan, "Modernism in American Literature," *American Quarterly* 2, no. 2 (1950): 105.

23. Fredric Jameson, *A Singular Modernity* (London: Verso, 2002), 169.

24. Clement Greenberg, "Avant-Garde and Kitsch," in *Art and Culture: Critical Essays* (Boston: Beacon Press, 1961), 6.

25. Clement Greenberg, "Modernist Painting," in Francis Frascina and Jonathan Harris, eds., *Art in Modern Culture: An Anthology of Critical Texts* (New York: HarperCollins, 1992), 28. Greenberg's essay was initially broadcast in 1961 as a lecture on VOA.

26. Lincoln Kirstein, "The State of Modern Painting," *Harper's*, October 1948.

27. Clive Bell, "The Aesthetic Hypothesis," in Charles Harrison and Paul Wood, eds., *Art in Theory: An Anthology of Changing Ideas* (Oxford: Blackwell, 2003), 107–8, originally published in Bell's 1914 book *Art* (London: Chatto and Windus).

28. John Crowe Ransom, "The Concrete Universal: Observations on the Understanding of Poetry," in *Poems and Essays* (New York: Vintage, 1955), 159–85; W. K. Wimsatt, "The Structure of the 'Concrete Universal' in Literature," *PMLA* 62, no. 1 (1947): 262–80. For Ransom, the Concrete Universal was the objective or material manifestation of "an idea in the mind which proposes a little universe, or an organized working combination of parts, where there is a single effect to be produced, and the heterogeneous parts must perform their several duties faithfully in order to bring it about" (163).

29. Kermode, "Modernisms," 53; Lionel Trilling, "The Function of the Little Magazine," in *The Liberal Imagination* (New York: Viking, 1950), 98–99.

30. Michael Fried, "Three American Painters," in Francis Frascina and Charles Harrison, eds., *Modern Art and Modernism: A Critical Anthology* (New York: Harper and Row, 1983), 117.

31. Daniel Fuchs, "Saul Bellow and the Modern Tradition," *Contemporary Literature* 15, no. 1 (1974): 67–89.

32. See especially Terry Eagleton, *The Ideology of the Aesthetic* (Malden, MA: Blackwell, 1990), and Raymond Williams, *Culture and Society 1790–1950* (New York: Columbia University Press, 1958).

33. Irving Howe, *World of Our Fathers* (New York: Harcourt Brace Jovanovic, 1976), 603; Howe, "Idea of the Modern," 140–41.

34. Daniel Bell, "Beyond Modernism, Beyond Self," in *The Winding Passage: Essays and Sociological Journeys, 1960–1980* (New York: Basic Books, 1980), 275–76.

35. Lionel Trilling, "On the Modern Element in Modern Literature," *Partisan Review*, January–February 1961: 10.

36. Astradur Eysteinsson, *The Concept of Modernism* (Ithaca, NY: Cornell University Press, 1990), 37; Douglas Mao and Rebecca Walkowitz, "Modernisms Bad and New," in Douglas Mao and Rebecca Walkowitz, eds., *Bad Modernisms* (Durham, NC: Duke University Press, 2006), 4, 3.

37. It should be noted, though, that over the past twenty years a large contingent of scholars and writers (myself among them) have undermined the simplistic notion that modernist artists were in unceasing combat with bourgeois society. Andreas Huyssens, Lawrence Rainey, Catherine Turner, John Xiros Cooper, Mark Morrisson, Maria DiBattista and Lucy McDiarmid, Kevin J. H. Dettmar and Stephen Watt, and many others have vastly expanded our understanding of the relationship of modernism to middle-class audiences and commercial institutions such as literary agents, bookstores, advertisers, and publishing houses. What has become clear is that most modernist artists—even the most avant-garde ones—were intimately caught up in the practices of bourgeois society and the commercial marketplace even as they excoriated them. It is perhaps most accurate to say that the vast majority of modernist art was implacably antibourgeois *in its self-presentation* and that, at least in the Anglo-American world, public discussion of modernist art and artists tended to center on modernism's *perceived* revolutionary or bohemian character.

38. Dwight Macdonald, "Midcult and Masscult," in *Against the American Grain* (New York: Da Capo, 1983), 39. Macdonald's essay "By Cozzens Possessed," in the same collection

(187–212), develops these same themes in an attack on one now-forgotten middlebrow novelist.

39. Catherine Turner, *Marketing Modernism Between the Two Wars* (Amherst: University of Massachusetts Press, 2004), esp. chap. 6.

40. Peter Bürger, *Theory of the Avant-Garde* (Minneapolis: University of Minnesota Press, 1984). Other writers have isolated modernism and the avant-garde in terms of tactics; Matei Calinescu, for instance, argues that "the avant-garde is in every respect more radical. . . . [It] borrows practically all its elements from the modern tradition but at the same time blows them up, exaggerates them, and places them in the most unexpected contexts, often making them almost completely unrecognizable" (*Faces of Modernity: Avant-Garde, Decadence, Kitsch* [Bloomington: Indiana University Press, 1977], 96). Several theorists, most provocatively Walter Benjamin, have pointed to the ways that the avant-garde uses the technologies of mechanical reproduction to undermine the "aura" of original works of art. In *The Concept of Modernism,* Eysteinsson persuasively attacks Bürger's argument, questioning the stability of the terms Bürger uses, in particular the nature of the "institution of art" and precisely how "life-praxis" is opposed to it. However, I am using Bürger's model less for his arguments about the *effects* of this dialectic and more for an explanation of artists' *motives,* and in this I think that Bürger is fundamentally correct.

41. Bürger, *Theory of the Avant-Garde,* 22. Ironically, in *The Total Art of Stalinism: Avant-Garde, Aesthetic Dictatorship, and Beyond* (Princeton, NJ: Princeton University Press, 1992), Boris Groys argues that socialist realism is, by Bürger's definition, the most successful avant-garde movement in history: "under Stalin the dream of the avant-garde was in fact fulfilled and the life of society was organized in monolithic artistic terms, though of course not those that the avant-garde itself had favored" (9). In *Politics of Modernism: Against the New Conformists* (London: Verso, 1989), Raymond Williams explains the difference between modernism and the avant-garde in similar terms, saying that modernists were artistically "radically innovative" and, rebelling against the incursions of the capitalist marketplace into the realm of art, sought "to provide their own facilities of production, distribution, and publicity." Modernists "proposed a new kind of art for a new kind of social and perceptual world." The avant-garde, by contrast, was a "fully oppositional formation, determined not only to promote [its] own work but to attack its enemies in the cultural establishments and, beyond these, the whole social order in which these enemies had gained and now reproduced their power" (51).

42. Louis Untermeyer, *Modern American Poetry and Modern British Poetry,* combined ed. (New York: Harcourt Brace, 1936).

43. Cleanth Brooks, *Modern Poetry and the Tradition* (Chapel Hill: University of North Carolina Press, 1939).

44. Quoted in Scott Donaldson, *Archibald MacLeish: An American Life* (Boston: Houghton Mifflin, 1992), 332. This accusation would dog MacLeish his entire career, as Donaldson points out—both Hayden Carruth and Robert Fitzgerald, reviewing MacLeish's 1948 collection *Actfive and Other Poems,* commented on his tendency to be "more concerned with his message than his craft" (quoted on 404).

45. John Crowe Ransom, "Criticism as Pure Speculation," in Ray B. West, ed., *Essays in Modern Literary Criticism* (New York: Rinehart, 1952), 228–45; also see Tobin Siebers, *Cold War Criticism and the Politics of Skepticism* (New York: Oxford University Press, 1993), 30.

46. Al Filreis, *Counter-Revolution of the Word: The Conservative Attack on Modern Poetry* (Chapel Hill: University of North Carolina Press, 2008), 41–42. In *American Night: The Literary Left in the Era of the Cold War* (Chapel Hill: University of North Carolina Press, 2012), Alan Wald complicates this dynamic even more, insisting that there was a separate "Communist literary modernism" alive and well into the 1950s.

47. I deal at length with what I call the "new critical consensus" between the leftist New York Intellectuals and the conservative New Critics regarding Ezra Pound's 1948 Bollingen Prize in my book *James Laughlin, New Directions, and the Remaking of Ezra Pound* (Amherst: University of Massachusetts Press, 2005).

48. Christine Lindey, *Art in the Cold War* (New York: New Amsterdam Books, 1990), 108.

49. Eric Foner, *The Story of American Freedom* (New York: Norton, 1998), xiii–xiv, 7–8. In *The Myth of American Individualism* (Princeton, NJ: Princeton University Press, 1994), Barry Allan Shain confirms the dominance of Foner's bipartite model of what freedom meant to the generation of the Founders but charges that that model is wrong: "Most 18th-century Americans cannot be accurately characterized as predominantly individualistic or, for that matter, classically republican," he says, asserting instead that "the vast majority of Americans lived voluntarily in morally demanding agricultural communities shaped by reformed-Protestant social and moral norms" (xvi).

50. Foner, *Story of American Freedom*, 260. See also Karl Popper, *The Open Society and Its Enemies* (Princeton, NJ: Princeton University Press, 1962), and Hannah Arendt, *The Origins of Totalitarianism* (New York: Harcourt, Brace, Jovanovich, 1973).

51. Foner, *Story of American Freedom*, 196, 205.

52. Roland Marchand, *Advertising the American Dream: Making Way for Modernity* (Berkeley: University of California Press, 1986).

53. Elizabeth A. Fones-Wolf, *Selling Free Enterprise: The Business Assault on Labor and Liberalism, 1945–1960* (Urbana: University of Illinois Press, 1994), 4.

54. Henry Luce, *The American Century* (New York: Farrar and Rinehart, 1941), 35, 15.

55. Foner, *Story of American Freedom*, 235–236.

56. In his autobiography, the combative Sidney Hook ridicules the League for Cultural Freedom and Socialism for saying that cultural freedom was impossible without socialism: "They left unexplained the reality of their own intellectual and cultural freedom in the nonsocialist economy of the United States" (*Out of Step* [New York: Carroll and Graf, 1988], 262).

57. Of the many valuable sources on the New York Intellectuals' and others' break with communism, I have been particularly appreciative of William O'Neill's *A Better World—the Great Schism: Stalinism and the American Intellectuals* (New York: Simon and Schuster, 1982); Neil Jumonville's *Critical Crossings: The New York Intellectuals in Postwar America* (Berkeley: University of California Press, 1990); Hugh Wilford's *The New York Intellectuals: From Vanguard to Institution* (Manchester, UK: Manchester University Press, 1995); and Jo-

seph Dorman's *Arguing the World: The New York Intellectuals in Their Own Words* (Chicago: University of Chicago Press, 2001).

58. Quoted in Michael Krenn, *Fall-Out Shelters for the Human Spirit: American Art and the Cold War* (Chapel Hill: University of North Carolina Press, 2005), 89.

59. "The Freedom Resolution," VOA script, February 27, 1953, LOC.

60. "United States Information Agency: Strategic Principles," 1953 (?), 16, White House Office, NSC Staff Papers 1948–1961, OCB Central File Series, Box 20, "OCB 040 USIA 1" folder, DDEL. It is instructive to note, however, that USIA and Foreign Service officers in the field were less sanguine about the transparency of the concept of "freedom" and reported back to Washington that the ideological program implicitly equated freedom and communism in the sense that both were ideologies. Furthermore, defining freedom as anything practiced outside of the Soviet/Chinese orbit was "too inclusive" and thus meaningless: "one of the chief weaknesses of a negative definition of free world philosophy . . . is that it offers nothing specific or concrete which can be conveyed to the targets. . . . How can the United States translate freedom into terms which will be meaningful to the Indonesian?" (OCB Memorandum, September 23, 1955, attachment "Selected Comments from Mission Reports on U.S. Ideological Program," pp. 2–4, White House Office, NSC Staff Papers 1948–1961, OCB Central File, Box 71, "OCB 091.4 Ideological Programs [File #3] [5] [June 1955–March 1956]" folder, DDEL).

61. Arthur M. Schlesinger, *The Vital Center: The Politics of Freedom* (Cambridge, Mass.: Riverside Press, 1949), 153, 185, 173.

62. Ibid., 169.

63. Hector St. John de Crèvecoeur, *Letters from an American Farmer* (Gloucester, MA: Peter Smith, 1968), 65.

64. Alexis de Tocqueville, *Democracy in America*, trans. Harvey C. Mansfield and Delba Winthrop (Chicago: University of Chicago Press, 2000), vol. 2, pt. 2, 482, 488.

65. Herbert Hoover, *American Individualism* (Garden City, NY: Doubleday, 1923). In this pamphlet, Hoover also anticipated the New Deal–era attacks on government involvement in the economy, stating that "with the vast development of industry and the train of regulating functions of the national and municipal government that followed from it; with the recent vast increase in taxation due to the war;—the Government has become through its relations to economic life the most potent force for maintenance or destruction of our American individualism" (52).

66. Reinhold Niebuhr, *The Children of Light and the Children of Darkness* (New York: Scribner's, 1960), 3.

67. T. B. Bottomore, *A Dictionary of Marxist Thought* (Cambridge, MA: Harvard University Press, 1983), 228.

68. Unlike many other Cold War thinkers, though, Niebuhr himself did not feel that individual self-determination was the end result of man's essential freedom: for Niebuhr, human beings were also essentially "social" and cannot "fulfill [their] li[ves] within [themselves] but only in responsible and mutual relations with [their] fellows" (*Children of Light*, 4).

Niebuhr criticizes the "excessive individualism" of the "bourgeois world view" in *The Children of Light and the Children of Darkness*.

69. Dean Acheson, speech at Berkeley, CA, March 16, 1950, quoted in Scott Lucas, *Freedom's War: The American Crusade Against the Soviet Union* (New York: New York University Press, 1999), 84.

70. Another trope of popular entertainments rooted in Cold War anxieties was "containment," which was introduced as a geopolitical imperative in George Kennan's "Long Telegram" and then, according to influential studies by Elaine Tyler May and Alan Nadel, seeped throughout the culture. See Elaine Tyler May, *Homeward Bound: American Families in the Cold War Era* (New York: Basic Books, 1990), and Nadel, *Containment Culture*.

71. *The Fountainhead* was made into a 1949 film starring Gary Cooper, who became—in part because of this film and the 1952 film *High Noon*—the very embodiment of self-reliant American individualism. See also "Jackson Pollock: Is He the Greatest Living Painter in the United States?" *Life*, August 8, 1949.

72. Robert Motherwell, "What Abstract Art Means to Me," *Bulletin of the Museum of Modern Art* 18, no. 3 (1951): 12.

73. Jumonville, *Critical Crossings*, 160. Jumonville points to Greenberg's essay "Avant-Garde and Kitsch" and Harold Rosenberg's essay "Herd of Independent Minds" (*Commentary*, September 1948: 244–52), and I would add Rosenberg's "The American Action Painters" (in *The Tradition of the New* [New York: Horizon, 1959]) to this list.

74. Katerina Clark, "Socialist Realism in Soviet Literature," in Neil Cornwell, ed., *The Routledge Companion to Russian Literature* (New York: Routledge, 2001), 174.

75. Vladimir Lenin, "Party Organization and Party Literature," 1905, Marxists Internet Archive, http://www.marxists.org/archive/lenin/works/1905/nov/13.htm, accessed April 19, 2013.

76. See especially Leon Trotsky, *Literature and Revolution* (New York: Russell & Russell, 1957).

77. Zhdanov quoted in Abram Tertz, *On Socialist Realism* (New York: Pantheon, 1960), 24.

78. See Czeslaw Milosz, *The Captive Mind* (New York: Knopf, 1953).

79. *Culture and Art in the USSR* (N.p.: n.p., 1961), unpaginated.

80. C. Vaughan James, *Soviet Socialist Realism: Origins and Theory* (New York: St. Martin's Press, 1973), 85–86. James's book is probably the best English-language presentation of the philosophical bases of socialist realism as practiced in the Soviet Union because it provides a careful and detailed summary of *Bases of Marxist–Leninist Aesthetics*, the Soviet Union's quasi-official publication explaining Marxist–Leninist aesthetic analysis and socialist realism.

81. K. Andrea Rusnock, *Socialist Realist Painting During the Stalinist Era (1934–1941): The High Art of Mass Art* (Lewiston, NY: Edwin Mellen Press, 2010), 18–25.

82. "Cultural Relations Between the Soviet People and Foreign Countries," *VOKS Bulletin* 64 (1950): 22.

83. Jean-François Fayet, "VOKS: The Third Dimension of Soviet Foreign Policy," in Jessica C. E. Gienow-Hecht and Mark C. Donfried, eds., *Searching for a Cultural Diplomacy* (New York: Berghahn Books, 2010), 47.

84. Vladimir Kemenov, "Aspects of Two Cultures," *VOKS Bulletin* 52 (1947): 21–24. See also A. K. Vasiliev, "Features of Socialist Realism," *VOKS Bulletin* 53 (1948): 28–49.

85. Vasiliev, "Features of Socialist Realism," 45.

86. *Culture and Art in the USSR*, unpaginated.

87. Maxim Gorky, "Soviet Literature," in *Maxim Gorky on Literature: Selected Articles* (Moscow: Foreign Languages Publishing House, 1967), 254–66.

88. "Against Formalism in Soviet Music," *VOKS Bulletin* 54 (1948): 11.

89. V. M. Zimenko, "Socialist Realism and the Artist's Individuality," *VOKS Bulletin* 74 (1952): 42.

90. Cora Sol Goldstein, "The Control of Visual Representation: American Art Policy in Occupied Germany, 1945–9," *Intelligence and National Security* 18, no. 2 (2003): 285.

91. Quoted in Stephen Spender, untitled article in *Cuadernos* 1, no. 1 (1953): 100, my translation from the Spanish.

92. Schlesinger, *Vital Center*, 125, 145, 79, 147.

93. Stephen Spender, untitled essay in Richard H. Crossman, ed., *The God That Failed* (New York: Harper & Bros., 1949), 266–67.

94. Alfred H. Barr, "Is Modern Art Communistic?" *New York Times Magazine*, December 14, 1952.

2. "ADVANCING AMERICAN ART"

1. ShiPu Wang, *Becoming American: The Art and Identity of Yasuo Kuniyoshi* (Honolulu: University of Hawai'i Press, 2011), 4.

2. "Telling Tokio," *New Yorker*, March 28, 1942.

3. Hugo Weisgall, "Yasuo Kuniyoshi," in *Advancing American Art*, exhibition catalog (Prague: USIS, 1947), unpaginated.

4. Quoted in Michael Krenn, *Fall-Out Shelters for the Human Spirit: American Art and the Cold War* (Chapel Hill: University of North Carolina Press, 2005), 25.

5. LeRoy Davidson, "Advancing American Art," *American Foreign Service Journal* 23, no. 12 (1946): 9.

6. Ibid., 10, 37.

7. "Retired American Art," *Newsweek*, July 5, 1948.

8. William Benton to Representative Fred Busbey, 1947, RG 59 (General Records of the Assistant Secretary of State for Public Affairs 1945–1950), Subject File, Box 7, NARA.

9. AFA director Burton Cumming alluded to Benton's ownership of the 1943 Kuniyoshi painting *Somebody Tore My Poster* in a May 26, 1952, letter to Benton (AFA Archive, Box 66, "1951 Berlin Festival" folder, AAA).

10. Ralph M. Pearson, "State Department Exhibition for Foreign Tour," *Art Digest*, October 15, 1946, 29.

11. Hugo Weisgall, introduction to *Advancing American Art*, unpaginated.

12. Ibid. The last two sentences are taken verbatim from Alfred Frankfurter's "American Art Abroad: The State Department's Collection," *Art News*, October 1946.

13. "Art Program of the Department of State," 1947 (?), "Advancing American Art" microfilm reel, AAA.

14. John Taber to George Marshall, February 4, 1947, "Advancing American Art" microfilm reel, AAA.

15. AAPL National Vice-President Albert T. Reid, "League Protests to the Department of State," *Art Digest*, November 15, 1946.

16. "Exposing the Bunk of So-Called Modern Art," *New York Journal-American*, December 3, 1946, quoted in Margaret Lynne Ausfeld and Virginia M. Mecklenburg, *Advancing American Art: Politics and Aesthetics in the State Department Exhibition, 1946–48* (Montgomery, AL: Montgomery Museum of Fine Arts, 1984), 19. A constituent complained to Tennessee senator Kenneth McKellar, lamenting that "the names of the artists—Shahn, Zerbe, Prestopino, Kuniyoshi, Guglielmi—do not seem to have the flavor of an American background but bring visions of a transplanted European hodgepodge at its worst" (quoted in Ausfeld and Mecklenburg, *Advancing American Art*, 20).

17. Loy Henderson to Richard Heindel, chief of the Division of Libraries and Institutes, Department of State, memo, November 5, 1946, "Advancing American Art" microfilm reel, AAA.

18. Benton to W. Bedell Smith, March 8, 1947, RG 59 (General Records of the Assistant Secretary of State for Public Affairs 1945–1950), Subject File, Box 7, AAA.

19. William Benton, testimony, US House of Representatives, Committee on Appropriations, *Hearings before the Subcommittee on Appropriations on the Department of State Appropriations Bill for 1948*, 80th Cong., 1st sess., March 20, 1947, 417–18.

20. Harry S. Truman to Benton, April 2, 1947, RG 306, USIA Historical Collection, Box 127, "Advancing American Art" folder, NARA.

21. NSC-68 is viewable in its entirety at the Harry S. Truman Presidential Library website at http://www.trumanlibrary.org/whistlestop/study_collections/coldwar/documents/pdf/10-1.pdf.

22. George Dondero, "Modern Art Shackled to Communism," August 16, 1949, "Advancing American Art" microfilm reel, AAA.

23. National Sculpture Society, statement, January 21, 1952, AFA Archive, Box 6, "National Sculpture Society" folder, AAA.

24. Wheeler Williams, testimony, US House of Representatives, *The American National Exhibition, Moscow, July 1959 (The Record of Certain Artists and an Appraisal of Their Works Selected for Display), Hearings Before the Committee on Un-American Activities*, 86th Cong., 1st sess., July 1, 1959, 921–25.

25. Quoted in "Artists Protest Halting Art Tour," *New York Times*, May 6, 1947.

26. American Veterans' Committee Chapter 558 to George Marshall, May 22, 1947, "Advancing American Art" microfilm reel, AAA; "*Just What* Is Communistic Painting?" *United Nations World*, May 1948: 24–25.

27. James S. Plaut, Frederick S. Wight, René d'Harnoncourt, Alfred H. Barr Jr., Andrew C. Ritchie, Hermon More, and Lloyd Goodrich, "A Statement on Modern Art," March 1950, "Advancing American Art" microfilm reel, AAA.

28. Alfred H. Barr, "Is Modern Art Communistic?" *New York Times Magazine*, December 14, 1952. In this article, Barr calls the traditionalist artist guilds "reckless and resentful academic artists."

29. Robert Goldwater to Nancy Coldwell, letter, May 20, 1952, Lloyd Goodrich Papers, Box 9, "*Magazine of Art* General Correspondence 1949–1952" folder, AAA.

30. In a letter to Henry Luce, quoted in Serge Guilbaut, "*Ménage à Trois*: Paris, New York, São Paolo, and the Love of Modern Art," in Barbara S. Groseclose and Jochen Vierich, eds., *Institutionalizing the History of Modern Art* (University Park: Pennsylvania State University Press, 2009), 164.

31. Quoted in Gary O. Larson, *The Reluctant Patron: The United States Government and the Arts, 1943–1965* (Philadelphia: University of Pennsylvania Press, 1983), 60–61.

32. US Department of State, Office of Public Affairs, "Memorandum on Art Program," February 1947, RG 59 (General Records of the Assistant Secretary of State for Public Affairs 1945–1950), Subject File, Box 7, NARA.

33. Walter Abell, "Industry and Painting," *Magazine of Art*, March 1946.

34. James Sloan Allen, *The Romance of Culture and Commerce* (Chicago: University of Chicago Press, 1986), 32. A wonderful collection of images of Container Corporation of America ads can be found online at http://www.fulltable.com/vts/c/concor/cc.htm.

35. William Benton, draft of statement, March 10, 1947, RG 59 (General Records of the Assistant Secretary of State for Public Affairs 1945–1950), Subject File, Box 7, NARA.

36. "Art Program of the Department of State," 1947 (?), "Advancing American Art" microfilm collection, AAA.

37. Rosamund Frost, foreword to *60 Americans Since 1800*, exhibition catalog (New York: Grand Central Art Galleries, 1946), unpaginated; Jo Gibbs, "State Department Sends Business-Sponsored Art as U.S. Envoys," *Art Digest*, November 15, 1946.

38. Davidson, "Advancing American Art," 37.

39. Fleischmann later became an art dealer and the chairman and chief executive of the Kennedy Galleries.

40. Foreign Service dispatch, November 1, 1956, RG 59 (General Records of the Department of State, Bureau of Educational and Cultural Affairs, General Records 1951–1963), Box 1, "Art Committee Candidates" folder, NARA; Maury Broderick, USIA, memo, 1957, RU 321, Box 32, "Fleischman" folder, SIA.

41. Madelyn Hunter and Marjorie Yahraes, "Collection of American Art," and Jane Allner, "Beauty in Industry," *Amerika* 49 (1960): 42, 14.

42. AFA, "AFA History," http://www.afaweb.org/about/history_page1.php, accessed May 13, 2014.

43. Margaret Cogswell, interviewed by the author, July 15, 2011, Washington, DC.

44. Whitney Museum of American Art, *Business Buys American Art*, exhibition catalog, (New York: Whitney Museum of American Art, 1960), RU 321, Box 30, "Business Buys American Art" folder, SIA.

45. Oscar Schisgall, "Our Newest Patron of the Arts," *Reader's Digest*, May 1960.

46. The PSB, created in April 1951, was originally composed of a director (initially Gordon Gray, president of the University of North Carolina), the undersecretary of state, the deputy secretary of defense, and the CIA director; representatives of other agencies were later included.

47. 22 USC, chap. 18, subchap. I, p. 1437.

48. Quoted in Krenn, *Fall-Out Shelters*, 69.

49. US Department of State, *Painting an Abstraction*, film, RG 306, "Movie Scripts 1942–1965" folder, NARA.

50. Bartlett H. Hayes Jr. to Edgar Breitenbush, Information Centers Branch, HICOG, 1951, Box 66, "1951 Berlin Festival" folder, AAA.

51. Krenn, *Fall-Out Shelters*, 71; W. J. Convery, memo, 1951, Box 66, "1951 Berlin Festival" folder, AAA.

52. Krenn *Fall-Out Shelters,* 73.

53. "Jackson Committee Report (Abridged)," White House Office, NSC Staff Papers 1953–1961, PSB Central Files, Box 22, "Jackson Committee Report (Abridged)" folder, DDEL.

54. James C. Hagerty, press release on creation of the OCB, July 8, 1953, p. 2, White House Office, NSC Staff Papers 1953–1961, PSB Central Files, Box 22, "PSB 334 PCIIA 3" folder, DDEL.

55. Gordon Gray to W. H. Jackson, March 10, 1953, White House Central Files, Office File, Box 230, DDEL.

56. Gray complained that the board never had a coherent mission and fell prey to bureaucratic territoriality. "It accomplished some things," he said in an oral history, "but it never really got off the ground" (Oral History Interview, June 18, 1973, HSTL).

57. Mallory Browne, PSB response to Jackson Committee report recommendation 29, September 21, 1953, PSB Central Files, Box 22, "PSB 334 PCIIA 6" folder, DDEL.

58. Dwight D. Eisenhower to president of U.S. Senate, July 27, 1954, White House Office, NSC Staff Papers 1948–1961, OCB Central File series, Box 14, "OCB 007 Cultural Activities (File #1) (03)" folder, DDEL.

59. OCB Memorandum, December 15, 1954, p. 3, White House Office, NSC Staff Papers 1948–1961, OCB Central File series, Box 14, "OCB 007 Cultural Activities (File #1) (03)" folder, DDEL.

60. See Penny von Eschen, *Satchmo Blows Up the World: Jazz Ambassadors Play the Cold War* (Cambridge, MA: Harvard University Press, 2006), for more on the performers who toured for the USIA.

61. Naima Prevots, *Dance for Export: Cultural Diplomacy and the Cold War* (Hanover, NH: Wesleyan University Press, 1998), 11.

62. Hagerty, press release on creation of the OCB, July 8, 1953.

63. Nicholas J. Cull, *The Cold War and the United States Information Agency* (New York: Cambridge University Press, 2008), 96.

64. Theodore Streibert to all USIA posts, memo, July 6, 1954, in US Department of State, *Foreign Relations of the United States 1952–54,* vol. 2: *National Security Affairs* (Washington, DC: US Government Printing Office, 1983), 1773–75, http://history.state.gov/historical-documents/frus1952-54v02p2/d361.

65. Quoted in Kenneth Osgood, *Total Cold War: Eisenhower's Secret Propaganda Battle at Home and Abroad* (Lawrence: Kansas University Press, 2008), 98.

66. This internal report is reprinted in full in Leo Bogart, abridged by Agnes Bogart, *Premises for Propaganda: The United States Information Agency's Operating Assumptions in the Cold War* (New York: Free Press, 1976), quotes from 91, 110.

67. Meeting memos, May 5, 1955, and February 29, 1956, RU 321, Box 6, "Sport in Art" folder, SIA.

68. Cogswell interview, July 15, 2011.

69. Franklin Burdette to Streibert, March 27, 1956, RU 321, Box 6, "Sport in Art" folder, SIA.

70. AFA, "Statement on Artistic Freedom," October 22, 1954, RU 321, Box 6, "Sport in Art" folder, SIA.

71. Streibert to Thomas Messer, July 3, 1956, AFA Papers, Box 68, "American Painting 1900–1950 Cancellation" folder, AAA.

72. Alfred H. Barr to Jock Whitney, 1956, RU 321, Box 6, "Sport in Art" folder, SIA.

73. Streibert to Whitney, May 23, 1956, RU 321, Box 6, "Sport in Art" folder, SIA.

74. James Schramm to Robert Hutchins, June 11, 1956, AFA Archive, Box 5, "Fund for the Republic" folder, AAA; Hutchins to Dwight Kirsch, July 12, 1956, AFA Archive, Box 68, "American Paintings 1900–1950 Cancellation" folder, AAA.

75. Messer to Joseph Lyford, July 6, 1956, AFA Archive, Box 5, "Fund for the Republic" folder, AAA.

76. Lois Bingham, memo, August 23, 1962, RU 321, Box 6, "Sport in Art" folder, SIA.

77. ACCF, press release, June 21, 1956, AFA Archive, Box 7, "USIA–AFA Relations: Press Releases" folder, AAA.

78. "A Political Standard for Art?" *Des Moines Register*, June 23, 1956, RU 321, Box 28, "USIA Relations with AFA" folder, SIA.

79. Both Humphrey and Fulbright quoted in an AFA press release, June 1956, AFA Archive, Box 7, "USIA–AFA Relations: Press Releases" folder, AAA.

80. Dwight D. Eisenhower, "Remarks at the Dartmouth College Commencement Exercises, Hanover, NH," June 14, 1953, reproduced in Gerhard Peters and John T. W. Woolley, eds., *The American Presidency Project*, University of California at Santa Barbara, http://www.presidency.ucsb.edu/ws/?pid=9606, accessed May 13, 2014.

81. Dwight D. Eisenhower, quoted in MoMA, "Program for the Opening Ceremonies of the 25th Anniversary of the Museum of Modern Art, Oct. 19, 1954," press release, http://www.moma.org/momaorg/shared/pdfs/docs/press_archives/1874/releases/MOMA_1954_0095_89.pdf?2010, accessed May 13, 2014.

82. Patricia Hills, "'Truth, Freedom, Perfection': Alfred Barr's *What Is Modern Painting?* as Cold War Rhetoric," in Greg Barnhisel and Catherine Turner, eds., *Pressing the Fight: Print, Propaganda, and the Cold War* (Amherst: University of Massachusetts Press, 2010), 252.

83. Alfred H. Barr, *What Is Modern Painting?* pamphlet (New York: MoMA, 1952), 45.

84. Hills, "'Truth, Freedom, Perfection,'" 267.

85. "United States Participation in the Brussels Universal and International Exhibition, 1958," July 15, 1957, White House Central Files, Official File 1953–1961, Box 604, "OF 139-B-3 (3)" folder, DDEL; "Progress Report on US Exhibition at Brussels Fair," RG 43, Box 14, "PA-20" folder, NARA.

86. Sarah Nilsen, *Projecting America, 1958: Film and Cultural Diplomacy at the Brussels World's Fair* (Jefferson, NC: McFarland, 2011), 11.

87. Quoted in Krenn, *Fall-Out Shelters*, 131, and in Robert H. Haddow, *Pavilions of Plenty: Exhibiting American Culture Abroad in the 1950s* (Washington, DC: Smithsonian Institution Press, 1997), 74.

88. Harris K. Prior, introduction to *American Art: Four Exhibitions*, exhibition catalog (New York: AFA, 1958), unpaginated.

89. Grace McCann Morley, "Seventeen Contemporary American Painters," in *American Art: Four Exhibitions*, exhibition catalog, unpaginated.

90. "Memorandum of Conference with the President," June 25, 1958, Ann Whitman File, DDE Diary Series, Box 33, "June 1958—Staff Notes (2)" folder, DDEL; George Allen to Eisenhower, June 24, 1958, White House Office, Office of the Staff Secretary 1952–1961, subject series, alphabetical subseries, Box 24, "United States Information Agency (3)" folder, DDEL.

91. Ibid.

92. Eisenhower to Howard Cullman, June 26, 1958, White House Office, Office of the Staff Secretary 1952–1961, subject series, alphabetical subseries, Box 24, "United States Information Agency (3)" folder, DDEL.

93. Burke Wilkinson, memo, June 27, 1958, RG 43 (Records of International Conferences, Commissions, and Expositions), Records Related to US Participation in the Brussels Universal and International Exhibition of 1958, Box 16, NARA.

94. Fisher Howe, deputy assistant to secretary of state, to Arthur Minnich, White House assistant staff secretary, May 21, 1958, enclosure "Criticism of U.S. Exhibit at Brussels Fair," White House Central Files, Official File 1953–1961, Box 605, "OF 139-B-3 (13)" folder, DDEL.

95. Lois Bingham, introduction to *Highlights of American Painting*, exhibition catalog (Washington, DC: USIA, 1955), 11.

96. *Highlights of American Painting*, 62.

97. Krenn, *Fall-Out Shelters*, 122.

98. Ibid., 123.

99. Bingham, introduction to *Highlights of American Painting*, 9.

100. Shooting script for USIA, *Painting of the New World*, film (Washington, DC: USIA, 1955), RG 306, Movie Scripts 1942–1965, Box 32, NARA.

101. Dorothy Adlow, introduction to *Twentieth Century Highlights of American Painting*, exhibition catalog (Washington, DC: USIA, 1958), ix.

102. Walter Hixson, *Parting the Curtain: Propaganda, Culture, and the Cold War 1945–1961* (London: Palgrave Macmillan, 1997), xiv. Also see Yale Richmond, *U.S.–Soviet Cultural Exchange: Who Wins?* (Boulder, CO: Westview Press, 1987) and *Cultural Exchange and the Cold War: Raising the Iron Curtain* (University Park: Pennsylvania State University Press, 2000).

103. Memo regarding meeting of Subcommittee on Moscow Exhibits, 1959, RG 59 (General Records of the Department of State, Bureau of Educational and Cultural Affairs, General Records 1951–1963), Box 6, "Subcommittee on Moscow Exhibits" folder, NARA.

104. Emily Genauer, "United States Sending Best Art to Exhibit in Moscow," *New York Herald-Tribune*, May 31, 1959, copied in an internal White House memo, Bryce Harlow Records 1953–1961, Pre-accession Series, Box 7, "Moscow Exhibition (2)" folder, DDEL.

105. Walter quoted in *Congressional Record*, 86th Cong., 1st sess., June 3, 1959, 8790; Wheeler Williams (founder and president of the AAPL) and Eisenhower quoted in Krenn, *Fall-Out Shelters*, 161, 165.

106. Milton Brown, introduction to Jack Levine, *Jack Levine*, ed. Stephen Robert Frankel (New York: Rizzoli, 1989), 9.

107. Levine, *Jack Levine*, 29.

108. Brown, introduction to Levine, *Jack Levine*, 8.

109. Quoted in *Congressional Record*, 86th Cong., 1st sess., June 3, 1959, 8789.

110. Levine, *Jack Levine*, 41.

111. Ibid.

112. Quoted in *Congressional Record*, 86th Cong., 1st sess., June 3, 1959, 8790.

113. Quoted in Marilyn S. Kushner, "Exhibiting Art at the American National Exhibition in Moscow, 1959: Domestic Politics and Cultural Diplomacy," *Journal of Cold War Studies* 4, no. 1 (2002): 19.

114. Notes on telephone call from Richard Nixon to Christian Herter, June 25, 1959, Christian Herter Papers, telephone calls January 1, 1959, to April 27, 1959, Box 12, "CAH Telephone Calls 5/4/59 to 12/31/59 (3)" folder, DDEL.

115. Abbott Washburn to Bryce Harlow, memo, July 6, 1959, Bryce Harlow Records 1953–1961, Pre-accession Series, Box 7, "Moscow Exhibition (1)" folder, DDEL.

116. Quoted in Washburn to Harlow, memo, June 25, 1959, Bryce Harlow Records 1953–1961, Pre-accession Series, Box 7, "Moscow Exhibition (1)" folder, DDEL.

117. Lloyd Goodrich to Perry Rathbone, July 22, 1959, AFA Archive, Box 5, "Committee on Government and the Arts" folder, AAA.

118. Lloyd Goodrich, "American Art Today," typescript of catalog copy for 1959 Moscow exhibition, AFA Archive, Box 5, "Committee on Government and Art" folder, AAA.

119. Richard McLanathan, "American Art in Moscow," *Atlantic Monthly*, May 1960.

120. Statement by Harris Prior read over RFE, July 28, 1959, AFA Archive, Box 5, "Committee on Government and the Arts" folder, AAA.

121. McLanathan, "American Art in Moscow."

122. George Allen, speech to National Press Club, August 13, 1959, AFA Archive, Box 6, "Moscow Subcommittee" folder, AAA.

123. Osgood Caruthers, "Russians at U.S. Fair Debate Abstract Art and Right to Like It," *New York Times*, September 4, 1959. The Soviets' rigid official stance against abstraction and "formalism" appears to have been softening at this time as well. A January 1960 background report for RFE Munich observed that although the Soviet press still harshly criticized abstraction, a few pro-modernist voices could now be found: the poet Yevgeny Yevtushenko defended the "decorative significance" of abstraction in Komsomolskaya Pravda, and a *Literaturnaya Gazeta* article included the comments of a "Soviet abstractionist" who complained that "we are lagging behind the West [with our] primitive materialism and

Philistine realism" ("The Politics of Painting—1959," background report for RFE Munich, January 5, 1960, Charles Thayer Papers, Subject File, Box 16, "Subject File VOA Radio Free Europe/Munich" folder, HSTL).

124. McLanathan, "American Art in Moscow."

3. COLD WARRIORS OF THE BOOK

1. Ralph Bates, "Mr. Wilson's Visit in Suburbia," *New York Times Book Review*, March 31, 1946.

2. "'Hecate' Obscene, Publisher Is Fined," *New York Times*, November 28, 1946. The book was banned in Los Angeles and Boston as well, but a jury in a San Francisco municipal court agreed with Perlman.

3. US House of Representatives, Appropriations Committee, Subcommittee on Appropriations, *Hearings on State Department Appropriations Bill for 1948*, 80th Cong., 1st sess., March 20, 1947, 408–11.

4. US Senate, Foreign Relations Committee, *Hearings of the Subcommittee on Informational and Educational Exchange Act of 1947 (H.R. 3342)*, 80th Cong., 1st sess., July 2–5, 1947, 89–90.

5. John B. Hench, *Books as Weapons: Propaganda, Publishing, and the Battle for Global Markets in the Era of World War II* (Ithaca, NY: Cornell University Press, 2010), 45; also see Trysh Travis, "Books as Weapons and 'the Smart Man's Peace': The Work of the Council on Books in Wartime," *Princeton University Library Chronicle* 60, no. 3 (1999): 353–400.

6. Hench, *Books as Weapons*, 69.

7. Quoted in ibid., 70.

8. Quoted in ibid., 85.

9. John B. Hench, "A D-Day for American Books in Europe: Overseas Editions, Inc., 1944–45," in David Paul Nord, Joan Shelley Rubin, and Michael Schudson, eds., *A History of the Book in America*, vol. 5: *The Enduring Book* (Chapel Hill: University of North Carolina Press, 2009), 193.

10. PSB D-33, US Doctrinal Program, June 29, 1953, quoted in Kenneth Osgood, *Total Cold War: Eisenhower's Secret Propaganda Battle at Home and Abroad* (Lawrence: Kansas University Press, 2008), 294.

11. "Report of OCB Working Group on Books, Publications, and Libraries," June 10, 1954, RG 59 (General Records of the Department of State Executive Secretariat), Subject and Special Files 1953–1961, Box 36 (Berlin Conference to Cultural Presentations Committee), "Books and Publications" folder, NARA.

12. Ibid.; E. P. Lilly, "Targets for American Doctrinal Warfare," January 21, 1953, White House Office, NSC Staff Papers, OCB Secretariat Series, Box 2, "Doctrinal Warfare (Official) (file #2) (1)" folder, DDEL; PSB, September 1952 progress report on the Panel on Doctrinal Warfare, White House Office, NSC Staff, Papers 1948–1961, OCB Secretariat Series, Doctrinal Warfare (Official), Box 2, DDEL.

13. Dan Lacy and Robert W. Frase, "The American Book Publishers Council," in Nord, Rubin, and Schudson, *A History of the Book in America*, 5: 200.

14. Quoted in Osgood, *Total Cold War*, 95–96.

15. "Report of OCB Working Group on Books, Publications, and Libraries."

16. Christian Kanig illustrates the Soviets' top-down approach to book distribution in "Establishing a Beachhead with Print: Literature and Reeducation in Occupied Germany, 1945–1949," in Greg Barnhisel and Catherine Turner, eds., *Pressing the Fight: Print, Propaganda, and the Cold War* (Amherst: University of Massachusetts Press, 2010), 71–88. As the USSR consolidated its power and influence in East Germany in 1946 and 1947, Kanig shows, the Red Army forced bookstore owners to stock books published by Soviet or Red Army publishing firms.

17. Amanda Laugesen, "Books for the World: American Book Programs in the Developing World, 1948–1968," in Barnhisel and Turner, *Pressing the Fight*, 131.

18. Quoted in Osgood, *Total Cold War*, 290.

19. Doctrinal Warfare panel report, 1952, p. 9, White House Office, NSC Staff Papers 1948–1961, OCB Secretariat Series, Box 2, "Doctrinal Warfare (Official) (File #1)" folder, DDEL; Dan Lacy, "The Role of American Books Abroad," *Foreign Affairs* 34, no. 3 (1956): 406.

20. US State Department, Bureau of Educational and Cultural Affairs, "Soviet Book Publishing in Free World Languages," report, 1961, Box 206, Folder 11, UARK.

21. William Kennedy to PSB director, March 6, 1952, PSB Files, Box 4, "Ford Foundation" folder, HSTL.

22. "Report of the Informational Media Guaranty Study Group," 1961, part II, p. 1, RG 306, Entry A1 6, Lot no. 70 D 423, Box 40, NARA.

23. For a fuller description of Franklin Publications, see Laugesen, "Books for the World."

24. William M. Childs and Donald E. McNeil, *American Books Abroad: Toward a National Policy* (Washington, DC: Helen Dwight Reid Educational Foundation, 1986), 57.

25. "Off Again, On Again," *Time*, May 4, 1953, http://content.time.com/time/magazine/article/0,9171,818387,00.html.

26. Curtis G. Benjamin, *U.S. Books Abroad: Neglected Ambassadors* (Washington, DC: Library of Congress, 1984), 89. Apart from Germany, Yugoslavia, and Poland, many other western European nations initially were served by the IMG program, but the connection largely ended by 1955, probably because those nations no longer had hard-currency shortages.

27. "USIA, IMG Statement of Policy," July 1957, RG 306, Entry A1 6, Lot no. 70 D 423, Box 40, "IMG Program" folder, NARA.

28. Quoted in Childs and McNeil, *American Books Abroad*, 57.

29. US Senate, Committee on Foreign Relations, *Informational Media Guaranty Program* (Washington, DC: US Government Printing Office, January 16, 1958), 7.

30. Childs and McNeil, *American Books Abroad*, 56.

31. Quoted in Benjamin, *U.S. Books Abroad*, 17–18.

32. U.S. Senate, *Mutual Security Appropriations for 1954: Hearings Before the Committee on Appropriations, U.S. Senate, Eighty-third Congress, First Session on H.R. 6391*, RG 306, Entry A1 6, Box 40, "IMG Legislative History" folder, NARA.

33. US House of Representatives, *Hearings on Mutual Security Appropriations Bill of 1956* and *Hearings on Mutual Security Appropriations Bill of 1958*, RG 306, Entry A1 6, Box 40, "IMG Legislative History" folder, NARA.

34. Childs and McNeil, *American Books Abroad*, 59.

35. Benjamin, *U.S. Books Abroad*, 19.

36. *American Ideas Abroad: The Informational Media Guaranty Program*, pamphlet, Series 17/1/6, Box 24, "IMG" folder, ALA.

37. The case of Franklin Books is in some ways an even more striking demonstration of the marshaling of literature for political purposes, but Franklin's operations were aimed primarily at Middle Eastern audiences, and thus its history falls outside of the scope of my investigation.

38. See Julie Irene Prieto, "'The Sword and the Book': The Benjamin Franklin Library and US–Mexican Relations, 1936–1962," *Book History* 16 (2013): 294–317, for a fuller discussion of the Franklin Library in Mexico City.

39. William Benton, testimony, US House of Representatives, Appropriations Committee, Subcommittee on Appropriations, *Hearings on State Department Appropriations Bill for 1948*, 381.

40. W. McNeil Lowry and Gertrude S. Hooker, "International Educational and Cultural Exchange," draft report, Ford Foundation, June 25, 1962, p. 17, Box 574, folder 1, Alfred A. Knopf Archive, HRC.

41. Dan Lacy, "The Overseas Book Program of the United States Government," *Library Quarterly* 24, no. 2 (1954): 178.

42. George Allen, "Books and the American Image," *Atlantic Monthly*, May 1961.

43. "Report on the Book and Library Program," July 1953, RG 306 (USIA Historical Collection), General Records of the USIA, Historical Collections, Subject Files 1953–2000, Box 182, "Books, Reports, Book Selection Committee 1947" folder, NARA.

44. Benjamin, *U.S. Books Abroad*, 91.

45. Sol Schindler, interviewed by the author, October 4, 2008, Washington, DC.

46. Ibid.

47. *Manual for Launching Books in Foreign Countries*, RG 306 (USIA Historical Collection), General Records of the USIA, Historical Collections, Subject Files 1953–2000, Box 174, NARA.

48. Lacy and Frase, "American Book Publishers Council," 200.

49. Schindler interview, October 4, 2008.

50. Ibid.

51. Dan Lacy, memo, October 8, 1951, RG 306, Entry A1 6, Box 147, "Advisory Committee on Books Abroad" folder, NARA.

52. Robert Crowell to Translation Program, IIA, Department of State, memo, August 6, 1951, RG 306 (USIA Historical Collection), General Records of the USIA, Historical Collection, Subject Files 1953–2000, Box 174, NARA.

53. Crowell's recommendations made it into the *Manual for Launching Books in Foreign Countries*, published for internal use by the Information Center Division in 1954.

54. Minutes of the Twenty-First Meeting of the US Advisory Commission on Educational Exchange, December 4–5, 1952, RG 59 (General Records of the Department of State, Bureau of Educational and Cultural Affairs, General Records 1951–1963), Box 10, "IAE/S" folder, NARA.

55. Quoted in Louise S. Robbins, "The Overseas Libraries Controversy and the Freedom to Read: U.S. Librarians and Publishers Confront Joseph McCarthy," in Hermina G. B. Anghelescu and Martine Poulain, eds., *Books, Libraries, Reading, and Publishing in the Cold War* (Washington, DC: Library of Congress Center for the Book, 2001), 29.

56. Minutes of the Twenty-Third Meeting of the US Advisory Commission on Educational Exchange, RG 59 (General Records of the Department of State, Bureau of Educational and Cultural Affairs, General Records 1951–1963), Box 10, "IAE/S" folder, NARA.

57. Osgood, *Total Cold War*, 296.

58. Robbins, "Overseas Libraries Controversy," 32–33; Dwight D. Eisenhower, "Remarks at the Dartmouth College Commencement Exercises, Hanover, NH," June 14, 1953, reproduced in Gerhard Peters and John T. Woolley, eds., *The American Presidency Project*, http://www.presidency.ucsb.edu/ws/?pid=9606, accessed May 12, 2014; IIA to diplomatic and consular officers, memo, July 15 1953, RG 306 (USIA Historical Collection), General Records of the USIA, Historical Collection, Subject Files, Box 177, NARA.

59. Osgood, *Total Cold War*, 296.

60. Minutes of the Third Meeting of the Books Abroad Committee, January 11, 1954, RG 306 (Advisory Commission on Information, General Records 1953–57), Box 1, "Books Abroad Advisory Committee" folder, NARA.

61. USIA to Alfred A. Knopf, October 11, 1961, Box 301, Folder 6, Knopf Archive, HRC.

62. USIA to William Koshland, July 22, 1960, Box 301, Folder 6, Knopf Archive, HRC.

63. USIA to Thomas Lowry, October 26, 1961, Box 301, Folder 6, Knopf Archive, HRC.

64. Lowry to John Updike, August 28, 1963, Box 301, Folder 6, Knopf Archive, HRC. Knopf had received a request from a Yugoslav firm to publish *Rabbit, Run* in Serbo-Croatian.

65. Lowry to Knopf, August 28, 1963, Box 301, Folder 6, Knopf Archive, HRC.

66. Information about the books included in the translation program comes from USIA, *Books Published Abroad July 1, 1950–June 30, 1956* (Washington, DC: USIA, 1956).

67. "Progress Report on the U.S. Ideological Program," August 24, 1955, pp. 1–2, White House Office, NSC Staff Papers 1948–1961, OCB Central File Series, Box 71, "OCB 091.4 Ideological Programs (File #3) (5) (June 1955–March 1956)" folder, DDEL. Included in this series were titles such as Charles Henry Darke's *Cockney Communist*, Eugene Owen Golob's *The Isms: A History and Evaluation*, Nathan Constantin Leites and Elsa Bernaut's *The Case of the Moscow Trials*, and Walt Whitman Rostow's *The Prospects for Communist China* (titles from June 14, 1955, memo to Edward Lilly, OCB, White House Office, NSC Staff Papers 1948–1961, OCB Central File series, Box 110, "OCB 350.01 [File #2] [3]" folder, DDEL).

68. Edward P. Lilly, memo of conversation between redacted CIA officer and PSB, November 21, 1952, White House Office, NSC Staff Papers, OCB Secretariat series, Box 2, "Doctrinal Warfare (Official) (File #1) (4)" folder, DDEL.

69. VOA transcript, February 24, 1956, COL.

70. John Jacobs, "Frederick Lewis Allen—Spokesman for America," VOA script, February 17, 1954, LOC.

71. Russell Riley to Franklin Burdette, memo, n.d., RG 306, Box 177 ("Finnish Program"), "Books Referred to State, 1955–56" folder, NARA.

72. Mary Stewart French (head of Community Groups Unit, Office of Educational Exchange, Department of State), "The Arts and the Educational Exchange Program," report, 1961 (?), Box 47, Folder 18, UARK.

73. Heinrich Straumann, *American Literature in the Twentieth Century*, 3rd ed. (1951; New York: Harper & Row, 1965), xiii.

74. "Books Suitable for Foreign Translation," 1955, RG 306 (USIA Historical Collection), General Records of the USIA, Historical Collections, Subject Files 1953–2000, Box 185, "Book Translations Handbook" folder, NARA.

75. "American Literature: A Bibliography," RG 306 (USIA Historical Collection), General Records of the USIA, Historical Collections, Subject Files 1953–2000, Box 133, NARA.

76. *Willa Cather: La esencia universal de la vida pionera; Robert Frost; Francis Donahue, Eugene O'Neill; Ernest Hemingway y el hombre inconquistable; William Faulkner y su condado imaginario*, USIA pamphlets, my translations of pamphlet titles and quoted text, RG 306 (USIA Historical Collection), General Records of the USIA, Historical Collections, Subject Files 1953–2000, Box 145, NARA.

77. Bosquet's book was not actually a "translated" title, having been initially published in French, but its publication went through the Books in Translation program bureaucracy.

78. Alain Bosquet, *Anthologie de la poésie américaine* (Paris: Librairie Stock, 1956), 314, 24.

79. Lawrence Schwartz, *Creating Faulkner's Reputation: The Politics of Modern Literary Criticism* (Knoxville: University of Tennessee Press, 1988), esp. 73–98 and 142–71.

80. William Faulkner, "Banquet Speech," December 10, 1950, Nobelprize.org, http://www.nobelprize.org/nobel_prizes/literature/laureates/1949/faulkner-speech.html.

81. Joseph Blotner, *William Faulkner: A Biography*, 2 vols. (New York: Random House, 1974), 2:1338, 1346, 1349.

82. Philip Raine to International Exchange Service, memo, June 22, 1954, Box 144, Folder 13, UARK.

83. See note 76.

84. Philip Raine to International Exchange Service, memo, June 22, 1954.

85. NSC-68 is viewable in its entirety at the Harry S. Truman Presidential Library website at http://www.trumanlibrary.org/whistlestop/study_collections/coldwar/documents/pdf/10-1.pdf.

86. Quoted in Blotner, *William Faulkner*, 2:1504.

87. Transcript of VOA radio discussion between Howe, Ellison, and Lyman Bryson, Box 144, Folder 13, UARK. Ralph Ellison was, of course, not a Mississippian but an Oklahoman; he did attend college at Tuskegee, but that school is in Alabama.

88. Muna Lee to John Campbell, the public-affairs officer of the São Paolo consulate, letter, 1954, Box 144, Folder 13, UARK.

89. Quoted in Blotner, *William Faulkner*, 2:1507.

90. Leon Picon, interviewed by Lew Schmidt, October 30, 1989, Foreign Affairs Oral History Project, Association for Diplomatic Studies and Training, http://www.adst.org/OH%20 TOCs/Picon,%20Leon.toc.pdf, accessed May 13, 2014.

91. James Donovan Jr., staff director of the US Advisory Commission on International Educational and Cultural Affairs of the State Department, to Joseph Blotner, December 9, 1964, Box 144, Folder 14, UARK.

92. William Faulkner, *To the Youth of Japan* (Tokyo: USIS, August 1955).

93. USIS, prod., *Impressions of Japan*, 16mm film, 1955, ARC identifier 51673, local identifier 306.5458, NARA.

94. Foreign Service dispatch, September 22, 1955, Box 144, Folder 14, UARK.

95. Quoted in Foreign Service dispatch, October 25, 1955, Box 144, Folder 14, UARK.

96. Quoted in a report on Faulkner's trip to Greece, Box 144, Folder 14, UARK.

97. Duncan Emrich, Foreign Service dispatch, March 1957, Box 144, Folder 14, UARK.

98. Minutes of the First Meeting of Advisory Committee on the Arts, January 15, 1958, RG 59 (General Records of the Department of State, Bureau of Educational and Cultural Affairs), General Records 1951–1963, Box 6, NARA.

99. William Faulkner to Frederick A. Colwell, May 31, 1958, Box 144, Folder 18, UARK.

100. A silent film—really, more of a collection of raw footage—of Faulkner's 1961 trip to Venezuela is available at the National Archives in College Park, MD (USIS, prod., *William Faulkner in Venezuela*, ARC Identifier 49151, local identifier 306.2796, NARA).

101. Hugh Jencks, report on Faulkner's visit to Venezuela, 1961, Box 144, Folder 14, UARK.

102. USIA, *19th Review of Operations* (Washington, DC: USIA, 1962).

103. Mary Niles Maack, "Books and Libraries as Instruments of Cultural Diplomacy in Francophone Africa During the Cold War," *Libraries and Culture* 36, no. 1 (2001): 66.

104. Robert H. Haddow, *Pavilions of Plenty: Exhibiting American Culture Abroad in the 1950s* (Washington, DC: Smithsonian Institution Press, 1997).

105. USIA, "Current Books Recommended for USIS," memo, April 16, 1962, Box 593, Folder 8, Knopf Archive, HRC.

106. "List of books USIA will not procure unless directed to do so by State Department," 1953, RG 306, Box 177, "Finnish War Program" folder, NARA; Dorothy Sterling, "The Soul of Learning," *English Journal* 57, no. 2 (1968): 169.

107. Mary Dudziak, *Cold War Civil Rights: Race and the Image of American Democracy* (Princeton, NJ: Princeton University Press, 2011).

4. *ENCOUNTER* MAGAZINE AND THE TWILIGHT OF MODERNISM

1. On modernism and little magazines, see Frederick Hoffman, Charles Allen, and Carolyn F. Ulrich, *The Little Magazine: A History and a Bibliography* (Princeton, NJ: Princeton University Press, 1946); Jayne E. Marek, *Women Editing Modernism: "Little" Magazines and Literary History* (Lexington: University Press of Kentucky, 1995); Kevin J. H. Dettmar

and Stephen Watt, *Marketing Modernisms: Self-Promotion, Canonization, Rereading* (Ann Arbor: University of Michigan Press, 1996); Mark Morrisson, *The Public Face of Modernism: Little Magazines, Audiences, and Reception, 1905–1920* (Madison: University of Wisconsin Press, 2000); Robert Scholes, *Modernism in the Magazines: An Introduction* (New Haven, CT: Yale University Press, 2010); and the three volumes of Peter Brooker and Andrew Thacker's *Oxford Critical and Cultural History of Modernist Magazines* (Oxford: Oxford University Press, 2009, 2012, 2013).

2. Malcolm Cowley, *Exile's Return: A Literary Odyssey of the 1920s* (New York: Penguin, 1994), 188.

3. Neil Berry, "*Encounter,*" *Antioch Review* 51, no. 2 (1993): 199.

4. Christopher Lasch, "The Cultural Cold War: A Short History of the Congress for Cultural Freedom," in *The Agony of the American Left* (New York: Vintage, 1969), 61–114; Jason Epstein, "The CIA and the Intellectuals," *New York Review of Books*, April 20, 1967; "CIA Tie Confirmed by Cultural Group," *New York Times*, May 10, 1966; Michael Wood, "A Short Account of International Student Politics & the Cold War with Particular Reference to the NSA, CIA, etc.," *Ramparts*, March 1967: 29–39; Tom Braden, "I'm Glad the CIA Is 'Immoral,'" *Saturday Evening Post*, May 20, 1967; Peter Coleman, *The Liberal Conspiracy* (New York: Free Press, 1989); Frances Stonor Saunders, *The Cultural Cold War: The CIA and the World of Arts and Letters* (New York: New Press, 2000); and Giles Scott-Smith, *The Politics of Apolitical Culture: The Congress for Cultural Freedom, the CIA, and Post-war American Hegemony* (London: Routledge, 2002).

5. Quoted in Saunders, *Cultural Cold War*, 47.

6. Sidney Hook, *Out of Step: An Unquiet Life in the 20th Century* (New York: Carroll and Graf, 1988), 420; minutes from the CCF Executive Committee meeting, January 24, 1955, Box 1, TAM.

7. Diana Trilling, "Liberal Anti-communism Revisited," in *We Must March My Darlings* (New York: Harcourt Brace Jovanovich, 1977), 60.

8. Mikael Warner, "Origins of the Congress for Cultural Freedom, 1949–1950," Center for the Study of Intelligence, CIA, https://www.cia.gov/library/center-for-the-study-of-intelligence/csi-publications/csi-studies/studies/95unclass/Warner.html, accessed 8 May 2007.

9. Melvin Lasky, "Proceedings: The Congress for Cultural Freedom," c. 1950, Series III, Box 1, IACF.

10. Michael Scammell, *Koestler: The Literary and Political Odyssey of a Twentieth-Century Skeptic* (New York: Random House, 2009), 358.

11. Warner, "Origins."

12. Scammell, *Koestler,* 354, 368; Stanislao G. Pugliese, *Bitter Spring: A Life of Ignazio Silone* (New York: Farrar, Straus, and Giroux, 2009), 202.

13. Lasky, "Proceedings."

14. Saunders, *Cultural Cold War*, 87–93.

15. "Masterpieces of the XXth Century," 1952, Allen Tate Papers, Box 16, "Congress for Cultural Freedom" folder, PUL.

16. CCF, "General Purpose" statement, 1951, Series III, Box 4, IACF.

17. Stephen Spender, "Statement to Editorial Board of Twentieth Century, Dec. 20 1951," Se ries II, Box 294, IACF.

18. Giles Scott-Smith, "The 'Masterpieces of the Twentieth Century' Festival and the Con-vgress for Cultural Freedom: Origins and Consolidation 1947–1952," *Intelligence and National Security* 15, no. 1 (2000): 136.

19. James Johnson Sweeney, *Twentieth Century Masterpieces*, exhibit catalog (London: Arts Council, 1952), Series III, Box 2, IACF.

20. Albert Donnelly, secretary of the American Committee, Masterpieces of the Twentieth Century festival), to Allen Tate, April 8, 1952, and René Tavernier to Tate, March 19, 1952, Tate Papers, Box 16, "Congress for Cultural Freedom" folder, PUL.

21. Donnelly to Julius Fleischmann, 1951 (?), Box 7, Folder 11, TAM.

22. Nicolas Nabokov to Fleischmann, 1951 (?), Nicolas Nabokov Papers, Box 1, Folder 5, HRC.

23. Hook, *Out of Step*, 445.

24. Scott-Smith, "The 'Masterpieces of the Twentieth Century' Festival," 137.

25. Saunders, *Cultural Cold War*, 163, 337–38.

26. Saunders quotes Braden recounting his meetings with Levitas in 1952 in which Levitas asked for (and received) several thousand dollars to keep his magazine afloat (*Cultural Cold War*, 163); also see Charles McGrath, "A Liberal Beacon Burns Out," *New York Times*, January 23, 2006.

27. Matthiessen's statement is from an interview with him by Patty Sattalia of the Pennsylvania State University in its series "Conversations from Penn State," http://conversations. psu.edu/episodes/peter_matthiessen; and the evidence about Plimpton is in Joel Whitney, "The *Paris Review*, the Cold War, and the CIA," *Salon.com*, May 12, 2012, http://www. salon.com/2012/05/27/exclusive_the_paris_review_the_cold_war_and_the_cia/. Also see John M. Crewdson, "Worldwide Network for Dissemination of Propaganda Was Built by CIA," *New York Times* December 26, 1977. On the same topic, also see Eric Bennett, "How the CIA Flattened Literature," *Chronicle of Higher Education*, February 10, 2014, in which Bennett argues that CIA subsidies (channeled through Farfield) brought the master of fine arts program at the University of Iowa—and its characteristic model for short fiction—to postwar dominance.

28. Michael Goodwin to Nabokov, 1951, Series II, Box 94, IACF.

29. Goodwin to Nabokov, December 31, 1951, Series II, Box 94, IACF.

30. Spender, "Statement to Editorial Board of Twentieth Century, Dec. 20 1951."

31. Nabokov to Goodwin, January 11, 1952, Series II, Box 94, IACF.

32. Michael Josselson to Stephen Spender, March 5, 1953, Series II, Box 294, IACF.

33. Quoted in Hugh Wilford, *The Mighty Wurlitzer: How the CIA Played America* (Cambridge, MA: Harvard University Press, 2008), 264; Irving Kristol to Josselson, September 15, 1953, March 17, 1954, Series II, Box 94, IACF.

34. Scott-Smith, *Politics of Apolitical Culture*, 126.

35. "First Report and Preliminary Recommendations of the Panel on Doctrinal Warfare," Annex B, "Preliminary Analysis of the Problem," Dec. 1952 (?), 3, White House Office, NSC

Staff Papers, OCB Secretariat Series, Box 2, "Doctrinal Warfare (Official) (File #1) (3)" folder, DDEL.

36. Kristol to Melvin Lasky, April 22, 1953, Series II, Box 30, IACF. *Confluence* emanated from the Harvard University International Summer Seminar, directed by Henry Kissinger, which received its initial funding from the CIA. Kissinger also approached the Ford Foundation, through James Laughlin, for funding, and after suggesting some modifications to the magazine, Laughlin agreed to pitch the proposal to Ford (Laughlin to Milton Katz, March 17 1953, Box 30, "Milton Katz" folder, IPI). In the end, Laughlin's Intercultural Publications provided *Confluence* with a $6,000 grant in 1953, and once Intercultural was defunct, the Ford Foundation stepped in to provide funding (James Laughlin to Paul Buck, May 11, 1953, Reel 1058, Grant 55–32, section 4, FFA; Inderjeet Parmar, *Foundations of the American Century* [New York: Columbia University Press, 2012], 103–4).

37. Saunders, *Cultural Cold War*, 169.

38. Irving Kristol, "'Civil Liberties,' 1952—a Study in Confusion," *Commentary* 13 (March 1952): 234–35.

39. Stephen Spender, *The Thirties and After* (New York: Random House, 1978), 128.

40. Josselson to Spender, March 5, 1953.

41. Hugh Wilford, "Calling the Tune? The CIA, the British Left, and the Cold War, 1945–1960," *Intelligence and National Security* 18, no. 2 (2003): 43.

42. Kristol to François Bondy, November 12, 1952, Series II, Box 29, IACF.

43. Spender to Louis MacNeice, July 6, 1953, Box 78, BU.

44. Scammell, *Koestler*, 432.

45. Kristol to Josselson, August 25, 1953, Series II, Box 94, IACF.

46. Kristol to Josselson, September 15, 1953, Series II, Box 94, IACF.

47. Kristol to Josselson, September 16, 1953, Series II, Box 94, IACF.

48. Spender to Josselson, May 5, 1953, Series II, Box 294, IACF.

49. Spender to Josselson, January 22, 1954, Series II, Box 294, IACF.

50. Spender to Sidney Hook, June 5, 1955, Series II, Box 294, IACF.

51. Spender to Josselson, March 30, 1955, Series II, Box 294, IACF.

52. Lasky to Spender, November 13, 1962, Michael Josselson Papers, Box 22, Folder 5, HRC.

53. Irving Kristol, "An Autobiographical Memoir," in *Neoconservatism: The Autobiography of an Idea* (New York: Free Press, 1995), 23.

54. Josselson to Richard Krygier, September 30, 1953, Series I, Box 1, IACF.

55. Josselson to Spender, March 5, 1953, and September 1953, Series II, Box 294, IACF.

56. Kristol to Josselson, September 16, 1953, Series II, Box 94, IACF.

57. Josselson to Kristol, December 4, 1954, and March 1954, Series I, Box 2, and Series II, Box 94, IACF.

58. Josselson to Kristol, December 29, 1956, Series I, Box 7, IACF.

59. Kristol to International Committee, CCF, memo, November 6, 1953. Series II, Box 294, IACF.

60. Josselson to Kristol, December 4, 1954, Series I, Box 2, IACF; Scott-Smith, *Politics of Apolitical Culture*, 129.

61. See Saunders, *Cultural Cold War*; Scott-Smith, *Politics of Apolitical Culture*; and Coleman, *The Liberal Conspiracy*.

62. Michael Josselson, "Confidential Report on the Financial History of the Congress for Cultural Freedom," n.d., Josselson Papers, Box 27, Folder 2, HRC.

63. "In the Mood," #A-181, RFE program script, January 14 1957, IACF.

64. Kristol, "An Autobiographical Memoir," 15. Fleischmann's involvement in funding *Encounter* could not have been secret (although the source of his money was), as James Laughlin refers to it in a letter to Robert Hutchins: "This [magazine] is the one that Rockefeller F[oundation] was going to back, but then didn't. I guess Junie Fleischmann must be cashing up" (June 1, 1953, New Directions Publishing Corp. Records, HVD).

65. Josselson to Kristol, January 28, 1954, Series II, Box 94, IACF.

66. Josselson to Kristol, July 3, 1954, Series I, Box 1, IACF; the 1959 figure is from Saunders, *Cultural Cold War*, 219.

67. Kristol, "An Autobiographical Memoir," 15. In an interesting tidbit, Kristol told Frank Kermode (who succeeded Spender as *Encounter*'s English editor) that at the time of the magazine's founding Tom Braden—whose article "I'm Glad the CIA Is 'Immoral'" was a notorious self-congratulatory piece by an agent about the CIA's cultural Cold War operations—"had thought of approaching me to become a CIA agent. But he ran a security check, and I failed to achieve the standard set of 'agency clearance'" (May 23, 1967, Frank Kermode Papers, Box 17, Folder 12, PUL).

68. Spender to Josselson, April 29, 1967, Box 25, HRC. Josselson maintained that only he knew of the CIA connections, although Saunders and others speculate that Lasky and CCF members Irving Brown and James Burnham must also have been aware of the connections, so when Lasky took over Kristol's job, an *Encounter* editor would have known of the CIA funding.

69. Quoted in Scammell, *Koestler*, 509.

70. Quoted in Hugh Wilford, *The CIA, the British Left, and the Cold War: Calling the Tune?* (London: Frank Cass, 2003), 289.

71. Braden, "I'm Glad the CIA Is 'Immoral.'" Kristol himself expressed perplexity about what Braden meant: "I have tried, and my lawyers have tried, to get Braden to specify exactly whom he had in mind. But he refuses. Instead, he is now redefining 'agent' to mean anyone who was wittingly or unwittingly involved in a CIA-sponsored enterprise!" (Kristol to Frank Kermode, May 23, 1967, Kermode Papers, Box 17, Folder 12, Rare Books and Manuscripts, PUL).

72. Saunders, *Cold War Culture*, 323, 321.

73. Josselson, "Confidential Report on the Financial History of the Congress for Cultural Freedom."

74. Kristol, "An Autobiographical Memoir," 16.

75. Ibid., 18.

76. Norman Podhoretz, *Breaking Ranks: A Political Memoir* (New York: Harper and Row, 1979), 84.

77. Kristol to Josselson, December 1, 1955, Series I, Box 1, IACF.

78. Saunders, *Cold War Culture*, 217, 323–24. Saunders recounts two instances where *Encounter* refused to publish articles because of CCF directives: Dwight Macdonald's 1958 article "America! America!" and a 1954 piece by Emily Hahn on American policy in China. Regarding the latter instance, Saunders provides some evidence that the orders to spike the article came directly from the CIA.

79. This issue refuses to die as well. In a May 2012 article in *Salon.com* ("The *Paris Review*, the Cold War and the CIA," May 27, 2012), Joel Whitney uses the recently opened *Paris Review* archives to detail the financial links between the CCF and the magazine, suggesting that the CCF—and, by implication, the CIA—had influence over the contents of that journal, including what authors would appear in its renowned series of interviews. But regarding the similar accusations made about *Encounter*, I feel that the evidence simply does not support the claims that these journals danced to the CIA's tune (to use Saunders's metaphor from *Who Paid the Piper?* the British title of her book *The Cultural Cold War*). Moreover, these dark, conspiratorial innuendoes show ignorance of how complicated and indirect the relationship was between the CIA, the CCF, and the groups the CCF supported and of how absurd it would have been to expect people such as James Burnham, Sidney Hook, François Bondy, Nicola Chiaromonte, Irving Kristol, and George Plimpton to follow orders. I agree that the CIA may have *tried* to achieve what Whitney and Saunders credit it with accomplishing; this hypothesis, however, is very different from providing evidence that the agency's efforts were successful and manifested in the pages of *Encounter* or the *Paris Review*.

80. Scott-Smith, *Politics of Apolitical Culture*, 126.

81. Spender, *The Thirties and After*, 128

82. Nabokov to George Kennan, August 17, 1956, George Kennan Papers, Series 1, Box 32, Folder 13, Public Policy Papers, PUL.

83. Trustees of Encounter, "Editorial Note," 1967, Kermode Papers, Box 17, Folder 28, PUL.

84. Josselson to Kristol, May 7, 1967, Josselson Papers, Box 26, Folder 4, HRC.

85. Spender to Josselson, October 22, 1953, Series II, Box 94, IACF.

86. Kristol to International Committee, CCF, November 6, 1953, Series II, Box 94, IACF.

87. Saunders, *Cultural Cold War*, 184; for the article in question, see Leslie Fiedler, "A Postscript on the Rosenberg Case," *Encounter* 1, no. 1 (1953): 12–21. Although the CCF and many of its sympathizers were scandalized by Fiedler's contemptuous article, Saunders also asserts that CIA agent Tom Braden, who helped funnel funds from Langley to Paris, admitted that the agency pushed for the article to be accepted at *Encounter* and in fact paid "circulation funds"—that is, agreed to buy a set number of copies of the journal once it reached newsstands—in exchange for ensuring that the piece would appear (186).

88. Kristol to Josselson, July 31, 1953, Series II, Box 94, IACF.

89. Spender to Josselson, October 22, 1953, Series II, Box 94, IACF.

90. Spender to Czeslaw Milosz, October 23, 1953, and Spender to Albert Camus, November 13, 1953, "Selected Documents" Box, BU.

91. "The Editors' Reflections on *Encounter*," 1954, Series II, Box 95, IACF.

92. Peter Wiles, "Two Wandering Satellites: Poland and Hungary," *Encounter* 8, no. 1 (1957): 23.

93. Hoffman, Allen, and Ulrich, *The Little Magazine*, 2.

94. Jeffrey J. Williams, "The Rise of the Theory Journal," *New Literary History* 40, no. 4 (2009): 686.

95. Jason Harding, "The Idea of a Literary Review: T. S. Eliot and *The Criterion*," in Peter Brooker and Andrew Thacker, eds., *The Oxford Critical and Cultural History of Modernist Magazines*, vol. 1: *Britain and Ireland 1880–1955* (New York: Oxford University Press, 2009), 346.

96. Ibid., 356.

97. Ibid., 351.

98. Ibid., 345.

99. Kristol to Herbert Luthy, July 14, 1953, "Selected Documents" box, BU.

100. Irving Kristol, "After the Apocalypse," *Encounter* 1, no. 1 (1953): 1.

101. Kristol to CCF, September 26, 1952, Series II, Box 30, IACF. This book appears never to have been published.

102. Michael Polanyi, "The Magic of Marxism," *Encounter* 7, no. 6 (1956): 11.

103. Herbert Luthy, "'Of Poor Bert Brecht,'" *Encounter* 7, no. 1 (1956): 34.

104. Mark Alexander, "New Directions in Soviet Literature?" *Encounter* 2, no. 6 (1954): 42.

105. "From the Other Shore," *Encounter* 11, no. 5 (1958): 77; the *Encounter* article's quote from the Soviet magazine is in italics.

106. George Steiner, "Marxism and the Literary Critic," *Encounter* 11, no. 5 (1958): 33–43.

107. Fredric Jameson, *A Singular Modernity* (London: Verso, 2002), 165–66. Jameson distinguishes late modernism from what he calls "high modernism" as well as from "proto-modernism" on the grounds that late-modernist art tends to be self-reflexive about the creation of art itself. "The late modernist reflexivity," he says, "has to do with the status of artist as modernist and involves a constant and self-conscious return to art about art, and art about the creation of art. This status is a fundamentally different one, psychologically and socially, from the modernist and proto-modernist or Romantic notion of the artist as seer or as the guardian of the Absolute" (198–99). Although his primary example for late modernism is Greenberg's advocacy of the abstract expressionists and their subject matter (which is painting itself and the materials used in painting), for literature he points to the rise of the reputation of Wallace Stevens and the decline of Eliot and Pound, who "held to the Absolute and Utopianism, in ways no longer appropriate to the postwar era" (168).

108. Tom Scott, "A Ballad—After Villon," *Encounter* 1, no. 1 (1953): 22.

109. Edith Sitwell, "Two Songs," *Encounter* 1, no. 1 (1953): 34–35.

110. Spender to James Joll, n.d., Box 88, BU.

111. Frances Cornford, "The Lost Sailor—Poem After Heredia," *Encounter* 1, no. 2 (1953): 64; Michael Hamburger, "Philoctetes," *Encounter* 1, no. 2 (1953): 45; Arthur Waley, "The Hymn of the Soul," *Encounter* 1, no. 3 (1953): 26–28; Sydney Goodsir Smith, "The Tarantula of Luve," *Encounter* 2, no. 2 (1954): 11; Chester Kallman, "Two Poems from Rome," *Encounter* 1, no. 3 (1953): 56; Elizabeth Jennings, "Florence," *Encounter* 2, no. 1 (1954): 33.

112. Robert Fitzgerald, "Gloom and Gold in Ezra Pound," *Encounter* 7, no. 1 (1956): 22.

113. Robert Lowell, "Ford Madox Ford 1873–1939," *Encounter* 2, no. 4 (1954): 32.

114. Robert Lowell, *Letters of Robert Lowell* (New York: Farrar, Straus and Giroux, 2005), 222–24.

115. Mark McGurl, *The Program Era: Postwar Fiction and the Rise of Creative Writing* (Cambridge, MA: Harvard University Press, 2009).

116. Edmund Wilson, "The Messiah at the Seder," *Encounter* 7, no. 4 (1956): 20–31.

117. William Faulkner, "Mississippi," *Encounter* 3, no. 4 (1954): 3–16.

118. Herbert Read, "The Drift of Modern Poetry," *Encounter* 4, no. 1 (1955): 10.

119. Stephen Spender, *The Struggle of the Modern* (Berkeley: University of California Press, 1963), 110, 114.

120. Graham Hough, review of *The Romantic Image* by Frank Kermode, *Encounter* 9, no. 4 (1957): 75.

121. Alberto Lacerda, "Lago," *Encounter* 1, no. 1 (1953): 33.

122. Anthony Cronin, "A Massacre of Authors," *Encounter* 6, no. 4 (1956): 31.

123. George Aldis, "Portrait of D. H. Lawrence," *Encounter* 2, no. 6 (1954): 50.

124. Stephen Spender, "Letter to a Young Writer," *Encounter* 2, no. 3 (1954): 5.

125. Stephen Spender, "Notes from a Diary," *Encounter* 7, no. 2 (1956): 70.

126. Melvin Lasky, preface to *Encounters: An Anthology from the First Ten Years of* Encounter *Magazine* (New York: Basic Books, 1963), xii.

127. Graham Hough, "Redressing the Balance," *Encounter* 11, no. 1 (1958): 90.

128. Kathleen Raine, "Blake and Tradition," *Encounter* 7, no. 5 (1956): 51; for Eliot's comment on Blake, see T. S. Eliot, "Blake," in *The Sacred Wood and Major Early Essays* (Mineola, NY: Dover, 1998), 91.

129. Hough, "Redressing the Balance," 90.

130. Michael Hamburger, "Art and Nihilism: The Poetry of Gottfried Benn," *Encounter* 3, no. 4 (1954): 49.

131. T. S. Eliot, *Notes Toward the Definition of Culture* (New York: Harcourt, 1949), 17.

132. Harold Rosenberg, "French Silence and American Poetry," *Encounter* 3, no. 6 (1954): 19.

133. Hough, review of *The Romantic Image*, 74.

134. Stuart Hampshire, "An Act of Resignation," *Encounter* 10, no. 1 (1958): 73.

135. Leslie Fiedler, "Poets, Priests, and Scientists," *Encounter* 2, no. 4 (1954): 72.

136. Burns Singer, "Scarlet Eminence: A Study in the Poetry of Hugh MacDiarmid," *Encounter* 8, no. 3 (1957): 55.

137. K. W. Grandsen, "The Dustman Cometh," *Encounter* 11, no. 1 (1958): 86, 84.

138. Lindsay Anderson, "Get Out and Push!" *Encounter* 9, no. 5 (1957): 14–22; Stephen Spender, "From a Diary," *Encounter* 11, no. 6 (1958): 75.

139. K. W. Grandsen, "Adolescence and Maturity," *Encounter* 11, no. 2 (1958): 84.

140. Jack Kerouac, "Beatific: The Origins of a Generation," *Encounter* 13, no. 2 (1959): 57–61.

141. Leslie Fiedler, "The Un-Angry Young Men," *Encounter* 10, no. 1 (1958): 9.

142. ACCF, draft statement on the International Association for Cultural Freedom, January 5, 1955, Series II, Box 30, IACF.

143. Kenneth Tynan, "American Blues," *Encounter* 2, no. 5 (1954): 19; Irving Kristol, "American Ghosts," *Encounter* 3, no. 1 (1954): 74.

144. Spender, "Letter to a Young Writer," 5.

145. Spender, *Struggle of the Modern*, 76.

146. Spender, *The Thirties and After*, 158.

147. Stephen Spender, "Ghosts of a Renascence," *Encounter* 1, no. 3 (1953): 2.

148. Harold Rosenberg, "The American Action Painters," in *The Tradition of the New* (New York: Horizon, 1959), 31.

149. Meyer Schapiro, "Recent Abstract Painting," in *Modern Art, 19th and 20th Centuries: Selected Papers* (New York: George Braziller, 1978), 218, 222.

150. George Kennan, typescript of closing speech to CCF Berlin conference, June 22, 1960, Josselson Papers, Box 27, Folder 2, HRC. Kennan's talk, titled "'That Candles May Be Brought . . . ,'" appeared in *Encounter* 14, no. 2 (1961): 72–74.

151. Leslie Fiedler, "The 'Good American,'" *Encounter* 2, no. 3 (1954): 53.

152. Wilford, *The Mighty Wurlitzer*, 274.

153. Spender, "Ghosts of a Renascence," 3.

154. Lionel Trilling, "The Person of the Artist," *Encounter* 9, no. 2 (1957): 73.

155. Dwight Macdonald, "I Choose the West," in *Memoirs of a Revolutionist* (New York: Meridian, 1958), 197.

156. Quoted in Carol Brightman, *Between Friends: The Correspondence of Hannah Arendt and Mary McCarthy* (New York: Harcourt Brace, 1995), 14.

157. See especially Norman Podhoretz, *Making It* (New York: Harper Colophon, 1980). Trilling, in "On the Modern Element in Modern Literature" (in *Beyond Culture: Essays on Literature and Learning* (New York: Viking, 1965), 1–31), also saw in modernism an implacable opposition to the values of American society, a view shared by Bell, Podhoretz, and Kristol in their later stages.

158. Norman Podhoretz, "The Know-Nothing Bohemians," *Partisan Review* 25, no. 2 (1958): 305–18.

159. Andrew O'Hagan, "Jack Kerouac: Crossing the Line," *New York Review of Books*, March 21, 2013.

5. *PERSPECTIVES USA* AND THE ECONOMICS OF COLD WAR MODERNISM

1. John Peale Bishop, "The American Culture: A Symposium. III. The Arts," *Kenyon Review* 3, no. 2 (1941): 183–84.

2. Although many scholars and journalists have written on *Encounter* and the CCF, *Perspectives USA* and its parent organization, Intercultural Publications, are barely known, even among scholars of modernist art and literature or historians of publishing. Ludovic Tournès provided a brief descriptive overview of the journal in the French history journal *Vingtième siècle: Revue d'histoire* 76 (October–December 2002): 65–77. I contributed an early version of this chapter to *Modernism/Modernity* 14, no. 4 (2007): 729–54; and since then two as yet unpublished theses that deal extensively with *Perspectives USA* have appeared:

Elspeth Healey, "Writing Communities: Aesthetics, Politics, and Late Modernist Literary Consolidation," PhD diss., University of Michigan, 2008, and Matthew Corcoran, "Pure Child of a Wavering Mother: *Perspectives USA*, 1952–1956," MA thesis, Harvard University, 2012. Both have distinct takes from and add valuable additional research to my own work.

3. Laughlin put this resentment in his long, autobiographical poem *Byways* ([New York: New Directions, 2005], 34–35):

> In the suite next
> To ours were two swells,
> Peter Jay and Anthony Bliss,
> They were lads from old and
> Distinguished New York families
> Who had been to school at Groton.
> We tried to be friendly with our
> Neighbors, but there was no response
> Except obvious snubs when we passed
> Them in the corridor

4. In a June 25, 1938, letter to Dwight Macdonald, Laughlin wrote, "When I finish Harvard I hope to go to work in our Allequipa [*sic*] plant and get some lowdown for a book on it. I'd like to do one of those cross-section novels that show what everybody is doing from the guy on the bottom to the guy on the top" (New Directions Publishing Corp. Records, Series I, "Dwight Macdonald" folder, HVD). To Robert Hutchins, Laughlin jovially explained that Jones & Laughlin Steel, the source of the family fortune, was created precisely to keep more Laughlins from the temptations of art: "Do you know, by the way, why Grandpappy's Pappy, who was a banker, started J&L? It was because Grandpappy's brother Henry wanted to go to Paris to be a painter and Grandpappy feared he would lead his four brothers to perdition, so he got Puddler [Benjamin] Jones to start the Furnace and put the boys to work in it" (February 23, 1952, Dwight Macdonald Correspondence folder, New Directions Publishing Corp. Records, HVD).

5. Hayden Carruth, interviewed by the author, July 4, 2005, Munnsville, NY.

6. James Laughlin, "Preface," *New Directions in Prose and Poetry* 1 (1936): viii.

7. Although Laughlin did not serve in the war because of a psychological deferment, he contributed to the war effort by making available to the army his ski area in Alta, Utah, for Alpine training (he had purchased the mountain and ski area with the money he received from his family as a graduation gift).

8. Dudley Fitts, ed., *Anthology of Contemporary Latin-American Poetry* (Norfolk, CT: New Directions, 1942). Fitts wrote Laughlin (July 17, 1941) that the "government" had provided $3,000 to pay for permissions, translations, and editing of the book. Robert MacGregor of New Directions asked Horace Hart of the Department of Commerce (August 9, 1960) about subsidies for publishing in Latin America, remembering that the Fitts anthology had been "underwritten" by Nelson Rockefeller's office (OIAA), "for this 700 page book sold for only $2.50"(New Directions Publishing Corp. records, Series I, "Dudley Fitts, Cor-

respondence" and "United States Information Service" folder, HVD). Laughlin wrote in a 1945 letter to the War Production Board that OIAA had also helped New Directions obtain extra rationed paper to print the anthology (James Laughlin to War Production Board, July 18, 1945, HVD).

9. James Laughlin, unpublished statement on *Perspectives USA*, 1952, Box 29, IPI. Laughlin published a small book of poems about his trip to Germany: *Report on a Visit to Germany* (Lausanne: Henri Held, 1948).

10. James Laughlin, "A Few Random Notes from the Editor," *New Directions in Prose and Poetry* 10 (1948): 510–12.

11. James Laughlin, interviewed by Charles T. Morrissey, May 22, 1973, Ford Foundation Oral History Project, pp. 4–5, FFA. Laughlin had known Hutchins for several years because New Directions had published four books by Hutchins's first wife, Maude, and Laughlin often stopped in Chicago to stay with the Hutchins family on his way west for ski trips.

12. Laughlin to Hutchins, November 6, 1951, New Directions Publishing Corporation records, Series I, "Robert M. Hutchins" folders, HVD.

13. Dwight Macdonald, *The Ford Foundation: The Men and the Millions* (New York: Reynal, 1956), 3.

14. Ford Foundation, "Mission," http://www.fordfoundation.org/about-us/mission, accessed May 20, 2014.

15. Quoted in Harry Ashmore, *Unseasonable Truths: The Life of Robert Maynard Hutchins* (New York: Little, Brown, 1989), 313, emphasis in original.

16. Ford Foundation, "Report of the Study for the Ford Foundation on Policy and Program," November 1949, http://www.fordfoundation.org/pdfs/about/Gaither-Report.pdf, accessed May 20, 2014.

17. Ford Foundation memo, July 1952, Box 29, "Background Material" folder, IPI

18. Hutchins to Dyke Brown, August 13, 1953, Box 29, "Background Material" folder, IPI.

19. See Inderjeet Parmar, *Foundations of the American Century: The Ford, Carnegie, & Rockefeller Foundations in the Rise of American Power* (New York: Columbia University Press, 2012), for a much more extensive description of these and other programs.

20. Corcoran, "Pure Child of a Wavering Mother," 15.

21. Dwight Macdonald, "Foundation: Next Winter or by Plane," *New Yorker*, December 17, 1955; Ashmore, *Unseasonable Truths*, 320

22. Macdonald, "Foundation"; Macdonald, *The Ford Foundation*, 53.

23. Hutchins to George Kennan, July 9, 1951, George Kennan Papers, Series I (Correspondence), Box 21, Folder 7, PUL. Kennan was already the recipient of Ford Foundation money through his East European Fund and a publishing venture called "Chekhov Books."

24. Laughlin could, of course, have run New Directions as a nonprofit or a vanity project—he had the means to subsidize it indefinitely—but as he pointed out to Ezra Pound in 1939, he wanted the house to be run as a business, an "efficient mechanism" (Laughlin to Ezra Pound, December 5, 1939, Ezra Pound Papers, Box 28, Yale Collection of American Literature, Beinecke Library, Yale University).

25. "Proposal for a Quarterly Magazine on American Materials for Distribution Abroad," Reel 1057, Grant 52-86, section 2, FFA.
26. Laughlin to Allen Tate, March 14, 1952, Allen Tate Papers, Box 27, PUL.
27. James Laughlin, oral history, p. 7, Ford Foundation Oral History Project, FFA; Laughlin to Warren F. Roberts of the Harry Ransom Center, October 3, 1973, and Laughlin to Helen Harrison of the Pollock-Krasner House, October 17, 1992, New Directions Publishing Corp. Records, Series II, "Intercultural Publications" folder, HVD.
28. Laughlin to Hutchins, December 11, 1951, New Directions Publishing Corp. Records, Series I, "Robert M. Hutchins" folders, HVD.
29. Laughlin to Hutchins, February 6, 1952, New Directions Publishing Corp. Records, Series I, "Robert M. Hutchins" folders, HVD.
30. "Proposal for a Quarterly Magazine," 3.
31. Ibid., 2.
32. Hayden Carruth to Hutchins, memo, September 24, 1952, Box 29, "Background Material" folder, IPI.
33. Press release, February 29, 1952, Reel 1057, Grant 52-86, section 2, FFA.
34. Laughlin to Tate, February 27, 1952, Tate Papers, Box 27, PUL.
35. Transcript of VOA broadcast, 1952, Reel 1057, Grant 52-86, section 4, FFA, my translation.
36. Although Intercultural's initial mission was solely the quarterly publication of *Perspectives*, in July 1952 the Ford Foundation granted it another $200,000 "to permit the development of additional exchange projects in the field of publications"—projects that eventually included sponsorship of UNESCO's journal *Diogenes*, the loan of paintings to be displayed in art exhibitions in India, the export of inexpensive books to India, publication of "Country Perspectives" pamphlets jointly with the *Atlantic Monthly*, even sponsorship of a "special number of the Polish language magazine KULTURA which is published in Paris by a group of exiled Polish intellectuals" (Ford Foundation memo, July 1952, Box 29, "Background Material" folder, IPI).
37. In the Office of Strategic Services London, Casey was in the Secret Intelligence branch and from there led the effort to infiltrate Germany, as he details in his 1988 book *The Secret War Against Hitler* (Washington, DC: Regnery Gateway). Angleton and Pearson, although acquainted with Casey, worked in "X-2," the counterintelligence branch. When Casey joined the Intercultural board, he was listed as the head of a consulting firm called "Business Reports, Inc." He went on to head the Securities and Exchange Commission and, under President Reagan, the CIA. Alfred Knopf as well had shown himself willing to work with the government, especially with the USIA's Books in Translation program, as detailed in chapter 3.
38. Henry Ford II, "*Perspectives USA*," Ford Foundation press release, April 7, 1952, Reel 1057, Grant 52-86, section 2, FFA; Laughlin to Tate, March 14, 1952, Tate Papers, Box 27, PUL. The advisory board eventually came to include MacLeish, Lionel Trilling, Harry Levin, Cleanth Brooks, Delmore Schwartz, John Crowe Ransom, Tate, Edmund Wilson, Malcolm Cowley, W. H. Auden, R. P. Blackmur, Robert Penn Warren, Norman Holmes Pearson, Thomas Merton, Tennessee Williams, and Alfred Kazin, among many others.

39. James Atlas, *Delmore Schwartz: The Life of an American Poet* (New York: Farrar, Straus and Giroux, 1977), 305. Carruth noted in an interview that "Jay [Laughlin] wanted Del, [who] was in kind of bad shape. He'd been fired from Syracuse University because he couldn't meet his classes properly, he was drunk all the time, and belligerent. Jay gave him the job of writing one-paragraph reviews, like the book reviews at the back of the *New Yorker*, for *Perspectives*, on books of American poetry and criticism, things like that. So Delmore used to come into the office every afternoon, at two o'clock or so, sit around, bang on the typewriter. He didn't really do very much. Delmore . . . was extremely paranoid. And crazy, too. He did very strange things. He stood out on Sixth Avenue waving his arms and claiming that Governor Rockefeller had seduced his wife, like that. He was totally off the wall" (Carruth interview, July 4, 2005). Laughlin was so close to Schwartz for so long that Saul Bellow inserted a Laughlin stand-in character ("Callahan") in *Humboldt's Gift*, his fictionalized version of Schwartz's life. Another problematic employee—or, probably more accurately, "consultant"—was Edouard Roditi, a longtime friend of Laughlin who had helped put together European editions of *New Directions in Prose and Poetry*. Roditi was the "supervisor of translations" for *Perspectives*, but internal Intercultural correspondence suggests that he was billing Intercultural for work that he never did, so Laughlin, with the board's blessing, cashiered him in November 1952. Elisabeth Mann Borgese—Thomas Mann's daughter—took over as translations supervisor after he was fired.

40. Carruth interview, July 4, 2005.

41. Hayden Carruth, *Beside the Shadblow Tree: A Memoir of James Laughlin* (Port Townsend, WA: Copper Canyon Press, 1999), 14.

42. Ibid., 16; Fellows in American Letters of the Library of Congress, *The Case Against the Saturday Review of Literature* (Chicago: Modern Poetry Association, 1949).

43. Carruth, *Beside the Shadblow Tree*, 14.

44. Carruth interview, July 4, 2005.

45. Hayden Carruth, *Reluctantly: Autobiographical Essays* (Port Townsend, WA: Copper Canyon Press, 1998), 75.

46. Carruth, *Beside the Shadblow Tree*, 9.

47. Ibid., 19. While at Bloomingdale, Carruth was unresponsive to most therapy, so his doctor prescribed that he write poems documenting his stay. These poems were later published as *The Bloomingdale Papers* (Athens: University of Georgia Press, 1975).

48. Carruth, *Beside the Shadblow Tree*, 18. Laughlin obviously understood what Carruth was going through because mental illness—in particular depression and bipolar disorder—ran in his own family, and he, his grandfather, his father, and (tragically) his children were afflicted. Laughlin's son Robert committed suicide in 1985 at age twenty-seven.

49. Tate to Laughlin, February 18, 1952, Box 58, IPI.

50. Laughlin to Tate, April 7, 1952, Tate Papers, Box 27, PUL.

51. Carruth interview, July 4, 2005.

52. James Laughlin, "The Publisher: The Function of This Magazine," *Perspectives USA* 1 (Fall 1952): 1.

53. Lionel Trilling, "Editor's Commentary," *Perspectives USA* 2 (Winter 1953): 5.
54. "Circulation and Pricing Memorandum," Box 29, IPI.
55. Documents in Alfred A. Knopf Archive, Box 576, Folder 4, HRC.
56. Laughlin to T. S. Eliot, February 10, 1951, New Directions Publishing Corp. Records, Series II, "Intercultural Publications" folder, HVD.
57. Laughlin to Tate, February 27, 1952, Tate Papers, Box 27, PUL.
58. Jacques Barzun, "Editor's Commentary," *Perspectives USA* 3 (Spring 1953): 6.
59. LeRoy Leatherman, "A Question of Image: The Dance–Theater of Martha Graham," *Perspectives USA* 4 (Summer 1953): 46.
60. Dave Brubeck, "Jazz Perspective," *Perspectives USA* 15 (Spring 1956): 27.
61. See Gregory Barnhisel, *James Laughlin, New Directions, and the Remaking of Ezra Pound* (Amherst: University of Massachusetts Press, 2005), for a fuller explanation of this alignment.
62. Arthur Mizener, "The Novel in America, 1920–1940," *Perspectives USA* 4 (Summer 1953): 138–39.
63. James Baldwin, "Everybody's Protest Novel," *Perspectives USA* 2 (Winter 1953): 97.
64. Mark McGurl, *The Program Era: Postwar Fiction and the Rise of Creative Writing* (Cambridge, MA: Harvard University Press, 2009).
65. Hayden Carruth, "Tradition in American Poetry," *Perspectives USA* 4 (Summer 1953): 14–16.
66. Laughlin to Alfred A. Knopf, November 24, 1952, Knopf Archive, Box 576, Folder 4, HRC.
67. Hayden Carruth, "The Poetry of Ezra Pound," *Perspectives USA* 16 (Summer 1956): 148, 153.
68. Healey, "Writing Communities," 210.
69. Ibid., 237–38.
70. The first comment comes from George Barker, "In All Directions," *The Nation*, March 21, 1942: 347; the second from Randall Jarrell, "In All Directions," *Partisan Review* 9, no. 4 (1942): 347; and the third from Gerard Previn Meyer, "Night-World Voyagers, and Others," *Saturday Review of Literature*, November 29, 1947: 30.
71. Both Schwartz and Rexroth are quoted in Healey, "Writing Communities," 169–70.
72. Jerome Mellquist, "Marsden Hartley," *Perspectives USA* 4 (Summer 1953): 73–74.
73. Cleve Gray, "Jacques Villon," *Perspectives USA* 3 (Spring 1953): 69.
74. Robert Goldwater, "Arthur Dove," *Perspectives USA* 2 (Winter 1952): 80.
75. Laughlin praised Lustig—who designed dozens of covers for *New Directions* between 1941 and his death in 1955—in effusive terms in *Print* magazine (October–November 1956). The Kind Company currently maintains a website devoted to Lustig on which reproductions of all of his work for New Directions, Knopf, and others are available (http://www.alvinlustig.com/index.php).
76. Selden Rodman, "Ben Shahn: Painter of America," *Perspectives USA* 1 (Autumn 1952): 88.
77. Ibid. Rodman, a few years older than Laughlin, was a minor fixture of the midcentury Ivy League/New York literary and intellectual scene. He founded the Yale literary magazine *Harkness Hoot*, which Laughlin had read while at Harvard; he played tennis with Ezra Pound in Rapallo; his sister Nancy married Dwight Macdonald and helped fund *Partisan Review*. He laid out his skeptical views about abstract expressionism most clearly in *The*

Insiders (Baton Rouge: Louisiana State University Press, 1960), particularly in the chapter "The Artist as Antihumanist" (30–37).

78. Kenneth Rexroth, "The Visionary Painting of Morris Graves," *Perspectives USA* 10 (Winter 1955): 58–59.

79. Laughlin to G. B. Cumming of the AFA, October 26, 1952, AFA Archive, AAA; Laughlin to Robert Wickham, 1953, New Directions Publishing Corporation records, Series I, "Ford Foundation" folder, HVD. In the end, the show included such paintings as Marsden Hartley's *Robin Hood Cove, Georgetown, Maine*; Kuniyoshi's *Mother and Daughter*; Georgia O'Keeffe's *Large Dark Red Leaves on White*; John Marin's *Heavy Seas in Reds and Greens*; Jack Levine's *Coronation of the King of Greece*; Charles Demuth's *My Egypt*; Milton Avery's *Anemones*; Jackson Pollock's *No. 8*; Ben Shahn's *Composition with Clarinets and Tin Horn*; and Charles Sheeler's *Winter Window*. Laughlin apparently expressed this same condescending attitude in public, unfortunately. Douglas Ensminger, the Ford Foundation's representative for India, wrote to Milton Katz that "both Laughlin and [Intercultural director Richard J.] Weil created very bad impressions in many places in both Pakistan and India. They called on the Education Minister in Pakistan and took on themselves the high and noble task of telling the Minister all of the shortcomings of Pakistan's educational system. . . . The American Embassy informed me that they have received more protests from the Bombay and Calcutta Consular Offices regarding the behavior of Laughlin and Weil than about any other people who have traveled in India the past year. . . . It appears to have been a lack of judgment public relationswise [*sic*] by being indiscreet in evaluating the competence or lack of competence of the Indian publishers" (February 6. 1953, Robert Maynard Hutchins Papers, addenda, Box 5, University of Chicago Special Collections Research Center).

80. Wayne Andrews, "Looking at the Latest of Frank Lloyd Wright," *Perspectives USA* 4 (Summer 1953): 115.

81. Hugh Morrison, "American Houses: Modern Style," *Perspectives USA* 5 (Fall 1953): 92.

82. Jacques Barzun, "America's Romance with Practicality," *Perspectives USA* 1 (Fall 1952): 83. Barzun had first delivered this essay as an address at Walter Paepcke's first Aspen Institute in 1951 and then it originally appeared in print in *Harper's* in 1952.

83. Archibald MacLeish, "The Irresponsibles," *The Nation*, May 18, 1940: 618–23.

84. Allen Tate, "To Whom Is the Poet Responsible?" *Perspectives USA* 6 (Winter 1953): 14.

85. Nathan Glick, "American Culture in Perspective," VOA script, May 25, 1953, LOC.

86. "Review of Progress, April 1952–December 1952," Box 29, "Background Material" folder, IPI.

87. Laughlin to Shepard Stone, February 5, 1954, Box 31, Folder S, IPI.

88. Minutes of Ford Foundation Board Meeting, February 23–26, 1953, Fund for the Republic Archive, Box 26 Folder 11, PUL.

89. Healey, "Writing Communities," 219.

90. Milton Katz to Laughlin, April 23, 1952, Box 30, "Milton Katz" folder, IPI.

91. Laughlin to Don Price, March 21, 1954, quoted in Volker Berghahn, *America and the Intellectual Cold Wars in Europe* (Princeton, NJ: Princeton University Press, 2001), 173–74.

92. Laughlin to Shepard Stone, March 27, 1954, quoted in ibid., 175.

93. James Laughlin, "1954 Annual Report on the Fund for Intercultural Activities," Box 29, IPI. Laughlin was joined in this strategy by a small, short-lived, but intriguing group called the "National Committee for an Adequate Overseas U.S. Information Program," headed by public-relations godfather Edward L. Bernays. Laughlin attended the group's conference in December 1954, at which it proposed a more effective public-relations campaign than the one at the time being run by the USIA: the National Committee worried that the USIA's campaign was too emotional, too focused on appealing representations of American life rather than on clear explanations of American objectives—too top-down from Washington and too transparently propagandistic. In 1955, Bernays wrote to Laughlin asking if Intercultural might work with the committee, but nothing came of that proposition (Edward L. Bernays to Laughlin, August 16, 1955, Box 38, "National Committee for an Adequate Overseas U.S. Information Program" folder, IPI).

94. Laughlin to Macdonald, October 20, 1955, Dwight Macdonald Papers, YALE. Macdonald's profile of the Ford Foundation stretched across four issues of the *New Yorker* in December 1955; the section discussing *Perspectives USA* appeared in the December 3 issue, on pages 102–5.

95. Alice Widener, "Who's Running the Ford Foundation?" *American Mercury*, June 1953: 3–7.

96. William J. Casey to Laughlin, March 5, 1953, Box 29, "IPI Board of Directors: Casey" folder, IPI.

97. Laughlin to Casey, April 6, 1953, Box 31, "IPI Board of Directors (Correspondence 1953)" folder, IPI; Corcoran, "Pure Child of a Wavering Mother," 49.

98. Casey to Laughlin, June 3, 1953, Box 29, "IPI Board of Directors: Casey" folder, IPI; Carruth to Laughlin, September 21, 1954, Box 37, "Hayden Carruth" folder, IPI. The Drucker article in question never appeared in *Perspectives*, although the journal had included his article "The American Genius Is Political" in the third issue.

99. The resolution authorizing the Reece Commission stated that its purpose was "to conduct a full and complete investigation and study of education and philanthropic foundations and other comparable organizations which are exempt from Federal taxation to determine if any foundations and organizations are using their resources for purposes other than the purposes for which they were established, and especially to determine which such foundations and organizations are using their resource for un-American and subversive activities; for political purposes; propaganda, or attempts to influence legislation" (HR 217, 83rd Cong., 1st sess. [1953]).

100. Norman Dodd, *Report of the Special Committee of the House of Representatives to Investigate Tax-Exempt Foundations, Nov. 1 1953–April 30, 1954* (New York: Long House, 1954), 15, available at http://www.scribd.com/doc/3768227/Dodd-Report-to-the-Reece-Committee-on-Foundations-1954, accessed May 20, 2014.

101. Thomas C. Reeves, *Freedom and the Foundation: The Fund for the Republic in the Era of McCarthyism* (New York: Knopf, 1969), 102.

102. Paul Jacobs, memos of December 11, 1955, meeting between Hutchins and ACCF, Fund for the Republic Archive, Box 199, Bolder 7, PUL. The ACCF publicly protested the Reece Commission, but its members (in particular Sidney Hook and James Farrell) were equally unhappy with Hutchins and the Fund for the Republic for their seeming unwillingness

to understand that Communists were uniquely dangerous to cultural freedom and thus should fall into a special category, except from usual protections (ACCF Papers, Box 14, Folders 3 and 9, TAM).

103. Wyzanski quoted in Corcoran, "Pure Child of a Wavering Mother," 49.

104. *Intercultural Publications President's Report 1954*, Knopf Archive, Box 577, Folder 3, HRC.

105. Frederick Burkhardt, "A Study of *Perspectives* in England, France, Germany, and Italy," July 15, 1954, Reel 1058, Grant 55-32, FFA; Carlo Ragghianti to Frederick Burkhardt, July 24, 1954, Reel 1058, Grant 55-32, section 4, FFA.

106. Knopf to Laughlin, September 30, 1954, Reel 1058, Grant 55-32, section 4, FFA.

107. Hugh Wilford, *The New York Intellectuals: From Vanguard to Institution* (Manchester, UK: Manchester University Press, 1995), 201.

108. Josselson quoted in Franklin Lindsay to Dyke Brown, Ford Foundation, memo, October 22, 1953, Reel 1058, Grant 55-32, section 4, FFA. Josselson suggested that European audiences would prefer Kissinger's cultural and political journal *Confluence* because it included more European content.

109. Quoted in Burkhardt, "A Study of *Perspectives* in England, France, Germany, and Italy," 38.

110. A. Manell, public-affairs officer, US embassy, Belgium, to USIA, Washington, DC, Foreign Service dispatch, March 13, 1954, Reel 1058, Grant 55-32, section 4, FFA.

111. Laughlin to Price, 1954, Knopf Archive, Box 576, Folder 4, HRC.

112. Publishers of *Perspectives USA*, "The Questionnaire," 1954 (?), Reel 1058, Grant 55-32, FFA.

113. George Kennan, "International Exchange in the Arts," *Perspectives USA* 16 (Summer 1956): 9–14.

114. Jason Epstein, "The CIA and the Intellectuals," *New York Review of Books*, April 20, 1967, http://www.nybooks.com/articles/archives/1967/apr/20/the-cia-and-the-intellectuals/, accessed May 20, 2014.

6. AMERICAN MODERNISM IN AMERICAN BROADCASTING

1. Foy Kohler to Wilson Compton, February 12, 1952, Howland Sargeant Papers, Box 5, "International Information Administration 1951–52 (2)" folder, HSTL. The IIA itself was created in January 1952 to replace the Office of International Information ("Establishment of the United States International Information Administration," January 16, 1952, in U.S. Department of State, Office of the Historian, *Foreign Relations of the United States* [*FRUS*], 1952–1954, vol. 2, part 2, Document 292).

2. Letter from FBI, November 13, 1957, RG 59, Bureau of Public Affairs, east–west contact staff, 1955–57, Box 19, NARA.

3. *Amerika*'s articles are in Russian, translated from American originals. The English versions of these articles may well be available elsewhere, but I found them in a bound volume of mimeographed pages collecting every article that appeared in each issue of the Polish version of the magazine (*Ameryka*), which largely duplicated the Russian edition.

Using the *Classification List of Articles in "America Illustrated"* for both the Russian edition and the Polish edition, I cross-referenced the articles from the Russian *Amerika* to the Polish *Ameryka* and thus found these versions. The texts I am quoting are not translations; they are transcripts of the original articles, all of which were originally in English. Most were reprints of previously published articles, but some, such as Nathan Glick's, were original to USIA. The mimeographed volume is available at RG 306, "Publications About the U.S.," NARA.

4. James L. Tyson, *U.S. International Broadcasting and National Security* (New York: Ramapo Press, 1983), 6. Tyson was a media executive who became a fierce critic of the American media during the 1970s and 1980s, charging that they had been infiltrated by the Soviets. His history of the early days of VOA, though, is quite even-handed.

5. Ibid., 21.

6. Mallory Browne to Gordon Gray, February 12, 1952, PSB Files, Box 3, "Radio Free Europe" folder, HSTL.

7. William Benton to Harry S. Truman, May 9, 1947, and Truman to Benton, May 14, 1947, Harry S. Truman Papers, Official File, Box 165, "Voice of America 1" folder, HSTL. "MacLeish's operation" was the Office of Facts and Figures, and Truman was referring to *New York Times* columnist Arthur Krocks, Virginia senator Harry Flood Byrd, and New Hampshire senator Styles Bridges.

8. HR 5736, 112th Cong., 2nd sess. (2013).

9. David F. Krugler, *The Voice of America and the Domestic Propaganda Battles, 1945–1953* (Columbia: University of Missouri Press, 2000), 75.

10. Shawn J. Parry-Giles, *The Rhetorical Presidency, Propaganda, and the Cold War 1945–1955* (Westport, CT: Praeger, 2002), 79.

11. Alan L. Heil Jr., *Voice of America: A History* (New York: Columbia University Press, 2003), 49; Timothy Stoneman, "A Bold New Vision: The VOA Radio Ring Plan and Global Broadcasting in the Early Cold War," *Technology and Culture* 50, no. 2 (2009): 316–44.

12. Robert Pirsein, *The Voice of America: A History of the International Broadcasting Activities of the United States Government, 1940–1962* (New York: Arno Press, 1979), 147.

13. Ibid., 274.

14. "Jackson Committee Report (Abridged)," White House Office, NSC Staff Papers 1953–1961, PSB Central Files, Box 22, "Jackson Committee Report (abridged)" folder, DDEL.

15. Dwight D. Eisenhower to Benton, May 1, 1953, Eisenhower Diary, Box 3, "Dec 52–July 53 (3)" folder, DDEL.

16. Eisenhower quoted in John Foster Dulles to USIA director Arthur Larson, June 27, 1957, *FRUS 1955–1957*, vol. 9, 590.

17. Eisenhower to Benton, May 1, 1953, Eisenhower Diary, Box 3, "Dec 52–July 53 (3)" folder, DDEL. Benton, who had served as assistant secretary of state for public affairs under Truman and then as a senator from Connecticut, lost his reelection bid in 1952 and was at this time in private life.

18. "Jackson Committee Report (Abridged)."

19. The stories discussed in this chapter are the master scripts, which have been collected on microfilm reels and are held at the Library of Congress; the actual daily broadcast schedules and transcripts for each language service are available at the National Archives and Records Administration's Archives II facility in Maryland; other depositories, such as the Hoover Institution Library at Stanford University and the Bakhmeteff Archive at Columbia University's Rare Book and Manuscript Library, hold extensive but not complete collections of transcripts and broadcast schedules.

20. Pirsein, *Voice of America*, 372–73, quoting the administration and Larson.

21. Bertram Wolfe, "Aragon Repents; Picasso Dissents," VOA script, March 20, 1953, LOC.

22. VOA broadcast, February 19, 1956, COL; Nathan Glick, "Death of Prokofieff," VOA script, March 10, 1953, LOC.

23. Nathan Glick, "The Soviet Writers Congress," VOA script, December 16, 1954, LOC.

24. Bettina Hartenbach, "A Literary Stir Behind the Curtain," VOA script, June 14, 1956, LOC; "Literary Review #1," VOA transcript, February 26, 1956, COL.

25. Paul Nadanyi, "Literary Debacle in Hungary," VOA script, March 19, 1958, LOC.

26. Bettina Hartenbach, "Brooks Atkinson on the Soviet Theater," VOA script, January 14, 1958, LOC.

27. Sol Stein, "The Lost Meaning of Freedom," VOA script, January 26, 1953, LOC; Harry Sylvester, "*Declaration of Freedom*," VOA script, June 9, 1955, LOC; Don Agger, "The Freedom to Write," VOA script, May 23, 1957, LOC.

28. "The Future of Freedom," VOA script, September 12, 1955, LOC; Leonard Reed, "Aspects of Political and Economic Freedom," VOA script, September 13, 1955, LOC.

29. Press releases, RG 59, Entry P229, VOICE OF AMERICA (issues of *VOA Radio News* and related materials, 1951–1953), Box 1, NARA.

30. *Report on the Arts, USA*, no. 107, VOA script, October 23, 1952, RG 306, "VOA Research Reports," Box 5, Folders 1328–32, NARA.

31. *Arts and Letters*, no. 101, aired October 24, 1951, and *Arts and Letters*, no. 121, aired March 12, 1952, Voice of America Broadcast Master Scripts, RG 306, NANY.

32. *Arts and Letters*, aired March 21, 1951, Voice of America Broadcast Master Scripts, RG 306, NANY. After Hellman was called in front of the House Committee on Un-American Activities in 1952, and after her books were put on the proscribed lists for overseas libraries in 1953, it is unlikely that she would have been featured again on VOA programming.

33. *Arts and Letters*, aired March 21, 1951.

34. Internal VOA memo, 1952, RG 59, Entry P229 (issues of *VOA Radio News* and related materials, 1951–1953), Box 1, "Europe—Steinbeck" folder, NARA.

35. Press release, March 5, 1952, RG 59, Entry P229 (issues of *VOA Radio News* and related materials, 1951–1953), Box 1, NARA.

36. Press release, September 22, 1958, John Foster Dulles Papers, Public Policy Papers, Box 125, "George V. Allen" folder, Department of Rare Books and Special Collections, PUL.

37. VOA conducted frequent analyses of its audience's reactions to programming and compiled excerpts from the foreign media's responses to VOA messages. These audience studies asked refugees from the target nations to answer questions (such as "Is America an

uncultured nation?") and to discuss their reactions to VOA programming. These surveys and reports are collected with the VOA microfilm reels at the Library of Congress and are also available at the National Archives in Maryland.

38. Harry Sylvester, "America's First Modern Art Collection," VOA script, April 6, 1955, LOC.

39. "Mecca of Modern Art," *Amerika* 44 (1959): 56.

40. Lloyd Goodrich, "Art in Mid-century American Society," in Lamar Dodd, ed., *Voice of America Forum Lectures: Visual Arts in Mid-century America* (Washington, DC: USIA, 1961), 2, 7.

41. Bartlett Hayes, "The Cultural Environment"; McNeil Lowry, "Economics of the Arts in America"; and Goodrich, "Art in Mid-century American Society," all in Dodd, *Voice of America Forum Lectures*, unpaginated.

42. Huntington Hartford, "The Public Be Damned," *American Mercury*, March 1955: 35–42, reproduced at http://www.unz.org/Pub/AmMercury-1955mar-00035.

43. Harry Sylvester, "Another Controversy in Modern Art," VOA script, May 19, 1955, LOC.

44. Harry Sylvester, "The Controversy Over Modern Music," VOA script, April 13, 1955, LOC.

45. Nathan Glick, "American Culture: Highbrow and Lowbrow," VOA script, January 29, 1953, LOC.

46. Harry Sylvester, "The 'Great Books' Program," VOA script, September 19, 1955, LOC.

47. "Robert Hillyer on Amy Lowell and the Imagists," VOA script, July 21, 1952, NANY; David Levine, "Dos Passos Gets an Award," VOA script, May 22, 1957, LOC; Harry Sylvester, "Wallace Stevens: American Poet," VOA script, May 16, 1955, LOC; Ed Gordon, "T. S. Eliot in the United States," VOA script, May 15, 1956, LOC.

48. Karl Shapiro, "Recent American Poetry," *Amerika* (Polish ed.) 32: unpaginated.

49. See *Voice of America Forum Lectures: Contemporary American Poetry* (Washington, DC: Voice of America, 1965).

50. Harry Sylvester, "William Faulkner," VOA script, May 10, 1955, LOC. See also Don Agger, "Faulkner at Sixty," VOA script, September 19, 1957, LOC; and Ed Gordon, "'The Bear': A Faulkner Theme," VOA script, October 9, 1956, LOC.

51. John Pauker, "Wallace Stevens on Connecticut," "Kenneth Rexroth on San Francisco," and "William Carlos Williams on Rutherford, New Jersey," VOA scripts, all July 1955, LOC; "Marianne Moore on Brooklyn, New York," March 14, 1957, VOA script, LOC. Pauker wrote the emcee/host copy in which the eminent writers' words were embedded, so he is credited as the writer on the scripts.

52. Don Agger, "*J.B.*: A Modern Classic?" VOA script, May 1, 1958, LOC, for the Atkinson quote; "*J.B.*: The Pulitzer Prize Play," VOA broadcast script, May 5, 1959, LOC; "Thornton Wilder," VOA script, January 23, 1958, LOC.

53. "*J.B.*: The Pulitzer Prize Play"; "Thornton Wilder."

54. Dulles to Mary Martin, August 4, 1955; Martin to Dulles, August 1955, Dulles Papers, Public Policy Papers, Department of Rare Books and Special Collections, PUL.

55. Don Agger, "Robert Frost: The Poet's Poet," VOA script, February 6, 1958, LOC; Don Agger, "A New Honor for Robert Frost," VOA script, May 27, 1958, LOC; Don Agger, "Robert Frost at Eighty-Five," VOA script, March 24, 1959, LOC.

56. Ed Gordon, "Willa Cather's American Southwest," VOA script, October 2, 1956, LOC; Ed Gordon "Thomas Wolfe: The Man and His Letters," VOA script, October 16, 1956, LOC; Ed Gordon, "Carl Sandburg: America's Minstrel," VOA script, February 13, 1959, LOC.

57. Don Agger, "The 'Beat Generation,'" VOA script, August 22, 1958, LOC; D. C. Levine, "*Poetry: A Magazine of Verse*," VOA script, February 25, 1958, LOC; Don Agger, "Tennessee Williams: Poet of Violence," VOA script, March 19, 1959, LOC; Don Agger, "J. D. Salinger: Spokesman for a Generation," VOA script, November 6, 1959, LOC; Ed Gordon, "*New World Writing* Enters Its Fifth Year," VOA script, April 16, 1956, LOC.

58. Karl Shapiro, "The Power of Little Magazines," *Amerika* (Polish ed.) 19 (n.d.): unpaginated.

59. Don Agger, "Van Wyck Brooks and the Role of the Writer," VOA script, June 18, 1957, LOC; Hunton Downs, "Man in Modern Fiction," VOA script, January 29, 1959, LOC; Don Agger, "Writing in America: The *Harper's* Symposium," VOA script, October 1, 1959, LOC.

60. Nathan Glick, "Trends in the Modern American Novel," *Amerika* 54 (1960): 50.

61. Harry Sylvester, "Martha Graham's Dance Tour," VOA script, April 25, 1956, LOC; Don Agger, "O'Neill's *Long Day's Journey Into Night*," VOA script, May 8, 1957, LOC; Don Agger, "The Guggenheim Museum," VOA script, November 30, 1959, LOC; Don Agger, "Genius at Eighty-Eight: Frank Lloyd Wright," VOA script, October 17, 1957, LOC; Don Agger, "Design in Motion: Calder's Mobiles," VOA script, August 18, 1959, LOC; Don Agger, "Steichen: The Art of Photography," VOA script, April 30, 1959, LOC.

62. From Conover's own notes for a never-completed autobiography, quoted in Terence M. Ripmaster, *Willis Conover: Broadcasting Jazz to the World* (Princeton, NJ: iUniverse, 2007), 24.

63. William F. Gavin, quoted in ibid., 26.

64. Harry Sylvester, "A New Book About American Jazz," VOA script, September 8, 1955, LOC; Ed Gordon, "*The Story of Jazz*," VOA script, November 28, 1956, LOC; Don Agger, "Gershwin: An International Language," VOA script, July 7, 1958, LOC; Ed Gordon, "Jazz, the Reverend Kershaw, and the Listener Overseas," VOA script, March 19, 1956, LOC.

65. Harry Sylvester, "A New Kind of Musical Show," VOA script, June 1, 1955, LOC.

66. Leonard Reed, "*Porgy* Goes Abroad Again," VOA script, November 27, 1955, LOC.

67. Quoted in Penny von Eschen, *Satchmo Blows Up the World: Jazz Ambassadors Play the Cold War* (Cambridge, MA: Harvard University Press, 2006), 4.

68. Leonard Reed, "*Porgy* Goes Abroad Again," VOA script, November 27, 1955, LOC.

69. VOA transcript, March 19, 1956, COL.

70. VOA transcript, March 23, 1956, COL; Don Agger, "*A Raisin in the Sun*," VOA script, May 28, 1959, LOC.

71. Norman Jacobs, "American Negro Leaders Appeal to Premier Malenkov," VOA script, October 23, 1953, LOC; Z. Metz, "The Next President of the Borough of Manhattan Will Be a Negro," VOA script, October 20, 1953, LOC; Leonard Reed, "The Negro in America

Today," VOA scripts, October 6–8 and 20, 1954, LOC; Alan Paton, "The Negro in America Today," *Collier's*, October 15, 1954: 52–67. The six who signed the letter to Malenkov were clergyman Adam Clayton Powell Jr., Lester B. Granger of the Urban League, A. Philip Randolph of the Brotherhood of Sleeping Car Porters, Edward Welsh of the Congress of Industrial Organizations, Frank Crosswaite of the Negro Labor Committee, and George Schuyler of the *Pittsburgh Courier*.

72. See Joan Shelley Rubin, *The Making of Middlebrow Culture* (Chapel Hill: University of North Carolina Press, 1992), and Catherine Turner, *Marketing Modernism Between the Two Wars* (Amherst: University of Massachusetts Press, 2004).

CONCLUSION

1. George V. Allen, interview, April 7, 1966, 27, John Foster Dulles Oral History Project, PUL.

2. Lynn Keller, *Re-making It New: Contemporary American Poetry and the Modernist Tradition* (New York: Cambridge University Press, 1987), 10.

3. Brian McHale, *Postmodernist Fiction* (New York: Routledge, 1989), 10.

4. Leslie Fiedler, "Cross the Border—Close the Gap," in *A New Fiedler Reader* (Amherst NY: Prometheus, 1999), 272–73.

5. Jean-François Lyotard, "What Is Postmodernism?" trans. Régis Durand, in *The Postmodern Condition* (Manchester, UK: Manchester University Press, 1984), 81, emphasis in original.

6. Marianne DeKoven, *Utopia Limited: The Sixties and the Emergence of the Postmodern* (Durham, NC: Duke University Press, 2004), 17.

7. C. Wright Mills, *The Sociological Imagination* (1959; reprint, New York: Oxford University Press, 2000), 166.

8. Perry Anderson, *Origins of Postmodernity* (London: Verso, 1998), 13.

9. Don Agger, "The 'Beat Generation,'" VOA script, August 22, 1958, LOC.

10. Susan Sontag, "Against Interpretation," in *A Susan Sontag Reader* (New York: Vintage, 1983), 104.

11. Granville Hicks, "Themes in Contemporary American Fiction," *Amerika* (Polish ed.) 28 (n.d.): unpaginated.

12. Hilton Kramer, "The Age of the Avant-Garde," in *The Age of the Avant-Garde 1956–1972* (New York: Transaction, 2008). Also see J. David Hoeveler, *Watch on the Right: Conservative Intellectuals in the Age of Reagan* (Madison: University of Wisconsin Press, 1991), 118–19.

13. Hilton Kramer, *Twilight of the Intellectuals: Culture and Politics in the Era of the Cold War* (Chicago: Ivan R. Dee, 1999), xii.

14. Jürgen Habermas, "Modernity: An Incomplete Project," in *The Anti-aesthetic: Essays on Postmodern Culture*, ed. Hal Foster (New York: New Press, 2002), 7; also see Fredric Jameson, *Postmodernism, or the Cultural Logic of Late Capitalism* (Durham, NC: Duke University Press, 1990).

15. The statistics come from Nielsen Company, Television Bureau, *TV Basics: A Report on the Growth and Scope of Television* (New York: Nielsen, 2010), http://www.tvb.org/media/file/TV_Basics.pdf, accessed May 22, 2014.

16. Anderson, *Origins of Postmodernity*, 88.

17. James Laughlin to Robert Hutchins, February 19, 1951, Robert Maynard Hutchins Papers, addendum (accession 86-39), University of Chicago Special Collections Library.

18. Elizabeth Eisenstein, *The Printing Press as an Agent of Change: Communications and Cultural Transformations in Early Modern Europe*, 2 vols. (Cambridge: Cambridge University Press, 1979); Marshall McLuhan, *The Gutenberg Galaxy* (Toronto: University of Toronto Press, 1962).

19. George Kennan, "'That Candles May Be Brought . . . ,'" *Encounter* 14, no. 2 (1961): 72–74.

20. Stamford (CT) Historical Society, "Portrait of a Family: Stamford Through the Legacy of the Davenports: Abraham Davenport 1715–1789," 2009, http://www.stamfordhistory.org/dav_abraham1.htm, accessed September 17, 2013.

INDEX

Conover, Willis, 4, 242–243
Conquistador (poem), 37
conservative populists, 92
"containment," 268n70
Convery, W. J., 72
Coon, Carleton, *Adventures of the Mind*, 118
Coover, Robert, 251
Copland, Aaron, 139–140, 233
Corcoran, Matthew, 185
Cornford, Ernest, "Lost Sailor," 168
corporate use, of modernism, 66, 67
A Corporation Collects: The Glen Alden
 Corp. show, 69–70
Cortissoz, Royal, 30–31
Council on Books in Wartime, 95–96
Cowley, Malcolm, 136, 235, 238; *Portable
 Faulkner*, 124–125
Cox, Kenyon, 30–31
Craven, David, 8
The Criterion, 161, **161**, 162
Cronin, Anthony, 170, 171
Crossman, Richard, *The God That Failed*, 53,
 116, 142
"The Cross" (poem), 194
Crowell, Robert L., 110–112, **111**
Cuadernos (magazine), 147
cultural diplomacy, 69, 72–74, 124–125, 185
"cultural freedom," 28
The Cultural Cold War (Saunders), 7, 139
The Cultural Contradictions of Capitalism
 (Bell), 1, 254
culture, Kennan on, 215
Cummings, E. E., 198
The Cycle of American Literature (Spiller), 97

Dada movement, on bourgeois society and
 aesthetic autonomy, 37
Dali, Salvador, 26
Dallas County Patriotic Council, 76
Dallin, David J., *New Soviet Empire*, 116
Darkness at Noon (Koestler), 116, 142
Davenport, Abraham, 258
Davidson, LeRoy, 58, 59, 61, 67
Death Comes for the Archbishop (Cather), 239
Declaration of Freedom (Trueblood), 226

DeKoven, Marianne, 253; *Utopia Limited*, 252
Demuth, Charles, 231–232
de-Nazification, 120–121
Department of State, 94, 185
Der Monat, 148–149, 183–184, 213
Desert Music (Williams), 121–122
"The Destruction of Tenochtitlán" (Williams),
 198
"The Devil and Daniel Webster" (Benèt), 227
Dewey, John, 42
d'Harnoncourt, Rene, 226–227
Dictionary of Marxist Thought, 46
Dirksen, Everett, 95
Dix, Otto, 88
Doctor Zhivago, 225
Doctrinal Warfare panel, 101
*Documentary History of the Negro People in the
 U. S.* (Aptheker), 134
Dodd, Lamar, 231
Dodd, Norman, 211–212
Dondero, George, 62, 64, 81, 92, 210
Donnelly, Albert, 146
Dos Passos, John, 235; *U. S. A.* trilogy, 121–122
Doubleday, 93–94
Dove, Arthur, 200, 202, **208**
Dreiser, Theodore, *An American Tragedy*, 114,
 119–120; *Sister Carrie*, 114, 119–120
Drucker, Peter, 211
Dudziak, Mary, *Cold War Civil Rights*, 134
Dulles, John Foster, 238–239
Dymschitz, Alexander, 52

Eagleton, Terry, 34
Eberhart, Richard, 197, 198
Economic Cooperation Act (1948), 101–102,
 103
"economic freedom," 226
economics, of modernism, **179–216**
Edman, Irwin, 200
Eisenhower, Dwight, 230; Allen (George)
 and, 83, 249; on American National
 Exhibition (Moscow, 1959), 87; on artistic
 freedom, 80–81; on cultural-diplomatic
 programs, 73–74; election of, 72–73; on
 exchange and "people-to-people activity,"

Soviets, attitudes of, 50, 52; official stance against abstraction and "formalism" of, 275n123
The Soviet Slave Empire (Herling), 116
Soviet Writers Union, 225
Spaeth, Edith, 70–71
Spencer, Ted, 200
Spender, Stephen, 150; article ideas from, 157–158; on artistic fire of modernism burning out, 170–171; on CCF, 148; on Communist epistemology, 53; as editor of *Encounter*, 149–150; on Eliot, 174–175; on *Encounter*, 151, 160, 174; extended invitations to eminent writers, 166; on Fiedler's article, 159–160; on Masterpieces festival, 145; on materialism of contemporary society, 174; on modernism, 168; on Osborne, 173; on print, 257–258; relationship with Josselson, 151–152, 173; relationship with Kristol, 152–154; resignation of, 156
Sperber, Manès, *The Burned Bramble*, 228; Freedom Manifesto, 142
Spiller, Robert E., *The Cycle of American Literature*, 97
Spirit of Liberty (Hand), 118
State Department, 60, 102–103
Stefan, Karl, 94
Steichen, Alfred, 242
Stein, Gertrude, 32, 146, 181, 251–252; *Selected Writings*, 121–122
Steinbeck, John, 241; *The Grapes of Wrath*, 228
Steiner, George, 165
Steinway and Sons, 66–67
Sterling, Dorothy, *Tender Warriors*, 134
Stevens, Wallace, 197, 235–236, 237; "The Auroras of Autumn," 198; *The Man with the Blue Guitar*, 121–122; "To an Old Philosopher in Rome," 198, 200
Stevenson, Augusta, *Booker T. Washington: Ambitious Boy*, 133; *George Washington Carver: Boy Scientist*, 133
St. John de Crèvecoeur, Hector, 45
Stone, Shepard, 185, 209, 212–213
"Stopping by Woods on a Snowy Evening" (poem), 239

The Story of Temple Drake (film), 124
Strange Interlude (O'Neill), 121–122
Straumann, Heinrich, 135; *American Literature in the Twentieth Century*, 121
Streibert, Theodore, 75, 76, 77, 79–80, 223, 224
Studs Lonigan trilogy (Farrell), 121–122
Sweeney, James Johnson, 145
Swenson, May, 197
Sylvester, Harry, 230, 236
Symbolisms from Poe to Mallarmé: The Growth of a Myth (Chiari), 171
Syrett, Harold, *History of the American People*, 133

Taber, John, 61, 210, 220
Tannenbaum, Frank, *Philosophy of Labor*, 117
Taper, Bernard, *Gomillion Versus Lightfoot: The Tuskegee Gerrymander Case*, 133–134
"The Tarantula of Love" (poem), 168
Tate, Allen, 187, 188, 193; "The Cross," 194; "To Whom Is the Poet Responsible?," 205
Tate Gallery show, 58
television, 256
Telstar satellite, 256
Tempo Presente (magazine), 147
Tendenzpoesie, 165
Tender Warriors (Sterling), 134
Theory of the Avant-Garde (Bürger), 36
The Thin Man (Hammett), 115
"Third World," 250
This I Believe series, 229
Thomas, Benjamin, *Abraham Lincoln*, 119
Thompson, Virgil, 146
Thoreau, Henry David, *Walden*, 45
"Three Players of a Summer Game" (Williams), 196
"To an Old Philosopher in Rome" (poem), 198, 200
Tobacco Road (film), 95
Tocqueville, Alexis de, 45
Toklas, Alice, 181
totalitarianism, 53–54, 182
"To the Youth of Japan" (Faulkner), 129
Tournès, Ludovic, 289n2